D1384866

AMERICAN ART & ARTISTS

Series Editor: Brenda Gilchrist

THE AMERICAN SCENE

AMERICAN PAINTING OF THE 1930's

MATTHEW BAIGELL

PRAEGER PUBLISHERS · NEW YORK · WASHINGTON

Property of Library
Cape Fear Community College
Wilmington, NC

Published in the United States of America in 1974
by Praeger Publishers, Inc.
111 Fourth Avenue, New York, N.Y. 10003

© 1974 by Praeger Publishers, Inc.

All rights reserved

No part of this publication may be reproduced, stored in a retrieval system, or transmitted in any form or by any means, electronic, mechanical, photocopying, recording, or otherwise, without the prior permission of the copyright owner.

Library of Congress Cataloging in Publication Data

Baigell, Matthew.
 The American scene: American painting in the 1930's.
 (American art & artists)
 Bibliography: p.
 1. Painting, American. 2. Federal Art Project. 3. Social realism.
I. Title. II. Series.
ND212.B28 759.13 72–89639
ISBN 0-275-46620-5

Design by Ray Ripper

Printed in the United States of America

FOR RENEE

CONTENTS

I owe a special debt of gratitude to Brenda Gilchrist of Praeger Publishers for her expert guidance in all matters pertaining to this book. I also want to thank Jane Roos for her excellent editorial supervision, Ellyn Childs for her help in seeing the book through production, and Ray Ripper for his imaginative integration of text and illustrations. I am grateful, too, to those graduate students who shared with me the pleasure of exploring the art of the 1930's.

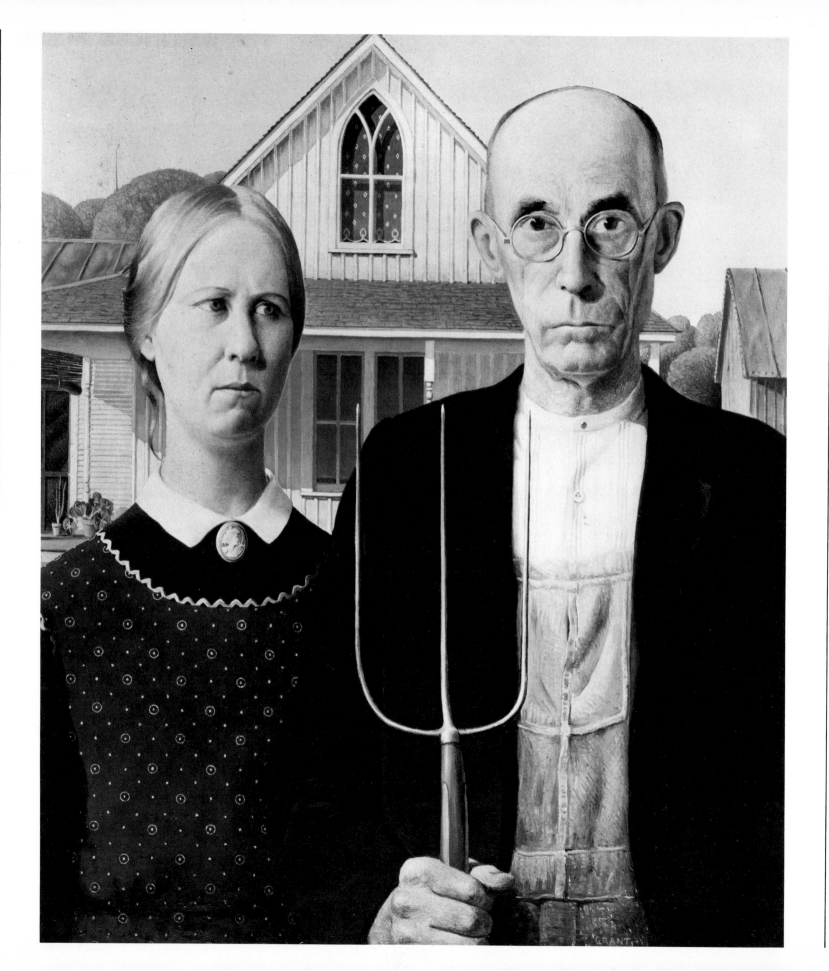

INTRODUCTION

Try, for a moment, to reconstruct images of the 1930's in your mind's eye. More than likely, your imagination will focus upon scenes that are derived from familiar paintings: a dust-bowl landscape, a dour Middle Western couple, or perhaps some Bowery derelicts (*Ill. 1, Colorplates 1–2*). Now, think back to any other decade of the twentieth century. Your images are probably based on photographs or on motion picture stills. Surprising, isn't it, that paintings from the 1930's have so completely insinuated themselves into American culture, even though this period has yet to receive adequate critical attention.

How can we account for the popularity of these images? Rarely had painters recorded so directly the great and immediate social issues and cultural problems of the day. In their search for a key to the perplexities facing virtually everyone, artists of the 1930's charted and documented the body of America as never before. They explored cities, small towns, and rural hamlets, and they painted, it would seem, every street and farm between Maine and California. In their search for clues, they scrutinized hay wagons and modern automobiles, revival meetings and urban political gatherings, dirt farms and enormous industrial complexes, quiet side streets and roaring midways (*Ill. 2, Colorplates 3–5*). Some wanted to return to the simpler ways of an earlier time; others chose to search the past for new beginnings. A few sought radical change and lent their art to revolutionary causes, while others were content to sit back and let the national scene unwind across their canvases. In any case, art had clearly entered the arena of life. The public of the 1930's could easily identify with these paintings; this remains true in the 1970's, despite the serious critical neglect. Current interest in the art of the 1930's, therefore, should not be viewed merely as a pretext for nostalgia and sentimentality, but as a genuine effort to recapture a large area of common human experiences.

The desire to document the look and feel of the country was a nationwide affair, even before the advent of the government projects in 1933. Views of the hallowed past, of the squalid present, and of a possibly happier future appeared with consistent regularity (*Ills. 3–5*). Certainly, the Depression prompted an increased exploration of American themes, since artists shared the same confusions as the general public. But it is also clear that the impetus to paint realistic American subject matter had been gathering strength in the years immediately preceding 1929.

The more nationalistic aspects of the "Paint America" movement were fed by the promise of an American Renaissance, which reflected a belief in the strength of American art as much as a rejection of modern European art and culture. Politically radical artists in particular found little worth in the preservation and perpetuation of recent European art. A wide range of artists therefore helped to give character and shape to what became known as the "American Scene movement." As the decade of the 1930's advanced, critics and public alike began to distinguish two major groups within the movement— the "Regionalists" and the "Social Realists." Artists were not necessarily happy with these labels, but, in a polemical age, they became rallying points for discussion, arguments, and antagonism. As much as the artists rejected the heritage of the immediately preceding modernist generation abroad, they abused their enemies at home.

Yet, there was more camaraderie among artists than ever before. Most were poor, their sources of economic sustenance having disappeared early in the Depression. Most took a turn on one or another of the government programs. These shared experiences helped to create a sense of artistic community that had been denied to earlier American artists.

The American Scene movement ended with the decade of the 1930's. Committed to the political, cultural, and social problems of the moment, it passed away in the face of problems demanding different kinds of approaches and solutions; truly a temporal phenomenon, the American Scene did not survive its time. If one must conclude, however, that it failed to survive because it owed its allegiance less to art than to the moment, one must also admit that the movement reflected its time with profound insight and in ways that are still important to future generations. For that we may be thankful.

The American Scene movement did not develop one characteristic style or reflect a single point of view. Thus, we cannot easily define the term or designate works that are representative of the entire movement. There are no paintings that epitomize the American Scene in quite the same way as Picasso's *Demoiselles d'Avignon* or *Ma Jolie* epitomizes the development of Cubism.

Usually, only those artists called "Regionalists" are considered to

13

2. Cameron Booth, *Iron Mines*, ca. 1939. Oil, 29½ x 45½ inches. The Minneapolis Institute of Arts.

1. Grant Wood, *American Gothic*, 1930. Oil, 29⅞ x 24⅞ inches. Courtesy The Art Institute of Chicago; Friends of American Art Collection.

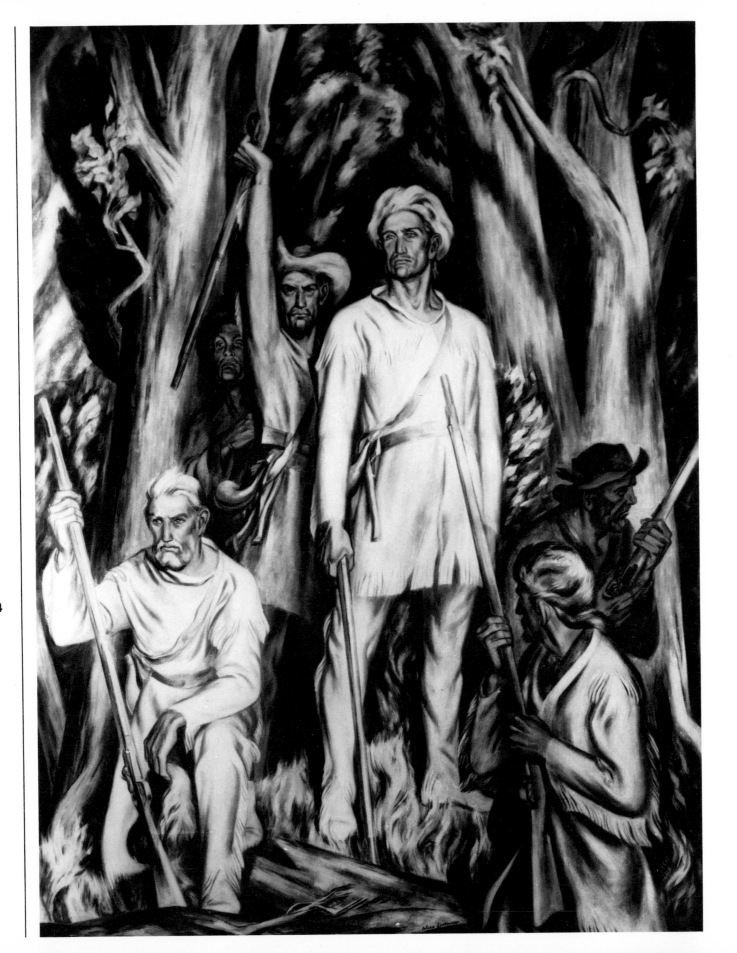

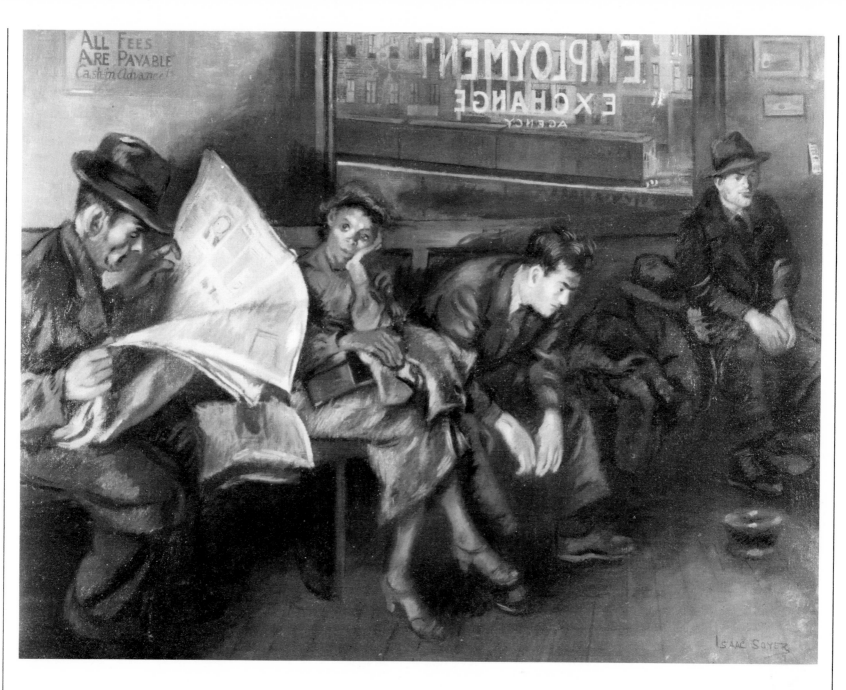

3. Ward Lockwood, *Daniel Boone*, ca. 1937. Post Office, Lexington, Kentucky. (Section of Fine Arts.) Photograph, Public Buildings Service.

4. Isaac Soyer, *Employment Agency*, 1937. Oil, 34½ x 45 inches. Collection Whitney Museum of American Art, New York.

be members of the American Scene movement, even though the Social Realist group also depicted themes from the American scene. Because the two groups shared common assumptions about the function of art and about its relationship to society, I see no reason to maintain rigid distinctions between them—particularly since neither group ever projected one comprehensive style or even a clearly defined set of attitudes. But since there are important differences between the Regionalist Thomas Hart Benton and the Social Realist Ben Shahn, I have used the traditional terms when appropriate. Quite simply, I would like to have it both ways.

I have omitted from this account artists who painted the American scene but who are not identified with the American Scene movement. The painters associated with Robert Henri are more properly considered as an earlier chronological group, even though the small-town and village neighborliness appearing in their work often recurs in American Scene painting. I have not considered Precisionists such as Charles Demuth and Charles Sheeler who, in the 1920's, developed styles that were antithetical to those of American Scenists. Fascinated with the forms of the environment rather than with the environment itself, these artists never developed such characteristic American

Scene traits as an interest in topicality, in anecdote, and in local custom. Two other figures, Charles Burchfield and Edward Hopper, were not included because their mature styles were formed well before 1930. Furthermore, their art reflects more of the sense of despair, alienation, and isolation that was characteristic of intellectual life in the 1920's. One may profitably view their paintings as pictorial equivalents of the writings of Harold Stearns, the earlier Van Wyck Brooks, or Joseph Wood Krutch—not to say those of T. S. Eliot. I considered as American Scene painters those who found their subject matter in various aspects of American life and who formed their mature styles around 1930. Representative figures include Thomas Hart Benton, Grant Wood, John Steuart Curry, Reginald Marsh, Ben Shahn, and Stuart Davis.

Because American Scene painting is almost automatically associated with some form of artistic or political isolationism, thus hindering unbiased observation, I have considered the origins and early chronology of the movement in greater detail than its termination. Furthermore, the basic premises of American Scene painting had been elaborated by 1935, and its subsequent history, although fascinating as social commentary, does not require the same kind of attention.

5. William Gropper, *Construction of Dam*, 1937. Department of the Interior, Washington, D.C. (Section of Fine Arts.) Photograph, Public Buildings Service.

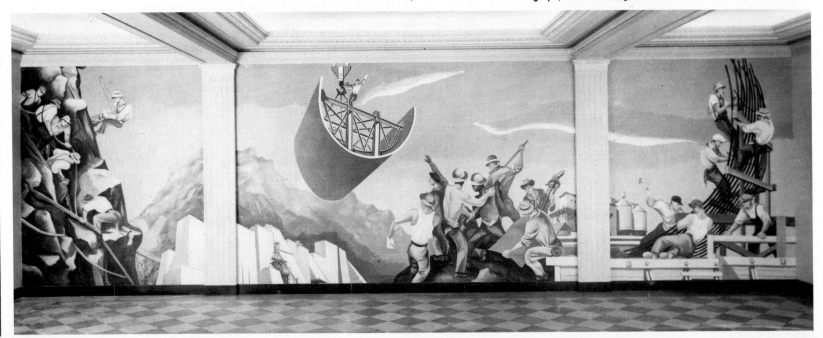

PART 1

THE AMERICAN SCENE

THE AMERICAN WAVE

THE GOVERNMENT PROJECTS

REGIONALISM AND SOCIAL REALISM

THE END OF THE 1930'S

THE AMERICAN SCENE

THE AMERICAN WAVE

The first clear evidence of the movement known as the *American Scene* appeared during the exhibition season of 1931–32. Initially, the movement was termed "the American Wave," a phrase that was used to describe an ambience that pervaded the art world, a feeling that gripped it, rather than a particular style or a specific group of painters. As characterized by Peyton Boswell, Sr., editor of *The Art Digest* and a major supporter of the trend, the American Wave was "a movement looking forward to the production of works of art that, avoiding foreign influences, actually expressed the spirit of land." This attempt to detach American art from foreign entanglements encouraged as well a re-evaluation of indigenous artistic traditions. Thus American folk art and movements such as the nineteenth-century Hudson River School, which had long been disregarded, began to receive new and enthusiastic attention.[1]

The American Scene was a movement of hope and optimism, of self-recognition and self-glorification—a movement that looked to the future as well as to the past. Complex and contradictory, it represented the fervent wish that America had artistically come of age and that it would now create an art expressive of its own traditions and aspirations. Many observers regarded the American Scene as the next step in the evolution of modern art and, at the same time, as the ultimate rejection of the entire modern movement as it had evolved in Europe.

Clearly, the aims of the American Scene were different from those of the European groups such as the School of Paris. The American Scene reflected an increased interest in realistic painting and a growing willingness of artists to become effective, even active, members of their communities, by sharing their experiences with the general public. For the public, it indicated a desire to enjoy an art in which their own likenesses and lives were mirrored. Perhaps for the last time in this century, the American Scene attempted to develop a democratic art easily accessible to the ordinary person, capable of moving him nostalgically, politically, and esthetically, by means of commonly recognizable images presented in easily understood styles.

The American Scene marked the rejection of personal sensibility as a dominant avenue of communication, cognition, and spiritual exploration. The imperatives of place, politics, social change, and history replaced individual consciousness as sources of artistic motivation. Once again, art was to become a vehicle for recording things more permanent and concrete than moments of personal experience, insight, and feeling. The American Scene reflected, as Lionel Trilling once remarked on American culture in general, "the chronic American belief that there exists an opposition between reality and mind and that one must enlist oneself in the party of reality."[2]

Although the American Scene fully emerged during the exhibitions of 1931–32, a groundswell was already apparent during the previous season (1930–31). The large regional, national, and international exhibitions in Chicago, Pittsburgh, and New York, which were then more important barometers of artistic interest and public taste, reflected a shift in interest to a realistic art that recorded explicitly American images. This change of direction was coaxed along by editorials and articles particularly in *The Art Digest,* the journal most responsive to the idea of an American Scene movement. Paintings by American artists portraying American themes were highly praised, particularly those representing common American experiences. As one critic described the season, the tendency was "to exalt Main Street as against Park Avenue or Beacon Hill."[3]

Certainly the most famous painting of the time was Grant Wood's *American Gothic,* shown at the Annual Exhibition of Painting and Sculpture at the Art Institute of Chicago (*Ill. 1*). But critics did not isolate specific works or artists as leaders of the new movement, since the shift in subject matter and style was observed to be taking place all over the country. "American art," it was stated, "has broken with tradition and is working out its own destiny in a new and national way [as] is proved by nearly all of the exhibitions held in the United States so far this season."[4]

As a result of this growing American consciousness, the Whitney Museum of American Art, the first museum devoted exclusively to American art, was founded in 1931. In addition, the editors of *The Arts* were pleased to note that "independent" artists rather than followers of the School of Paris scored higher in a reader's poll of favorite American painters. (These artists included Eugene Speicher, John Sloan, John Marin, Charles Burchfield, Edward Hopper, George Luks, and Rockwell Kent.)[5]

An explosive hostility to European modernism surfaced also during the 1930–31 exhibition season. Whereas paintings by Americans portraying American themes were praised, European inspired art was invariably criticized. What had earlier been viewed as a contest between traditional and modernist styles had very quickly become a battle between American and European art. Edward Alden Jewell, art critic for the *New York Times,* advised American artists to "sing" in their own voices or to stop singing altogether. The Worcester Art Museum even felt compelled to announce, upon purchasing George Bellows's *The White Horse* of 1922, that the artist had never traveled abroad and was not in the least affected by European art.[6] These assertions were more than equaled by violent attacks on the various modern styles. The disappearance of Cubist and Fauvist styles was no longer predicted, it was ascertained. With the demise of these styles, the period of "ultra-modernism" was considered to have ended. American artists, it was said, would now bear a major responsibility for developing new styles.

In retrospect, the many claims and challenges made that season were a quiet prelude to the verbal violence and euphoria that marked the American Wave season of 1931–32. Critics fell all over themselves praising American art. Jewell found that "today, with pride that has no need to wear the little tinkling bells of jingoism, we see the work of our artists taking a place that is second to none." Dorothy Grafly, a responsible Philadelphia critic, commented in a similar vein, after seeing the Pittsburgh Exhibition of Contemporary Painting and Sculpture (the Carnegie Institute International). She observed that if the show had "a message for the artist this year it is an American message. No other section [of the exhibition] is so aware of the objective vigor of contemporary life. . . . The art . . . turns outward rather than inward through its rich discovery of the American Scene. . . . Painters will find a deep national significance in everything from a stove pipe to an automobile tire."[7] Reacting to the styles and subjects of the American entries, she and others were borne along on an affirmative tide of belief in American art. When Franklin Watkins was awarded first prize at the exhibition for his *Suicide in Costume* (*Ill. 6*), it hardly mattered that this painting did not describe some aspect of the American Scene: an American had won the top award and that was what counted!

AMERICAN PAINTING OF THE 1930's

The sudden discovery of the excellence of American art prompted the Whitney Museum to sponsor a debate early in 1932, on the subject of "Nationalism in Art—Is it an Advantage?" Needless to say, the affirmative position won. Responding in similar fashion, the Artists' Professional League, searching for a slogan to express its beliefs, chose "I Am for American Art." And on Sundays throughout the winter of 1931–32, the art columns of the *New York Times* were used as a public forum for debating the need for and nature of American art. Predictably, the first Surrealist exhibition in America, which took place that season, was unenthusiastically received. So strong was the belief in the strength of American art that the Reinhardt Gallery in New York staged an exhibition in which European and American paintings were compared. Hopes were somewhat dashed when common critical opinion favored the European entries. However, treating the exhibition as if it were a type of sporting event, critics did find that the Americans showed more pep than the slightly fatigued Europeans.[8]

Economic considerations were also a key part of the American Wave. Of great significance was the overwhelming antagonism critics and representatives of professional organizations showed to dealers who sold inferior European paintings on the American market. Forbes Watson, editor of *The Arts,* a very fair-minded journal, wrote in the last issue of that magazine that the Parisian art dealers had turned modern art into a "kind of international dressmaker-painting, spattering it with the spirit of their own cynicism." An organization called "An American Group" was formed to fight the "French art racket." Others, commenting on the market now glutted with foreign works, noted that "decent" American artists ("decent" as artists and as individuals) had to compete with bizarre and eccentric ones who were still catering to a disoriented, novelty-seeking public.[9]

The moralizing tone of these observations clearly reflected the abrupt reaction to the 1920's that many people felt soon after the Crash.[10] The desire to restore a measure of sanity to the world as well as the need for a general housecleaning was epitomized a few years later by remarks Franklin Roosevelt made during his first inaugural address: "The money changers have fled from their high seats in the temple of our civilization. We may now restore that temple to the ancient truths. The measure of that restoration lies in the extent to

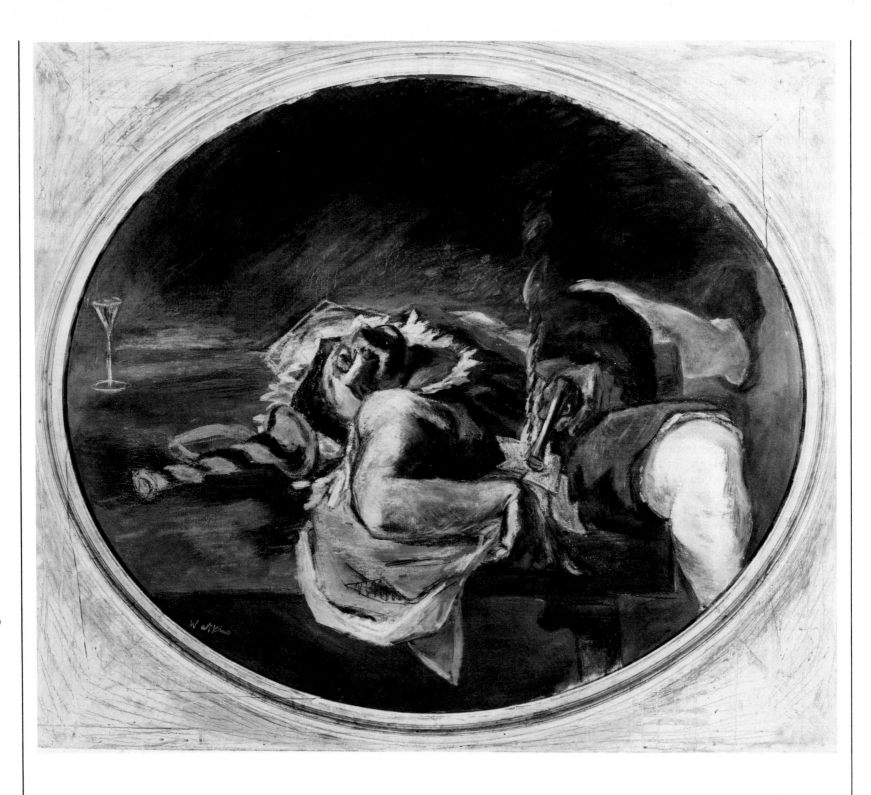

6. Franklin Watkins, *Suicide in Costume*, 1931. Oil, tempera, and pastel, 33¼ x 41¼ inches. Philadelphia Museum of Art; Given by a group of donors, '42-17-1.

which we apply social values more noble than mere monetary profits.[11]

The frenzies of the American Wave season were not, however, without their lighter moments. The prize winners at the Annual Exhibition of American Painting and Sculpture at the Art Institute of Chicago—William *Zorach,* Morris *Kantor,* and Nicolai *Cikovsky*—were praised as good American artists, who created typical American subjects. Of Kantor's painting, it was said that although he could be associated with such mystics as Blake, El Greco, and Redon, and although he obviously had learned from the Cubists and Surrealists, his painting "was purely American in theme" (*Ill. 7*).[12] Such observations remind one that much in the American Scene was, as one critic stated, "more anti-foreign than exuberantly patriotic."[13]

Such observations also indicate the problems that critics encountered when they tried to define the new American art. What was it supposed to look like? Was it a point of view, a set of styles, a particular range of subject matter—or all of these? Unfortunately, wishful thinking usually took the place of cogent analysis, and no one succeeded in giving a sound definition.

No critic was foolish enough to insist on a monolithic American style. Rather, an American feeling was supposed to emerge when a proper subject was united with an appropriate style. This would occur when artists examined more profoundly the beliefs and experiences that they shared with the public, instead of withdrawing into the farther reaches of their own imaginations. When artists understood better the traditions and aspirations of their country, when they began to portray peculiarly American subjects for which there were no handy European precedents, then a truly American art would emerge, free of foreign trappings.

But even if a good, working definition of American Scene painting never emerged, most would have agreed to the following assessment of the American Wave season. The sense of and feeling for place, lacking in recent American art, had returned (*Colorplate 6*). Currents of emotion and introspection, disdained as largely neurotic in quality and European in inspiration, had been replaced by a spirit of mental well-being and even repose. American artists had begun to explore their own responses to the environment and to reject European models. The basic source of artistic motivation now lay in the objective world. A healthy breach had finally opened between American and European art, and the specter of greatness was seen as looming just beyond the horizon. American art was coming of age.[14]

The onset of the Depression obviously contributed to the appearance of the American Wave. Certainly, much of the verbal bluster, like Herbert Hoover's empty bromides assuring rapid economic recovery, was a stiff-lipped response to the continuing crisis. The art journals tried to project an optimistic picture and to mobilize their public in support of American artists, who were then facing overwhelming economic disaster. Moses Soyer captured well the artist's plight when he wrote, "Depression—who can describe the hopelessness that its victims knew? Perhaps no one better than the artist taking his work to show the galleries. They were at a standstill. The misery of the artist was acute. There was nothing he could turn to."[15]

Between 1929 and 1932, national income fell from $81 billion to $41 billion, 85,000 businesses failed, 9 million savings accounts were wiped out, and 773 national banks and 3,600 state banks failed (causing losses of almost $3 billion). Wage losses were estimated at $26 billion.[16] Although effects of the Depression were pervasive, the evidence indicates that they did not actually cause the American Wave or the birth of American Scene painting. Certain aspects of the American Scene had begun to emerge before 1929 and would have surfaced anyway, if at a more leisurely pace.

The Crash, therefore, hastened and intensified, but did not necessarily cause, the rise of the American Scene. A precipitative agent, the Crash energized the belief in the high quality of American art, forced Americans to face the issue of European dominance over their artists, provoked artists into joining the movement, and gave prominence to theories of environmental influences upon artists. But one can point to a number of "before-and-after" instances in which tendencies just beginning to appear around 1927 had, by 1932, become overwhelmingly evident.

As early as the autumn of 1931, for example, observers suggested that the Depression had caused artists to forsake radical, modernist experiments for realistic styles and easily understood subject matter. The more abstract artists were reminded that their chances for sales increased in proportion to the comprehensibility of their work.[17] However, by 1927, critics had already discovered a new, nonradical, and realistic art with a particularly native flavor and had begun to

encourage painters to explore it further. Charles Burchfield and Edward Hopper were considered its leaders. Their paintings had, it was generally considered, captured the mood of contemporary America, its drab physical appearance and the growing nostalgia for that rather tawdry place called "home." That their America was forlorn and desolate bothered nobody; it was their example that was important. Their art was recognizably American in content and non-European in style.[18]

Others, recognizing in themselves their American heritage, began to paint the American Scene in more positive ways, often self-consciously. The mature style of Thomas Hart Benton, the most important painter of the American Scene, appeared by 1926. George Biddle, who helped initiate the first government art project in 1933, described the feelings evidently shared by many. In a revealing article written after his return from Europe in 1926, he recognized the need for a distinction between American and European art:

Slowly I began to feel how different from our own is the French or Paris mentality. . . . Most French art—indeed most European art—is fluent, detached, critical, aware of its artistry; while our best American art has always been sensitive, inhibited, romantic, passionate, naive in its realism, and often not too critical . . . of the problems of aesthetics. I believe that when I returned to America, three years ago [1926], I was more conscious than I had ever been before of my own and of my American inner attitude toward life; and felt that the moment in my career had arrived when I need preoccupy myself less in self-probings, and could allow my energy to flow into a more direct subconscious emotional expression of life. . . . I for one would be deeply unhappy anywhere else than in America. But this goes not to the essence. Of course an American, if he be one, will create best in terms of his America. But an artist . . . must probe and know his own depths and then he can express not only his America but the world's life which is in each of us.[19]

Stuart Davis also acknowledged, although less searchingly, his need for the American environment. After he returned from abroad in 1928, he said that the vitality of the American atmosphere compelled him to regard "working in New York as a positive advantage."[20] Similarly, Erle Loran, associated with artists of the North-Central states during the 1930's, felt tremendous excitement in rediscovering America after his return from Europe in 1930. Using the comparisons of the day, he remarked that a red barn stimulated him as much as a

Provençal *mas* ("farm-house") and, of more importance, that he felt much more attached to the American barn.[21] And, early in the Depression, Philip Evergood, who had trained in England and had crossed the Atlantic a few times during the 1920's, found the artistic and emotional pull of America too strong to resist. He returned to the United States, as he said, to develop his art further.[22]

Like the painters, critics began to discuss with growing intensity the appropriate kinds of artistic motivation. Increasingly, they found that independently derived styles based on familiar surroundings and attitudes were more important than art based on Parisian sources. Toward the end of the decade, virtually every exhibition review of reasonable length began or ended on this note. In the very week of the Crash, Lloyd Goodrich commented as follows in a review of Benton's work:

Waving the flag is a perilous business in art as well as in politics, but as a corrective to the indiscriminate worship of the judgement of Paris there is no harm in reminding ourselves occasionally that there is such a thing as a native quality in art, and that the way of artistic growth may very well be in the development of this quality rather than in the pursuit of the latest word.[23]

Chief among the participants in this continual discussion, but by no means the only one, was Thomas Craven, the principal ideologue of the American Scene. By 1925, he had elaborated three related ideas that he and others would repeat—and repeat—throughout the 1930's. First, recent European movements were worn out and sterile; they offered nothing new to American modernists who were using styles already a generation old. Second, modern European art had denied art's true function when it became merely a series of techniques rather than an instrument of communication. Third, Americans, because they were generally unsympathetic to metaphysical speculation, could not create a viable art based on abstract esthetic theories. At best, they would be doomed to copying feebly one European style after another.[24]

Critics also felt that America's Anglo-Saxon heritage imposed distinct limitations on the kind of emotional freedom and improvisatory ability necessary for creating works in modern idioms.[25] These observations, which were partly xenophobic and partly puritanic in origin,

23

7. Morris Kantor, *Haunted House*, 1930. Oil, 37¼ x 33¼ inches. Courtesy The Art Institute of Chicago.

8. Harry Gottlieb, *Their Only Roof*, ca. 1930–40. Oil, 30 x 40 inches. The C. Leonard Pfeiffer Collection of American Art, The University of Arizona, Tucson.

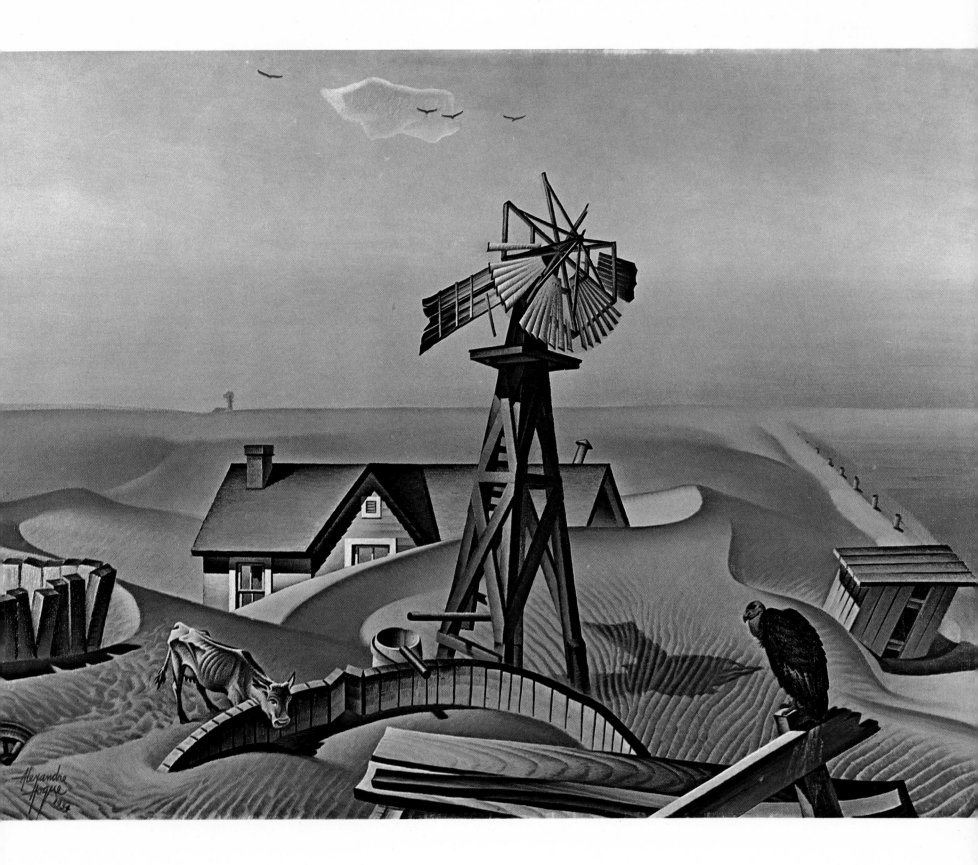

Colorplate 1. Alexandre Hogue, *Drouth-stricken Area*, 1934. Oil, 30 x 42¼ inches. Dallas Museum of Fine Arts, Dallas, Texas; Dallas Art Association Purchase.

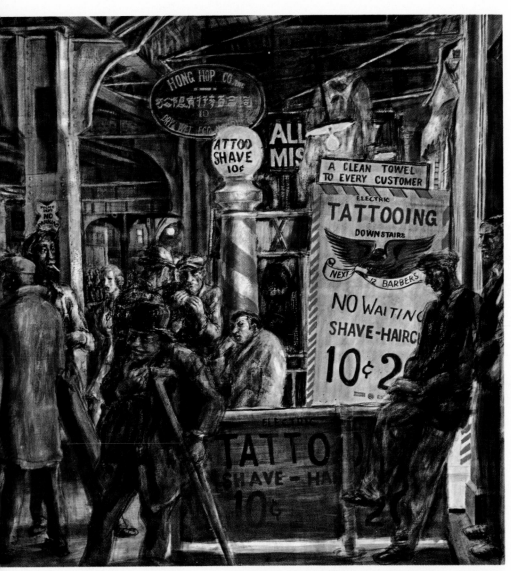

Colorplate 2. Reginald Marsh, *Tattoo and Haircut*, 1932. Tempera, 46½ x 48 inches. Courtesy The Art Institute of Chicago; Gift of Mr. and Mrs. Earle Ludgin.

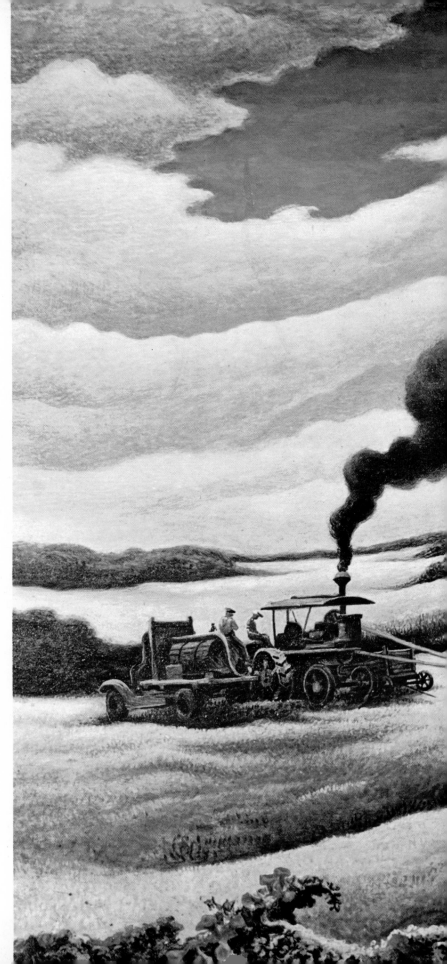

Colorplate 3. Thomas Hart Benton, *Threshing Wheat*, 1939. Oil and tempera, 26 x 42 inches. Courtesy The Sheldon Swope Art Gallery, Terre Haute, Indiana.

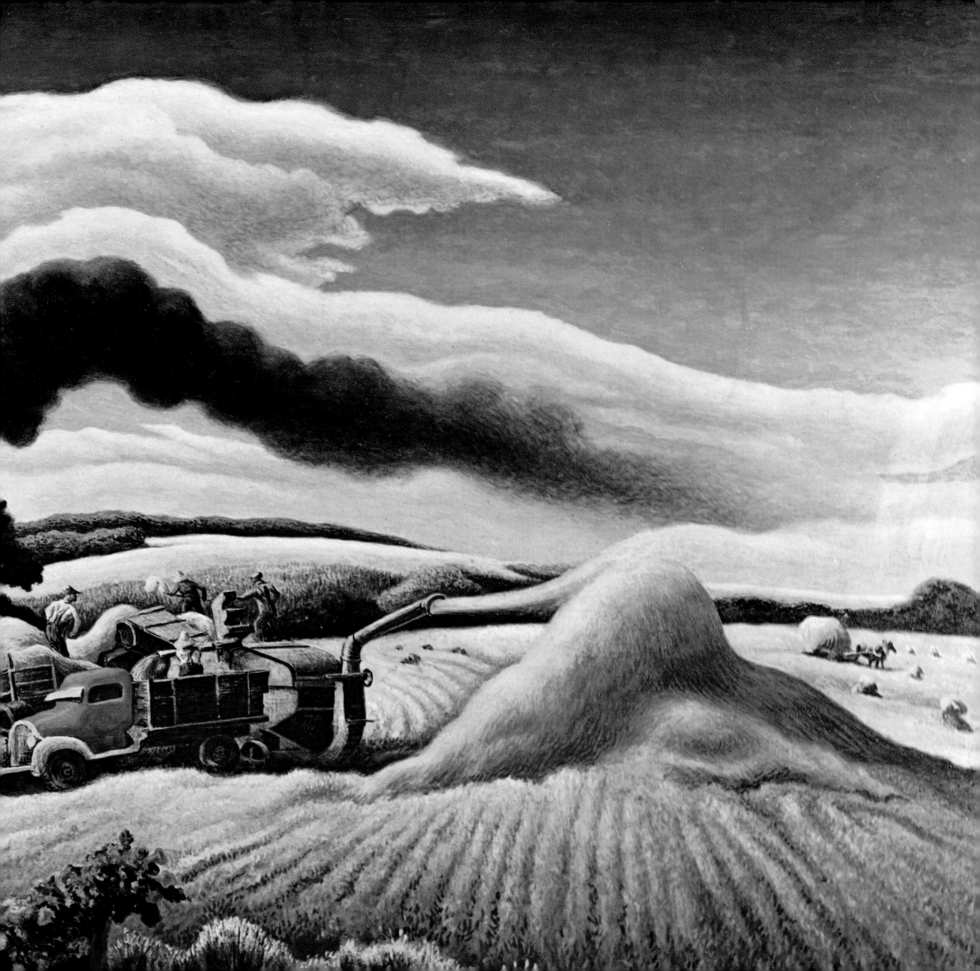

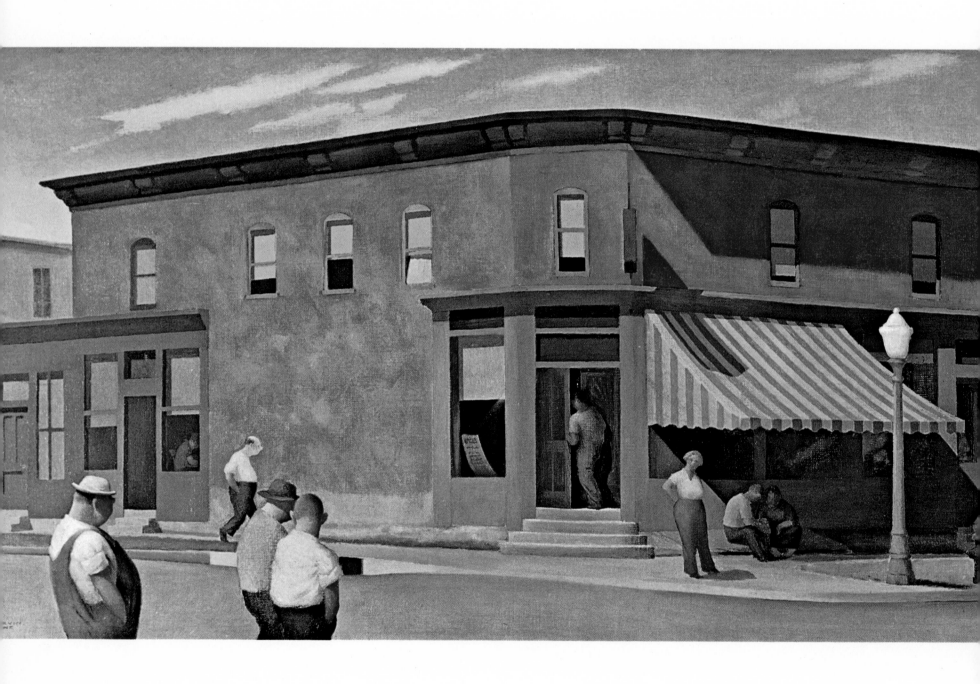

Colorplate 4. Marvin Cone, *Little Bohemia*, 1941. Oil, 15½ x
39½ inches. Marvin Cone Collection, Coe College, Cedar Rapids,
Iowa.

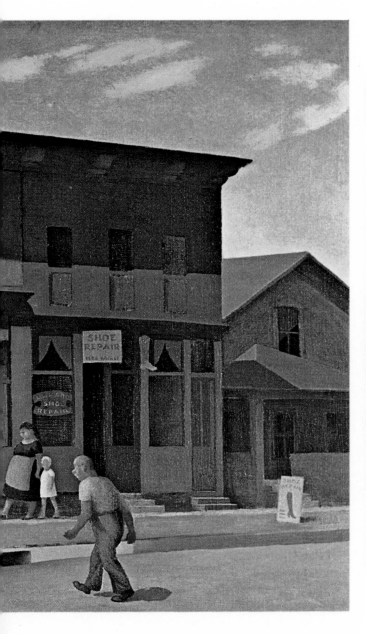

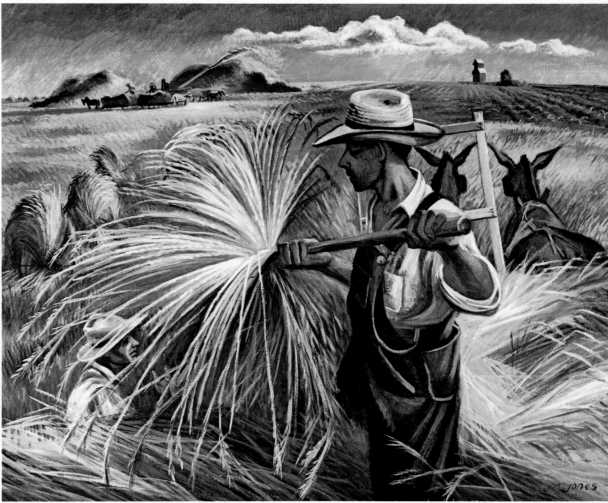

Colorplate 5. Joe Jones, *The Harvest*, ca. 1935. Oil, 30 x 40 inches. The C. Leonard Pfeiffer Collection of American Art, The University of Arizona, Tucson.

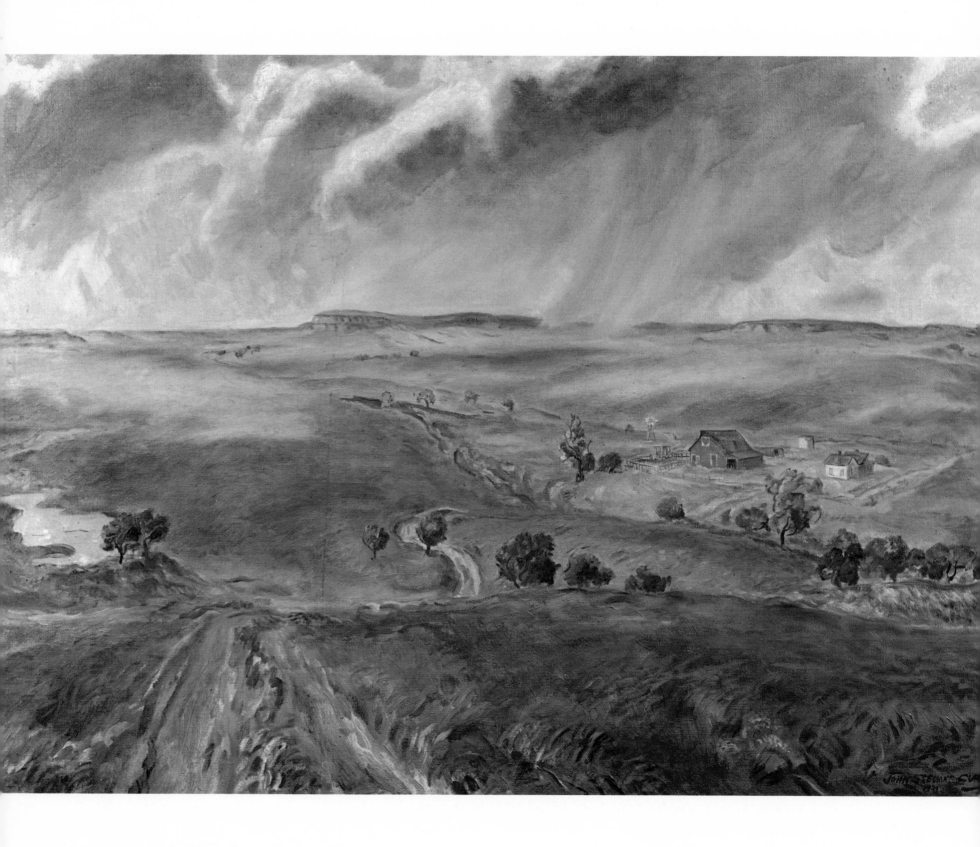

Colorplate 6. John Steuart Curry, *Spring Shower*, 1931. Oil,
30 x 44 inches. The Metropolitan Museum of Art, New York;
Arthur H. Hearn Fund, 1932.

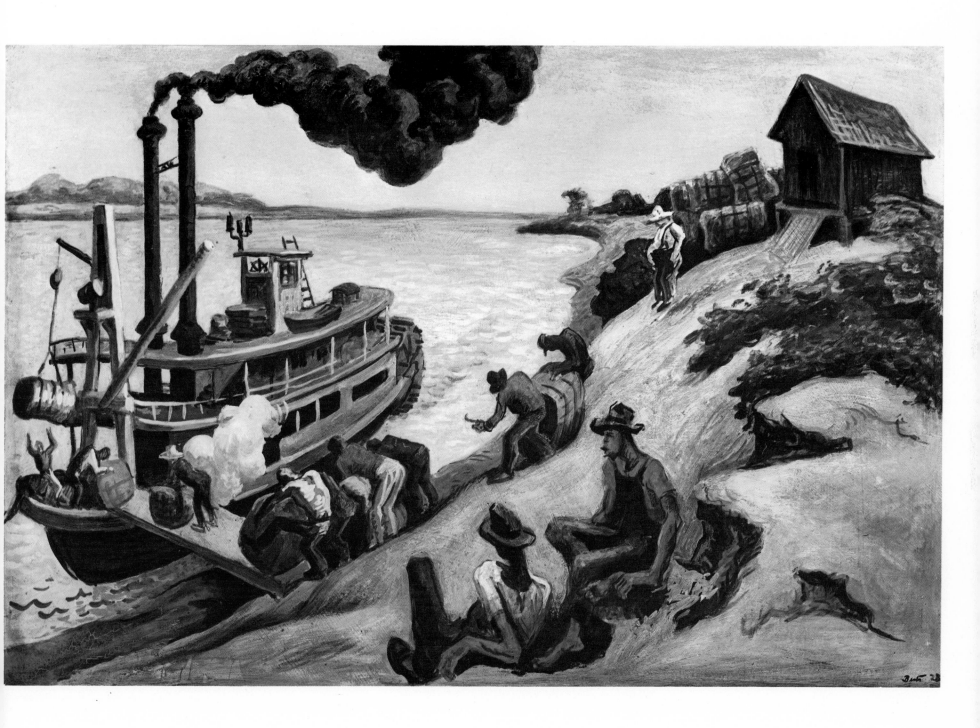

Colorplate 7. Thomas Hart Benton, *Cotton Loading*, 1928. Oil and tempera 28 x 39 inches. Courtesy Graham Gallery, New York.

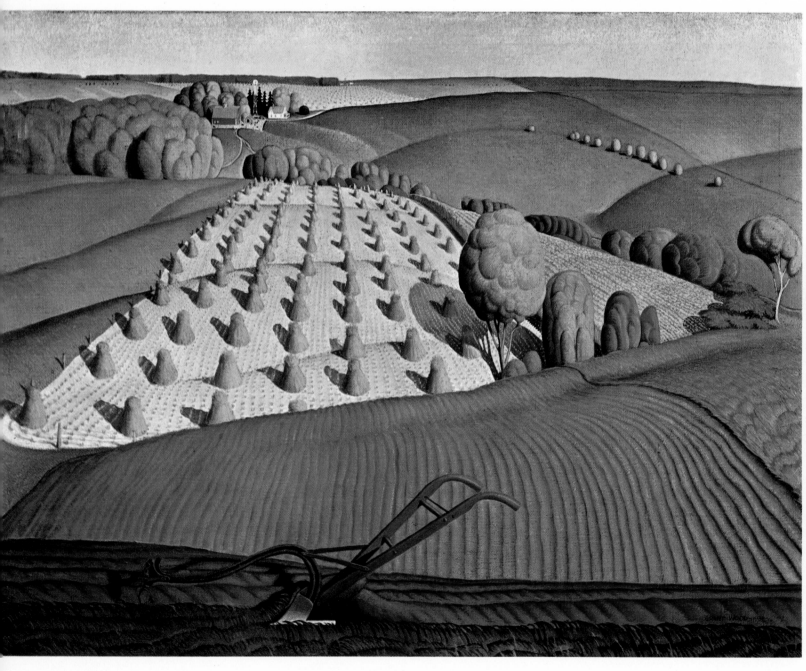

Colorplate 8. Grant Wood, *Fall Plowing*, 1931. Oil, 29¼ x 39¼ inches. Deere & Company, Moline, Illinois.

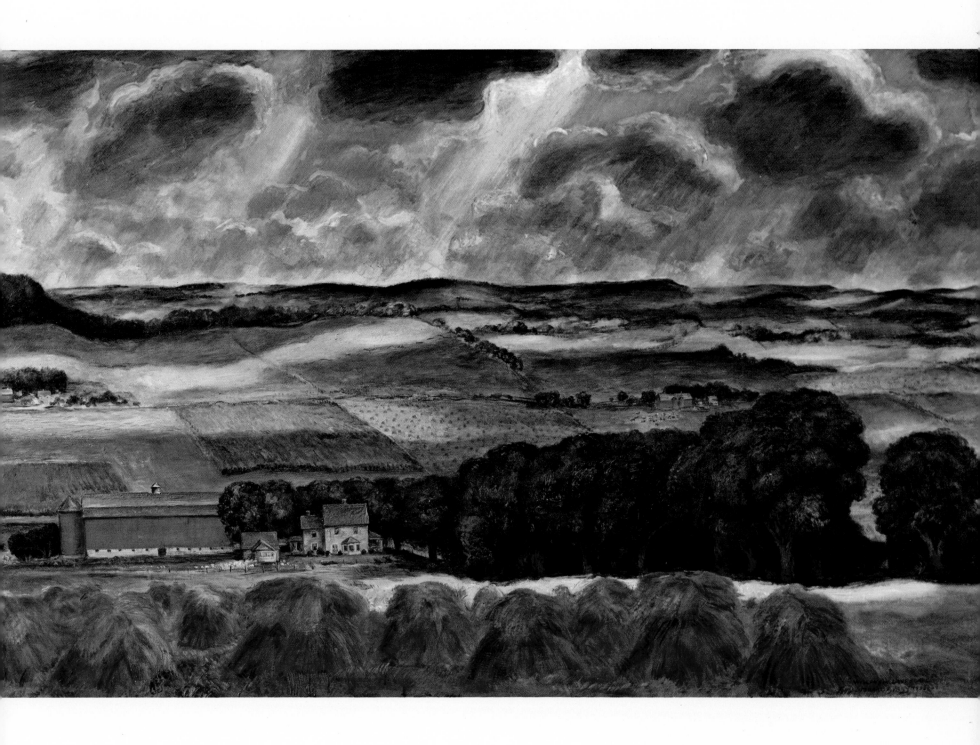

Colorplate 9. John Steuart Curry, *Wisconsin Landscape*, 1938–39. Oil and tempera, 42 x 84 inches. The Metropolitan Museum of Art; George A. Hearn Fund, 1942.

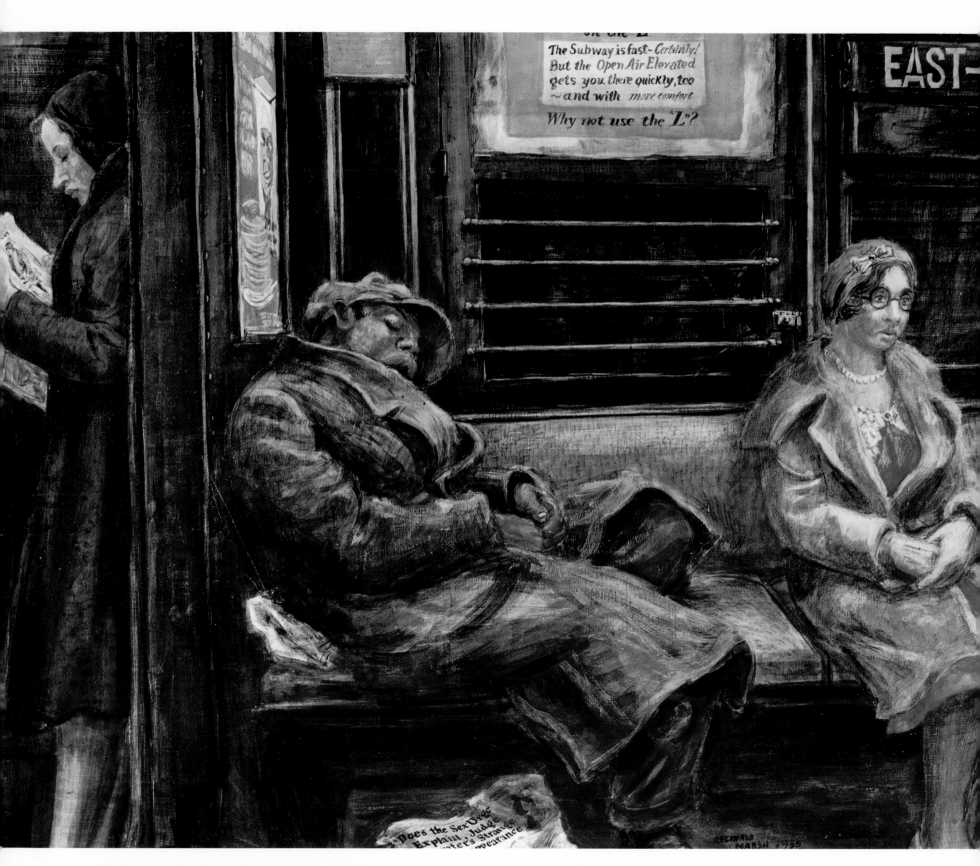

Colorplate 10. Reginald Marsh, *Why Not Use the El?*, 1930.
Tempera, 36 x 48 inches. Collection Whitney Museum of American Art, New York.

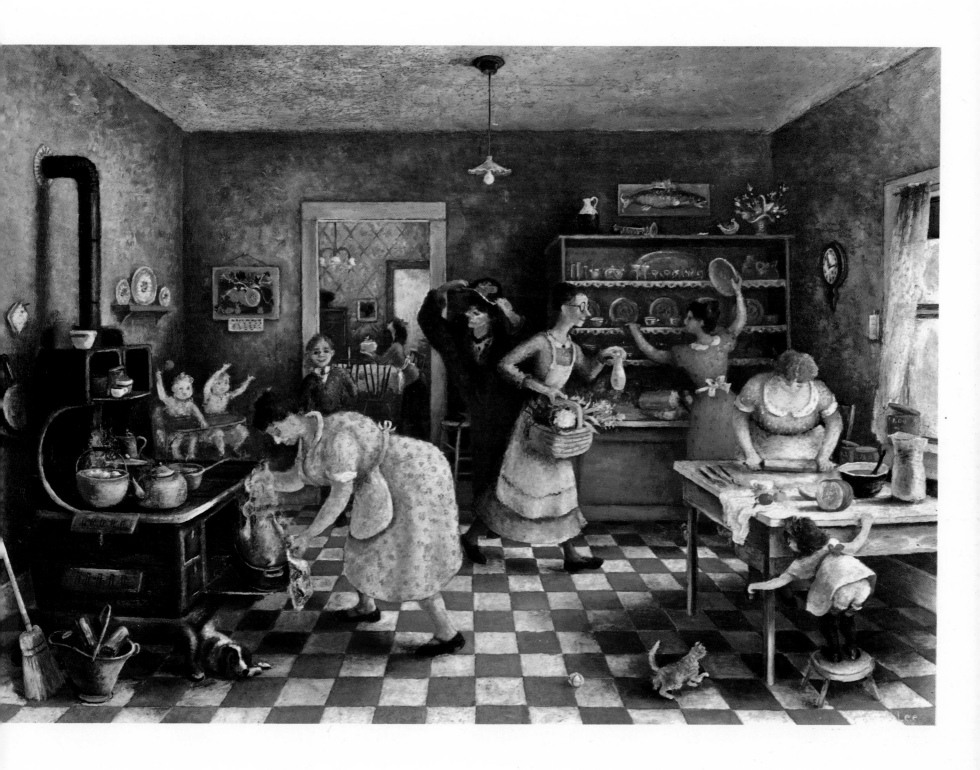

Colorplate 11. Doris Lee, *Thanksgiving*, 1935. Oil, 28⅛ x 40 inches. Courtesy The Art Institute of Chicago.

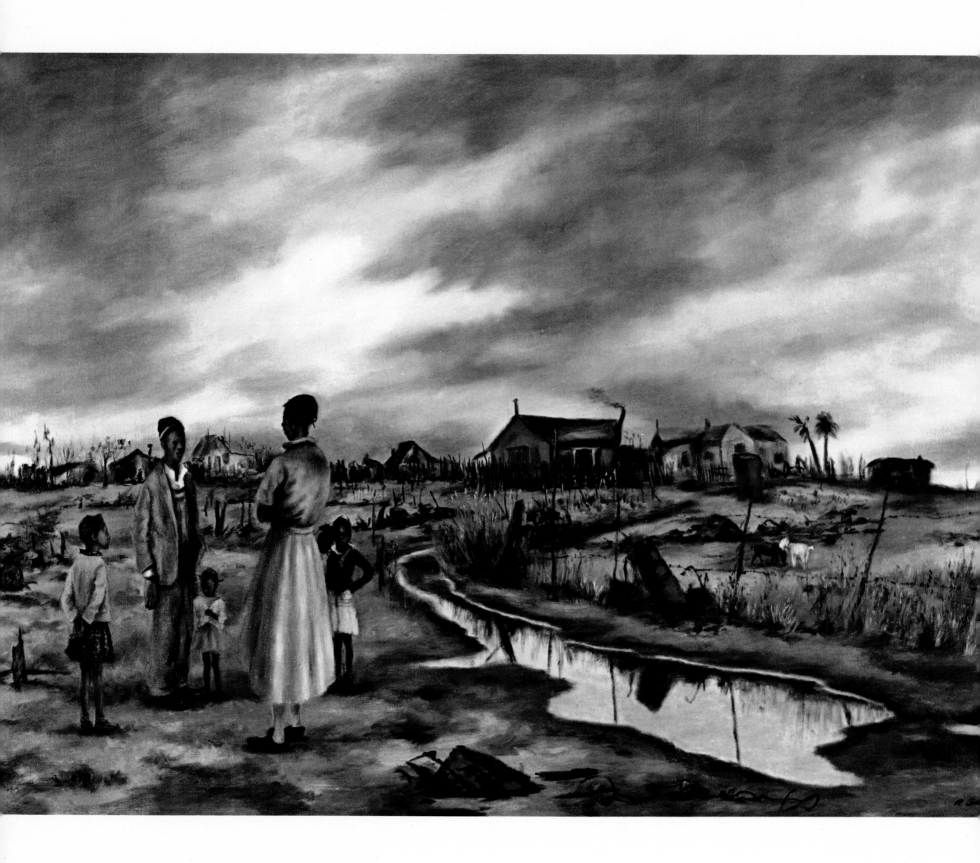

Colorplate 12. Alexander Brook, *Georgia Jungle*, 1939. Oil,
35 x 50 inches. Museum of Art, Carnegie Institute, Pittsburgh,
Pennsylvania.

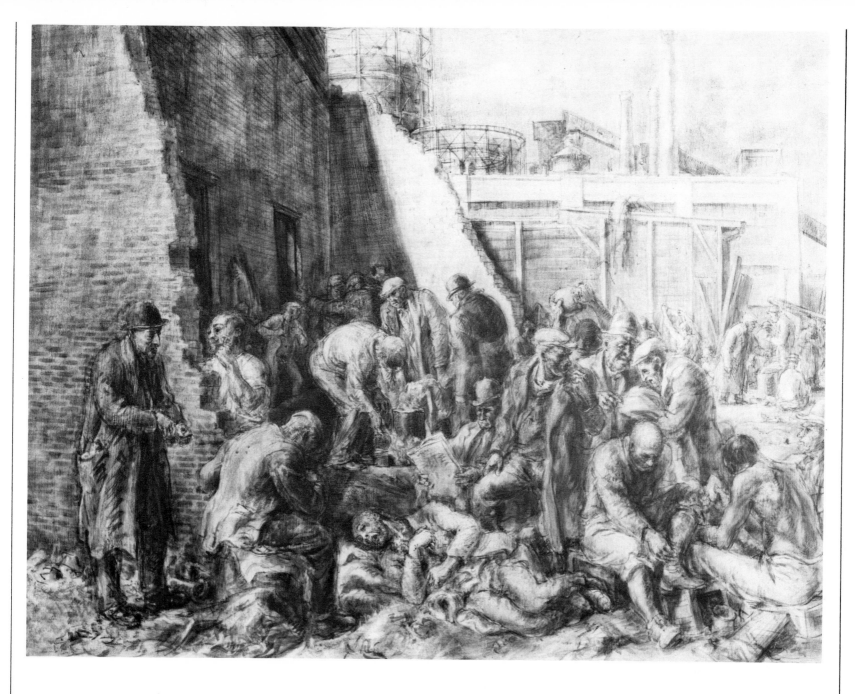

9. Reginald Marsh, *East Tenth Street Jungle*, 1934. Tempera,
30 x 40 inches. Collection Charles J. Rosenbloom.

sometimes prompted expressions of fear and distaste for bohemian life in Paris and New York. Craven articulated this point of view more keenly than most, but other forces then strong in the art world also found French libertinism corruptive.[26] Quite often, a strong moral tone pervaded the pages of *The American Magazine of Art* (which presumably reflected the outlook of its parent body, the American Federation of Art) and of *The Art Digest*. The editor of the latter devoted space in each issue to such staid organizations as the Art Division of the General Federation of Woman's Clubs and the Artists' Professional League. Although these groups were somewhat peripheral to the mainstream of American art, their attitudes—like those of Craven—reflected the sincere conviction that American art should remain closely tied to American life.

Generally, critics as well as professional organizations supported the concept of an art relevant to *all* Americans, rather than to a cultural elite. Thus virtually every issue of *The Art Digest* and of *The American Magazine of Art,* before and after 1929, devoted ample space to the activities of artists living in different parts of the country. The American Federation of Art, actively committed to enlarging the country's esthetic horizons, sponsored touring shows, regional exhibitions, and rural uplift programs, all of which received considerable publicity.

This coverage helped to give the American Wave a nationwide scope. It seemed as if the arts were flourishing in all areas of the country, a delightful idea which fueled the fantasies of those predicting the imminent arrival of an American Renaissance. A golden age of nationwide artistic fulfillment, the American Renaissance was, by the early 1930's, thought to be clearly in view. The buoyant optimism of its supporters fed directly into the euphoria surrounding the arrival of the American Wave.

On one level, the American Renaissance reflected the longstanding desire to compete with and to surpass European artistic achievements, thus proving to the world America's cultural coming of age. In *The American Renaissance,* R. L. Duffus concluded that "there can be no doubt that America, having expressed herself politically, mechanically and administratively, is on the point of attempting to express herself aesthetically. This has been thought before. . . . But now one begins to believe it true."[27]

As the effects of the Depression spread, editorals in the art journals grew more shrill in support of the American Renaissance. The opinions of persons such as Holger Cahill, future director of the Federal Art Project, and Juliana Force, head of the Whitney Museum, were sought to give the movement official sanction. And the entire issue of *Creative Arts* for November 1931 was devoted to the idea of the American Renaissance.

On another level, linked to an antibohemian point of view, the American Renaissance reflected the desire to create a moral and spiritually uplifting climate in American life, a task for which European art was deemed totally unsuited. In this regard, the American Renaissance itself was not the result of good taste, but rather the agent by which good taste would be spread throughout the land.[28]

The American Renaissance was to be achieved in good American fashion—through group effort, through purchases of native art, and through the exclusion of European art. America would buy itself a renaissance if it had to, and would severely restrict the importation of European art through tariffs.[29] All Americans were admonished to play a Medician role in support of American art ("a home is not culturally complete unless it contains good pictures").[30] According to the plan of John Cotton Dana (head of the Newark Museum), which was announced in 1914 and revived in 1931, "The formula is very simple: first we must buy it [art]; next we must study it; next we must criticize it; and finally, we must praise it when we can."[31]

At least three aspects of the American Renaissance are worth comment. First, many believed in its arrival, and it forms one of the interesting themes that run through the 1930's. Second, it was to be a group effort. The American Renaissance would not be led by another Michelangelo, but would occur without the benefit of individual genius. In fact, adherents of the Renaissance were opposed to unfettered individualism, which they associated with European art. And third, it would occur all over the country, in Gopher Prairie as well as in New York.

The egalitarian character and national scope of the Renaissance suggest yet another current that fed the American Wave and the rise of American Scene painting: the implicit acceptance of environmentalist theories to explain and justify an American art. Holger Cahill, for example, remarked in the mid-1930's that "art is a normal social

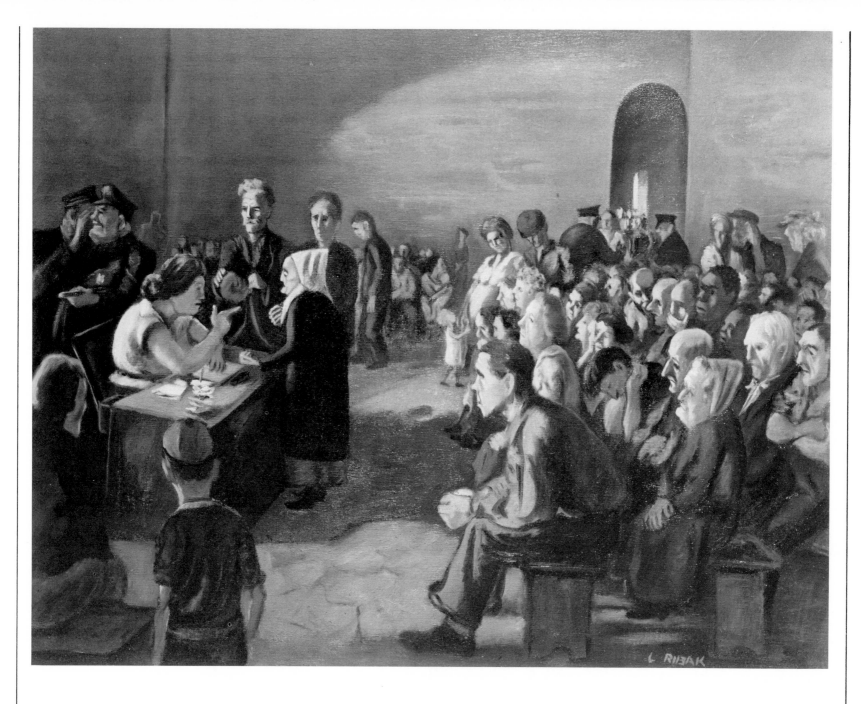

10. Louis Ribak, *Home Relief Station*, 1935–36. Oil, 28 x 36 inches. Collection Whitney Museum of American Art, New York.

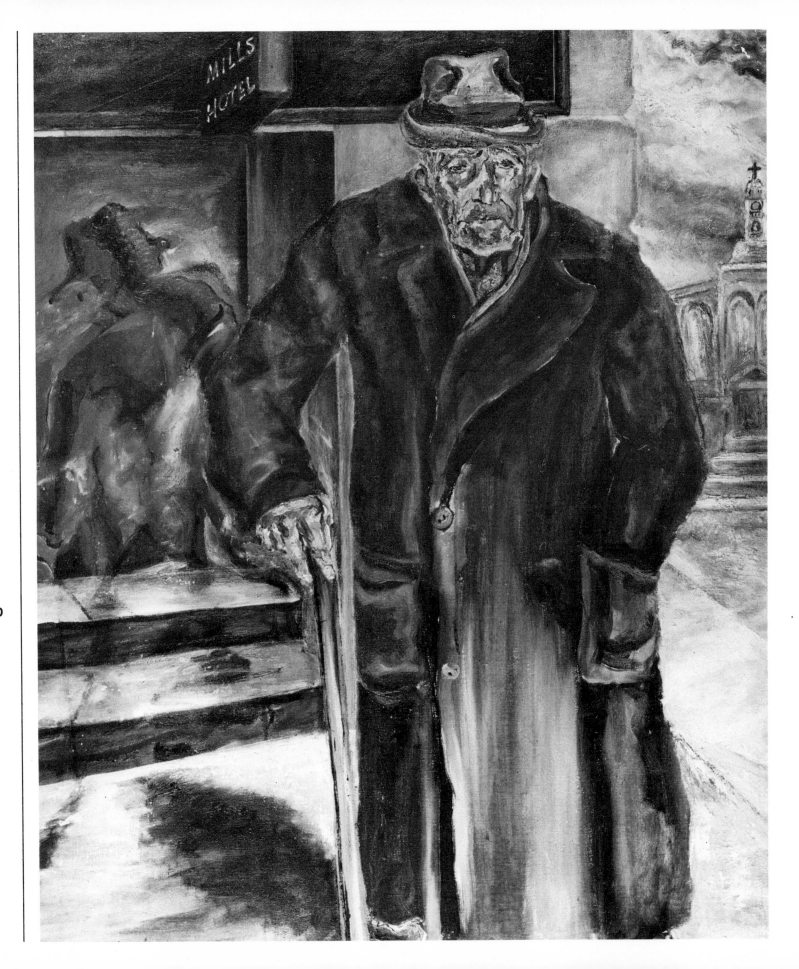

growth deeply rooted in the life of mankind and extremely sensitive to the environments created by human society." He further stated that "there is still space and time enough in America's way of living for every community and every state to cultivate its own personality, its own ideals and even its own peculiarities."[32] In these comments, Cahill mirrored the profound concern for the artist in his environment that lay at the heart of the American Scene.

But this environmentalist attitude was by no means new to American cultural thought. The early nineteenth century had seen the appearance of association psychology, with Archibald Alison as its most popular exponent. According to this theory, which contributed heavily to America's rising cultural nationalism, knowledge was thought to be derived from repeated experiences and associations of ideas. Since one's most extensive experiences and strongest associations were those arising from one's immediate surroundings—in the scenery, history, and traditions of one's own country—"then it must be obvious that the imagination of the artist must derive its forms and receive its complexions from the country in which he was born and in which he resides."[33]

This point of view, central to the democratic nature of the Hudson River School, was given a more precise and "scientific" focus later in the century by the French critic and historian Hippolyte Taine, whose works were first published in English in 1868. Taine explained the development of art in social and environmental terms, believing that an artist was conditioned by his race, his surroundings, and by the epoch in which he lived. To understand the taste, style, character, and sentiments of an artist, Taine concluded that "we must seek for them in the social and intellectual conditions of the community in the midst of which he lived."[34] From this, it followed that an artist functioned best when he was aware of his own heritage.

Taine's ideas are important to the American Scene for several reasons. Benton, who read Taine's work in Paris between 1908 and 1911, openly acknowledged his influence and promoted his theories in articles, lectures, and classroom instruction. Taine also helped to provide an intellectual framework for those searching out a usable American past. And finally, his concepts, whether derived directly from his writings or through intermediaries, became part of the general outlook of the American art world.

AMERICAN PAINTING OF THE 1930's

For example, the painter John La Farge, although primarily concerned with the ideal and the moral in art, was mindful of environment's role in the creation and understanding of art. Homer Saint-Gaudens, the conservative director of the Carnegie Institute, reminded his readers that worthwhile art was "not an exotic thing brought in from somewhere else." He exhorted American artists to "work toward one another and in common support toward a unified expression of the feeling of our race." Edward Hopper once wrote that the qualities indigenous to American art were "in part due to the artist's visual reaction to the land, directed and shaped by the more fundamental heritage of race." And even the modernist Max Weber suggested that "the environment, religion, tradition, the very physical features of the country of a people, determine to a large degree the character of their art."[35]

Thus Constance Rourke, the sensitive chronicler of American culture, was not unusual in her insistence that American artists "cannot take off from the same point of departure as the European artist," and that only through full use and understanding of native cultural tendencies can a major American art emerge. She was not speaking as a lone individual who sought the shelter of nationalism in a turbulent world, but rather as a student of environmental theory who was working from a large body of literature. And similarly, when Thomas Craven urged the American artist to provide an appropriate style for the peculiar American combination of frontier spirit and technological accomplishment, he was not parroting jingo sentiments, but expressing a complex of ideas concerned with art as a social phenomenon.[36]

For this reason, Craven agreed with Communism's anti-elitist artistic theories (although he objected to its political strictures) and acknowledged the importance of Mexican artists such as Diego Rivera, José Clemente Orozco, and David Alfaro Siqueiros, who derived their art from Mexican traditions and from experiences accessible to the common person.[37] Craven shared his admiration of the Mexican achievement with many others who hoped that American painters would develop an art similarly responsive to the backgrounds and aspirations of the American people. Very likely, the permeation of environmentalist theories of art made the acceptance of the Mexican achievement much easier for artists and critics alike.[38]

Known and acknowledged in this country before the Crash, mod-

11. Joseph Delany, *His Last Address*, ca. 1930–40. Oil, 34 x 42 inches. The C. Leonard Pfeiffer Collection of American Art, The University of Arizona, Tucson.

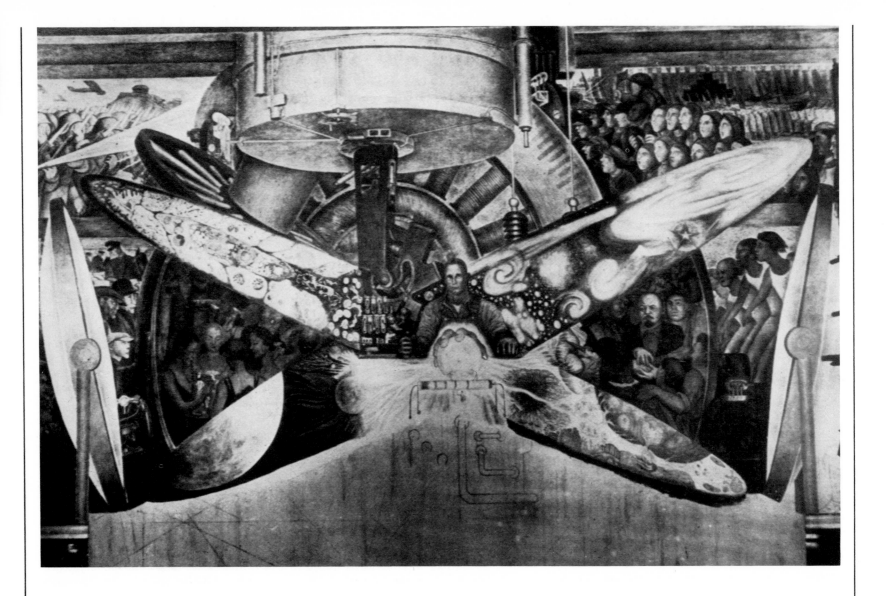

12. Diego Rivera, *Man at the Crossroads*, 1933. Destroyed.

ern Mexican art reached a peak of popularity between 1930 and 1932, and it served as a model for those anxious to see the rise of the American Scene movement. The Metropolitan Museum of Art presented a large exhibition of Mexican art in 1930; the American Federation of Art circulated an exhibition in 1930–31; the John Levy Galleries in New York held a winter-long cycle of exhibitions of Mexican art that season; and the Museum of Modern Art mounted a Rivera retrospective in 1931.[39] Orozco lived in New York from 1927 to 1932, except for time spent at Pomona and Dartmouth colleges in completing mural commissions. Rivera visited San Francisco in 1930 and New York between 1931 and 1933, interrupting the latter stay with a trip to Detroit to complete a set of murals at the Detroit Institute of Arts. Siqueiros lived in the Los Angeles area during 1932.

By their presence in this country, the Mexican artists also helped to promote an interest in mural painting, a point manipulated by the supporters of the American Renaissance. Altogether, Rivera, Orozco, and Siqueiros received thirteen commissions between 1930 and 1934.[40] But as with other aspects of the American Wave, an interest in mural painting had already begun to appear in the years before the Crash.

By 1927, critics and artists began increasingly to view murals as a way of infusing American art with greater meaning as well as of saving it from European domination. An ever increasing number of articles appeared on mural painting, and by 1930 a recognizable gain in the number of mural commissions had been reported.[41] Those in favor of increased mural activity included Craven, who thought that American cubists could be forced to record their observations of America in mural studies. "A few good murals in America," he said, "would do more to raise painting to a dignified and useful art than all the easel pictures in the world." Oliver M. Sayler, editor of the aptly titled *Revolt in the Arts,* linked the burgeoning antimodernist mood to the public's desire for a mural art. "The easel painting, product of an anemic era in bondage to the theory of art for art's sake, is losing ground to the mural painting executed on and for the spot where it is to remain." In the same book, John Sloan and Boardman Robinson noted the eagerness with which artists wanted to paint murals, Robinson particularly believing that murals would "restore the plastic arts to their historic utility." Orozco, more extreme than the Americans,

held that "the highest, the most logical, the purest and strongest form of painting is the mural."[42]

The program of decoration for the new buildings in Rockefeller Center and the exhibition of mural studies at the Museum of Modern Art in 1932 spurred further interest in this type of painting.[43] The key American figures in this development were Boardman Robinson and Thomas Hart Benton, both teachers at the Art Students League at this time. Robinson is credited with painting the first set of modern American murals, entitled *The History of Commerce,* for Kaufmann's Department Store in Pittsburgh (1930). Benton created three sets between 1930 and 1933: *America Today* for the New School of Social Research, New York; *The Arts of Life in America* for the Whitney Museum (now in the New Britain Museum of American Art); and *The Social History of Indiana* for the State of Indiana Pavilion at the Century of Progress International Exposition, Chicago (*Ill. 13*). These, together with the murals by the Mexican artists, provided a wealth of thematic and stylistic cues for a new generation of mural artists searching for ways to record their visions of America.

The quest for nationwide artistic growth and the interest in searching out unique American experiences, characteristic of the American Scene movement, had parallels in other phases of American cultural life during the 1920's. For example, the theories of Frederick Jackson Turner, although first stated in the 1890's, became very popular in the 1920's.[44] Turner, an environmentalist par excellence, held that the influence of the frontier was critical to the development of American democracy and that the existence of free land, more than the formulations of European theorists, lay behind the growth of the American nation.[45] For a critic like Craven and for an artist like Benton, who had read the historian's works by 1927 or 1928, Turner provided a theoretical framework for the application of environmentalist ideas to American art.

Similar ideas, as well as a solicitude for the environment itself, were expressed by the regionalist movement within the social sciences. To social scientists, "regionalism" did not imply a retreat into local archaeology, antiquarianism, or the maintenance of outmoded ways of living. In part, the movement was a rational approach to the utilization of resources across the nation, in part a reaction to the dehumanization and standardization of an industrial and urban society, and in

43

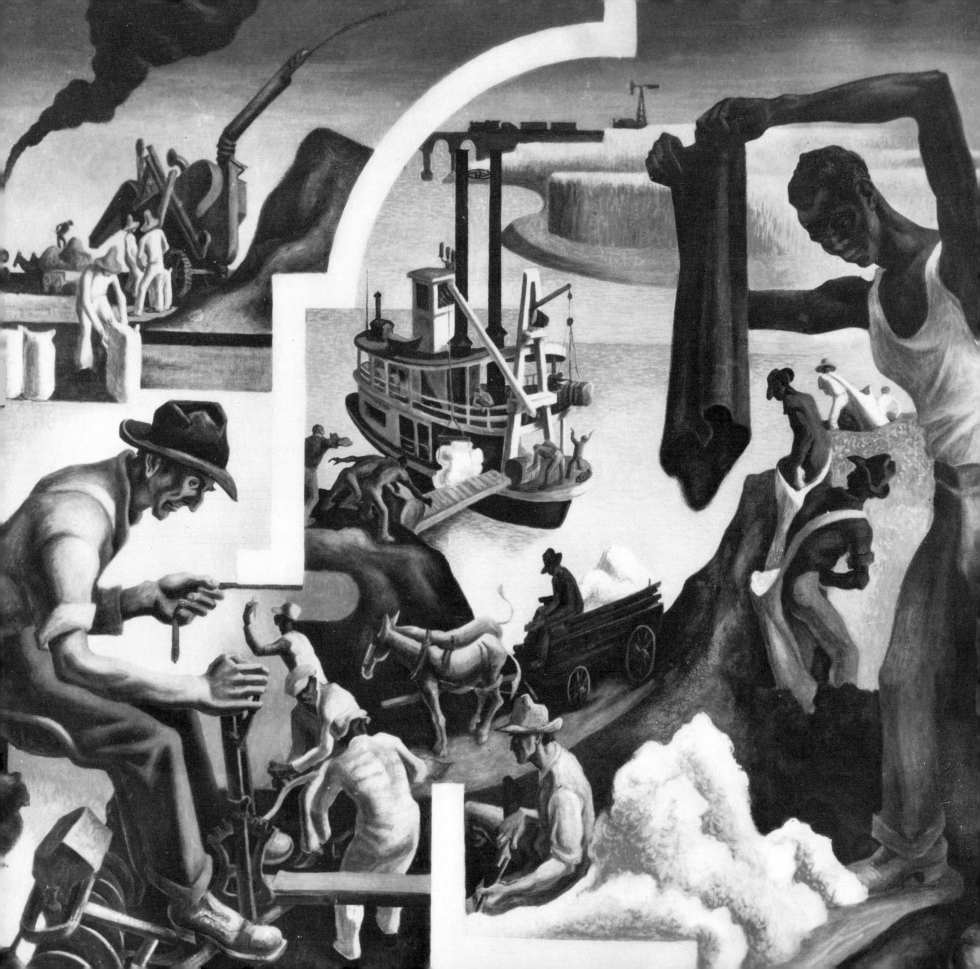

part a "retreat from the artistic leviathanism of the machine age, symbolized by the dominance of New York during the nineteen twenties."[46] Its advocates viewed the country as a grouping of separate sections which, while asserting their own independence, would nevertheless remain indispensable parts of the whole. They believed in a just balance between agricultural and industrial interests, between rural and urban needs, and between practical and abstract values. Lewis Mumford, a staunch regionalist, proclaimed that "the aim of [regionalism] is to begin again with the elemental necessities of life, to provide for these on a modern economic basis, and begin again that renewal of cities and regions which will bring about a new springtime in culture."[47] Accordingly, each region would develop its particular culture to the fullest extent.

A group of writers, centered at Vanderbilt University in the late 1920's and early 1930's, were actually called "Regionalists." This group included Allen Tate, John Crowe Ransom, Robert Penn Warren, and David Davidson. Opposed to the new industrialized South, they preferred the kind of agrarian culture associated with earlier times and attempted to keep it alive, but in a way presumably meaningful to the present.[48] Although they were earlier than the American Scene and not directly connected with it, the Regionalist poets conducted a similar search for unique American experiences.

13. Thomas Hart Benton, *The Old South*, 1930. Egg tempera and distemper, 91 x 96 inches. The New School for Social Research, New York.

THE AMERICAN SCENE

THE GOVERNMENT PROJECTS

By 1932, and certainly by 1933, the American Scene had become firmly established as the most popular movement in American art. Some critics were already beginning to wonder if it were not becoming too much of a good thing. As one stated, "The sheer problems of painting bored them [the painters]. Instead, they turned out canvas after canvas with dazzling speed, each man apparently bent on exhausting all the objects and rituals of his particular acquaintance."[1] Others, less concerned with quality, were excited by the increased visibility of American artists and by the evident growth of their audience. Equally significant was the realization that no single artist dominated the art world. The American Scene, eschewing the European star system, had become a democratic movement in a few short years.[2]

For the artists, however, this enthusiasm was hardly a cure-all; as the Depression worsened, their sources of income dried up. Despite the buoyant optimism that bubbled from the pages of the art magazines, artists were suffering acutely from loss of sales and from lack of exhibition opportunities. Between 1930 and 1933, many schemes to aid artists were reported, involving municipal, state, and federal funds. On at least two occasions, the American Federation of Art requested the federal government to sponsor a public-buildings decoration program.[3] The Gibson Committee, a relief organization in New York City, joined with the College Art Association in 1932 to provide artists with jobs, including the decoration of buildings. "The most amazing projects which were undertaken," it was reported, "have been the mural paintings with which over fifteen neighborhood houses and churches have been decorated."[4] In New York, twenty-five artists joined together in September 1933, to form the Emergency Work Bureau Artists Group (later called the "Unemployed Artists Group" and finally, in May 1934, the "Artists Union"). This organization, "motivated by a realization that only the artist can define the artist's needs and the conditions necessary for his maintenance as an artist," sent delegates to Washington in search of government support. In December 1933, it petitioned Harry Hopkins, director of the Federal Emergency Relief Administration, to institute programs in classroom instruction and in mural painting.[5]

An appeal for government support had, however, already been made directly to President Roosevelt. In May 1933, George Biddle wrote to the President, an old friend, concerning the need for a federally supported art program. Received favorably and acted upon almost immediately, the letter was subsequently regarded as an instrumental factor in establishing government support for the arts. The letter assumes added importance as a document because it brought together many elements lying behind the American Scene—the desire for a national art accessible to the public, the democratic nature of this art, the significance of the Mexican mural movement, and the importance of a mural art in this country.

There is a matter which I have long considered and which some day might interest your administration. The Mexican artists have produced the greatest national school of mural painting since the Italian Renaissance. Diego Rivera tells me that it was only possible because Obregon [Alvaro Obregon, president of Mexico, 1920–24] allowed Mexican artists to work at plumbers' wages in order to express on the walls of the government buildings the social ideals of the Mexican Revolution.

The younger artists of America are conscious as they have never been of the social revolution that our country and civilization are going through; and they would be eager to express these ideals in a permanent art form if they were given the government's cooperation. They would be contributing to and expressing in living monuments the social ideals that you are struggling to achieve. And I am convinced that our mural art with a little impetus can soon result, for the first time in our history, in a vital national expression.[6]

By December 1933, the Public Works of Art Project (PWAP) was established, the first of four programs eventually started by the government. A temporary program, it was terminated in June 1934. In the half-year of its existence, about 3,750 artists created 15,660 works in 32 separate classifications, including 700 murals. Edward Bruce served as director, Forbes Watson as technical director, and Edward Rowan as a chief assistant. To give the PWAP coherence, and to allow artists freedom of expression as well, the American Scene was chosen as the program's guiding theme. In effect, this gave the American Scene an official imprimatur and it acknowledged, as the summary report of the program indicated, the pre-eminence of the nationalistic movement in American art.[7]

14. Morris Graves, *Wheelbarrow*, 1934. (Public Works of Art Project.) Oil, 30 x 34 inches. National Collection of Fine Arts, Smithsonian Institution, Washington, D.C.

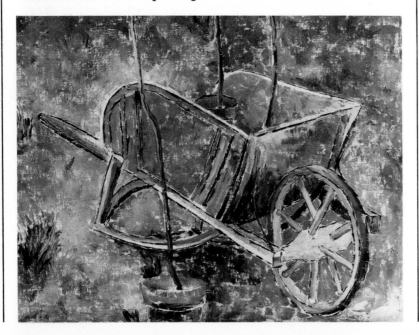

15. Grant Wood, *Agriculture*, ca. 1933. (Public Works of Art Project.) Collection unknown.

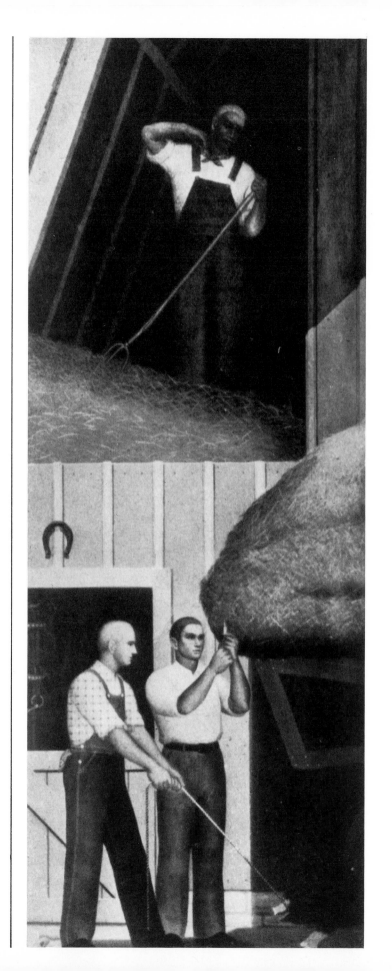

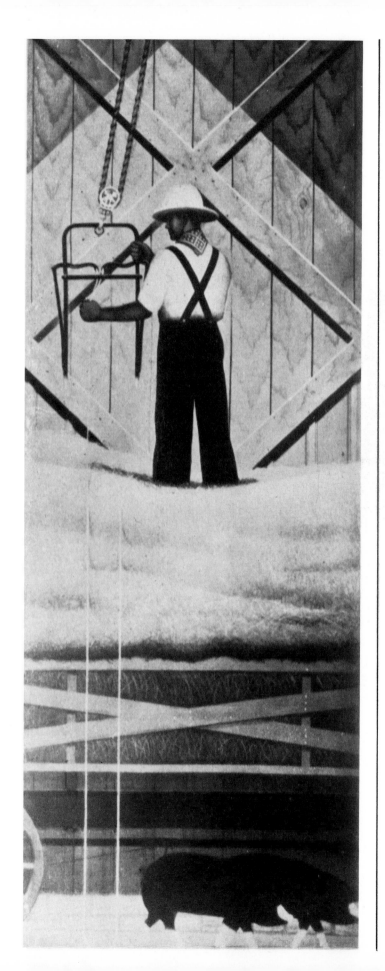
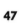

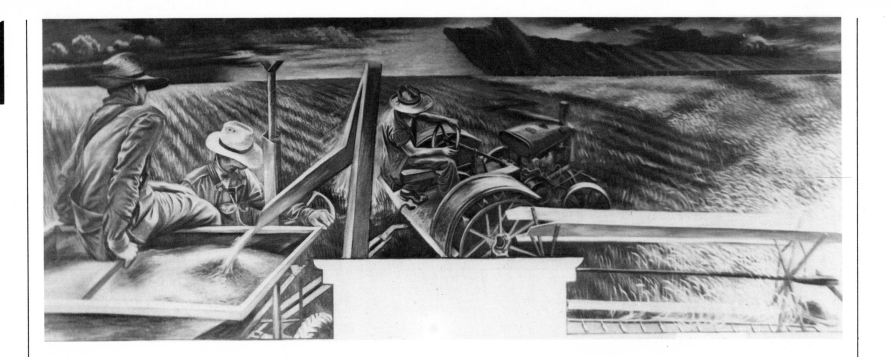

16. Joe Jones, *Wheatfield Scene*, ca. 1937. Post Office, Anthony, Kansas. (Section of Fine Arts.) Photograph, Public Buildings Service.

17. Kindred McLeary, *Lower East Side*, ca. 1938. Mural study for Madison Square Post Office, New York. (Section of Fine Arts.) Tempera, 23¼ x 20 inches. University of Maryland, College Park.

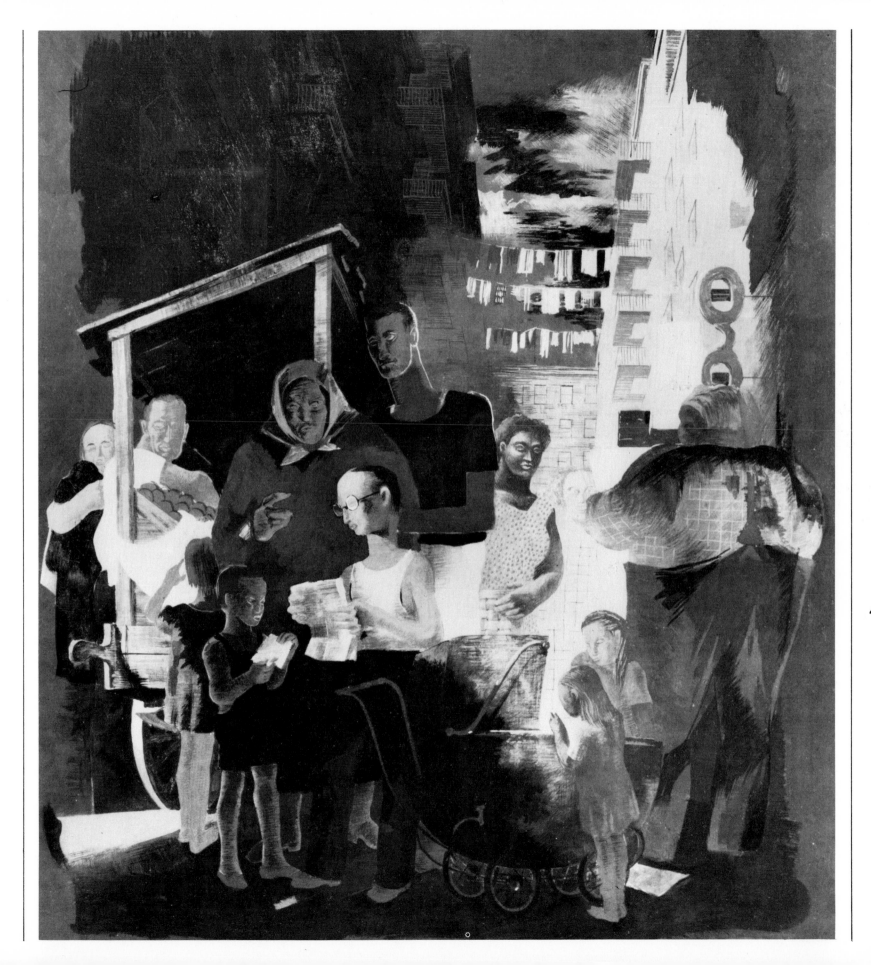

In one important respect, the PWAP was the most critical of all the government programs: its success or failure could have determined the fate of subsequent federal support to the arts. Fortunately, it was judged a splendid success and it fulfilled, beyond the wildest dreams, the hopes of many supporters. To some, the golden age had arrived. The federal government had assumed the role of patron of the arts, and the program's decentralized organizational structure enabled museum personnel, administrators, and artists across the country to contribute to its maintenance. Forbes Watson felt that it "quite easily may turn out to be the greatest step toward a finer civilization that the Government of the United States has ever previously taken."[8] Such government support demonstrated to the country as a whole the essential role that art played in people's lives. Artists could now consider themselves useful members of society, especially since the chasm between artists and their fellow men was clearly disappearing. The PWAP had made art respectable and had given artists a new sense of dignity. Even if the American Renaissance was still beyond the horizon, a democratic, nationwide art movement was certainly taking root.

Not incidentally, the PWAP was also judged an artistic success. Retrospective exhibitions held in 1934 at the Corcoran Gallery of Art and at the Museum of Modern Art were well received, and their favorable reception encouraged the development of further programs of support.

At the termination of the PWAP, chronic economic instability returned to the art world. Plans were introduced to continue government support through a fine arts foundation with a permanent undersecretary of fine arts, through a federal creative works program, and through a government financed plan of exhibitions and sales.[9]

Although the Artists Union—an assertive, provocative, and demonstrative group—wanted the PWAP to continue as a permanent agency, the government had other plans. The next project it initiated was the Section of Painting and Sculpture in the Treasury Department. Attacked at first by the Artists Union because it was too elitist,[10] the Section was charged with securing the best available art for new public buildings. Rather than function as a relief program, it sponsored competitions in which artists competed for the commissions. Under the leadership of Bruce, Watson, and Rowan, the three men

18. Moses Soyer, *Artists on WPA*, 1936. Oil, 36 x 42 inches. National Collection of Fine Arts, Smithsonian Institution, Washington, D.C.

19. George Biddle, *Tenement*, 1936. Oil, 156 x 127 inches. (Section of Painting and Sculpture.) Department of Justice, Washington, D.C. Photograph, Public Buildings Service.

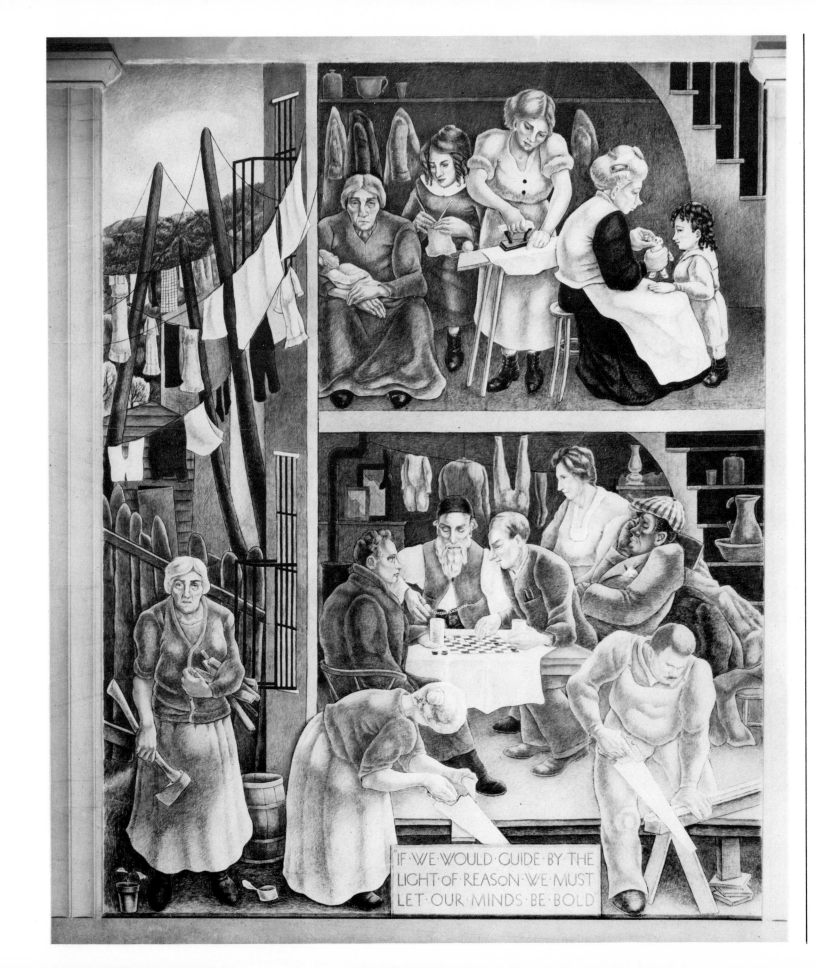

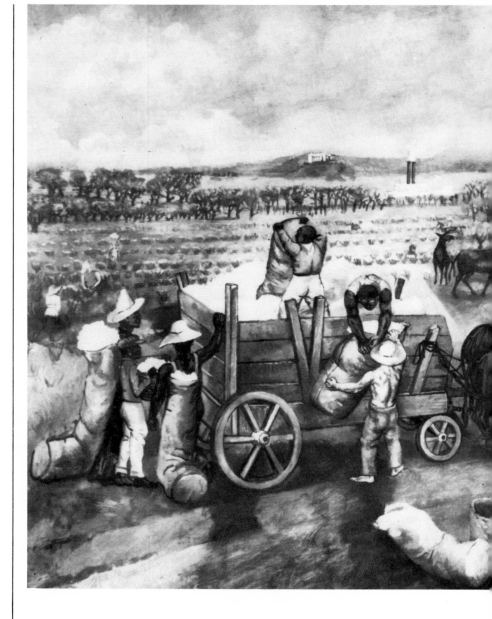

20. Philip Evergood, *Cotton from Field to Mill*, 1938. Oil. Post Office, Jackson, Georgia. (Section of Fine Arts.) Photograph, Public Buildings Service.

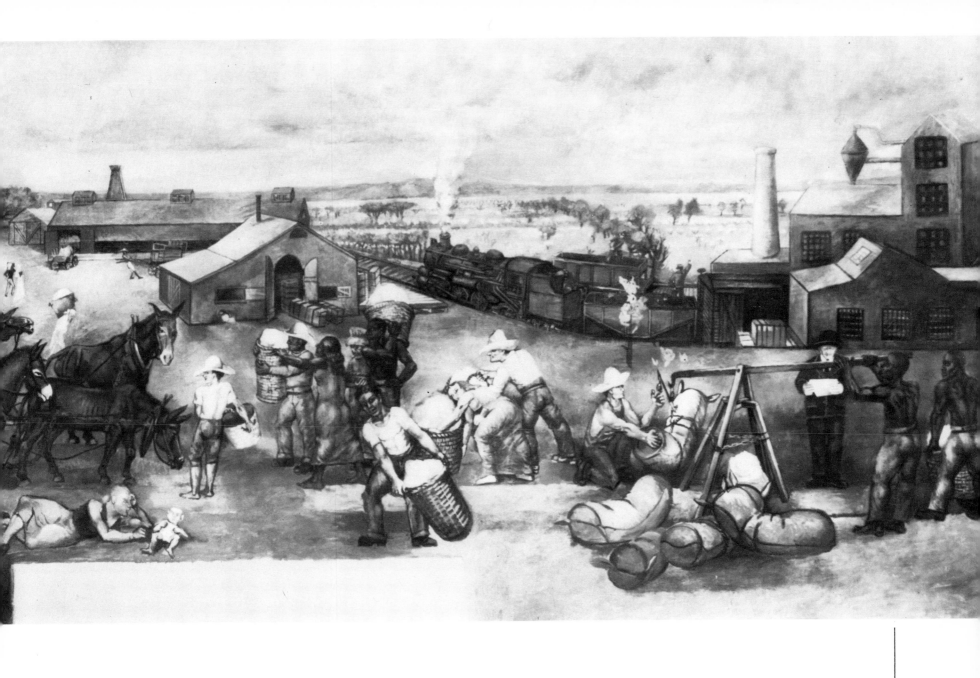

who headed the PWAP, the Section was established in October 1934. Under different names, and despite transfers to different federal agencies, this program lasted until 1943.

The Federal Art Project (FAP) of the Works Progress Administration, often confused with the Section, was not organized until May 1935. A relief project, the FAP supported artists, sponsored mural and sculpture projects, and developed other programs in art instruction, poster making, and photography. It provided funds for exhibitions, for the development of design laboratories, for the collection of bibliographies, and for the recording of American artifacts in what became known as the "Index of American Design." Basically a threefold enterprise of art production, art education, and art research, the FAP was the mainstay of the government art programs and lasted until 1943. The true, ideological child of the PWAP, the FAP was designed to "conserve the talents and skills of thousands of artists who, given the opportunity, are capable of making contributions of the utmost value to the enrichment of American life."[11] In its organizational structure, in its accessibility to both artists and public, and in the kinds of art it encouraged, the FAP adhered to virtually every tenet of the American Scene movement. The program's director, Holger Cahill, believed particularly in the principle "that it is not the solitary genius but a sound general movement which maintains art as a vital, functioning part of any cultural scheme."[12]

The Treasury Relief Art Projects, the least important of the four federal art projects, was established in mid-1935 and lasted until June 1939. This relief program was set up to supervise public-buildings decorations for which funds had not been allocated previously, and it was financed through the FAP.

Differences between the Section and the more egalitarian FAP became apparent from the start. Because mural competitions for the Section had to comply with local preferences and had also to gain final approval in Washington, artists tended to pursue an inoffensive middle ground of style and content. Limp platitudes, rather than strong statements, resulted in commissions, especially since censorship was exercised.[13] Art sponsored by the FAP was, by contrast, slightly more adventuresome and less conciliatory, and it explored ideological and stylistic extremes more readily. Probably no abstract murals were painted for the Section, but some were done under the Project's auspices, and individual artists, supported by the FAP, painted in a broad spectrum of styles. Abstract art was not officially discouraged, but Holger Cahill did set the tone of the FAP in these matters by stating that Americans "have come to see that preciosity (e.g., modernism) is related to the worship of esthetic fragments torn from their social contexts, and to the idea of art for the select few."[14] Cahill repeated this sentiment on several occasions, in slightly different words.

Whatever the political or esthetic range, however, the American Scene lay at the center of all the art projects. As never before, artists subjected the country to a minute factual scrutiny, as if by recording it they could possess it. Despite occasional intimations in the leftist press, the ideological content of most of these works was minimal. Even Thomas Craven realized that the celebration of American political systems was not the issue ("no self respecting artist could glorify capitalism"),[15] but that the crucial point was the sharing of experiences between the artist and his audience.

REGIONALISM AND SOCIAL REALISM

The term "Regionalism" was applied to certain painters of the American Scene with increasing frequency during the early 1930's, especially after the appearance of an article on Regionalist painters in *Time* magazine in December 1934. Although well suited to the writers associated with Vanderbilt University, the term had little meaning when it was applied to painters. It created (and still creates) a good deal of confusion, for try as they might, critics never succeeded in finding truly Regionalist painting in America during the 1930's. They saw plenty of localized subject matter, but they never discovered styles typical of particular sections of the country. The mobility of Americans and the brief history of each region precluded the development of isolated and static societies, in which genuine regionalist modes of expression might flourish.[1] (Ironically, Thomas Hart Benton, against whom the term was often used as an indictment, sought an all-encompassing image of America rather than a style or range of subject matter restricted to a particular region.)

Nevertheless, the term "Regionalism" unfortunately stuck, and in the eyes of both the critics and the public it became identified with three Middle Western painters—Benton, Grant Wood, and John Steuart Curry—even though Benton did not meet Curry until 1929 and Wood until 1934, after each had developed separate styles and aims. (The Eastern painter Reginald Marsh was often included with the group, probably because of Craven's writings.) Because of this linkage, Regionalist painting came to stand for an art of rural and country views, apolitical in content, often nostalgic in spirit, and usually unmindful of the effects of the Depression (*Colorplates 7–10*).

At least three reasons can be suggested to explain the identification of the three Middle Westerners with Regionalist painting, to the virtual exclusion of other American Scenists.

First, the mystique of the Middle West gripped the imaginations of many during the 1920's and 1930's. Frederick Jackson Turner, for example, believed that American democratic institutions first developed there and that the Middle West held "more in common with all other parts of the nation . . . than any other region." In fact, it was considered the most typical American region, geographically, industrially, and culturally.[2] During the 1920's, it had the added distinction of giving two Presidents to the country—Warren G. Harding and Herbert Hoover.

Within the art world, the mystique was fed by numerous articles in the journals. These stressed developments in the Middle West, to the extent that Grant Wood's Stone City Art Colony, for one, received far more publicity than it deserved. Even such a confirmed internationalist as René d'Harnoncourt of the Museum of Modern Art could state (and apparently believe) that he expected to see "real American art spring from the Middle West rather than the East." Benton never tired of praising the Middle West, and Craven viewed it as the logical center for the new art: "It is no accident that the leaders of the new school have come out of the Middle West: for in that region American particularism is at its highest and the frontier heritage of thought and conduct lives on in stark realities spreading distrust for all absolutes and preserving the hope and temper of democracy."[3] (In typical 1930's fashion, Craven has mixed concepts of geography, the environment, politics, nationalism, and esthetics within a single statement.) Where else but in the most American of regions would an American art arise?

Craven's own personality may well have been another reason for the popularity of the Middle Westerners. Not their only spokesman, he was nevertheless their most vociferous and abrasive publicist. In the heated political atmosphere of the 1930's, he was a master manipulator of the temperature of debate and argument. One gathers, from the tenor of many articles, that discussions of (and attacks on) the works of Benton, Wood, and Curry were really aimed at remarks Craven had made. By his skillfulness at forcing people to use terms as he defined them, Craven appropriated for his fellow Middle Westerners practically the whole of American Scene painting.

A third reason for identifying these artists with Regionalism lies in the works they created during the early 1930's. For it is an incontestable fact that Benton, Wood, and Curry created the most memorable individual paintings of the period. One tends to recall a gyrating figure by Benton, a tight-lipped introvert by Wood, or a rural view by Curry far more easily than a particular work by Shahn, Evergood, Stuart Davis, or by any other painter of the American Scene (*Ills. 21–22*). When all is said and done, the American Scene

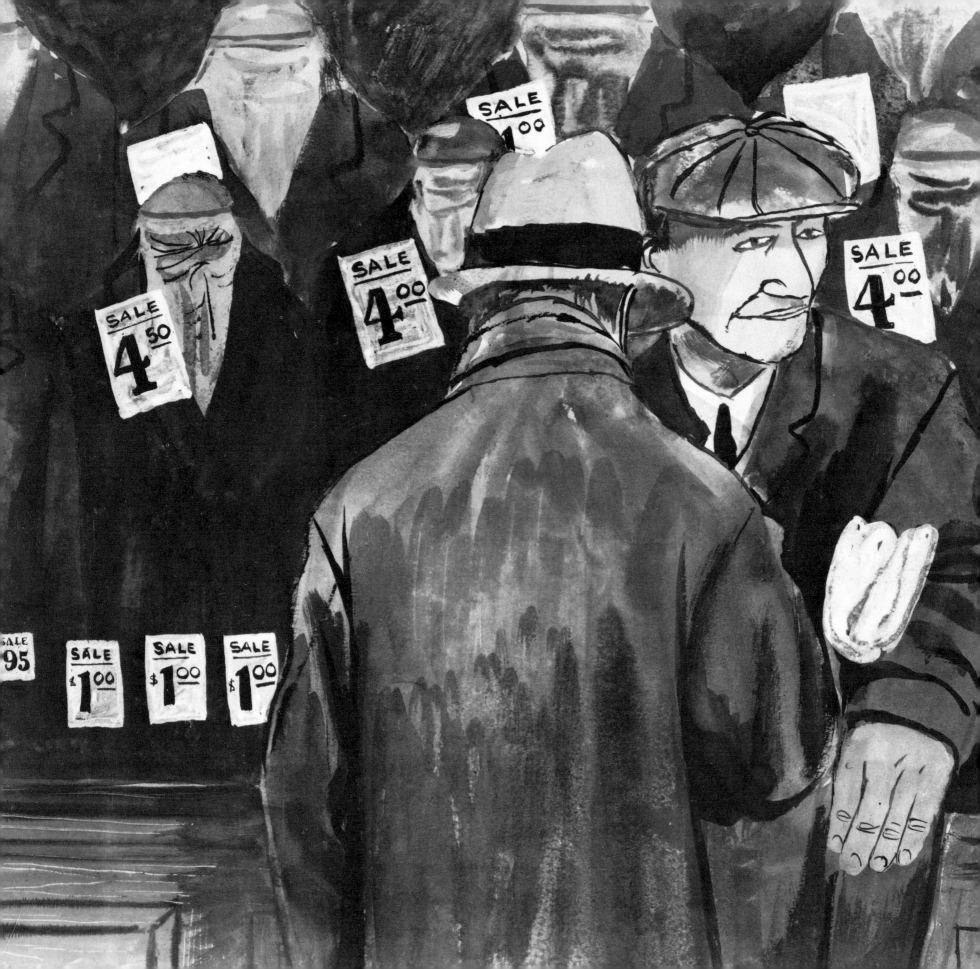

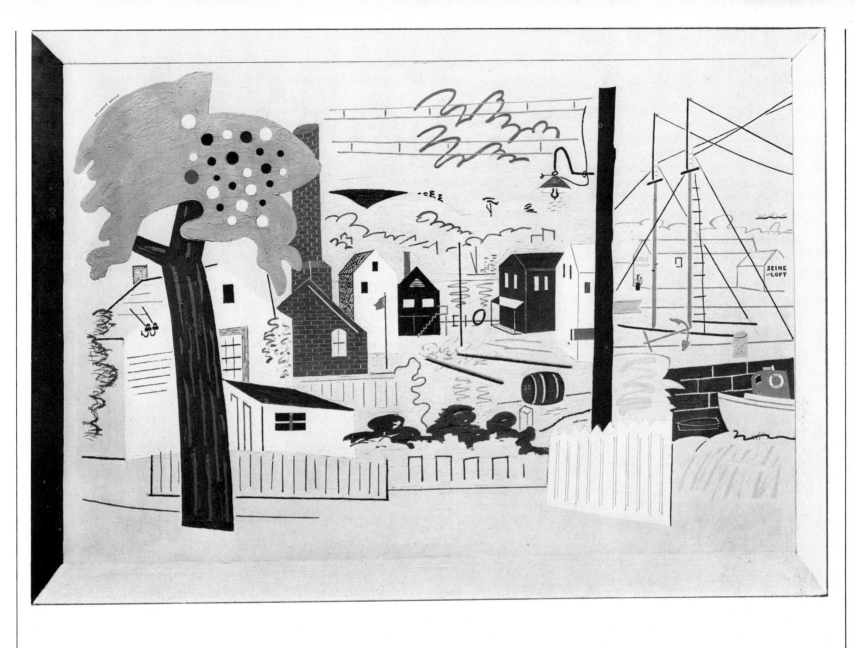

21. Ben Shahn, *The Bowery Clothing Store*, 1936. Gouache, 11 x 12¼ inches. Courtesy Kennedy Galleries, New York. (Detail.)

22. Stuart Davis, *Summer Landscape*, 1930. Oil, 29 x 42 inches. Collection The Museum of Modern Art, New York; Purchase.

THE AMERICAN SCENE

is more vividly inscribed in the images of Benton, Wood, and Curry than in those of any other painter.

The rise of a socially conscious faction within American Scene painting occurred slightly after the development of Regionalism. Called "Social Realism," this later branch of the American Scene was not as concerned with recording typical scenes, attitudes, and activities of the American majority culture. These painters did, however, portray commonly shared experiences, especially those of the urban poor and the working classes—with whom many Social Realists, often immigrants themselves, could easily identify. Generally projecting a sympathetic humanitarianism in their art, they also painted an idyllic vision of American life, one that had been sustained by generations of impoverished and persecuted Europeans. In fact, in their pursuit of the American dream, didactically planned through enlightened social engineering, the Social Realists were at times even less realistic than the Regionalists (*Ills. 23–24*).

In several areas, the Social Realists and the Regionalists shared certain characteristics. Both rejected an elitist conception of art and, with it, Parisian modernism. The Regionalists, for instance, considered Picasso the prime example of the international artist who culitvated artificial styles, while the Social Realists viewed him as the epitome of decadent bourgeois individualism. Both Regionalists and Social Realists longed for a democratic art integrated with the lives of ordinary citizens, and both groups often employed similar pictorial themes. Shahn, like Benton and Curry, depicted religious revival meetings—a subject generally associated with Regionalism (*Ills. 25–27*). Benton, Curry, and Marsh participated in an exhibition entitled "An Art Commentary on Lynching" in 1935—a topic more closely related to Social Realism (*Ill. 28*).[4] Joe Jones, a staunch political leftist from St. Louis, painted the eroded landscape of the despoiled Middle West (*Ill. 29*); Alexandre Hogue, a nonpolitical Southwesterner, became famous for his scenes of the equally ravaged Dust Bowl (*Colorplate 1*). Perhaps no artist savaged the Middle Western face and character as brutally as Grant Wood (*Ill. 1*).

But, just as clearly, differences between the two groups also existed. Jones conveyed the disparity between workers and managers in his *Roustabouts* (*Ill. 30*), while Curry stressed the domestic, communal aspects of outdoor living, rather than the horrors of a migratory existence or the backbreaking labor of repairing roads, in his *Roadmenders' Camp* (*Ill. 31*). Like Jones, many leftist painters produced works that carried no overt political message but were influenced by a general political orientation. Class consciousness, rather than local or national awareness, informed the art of these Social Realist painters. Hard times marked their point of departure; the stern realities of foreclosure and unemployment influenced their choice and treatment of subject matter.

It has been said by Herman Baron, founder of the American Contemporary Artists Galleries (ACA) in 1932 and a strong supporter of Social Realism, that the movement became viable only after an exhibition of Jones's paintings in the spring of 1935.[5] Although Baron exaggerated, it is true that Social Realism scarcely existed at the start of the Depression. To be sure, *The New Masses* magazine, founded in May 1926, as well as earlier leftist journals, had published cartoons by politically progressive artists, and Hugo Gellert, an art editor of *The New Masses,* had painted a mural in the building owned by the American Communist Party around 1927.[6] But these efforts did not constitute a burgeoning movement. Because a similar lackluster condition existed in literature, the magazine helped found the John Reed Club in 1929, to encourage the spread of pro-

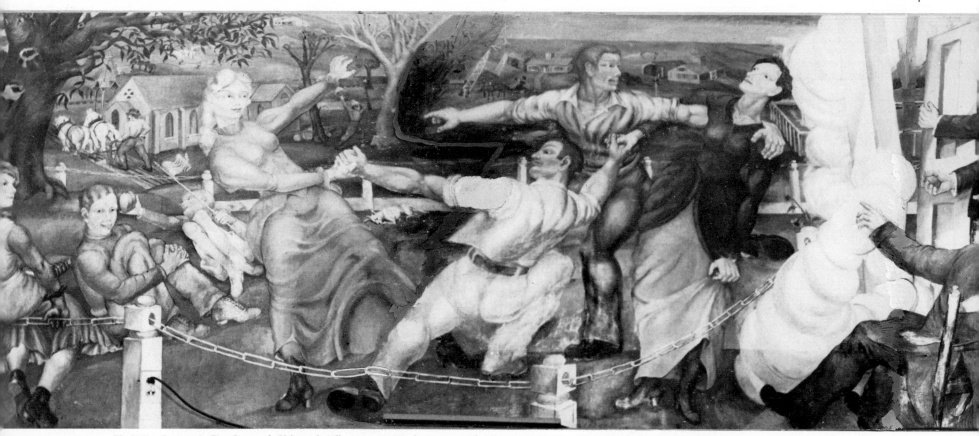

23. Philip Evergood, *The Story of Richmond Hill*, 1936–37. (Works Progress Administration.) Oil, 72 x 324 inches. Richmond Hill Branch Library, New York.

letarian writings. Within the next two years, the club began to sponsor art exhibitions; touring shows were organized and exhibitions held in New York and Chicago.[7] But not until 1933 was an art of "social repercussions" recognized by the conventional art press.[8] Also at this time the leftist press finally began to mobilize socially conscious artists by exhorting them to develop a proper revolutionary art.

To doctrinaire Communists, the artists were floundering and in clear need of guidance. But the extent of Communist leadership was probably less than the number of articles in the leftist press would lead one to believe. Political awareness was stressed through the John Reed Club exhibitions, through the various art schools associated with the club, through the Artists Union and its publication *Art Front,* through *American Artist* (the news bulletin of the American Artists Congress), and through the leftist literary press.[9] But the kind of language often found in the journals, and the kinds of directions given to artists, should not be confused with or substituted for the actual works. Although an art of explicit political sloganeering did appear, the paintings of major figures such as Shahn, Evergood, and the Soyer brothers are largely free of it (*Ills. 32–35*).

Nevertheless, generalizations can be made about the content of socially conscious art between roughly 1932 and 1935. Despite ample rhetoric, many painters portrayed their subjects as sad, drab, and spiritually depressed individuals, rather than as heroic workers bursting with the kind of vitality capable of building a new society. At this time also, authors of radical novels exhibited a similar psychological bent, and they often depicted workers as losing strikes, despite the fact that organized labor won many victories at the time.[10] Perhaps radical artists and writers, unable to surmount their underdog mentality, held serious doubts about the ultimate triumph of the working classes.

In any case, the differences between Regionalists and Social Realists had grown enormously in only a few exhibition seasons. Doris Lee's *Thanksgiving* (*Colorplate 11*), awarded a major prize in the 1935 Exhibition of American Paintings and Sculpture at the Art Institute of Chicago, mirrored the type of art that proponents of the American Scene had sought: a subject with which many could identify, presented in a style whose American roots could be traced to Currier and Ives prints as well as to the modern comic strip.[11] In contrast to this nearly perfect example of American Scene painting at its most nostalgic, Selma Freeman's *Strike Talk* (*Ill. 36*) projects the American Scene at its most militant. While at their sewing tables, garment workers plot their next move in the relentless struggle against their capitalist oppressors.

By 1935, the antagonisms between Regionalists and Social Realists also reached a high level of verbal, and occasionally physical, abuse. At least one of Benton's public lectures was halted by radicals during 1934. Leftists excoriated the Regionalists for their nationalism and for their incipient fascism; almost incidentally, the Regionalists were also attacked for the meager esthetic value of their works. (Marsh, for example, was simply written off as a member of the "Coney Island School of Art.") The concern of Benton and Craven for typical American experiences was considered dangerously similar to the demand of Hitler for a pure German art based on pure German experiences. In turn, Benton and Craven held that Communism, although it initially helped to break elitist patterns of art appreciation, locked artists into an abstract system of thought more rigid than the one it had intended to destroy. Communism, by denying value to immediate experience, substituted in its place economic theories devoid of ordinary human feeling. In one particular interchange, Curry, much less polemical than Benton or Craven, accused the Social

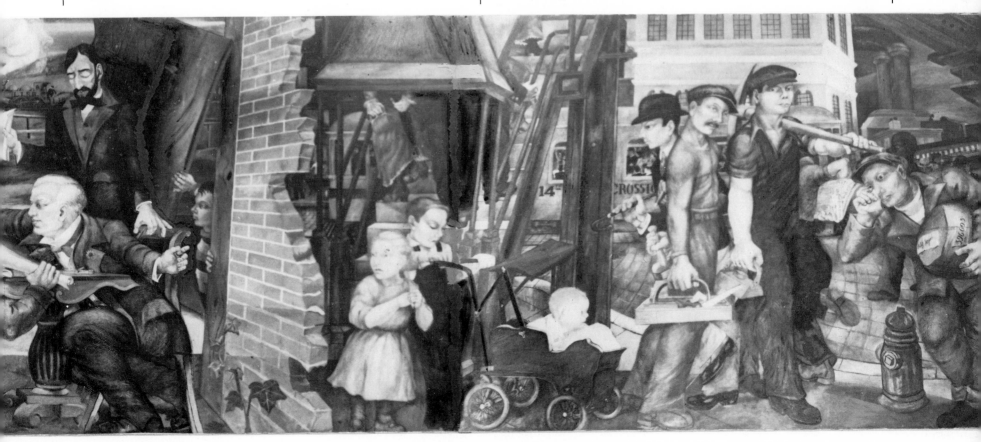

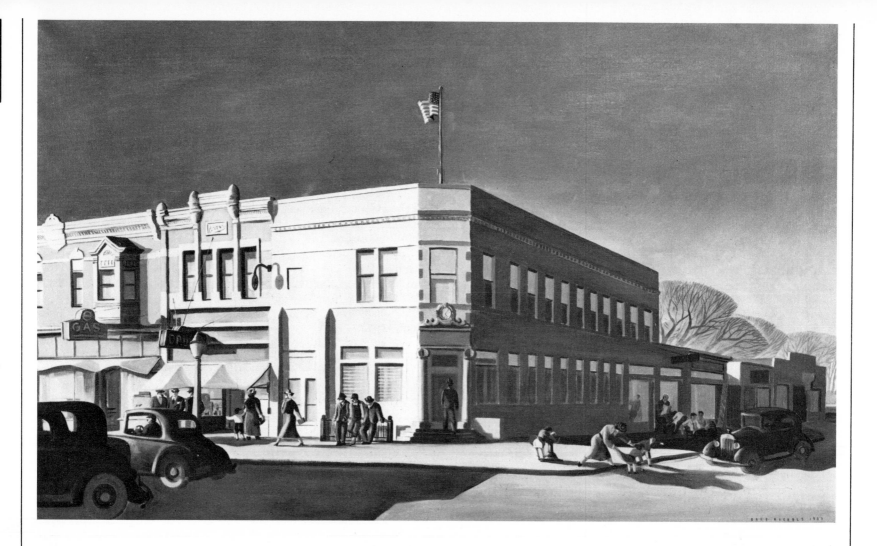

24. Dale Nichols, *City National Bank*, ca. 1930–40. Oil, 24 x 40 inches. The C. Leonard Pfeiffer Collection of American Art, The University of Arizona, Tucson.

Realists of painting symbolic figures rather than real people engaged in actual events. Perhaps he had Freeman's *Strike Talk* in mind when he advised artists of the John Reed Club to look at life, to go into a sweat shop and observe activities in Union Square, instead of painting stock figures to illustrate particular points.[12]

Although the central dispute between the two groups boiled down to the idea that the Regionalists wanted to create an art from local conditions and that the Social Realists wanted to change those conditions, the arguments used by each side often had nothing to do with their actual differences. In a period filled with incredible tensions—created by the Depression, by changing social and political values, and by Fascism abroad—each side argued as much to bolster its own cause and sense of certainty as to destroy the convictions of the other. Moreover, the militancy of the Social Realist attack was abetted by at least two important factors—the backgrounds of the artists and the development of the Popular Front.

Many Social Realists were either immigrants or the children of immigrant parents. Familiar primarily with life in urban ghettos, they they were not as responsive as were the Regionalists to the country's traditions (real or mythic). Moreover, the American heartland began, remotely, west of the Hudson River, perhaps a territory which they did not want to explore after reading such works as Sinclair Lewis's *Main Street* or Sherwood Anderson's *Winesburg, Ohio.* An art based on the appreciation, love, and possible glorification of that America —the direction in which they felt the American Scene movement was heading—threatened what was already a marginal relationship between them and the remainder of the country.

Furthermore, many Social Realists were Jewish. Since Hitler's initially restrictive, and ultimately lethal, policies toward Jewish artists were carefully reported in the art press (as well as in the daily press), ominous parallels between German nationalism and American Scene nationalism could easily be made. This became easier to do after Thomas Craven, in his *Modern Art,* called Alfred Stieglitz "a Hoboken Jew."[13]

Two statements, one by Hitler and one by Craven, might have suggested a disturbing similarity in esthetic attitude:

Art must not only be good but it must be popularly grounded. Only that

art which draws its inspiration from the body of people can be good art in the last analysis and mean something to the people for whom it has been created.

Again and again, with all the temper at my command, I have exhorted our artists to remain at home in a familiar land, to enter emotionally into strong native tendencies, to have done with alien cultural fetishes.[14]

No wonder a painter like Moses Soyer could warn artists against being "misled by the chauvinism of the 'Paint America' slogan. Yes, paint America, but with your eyes open. Do not glorify Main Street. Paint it as it is—mean, dirty, avaricious. Self glorification is artistic suicide. Witness Nazi Germany."[15] From the hindsight of the intervening years, Soyer's anger and fear are easily understood, but it is also equally clear that he was arguing principally with Craven, rather than with the vast majority of American Scenists.

The Social Realists understood and sought communion with people who, like themselves, had suffered deprivations. The onset of the Depression only emphasized their sympathies for the downtrodden, while the increasing popularity of Communism provided a political structure through which to channel their compassion, even if they were not Party members. The formation of the Popular Front in the mid-1930's, however, deflected some compassion for the downtrodden into hatred for the Regionalists.

Inaugurated officially at the Seventh World Congress of the Communist International in August 1934, the Popular Front called for alliances with democratic parties of the Western world, to act in common defense against Fascism. Although American Communists were encouraged to cooperate with New Deal policies, they were not encouraged to support the artistic nationalism of Craven. On the contrary, Craven and Benton were particularly attacked as "Fascists." Such actions had already been officially sanctioned by Alexander Trachtenberg, a major figure in Party cultural affairs. In 1934, he declared the Party's intention to sponsor a national writers congress (which took place in 1935) and a subsequent artists congress, in order to battle Fascism at home and abroad and to fight "the Roosevelt fostered national chauvinist art."[16] By the time the American Artists Congress was held in February 1936, hostilities were at peak intensity.

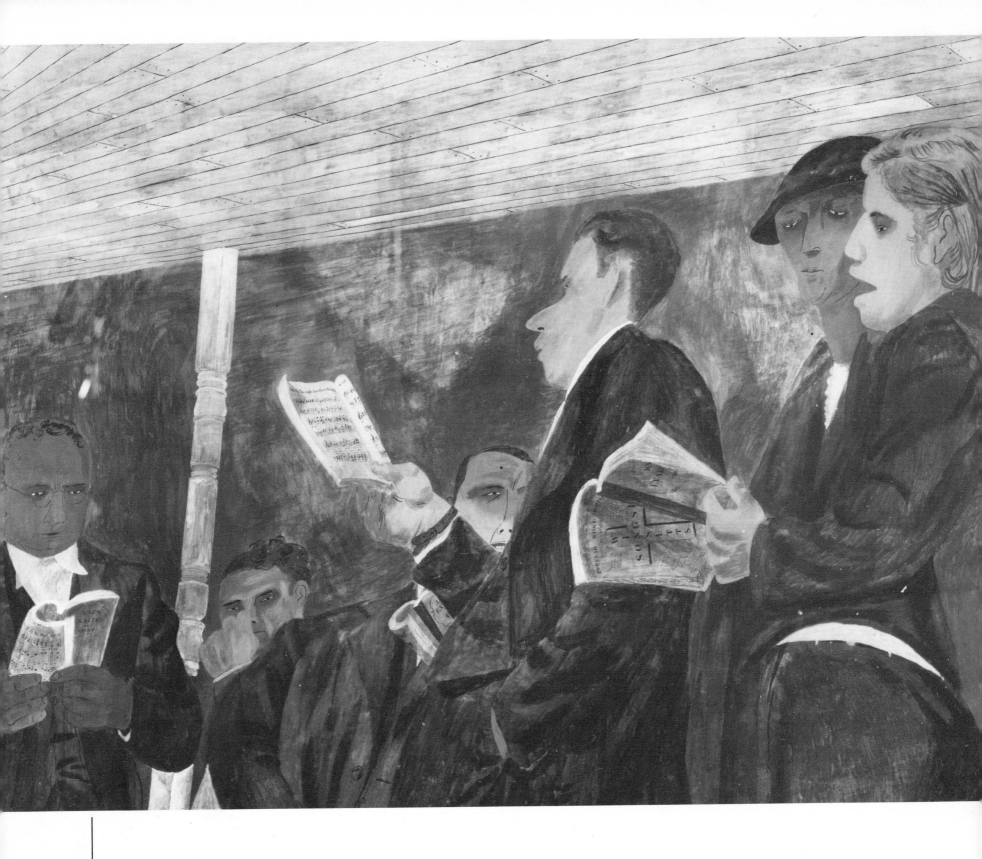

25. Ben Shahn, *Jesus Exalted in Song*, 1939. Tempera, 22 x 30 inches. Milwaukee Art Center Collection.

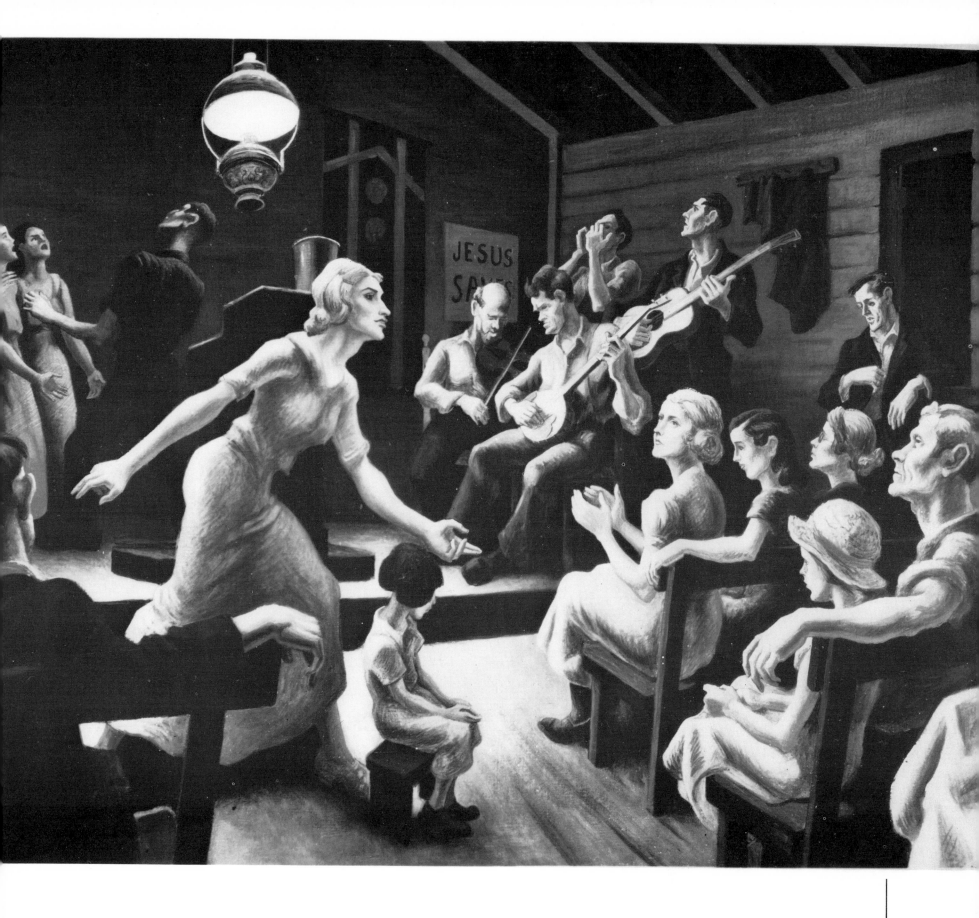

26. Thomas Hart Benton, *Lord Heal the Child*, 1934. Oil and tempera, 42 x 56 inches. Collection Mr. and Mrs. John W. Callison.

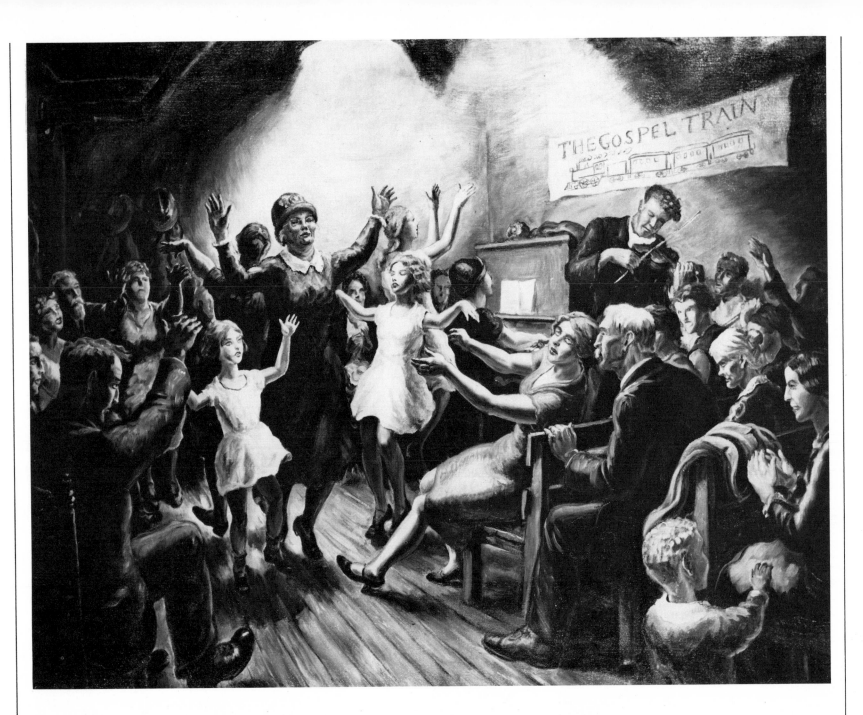

64

27. John Steuart Curry, *The Gospel Train*, 1929. Oil on canvas, 40 x 52 inches. Syracuse University Art Collection, Syracuse, New York.

28. John Steuart Curry, *The Fugitive*, 1933–40. Oil. Collection unknown.

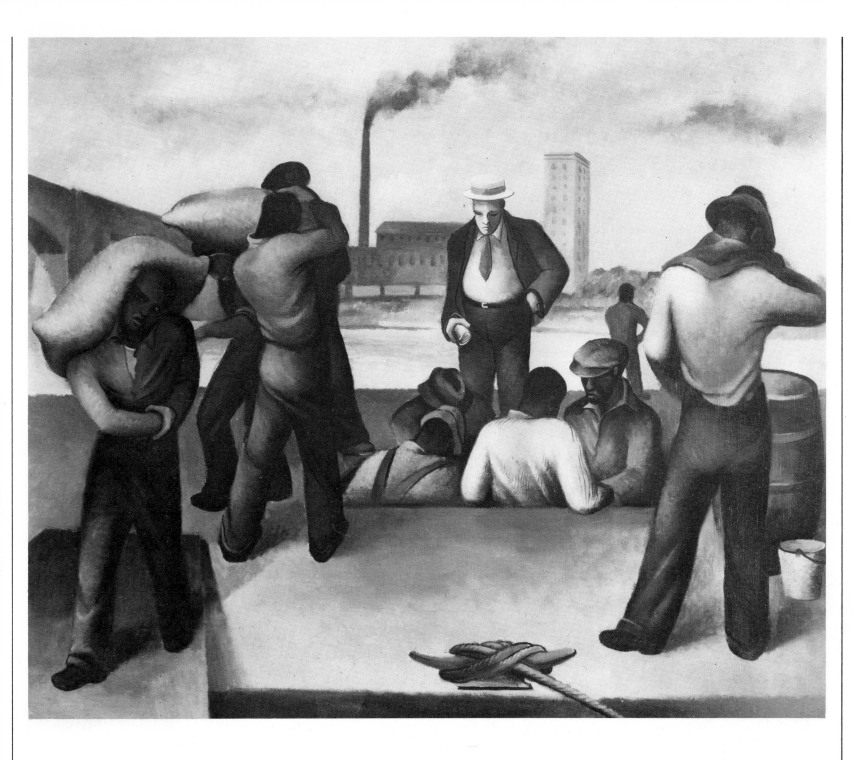

29. Joe Jones, *American Farm*, 1936. Oil and tempera, 30 x 40 inches. Collection Whitney Museum of American Art, New York.

30. Joe Jones, *Roustabouts*, 1934. Oil, 25 x 30⅛ inches. Worcester Art Museum, Worcester, Massachusetts; Gift of Aldus C. Higgins.

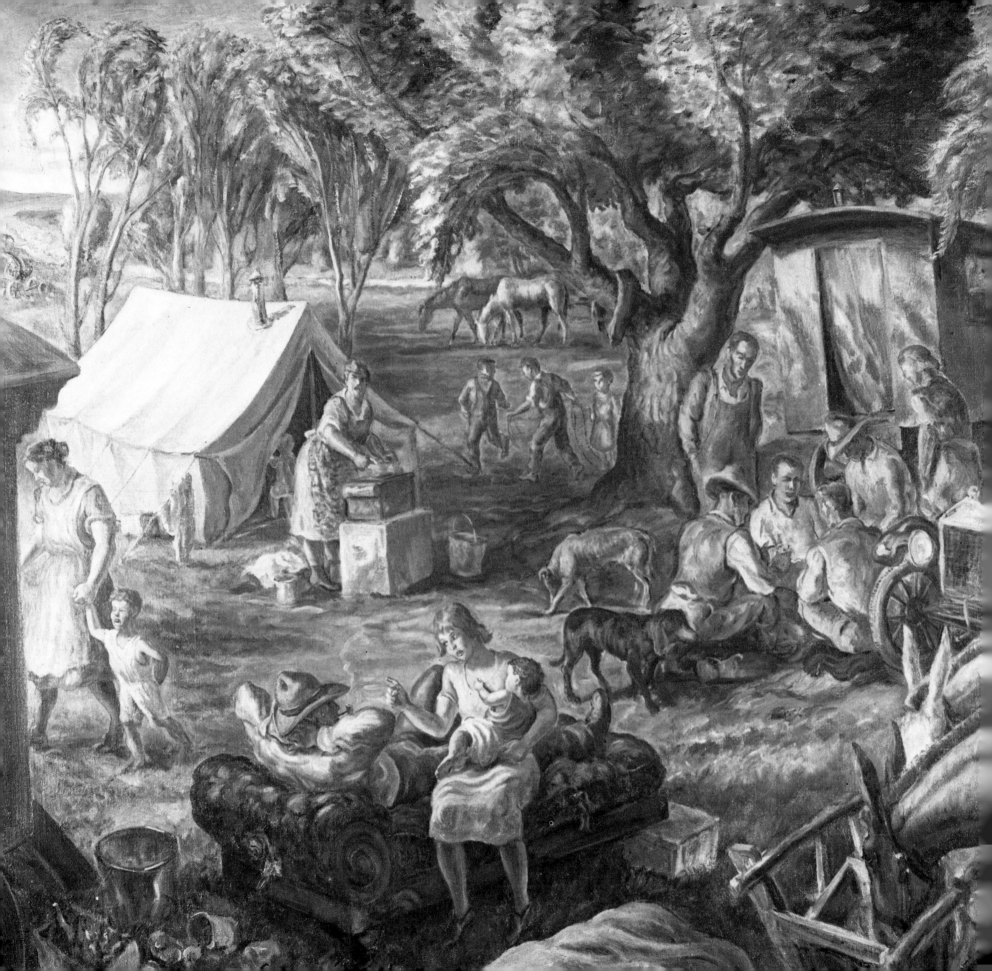

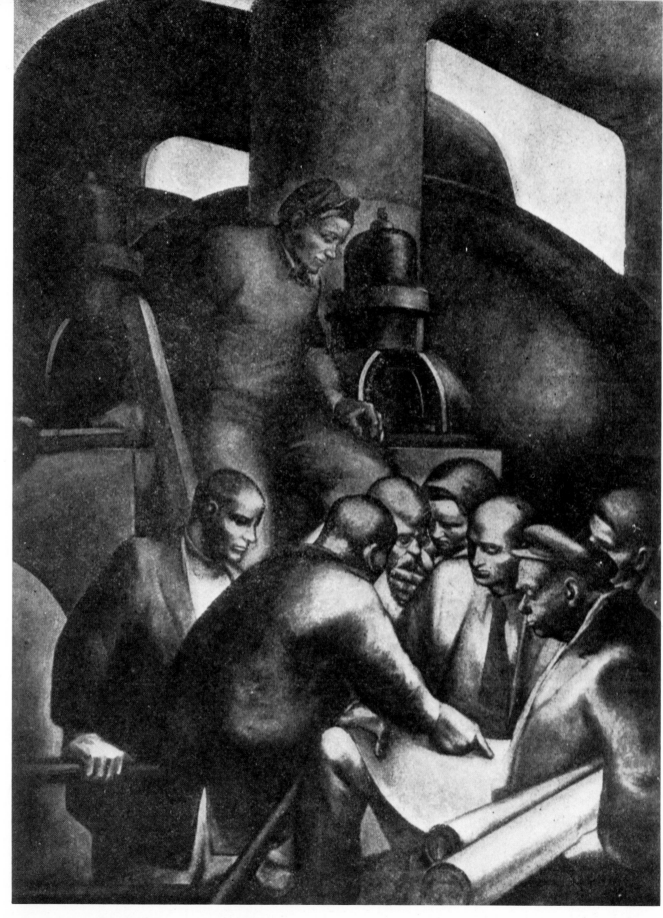

31. John Steuart Curry, *Roadmenders' Camp*, 1929. Oil, 48⅛ x 52 inches. University of Nebraska-Lincoln Art Galleries; F. M. Hall Collection. (Detail.)

32. Jacob Burke, *Industrial Planning*, ca. 1934–35. Collection unknown.

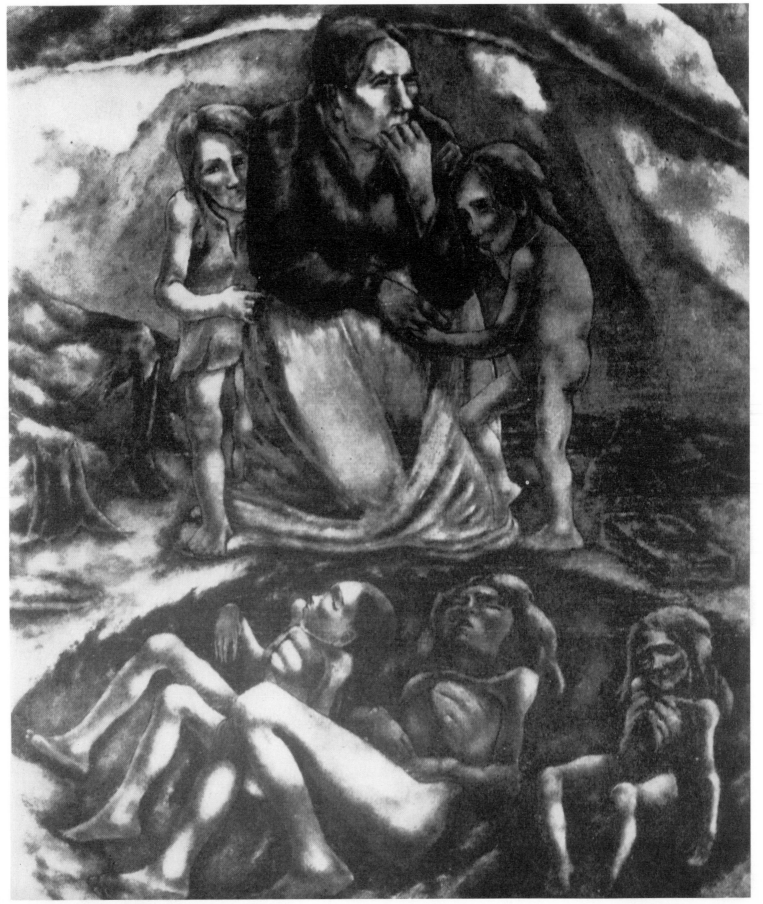

33. George Biddle, *Starvation*, ca. 1934–45. Collection unknown.

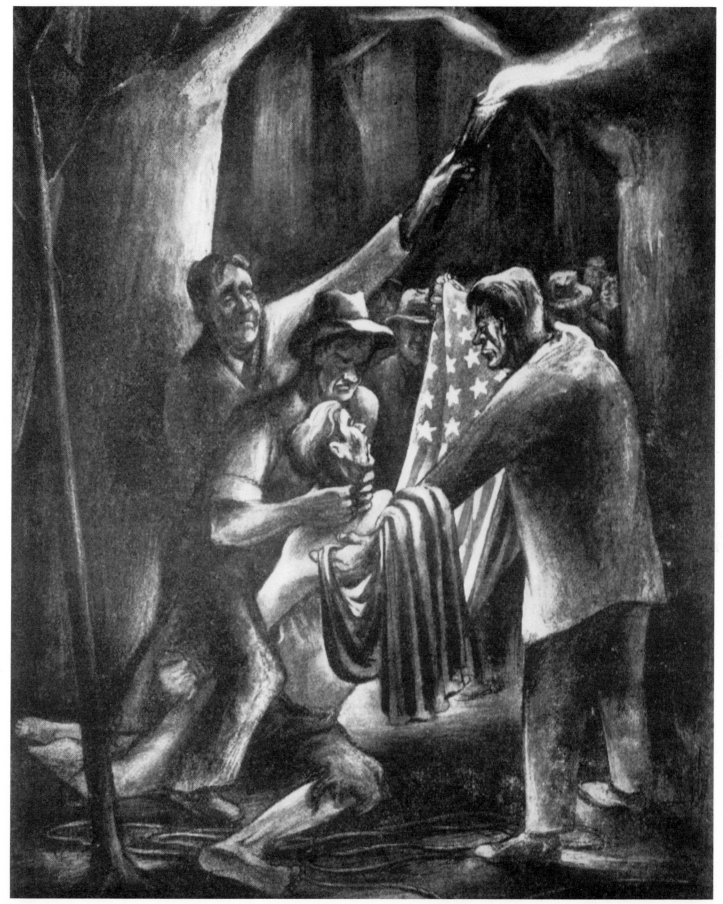

34. Russell Limbach, *Kiss That Flag*, ca. 1934–35. Collection unknown.

1

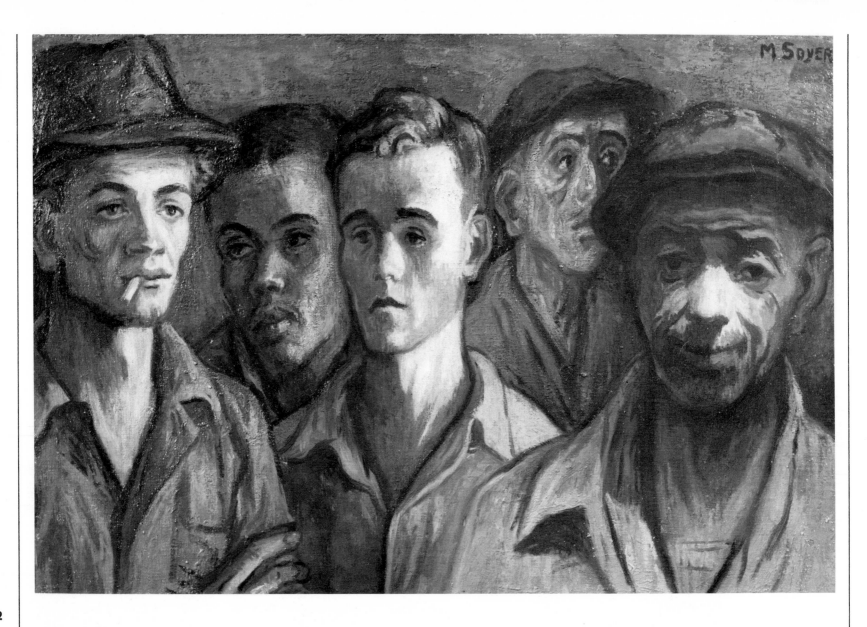

72

35. Moses Soyer, *Men of the Waterfront*, 1938. Oil, 20 x 30
inches. Collection Herbert A. Goldstone, New York.

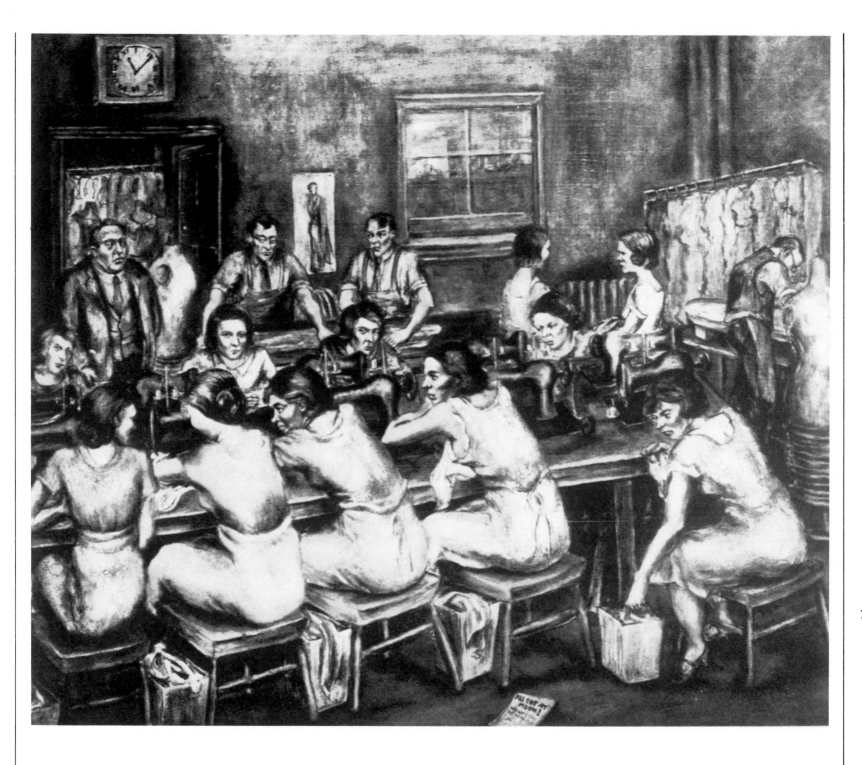

73

36. Selma Freeman, *Strike Talk*, ca. 1934–35. Collection unknown.

THE AMERICAN SCENE

THE END OF THE 1930'S

By 1936, the terrain of American Scene painting had been mapped, the major figures identified, and the distinctions between major groups recognized. The government programs, reinforcing rather than altering the direction of American painting, insured the continuing popularity of realistic painting, provided many artists with minimal means of support, and exposed the public to more art than ever before. In effect, the vitality of the American Scene movement was at its peak.

By 1937, critics discerned shifts of emphasis in the handling of subject matter and commented on the increased attention paid to composition and pictorial structure. Themes painted with more imagination began to replace bare presentations of facts. Even a vague romanticism, suppressed earlier in the decade by a strident realism, was noticed. Social protest painting developed into a "modern humanism," and the raw statements of Americana served increasingly as starting points for an art concerned with formal problems and personal interpretations.[1] Evidently, as arguments between Regionalists and the Social Realists grew more bitter and vindictive, their paintings grew less dissimilar.

Because of the vast number of paintings produced during this period (many of which have been lost or destroyed), it is difficult to chart precisely the nature of these changes. Perhaps critics, tired of the kinds of paintings exhibited in previous seasons and anxious to justify federal support of the arts, began to emphasize in their reviews quality rather than social attitude—that is, esthetic merit rather than nationalism or politics. Perhaps artists who had joined the Federal Art Project were no longer forced to appeal to a buying public and could indulge their fancies more freely, albeit within the generally realist context of the American Scene. Very likely, the institution of the Popular Front provided left-wing artists with an excuse to paint in a more personal way, their eloquent denunciations of the Regionalists notwithstanding. No doubt, Benton's departure from New York for Missouri in 1935 and his subsequent change of style, Curry's removal to Wisconsin in 1936, and the subtle shifts of emphasis in the works of artists like Shahn and Raphael Soyer later in the decade also contributed to the changing situation.

Paintings by three artists, active throughout the decade, perhaps best summarize the drift of American Scene painting after 1935. These are Alexander Brook's *Georgia Jungle* (1939), Ben Shahn's murals for the Bronx Central Annex Post Office (1938–39), and Curry's *The Tragic Prelude,* one of the panels painted for the Kansas State Capitol, Topeka (1938–39).

Brook's painting (*Colorplate 12*), a first-prize winner at the Carnegie International in 1939, is neither a folksy Regionalist painting of blacks nor a Social Realist documentary of human blight. Less militant and less picturesque than paintings of the early 1930's, it projects a very personal feeling about the human condition. It avoids the kind of overt political message that Arnold Blanch conveyed in his *The Third Mortgage* of 1935 (*Ill. 37*).

The subjects of Shahn's murals (*Ill. 38*), a panoramic display of American agriculture and industry, also lack specific social messages. Since they were painted for the Section of Fine Arts (the renamed Section of Painting and Sculpture), Shahn may have limited their content to a series of amiable observations. On the other hand, his noncommittal attitude might also reflect the loss of political purpose felt among left-wing artists, particularly after the Moscow Trials of 1936–37, the Stalinist murders of leftists during the Spanish Civil War, the Russo-Finnish War of 1939–40, and the Hitler-Stalin Pact of 1939.

Curry, too, seemed to reach for a ground of common understanding in *The Tragic Prelude* (*Ill. 39*). The ungainly figure of John Brown rises above the contending antislavery and proslavery forces. At their feet lie the dead of the Civil War. Behind, despite tornadoes and prairie fires, the endless trek westward continues. Not a work of local color, but a mural recording genuine concern for human freedom and social change, it summarizes many aspects of American Scene painting. It contains realistically portrayed figures, easily understood subject matter, elements of local and national history, and an appeal for political and even revolutionary change. Designed for public view in the Kansas capitol building, *The Tragic Prelude* would seem to be in intent, if not in realization, the quintessential mural of the American Scene.

74

37. Arnold Blanch, *The Third Mortgage,* 1935. Collection unknown. (Detail.)

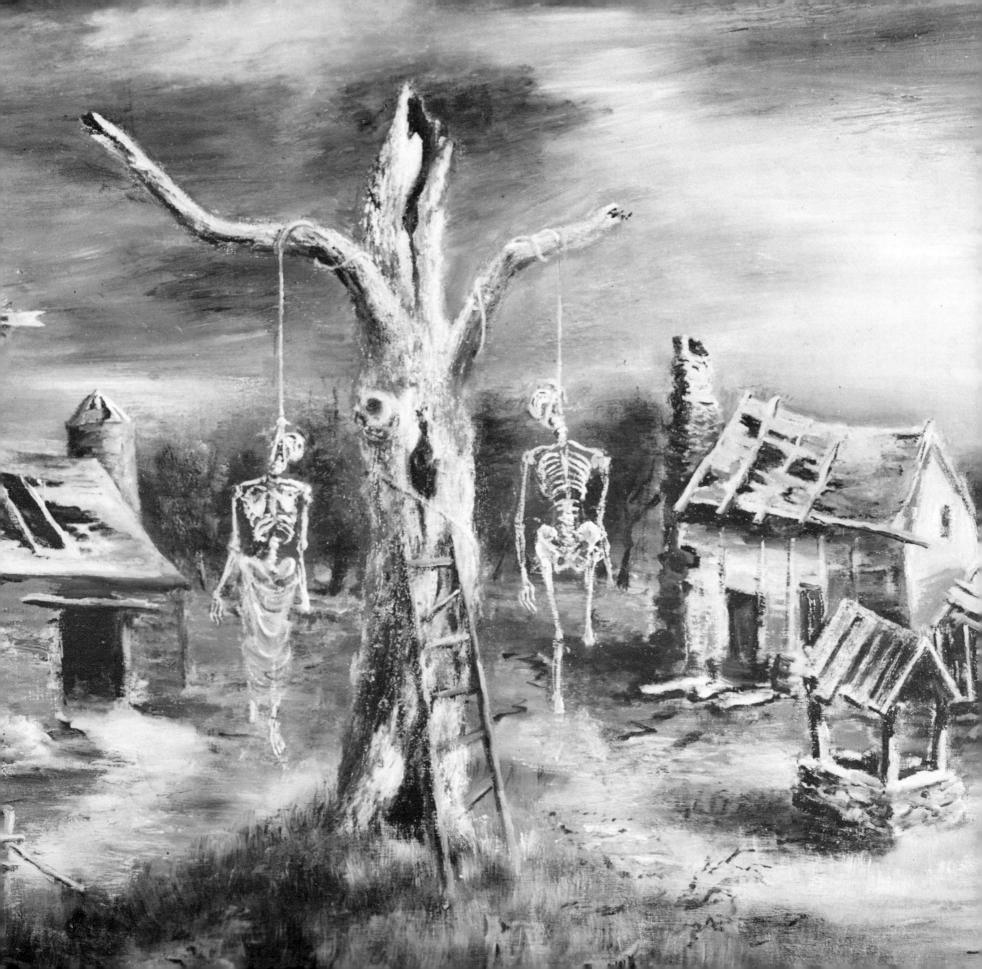

THE AMERICAN SCENE

38. Ben Shahn, *Steel Mill*, 1938–39. Post Office, Bronx Central Annex, Bronx, New York. (Section of Fine Arts.) Photograph, Public Buildings Service.

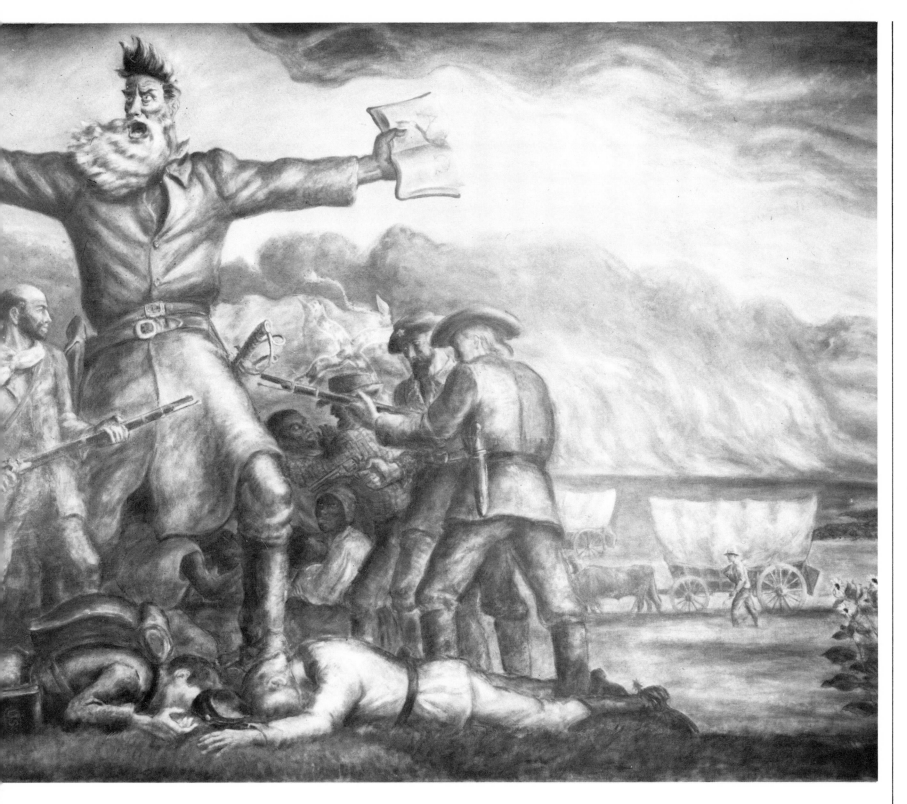

39. John Steuart Curry, *The Tragic Prelude*, 1938–39. Oil and tempera, 132 x 264 inches. Kansas State Capitol, Topeka.

THE AMERICAN SCENE

By 1939, it became apparent that an era was ending with the decade. Observers, even ardent supporters, began to speak of the American Scene in the past tense, as the movement increasingly became an historical rather than contemporary phenomenon. The publication of four books and the presentation of at least four major exhibitions allowed preliminary appraisals even before the decade ended. The books were Peyton Boswell, Jr.'s *Modern American Painting,* Edward Alden Jewell's *Have We An American Art?,* Martha Chandler Cheney's *Modern Art in America,* and Forbes Watson's *American Painting Today.*[2] The exhibitions included a large section at the New York World's Fair, one at the Golden Gate Exposition in San Francisco, the "48 States Mural Competition"—an exhibition showing preliminary studies of murals to be executed in a post office in each state—and the Carnegie International. Because of the start of World War II, the latter became largely an American show.[3]

The more sensible observers realized that an American style had not emerged and that a renaissance had not occurred. The appearance of an American art, one able to compete on equal terms with Europe's best, was still a desire rather than a fact. But most critics recognized that a solid foundation had been established upon which art could be created in the 1940's. Martha Cheney expressed this eternal American yearning in *Modern Art in America:* "It is not narrow Americanism or national pride that, for two decades, has pointed to signs that the central activity of a new major art type is destined to take place in America, within this century."[4]

Despite these dents to the optimism of the American critics, responses to the various exhibitions were generally favorable. A great number of works, relatively free of European influence, had been created. These had become more accessible to the public than ever before, and the government had become a patron of the arts. In fact, the Depression had begun to be considered a blessing in disguise. Never before, it was argued, had American art undergone such rapid transformation, nor had American artists gained such self-confidence and respect. Forbes Watson observed that "there is today a new pervasive spirit of art: a felt confidence, a self-sufficiency, and an artist solidarity, at scores of centers of activity—a vibrancy and vigor of the art-life never before sensed."[5] And George Biddle may well have reflected the feelings of many when he remarked that the Depression exerted "a more invigorating effect on American art than any past event in the country's history."[6]

Despite the mutual back-slapping and self-congratulations, an aura of uneasiness pervaded the art world. Most critics agreed that independence from European art was needed in 1930, but that the problems confronting artists in 1940 required different solutions. Even Benton admitted that the nativist leanings and rural emphasis of Regionalism had become too parochial at a time of global conflict.[7] And the humanitarian concerns of Social Realists in an era of so much human suffering had become an empty dream. The questions that were raised had two main points. Could a viable American art be sustained within the existing framework? Could a democratic art continue to flourish, if it were rooted in the social and cultural life of the nation, but make some accommodation to European modernism?

Peyton Boswell, Jr., looked for a second-generation American Scene movement and found at least one exemplary figure in it, Fletcher Martin (*Ill. 40*). Martin's style, according to Boswell, was not descriptive but evocative, "attuned to the exciting mosaic of life in America"; it was surging, restless, and occasionally crude.[8] But a second generation did not emerge and the notion remained an amiable and temporary fiction.

Other artists, not bound to a single school or point of view, began to explore a much more imaginative thematic and stylistic range. These included Darrel Austin, Alexander Brook, Julien Levi, Morris Graves, and Philip Guston (before his career as an Abstract Expressionist), all of whom gained prominence around 1940. Their appealing art, which rarely strayed beyond the point of comprehension, mediated between realism and abstraction, between social commitment and personal comment, and between American traditions and European modernism (*Ills. 41–45*). Both modern and safe, their works developed logically from the American Scene and were considered important to the development of American art at the time.[9]

The abstract and nonobjective painters connected with the American Abstract Artists, a group founded in 1936, played a marginal role in this development (*Ill. 46*). However, their art, like that of Austin and the others, pointed to the revival of European influences on American art, an observation often made around 1940.[10]

79

40. Fletcher Martin, *Trouble in Frisco*, 1938. Oil, 30 x 36 inches.
Collection The Museum of Modern Art, New York; Abby Aldrich
Rockefeller Fund.

41. Darrel Austin, *Europa and the Bull*, 1940. Oil, 29⅞ x 36¼ inches. From the collection of the Detroit Institute of Arts; Purchase, The William H. Murphy Fund.

42. Philip Guston, *Martial Memory*, 1941. Oil, 39¾ x 32¼ inches. The St. Louis Art Museum.

THE AMERICAN SCENE

Probably none of those favoring the development of an independent American art would have predicted the importance of yet another group of artists. Certainly few had the foresight to understand the implications of the arrival of the leaders of the School of Paris. During the late 1930's and early 1940's, André Breton, André Masson, Marc Chagall, Fernand Léger, Piet Mondrian, and Amédée Ozenfant all came to the United States.[11] Their presence destroyed any possibility that an American art would develop logically from the matrix of the American Scene and ultimately helped to reestablish the links between American artists and the European avant-garde.

The arrival of these artists had a fivefold effect upon American art. First, they reminded American artists of their international responsibilities, thus encouraging them to adopt broader points of view. Second, in a time of global conflict, the European artists revealed the provincialism of American Scene painting. Third, as "individualists," they served as potent symbols of the validity of personal rather than communal artistic aims. Fourth, in their disregard for environmentally based esthetics, they challenged a major premise of American Scene painting. Fifth, largely uninfluenced by American art, they confirmed the supremacy of the modern European tradition and established it as the only viable one to absorb and develop further. They provided Americans with radical alternatives rather than logical continuities, and, clearly, the time was ripe for drastic change.

That the major style, Abstract Expressionism, developed within the context of Surrealism is not a consideration here. But since many Abstract Expressionists matured during the 1930's, worked on government programs, and designed murals, they carried with them into the 1940's certain attitudes of the previous decade. Despite the violent differences in aims between the two generations of artists, these attitudes provided a measure of continuity between the two periods, and a brief consideration of them can serve as a conclusion to this section.

Rarely were artists so serious and so concerned about their roles as artists. They did not simply question what to paint, but rather what an artist should paint and what his motivations ought to be. They constantly redefined their roles within their profession. The simple enjoyment of making a painting or the exploration of a particular esthetic problem seemed almost less important than the need to provide a context for the role of the painter in society. In the 1930's, Benton had found that context within his environment, on the grounds that "a living art . . . is generated by direct life experiences of their makers within milieus and locales, to the human psychological content of which they are, by conditioning, psychologically attuned." Peter Blume, a Surrealist-influenced painter, had sought that context within an alliance between art and politics to struggle against the forces of repression. As he stated at the American Artists Congress in 1936, "We, as artists, must take our place in this crisis on the side of growth and civilization against barbarism and reaction, and help to create a better social order." Artists of the 1940's were not, however, as environmentally attuned or as politically committed, and they responded more personally to the question of the artist's place in society. Robert Motherwell remarked on the newer mood as follows: "The artist's problem is with what to identify himself. The middle-class is decaying, and as a conscious entity the working class does not exist. Hence the tendency of modern painters to paint for each other."[12]

Whatever the context, painters wanted their art to engage viewers in more than an esthetic experience. Benton aspired above all else to create paintings "the imagery of which would carry unmistakably American meanings for Americans and for as many of them as possible." Joseph Hirsch, associated with Social Realism in the 1930's, expressed his desire "to castigate the things I hate and paint monuments to what I feel is noble." And the Abstract Expressionists, finding their world too complicated and lunatic for such easy distinctions, viewed art as a vehicle for making human contact. Motherwell undoubtedly reflected the thoughts of many when he wrote as follows: "In our society, the capacity to give and to receive passion is limited. For this reason, the act of painting is a deep human necessity, not the production of a hand-made commodity."[13]

For artists proud of their individuality, the Abstract Expressionists paradoxically maintained organizational ties, although in a much looser manner than the artists of the 1930's. In place of John Reed Clubs, unions, and congresses, there was the Eighth Street Club. It met informally, but frequently, and it considered a similar range of problems concerned with the artist and society.

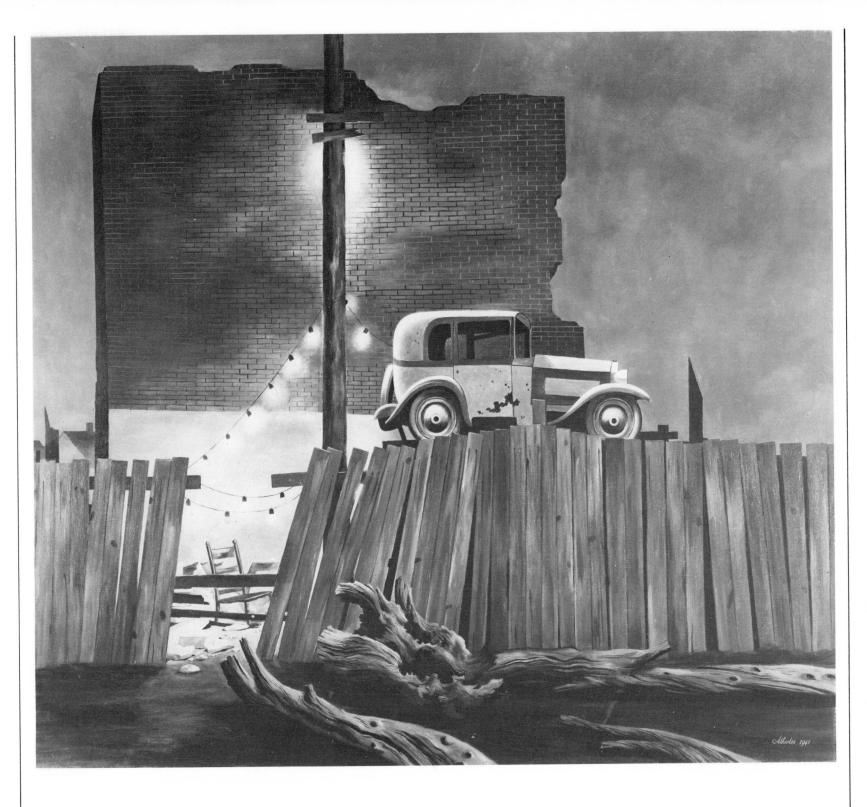

43. John Atherton, *Christmas Eve*, 1941. Oil, 30¼ x 35 inches.
Collection The Museum of Modern Art, New York; Purchase.

THE AMERICAN SCENE

But, after all, it was the differences between the two decades that were more important, and these spelled the demise of the American Scene. The younger painters were in fact much more concerned with the art and with the act of painting. Barnett Newman raised the key question when he asked if artists were involved in self-expression or in the world.[14] In Newman's view, those concerned with the world were not artists, and compromise was apparently impossible. With the general acceptance of Newman's position, American artists once again found guidance and sustenance within the evolving tradition of European art.

44. Jon Corbino, *Stampeding Bulls*, 1937. Oil, 28 x 42 inches. The Toledo Museum of Art, Toledo, Ohio.

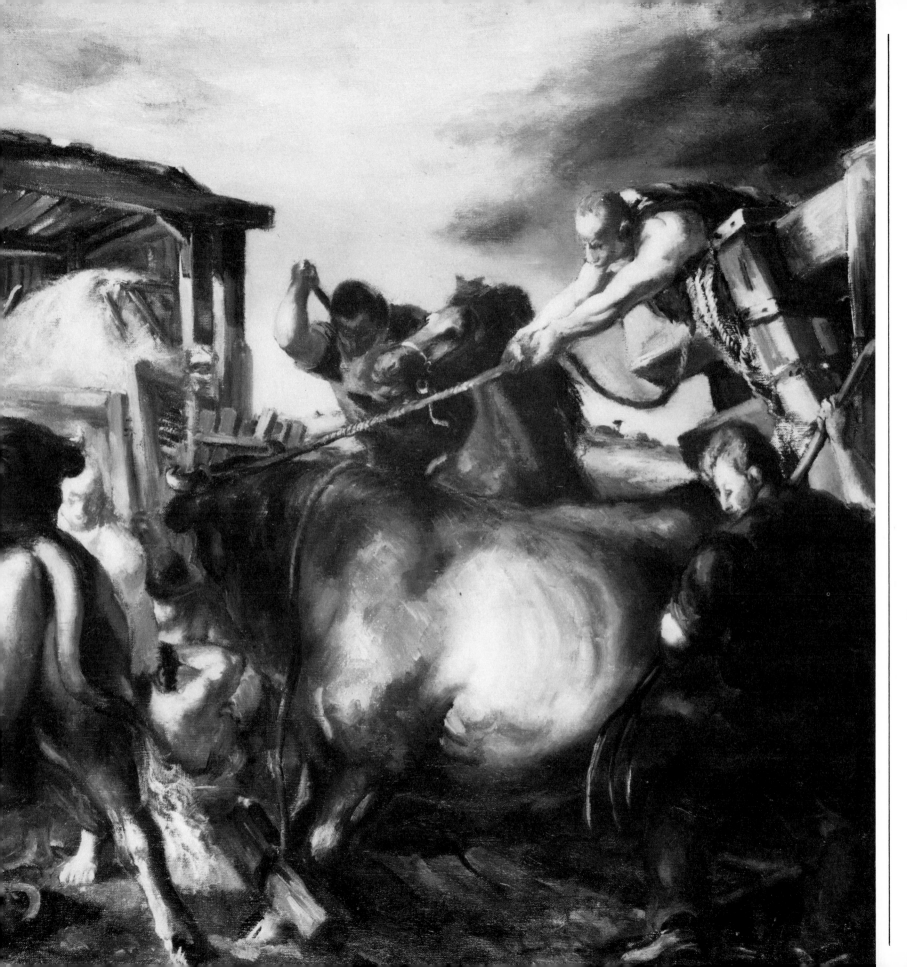

45. William Thon, *Eastwind*, 1942. Oil, 22¼ x 36 inches. Courtesy The Sheldon Swope Art Gallery, Terre Haute, Indiana.

46. George L. K. Morris, *Nautical Composition*, 1937–42. Oil, 51 x 35 inches. Collection Whitney Museum of American Art, New York.

PART 2

THE ARTISTS

THOMAS HART BENTON

GRANT WOOD

JOHN STEUART CURRY

REGINALD MARSH

STUART DAVIS

BEN SHAHN

THE ARTISTS

THOMAS HART BENTON

Thomas Hart Benton is the major painter of the American Scene. Well-read, articulate, and argumentative—a prolific painter and writer—Benton was also one of the most "visible" artists during the 1930's, often causing people to judge the American Scene on the basis of their feelings toward him. He ambitiously sought a style and a range of themes that would embody the experiences of the American majority culture. He shunned subject matter of momentary or picturesque interest, and he avoided psychological or political interpretation. He was unique among American Scenists in that his scope was national rather than local, rural as well as urban.

A Parisian modernist before World War I, Benton began after 1919 to seek out an American style and content. By 1926, his mature style had emerged and with it his ideological commitment to the development of an American art. He derived his commitment from a number of sources, the most significant of which included his family heritage (he was the grandnephew of a United States Senator and the son of a Congressman), nineteenth-century Populism, and the theories of Taine, Marx, Turner, and John Dewey.

Concerned with the fortunes and the destiny of the country because of his family's political interests, Benton also inherited a keen distrust for all kinds of centralization, whether in the arts, in business, or in politics. Taine's environmental theories, which Benton encountered in Paris between 1908 and 1911, influenced him for the rest of his life. His interest in Marxism reached a high point in the early 1920's when, like many others impressed by the developing Communist state in Russia, he felt that some type of socialist planning and guidance would create a better society for mankind. By the middle of the decade, however, he came to believe that abstract economic theories had nothing to do with America's past or its future. The pragmatic and environmentalist concerns of John Dewey, with whose writings Benton had been familiar for years, and those of Turner, whose works Benton had first seen around 1927, filled the gap left by his earlier Marxist leanings. The ideas of these men helped to give Benton's artistic interests a particularly American twist and directed his attention to the kinds of experiences the average American would be likely to encounter in a lifetime.[1]

Increasingly, through the 1920's, Benton was enchanted by the country—by its dreams, aspirations, and raw energies, and by the people who labored so hard to make it such a great nation so quickly. Although angered by the rapacious greed of businessmen, industrialists, and financiers, he chose not to dwell on the physical harm that they brought to the land itself, and he ignored as well the spiritual malaise that the business sector had helped to induce in the public by the 1920's. Rather, he devoted himself to observing the customs and the modes of living of average persons; he linked these with the explosive forces in American society which in Benton's own lifetime had transformed Indian lands successively into frontier territories, rural areas, urban districts, and powerful industrial regions. Through the depiction of people in action, rather than through the representation of abstract forces or ideas, he sought to touch the frantic pulse of America and the different environments it sustained.

Benton held that an individual's character depended in great measure upon immediately perceived experiences as well as upon habitual preferences and upon desires based on accumulated knowledge and observation. Artistic inspiration flourished best when it reflected these familiar environments, situations, and psychological attitudes. For Benton, worthwhile art, whatever its esthetic merits, could only grow from the locale in which the artist lived. To translate these beliefs into American paintings, Benton reasoned along the following lines: "If subject matter determined *form* and the subject matter was distinctively American, then . . . an American form, no matter what the source of technical means, would eventually ensue."[2] As a result, he usually sought typical American subject matter, preferring the general to the specific statement. To ensure an appropriate American form, Benton resorted to two devices. First, he sought a pictorial space that would suggest American meanings. He found it in the disjointed perspective that became his trademark in the 1920's. The turbulent rhythms thus established would suggest the disjunctive experiences, rapid growth rates, and clashing energies of the American nation.[3] Second, he gave his figures bulging muscles and "extra joints," as if to suggest the presence of great activity. Thus Benton selected typical American scenes in which constantly moving figures acted out American dramas in spatially charged landscapes. He wanted his paintings to have meaning for as many Americans as

possible. As he once said, "I was after a picture of America in its entirety."[4]

The Lord Is My Shepherd (Ill. 47), of about 1926, an early example of Benton's maturing art, depicts a scene with which many people could have or would have wanted to identify themselves. It represents a hard-working couple, religious, thrifty, and quite self-contained. However, it was through his mural studies that Benton best projected his image of America. In 1919, he began to paint a series of mural-scaled scenes recording the history of the country. Called the *American Historical Epic,* this series was intended to recount the activities of the anonymous American who helped build the nation but who was denied the fruits of his labor by modern industrial and technological processes. Benton completed the first two chapters, each containing five panels, before he abandoned the scheme in 1926. In the second chapter, painted between 1924 and 1926, Benton revealed fully his "American" style *(Ill. 48)*.

Benton explored more thoroughly his conception of an American art in the four sets of murals he painted between 1930 and 1936. The major monuments of the American Scene movement, these murals depicted various aspects of American life, from historical events to activities.

In the first set, painted for the New School for Social Research and entitled *America Today,* Benton surveyed typical urban and rural views, describing agricultural and industrial activities as well as leisure-time pleasures *(Ill. 50)*. Breaking with precedent, Benton did not visualize contemporary America through symbolic figures representing American juridical, political, and social virtues, or through popular contemporary figures posed in representative actions, or through industrial forces portrayed modernistically. Rather, his heroes were the ordinary hard-working, nonintellectual citizens whose actions were presented in larger-than-life images.

Unlike virtually all earlier American murals, Benton's set for the New School clashes with its physical surroundings and refuses to yield to the architecture around it. Compositionally, the panels were based on the layouts of picture pages in old magazines or in the rotogravure sections of the Sunday newspaper. These layouts provided Benton with a way of breaking the picture space into segments, in order to keep the panels constantly in motion. He could thus suggest a pictorial reality similar to the physical reality of an over-energized America. After completing the murals, Benton characteristically observed that he was less interested in making art than in showing the vigor and confusion of American life.[5]

The next set of murals, originally made for the Whitney Museum of American Art and now in the New Britain Museum of American Art, show the same people engaged in leisure activities—more specifically, in the arts that grow intimately out of the social and cultural environment *(Ill. 51)*. None of these arts, as Benton said, required special training or needed to be kept apart in a museum.[6]

In his third set of murals, made for the State of Indiana Pavilion at the Century of Progress Exposition in Chicago in 1933, Benton represented the history of a single area of the country. He illustrated the various social and environmental changes that had occurred in Indiana's agriculture, industry, education, and culture; he extended his scheme from the time of the mound builders to the present era *(Ill. 52)*. More concerned with the processes active in an evolving society than with particular events, Benton did not hold the viewing public at arm's length by portraying governors, generals, and great figures associated with the history of the state. He selected scenes with which the public could readily identify, so that the viewers could see themselves and their ancestors as participants in Indiana's development.

The relationships suggested by these murals profoundly affected Benton himself when he painted his next set, *The Social History of the State of Missouri (Ills. 53–54)*, for the State Capitol Building at Jefferson City in 1935–36. Created by a native son who shared with his audience a knowledge of the state's history and mythology, the murals were an American Scenist's dream come true. Benton conceived of the set almost as if it were a painted autobiography, and he mixed scenes of domestic, industrial, agricultural, and political life with motifs from the stories of Frankie and Johnny, Huck Finn, and Jesse James.

Although Benton never completed a group of murals for any federal project, he created excellent examples of the kind of art fostered by the various agencies. It was an art easily understood by the average, artistically untrained person, and content rather than form was the prime consideration. Happy to paint the many tasks

performed by Americans, Benton usually avoided the stern truths of the time—starvation, oppression (whether racial, religious, or economic), and political chicanery—in favor of themes concerned with the rewards of hard work, love of country, and social growth within the system. However, it is only fair to say that his murals included scenes of blacks and whites working side by side (unusual for the 1930's) and unsavory historical episodes, such as lynchings and tarrings and featherings. Not entirely sanguine about the course of American justice, he nevertheless had faith in the democratic ideals that had been nurtured over the years.

As Benton gave free rein to his descriptive powers through the 1930's, his concern for two-dimensional patterns, an inheritance from his School-of-Paris days, grew less obvious. Interwoven arrangements of forms and figures existing in different spatial planes loosened considerably; objects were now shaken loose from rigid compositional schema and given breathing room. At the same time, he began to contain the tumultuous forces propelling his figures, so that by mid-decade a more sedate sense of movement characterized his work, particularly the Missouri panels.

By 1935, the American Scene increasingly dominated the art world, as it received official sanction from the government projects. In addition, Benton had returned to Missouri permanently in 1935, where environmental factors differed considerably from those in New York. Never fully at ease in the intellectual and political circles of that city, Benton had always to prove his Americanism. Feeling much less threatened in the Middle West, he could allow the obviously slower and more comfortable pace of life to blunt the sharper edges of his impulsive pictorial rhythms.

In the remaining years of the decade, Benton's paintings became less assertively or stereotypically "American." Figures acted with fewer theatrical gestures, and the Missouri landscape became a recognizable backdrop. And Benton, a country boy at heart, began to lavish attention on the land itself, enlarging details of flowers and plants, adding comparatively lush passages of pigment, and giving greater coloristic variety to near and distant scenes (*Ill. 55*). Occasionally, he added mythological and biblical figures to the Missouri landscape, giving them an awkward and unsure relevance to current conditions (*Colorplate 13*).

Unlike Grant Wood who largely ignored the effect of World War II, Benton understood the growing parochial vulnerability of American Scene painting. And since, because of advancing age, he was excluded from participating in the more physically demanding aspects of life, those which he most enjoyed painting, he increasingly withdrew into himself. Athough remaining a realistic painter, he began to paint subjects that interested him personally, whether or not they carried broadly American connotations. When he did turn to specifically American themes, he became less concerned with a usable past and more concerned with the past itself; he commemorated the past as an historian and ceased to mine it for clues to understanding the present. In the 1930's, he could argue, as did others, that America should plan its future with its past in mind, that the two were indissolubly linked. After World War II, he came to realize that the America he had really sought was the one that had disappeared around the turn of the century. By implication, he admitted that his art had been a retrospective one: "Our basic cultural ideas, our beliefs as to what constitutes the 'American character,' our mythologies had their origins in the earlier conditions. It was these I tried to represent."[7]

47. Thomas Hart Benton, *The Lord Is My Shepherd*, ca. 1926. Tempera, 33¼ x 27⅜ inches. Collection Whitney Museum of American Art, New York.

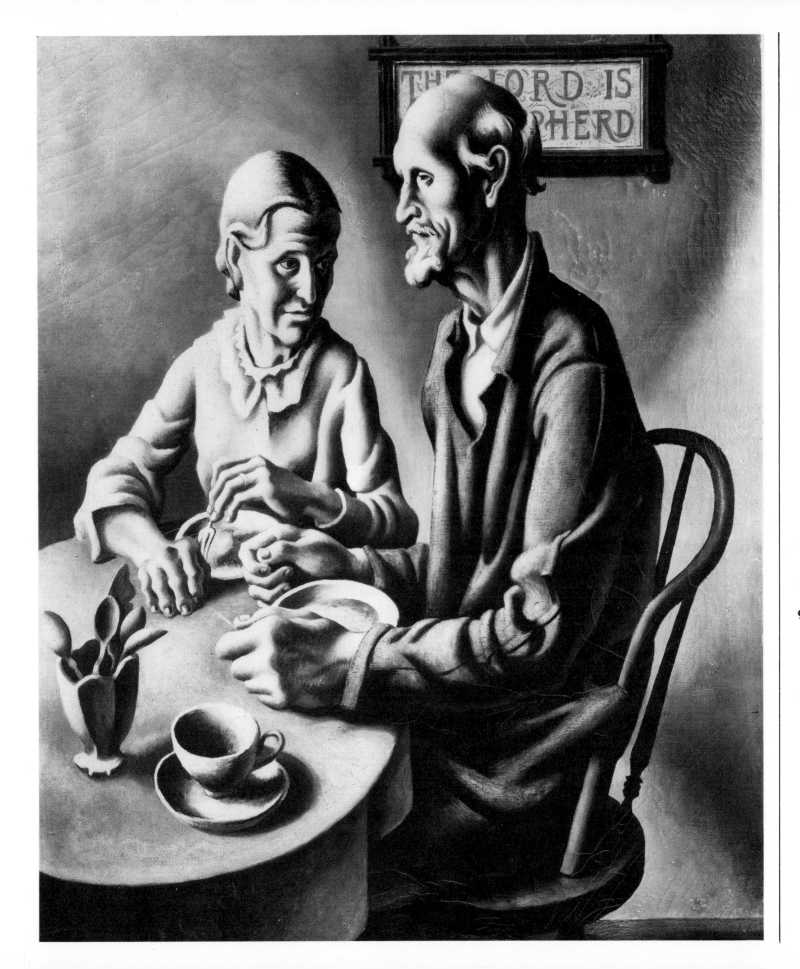

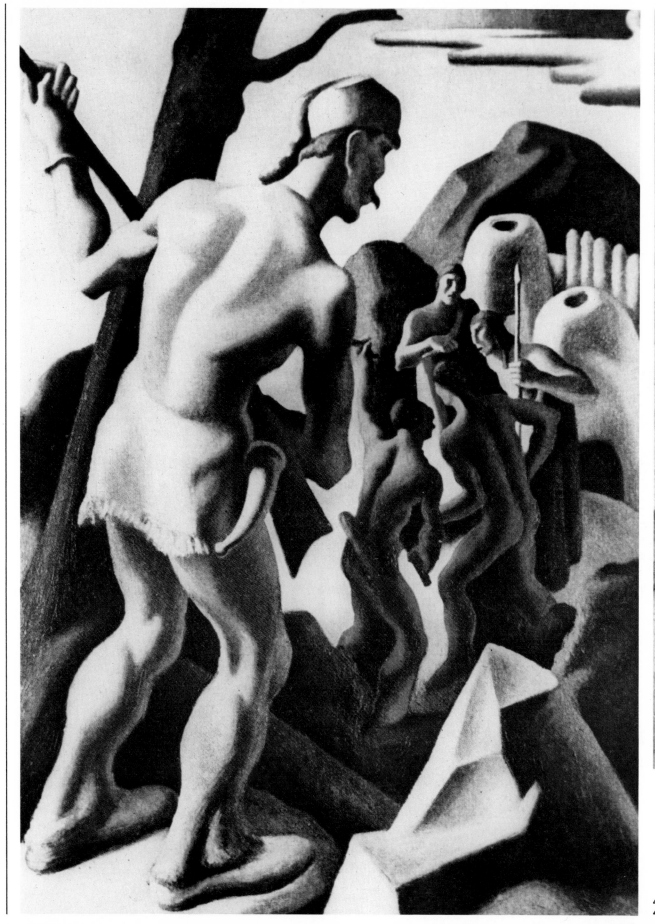

94

48. Thomas Hart Benton, *The Pathfinder*, 1924–26. O
48 inches. Collection Thomas Hart Benton.

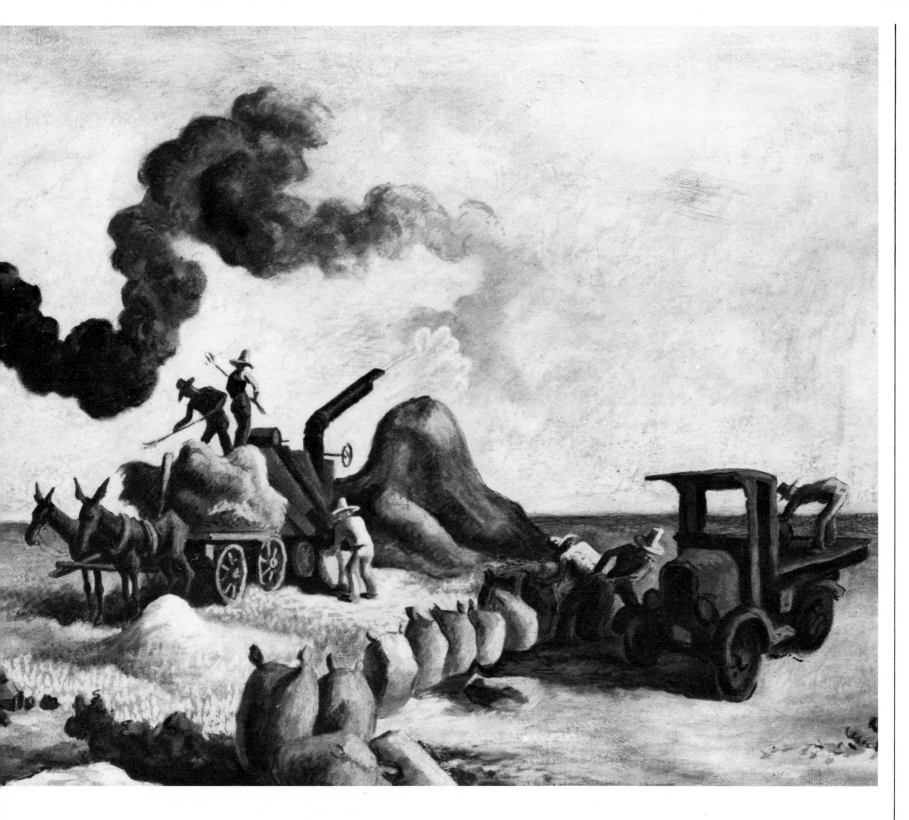

49. Thomas Hart Benton, *Louisiana Rice Fields*, 1928. Oil and tempera, 30 x 48 inches. Courtesy The Brooklyn Museum; J. B. Woodward Memorial Fund.

2 THE ARTISTS

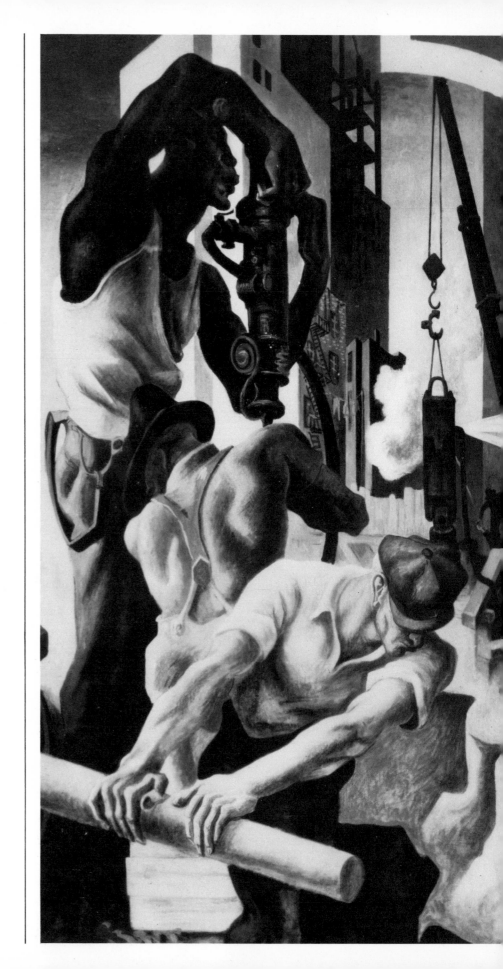

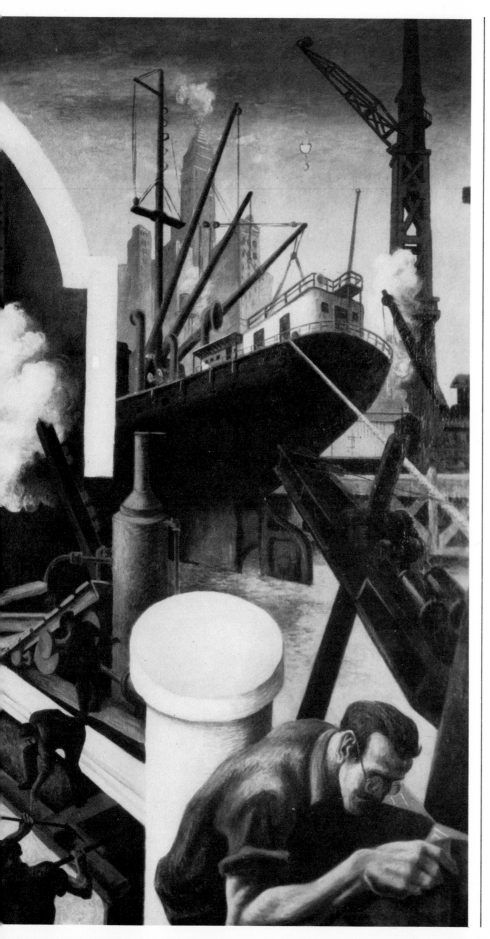

50. Thomas Hart Benton, *City Building*, 1930. Egg tempera and distemper, 91 x 107 inches. The New School for Social Research, New York.

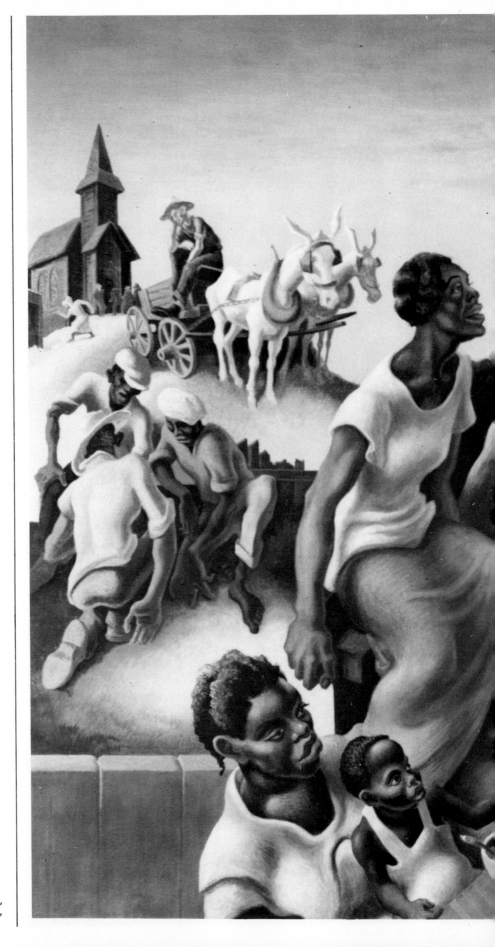

51. Thomas Hart Benton, *Arts of the South*, 1932. Tempera and oil glaze, 96 x 156 inches. The New Britain Museum of American Art, New Britain, Connecticut.

Pages 100–101:
52. Thomas Hart Benton, *Civil War, Industry, and Agriculture*, 1933. Egg tempera, 144 x 240 inches. Indiana University, Bloomington.

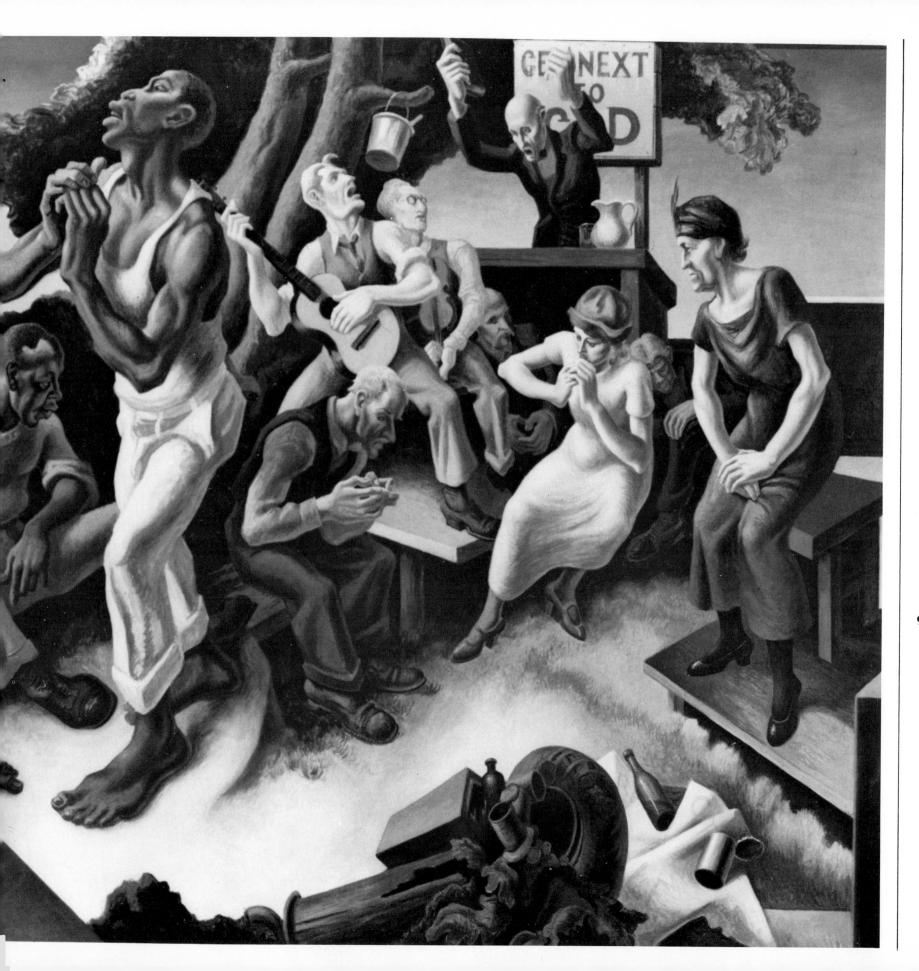

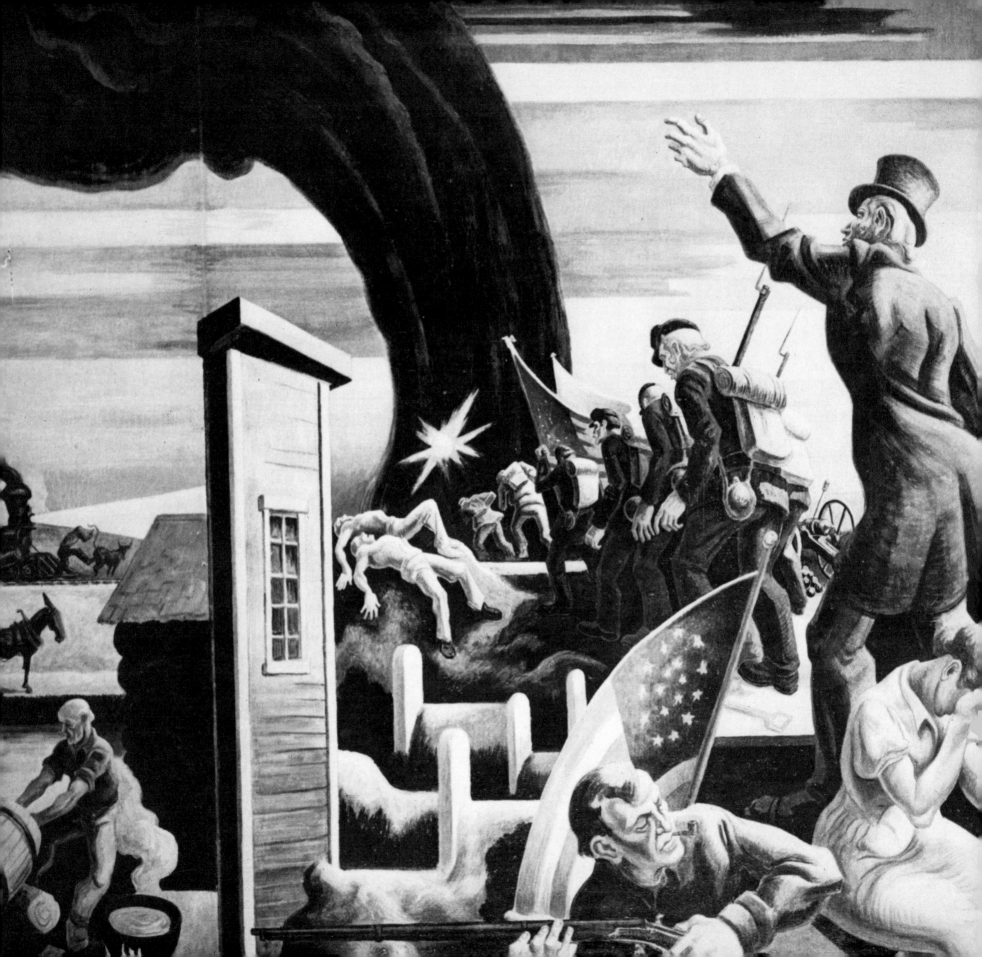

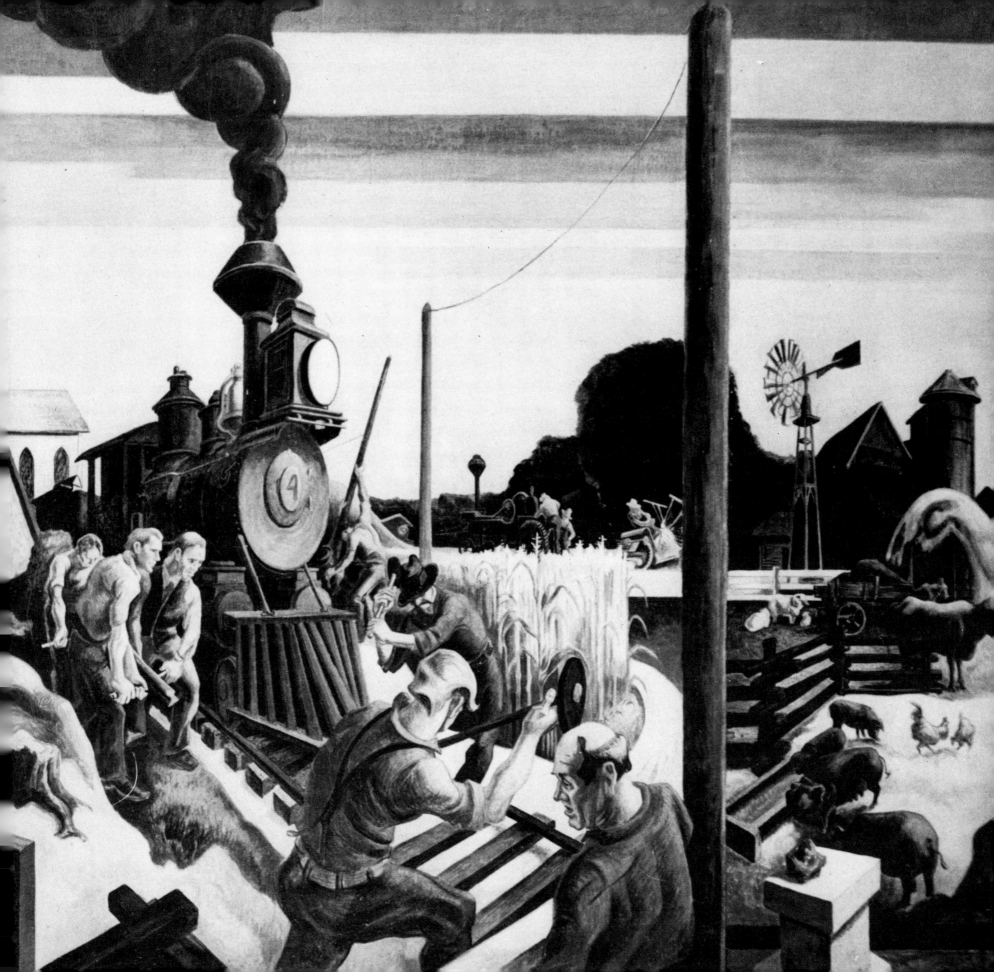

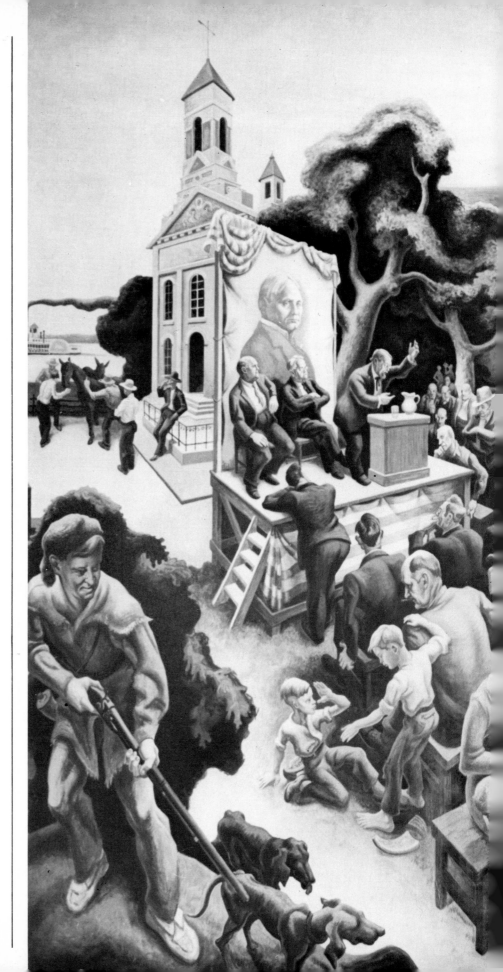

53. Thomas Hart Benton, *Politics and Agriculture*, 1936. Oil and tempera, 168 x 256 inches, Missouri State Capitol, Jefferson City. Photograph, Missouri Tourism Commission.

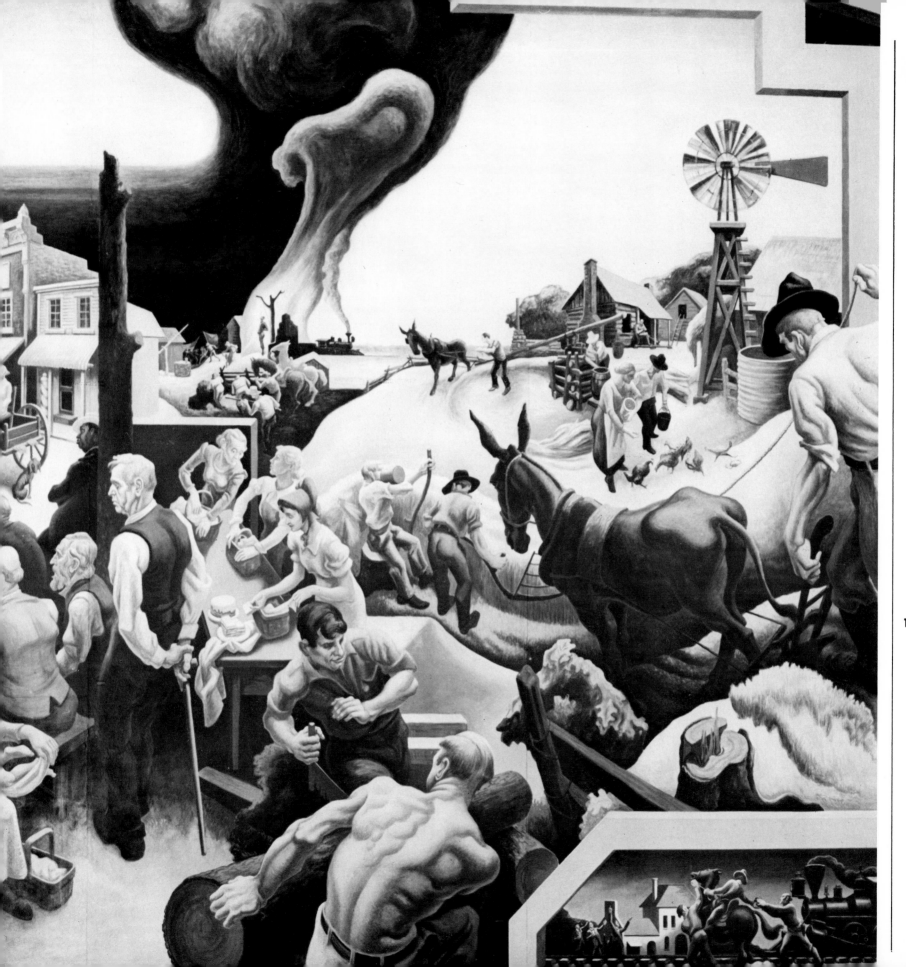

103

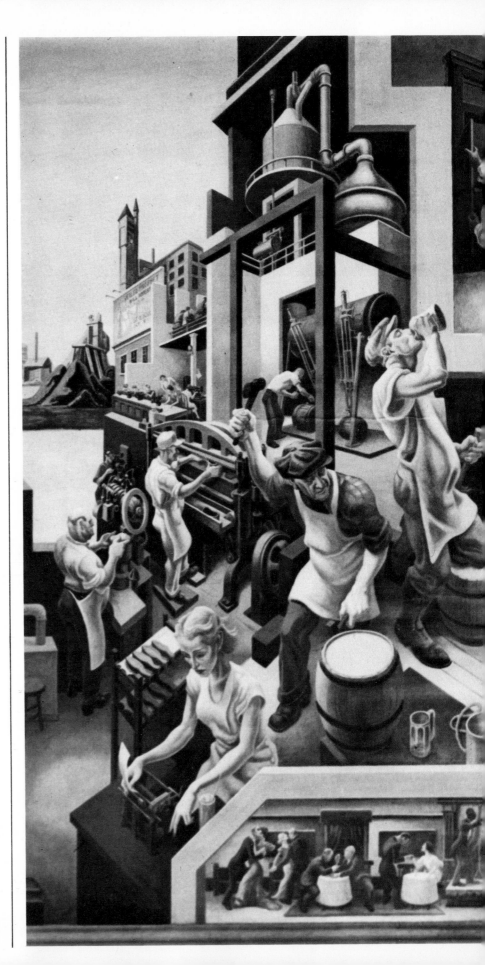

54. Thomas Hart Benton, *Industry*, and *Frankie and Johnny*, 1936. Oil and tempera. Missouri State Capitol, Jefferson City. Photograph, Missouri Tourism Commission.

Pages 106–7:

55. Thomas Hart Benton, *Cradling Wheat*, 1938. Tempera, 31 x 38 inches. The St. Louis Art Museum.

56. Thomas Hart Benton, *The Hailstorm*, 1940. Tempera, 33 x 40 inches. Joslyn Art Museum, Omaha, Nebraska; Gift of the James A. Douglas Foundation.

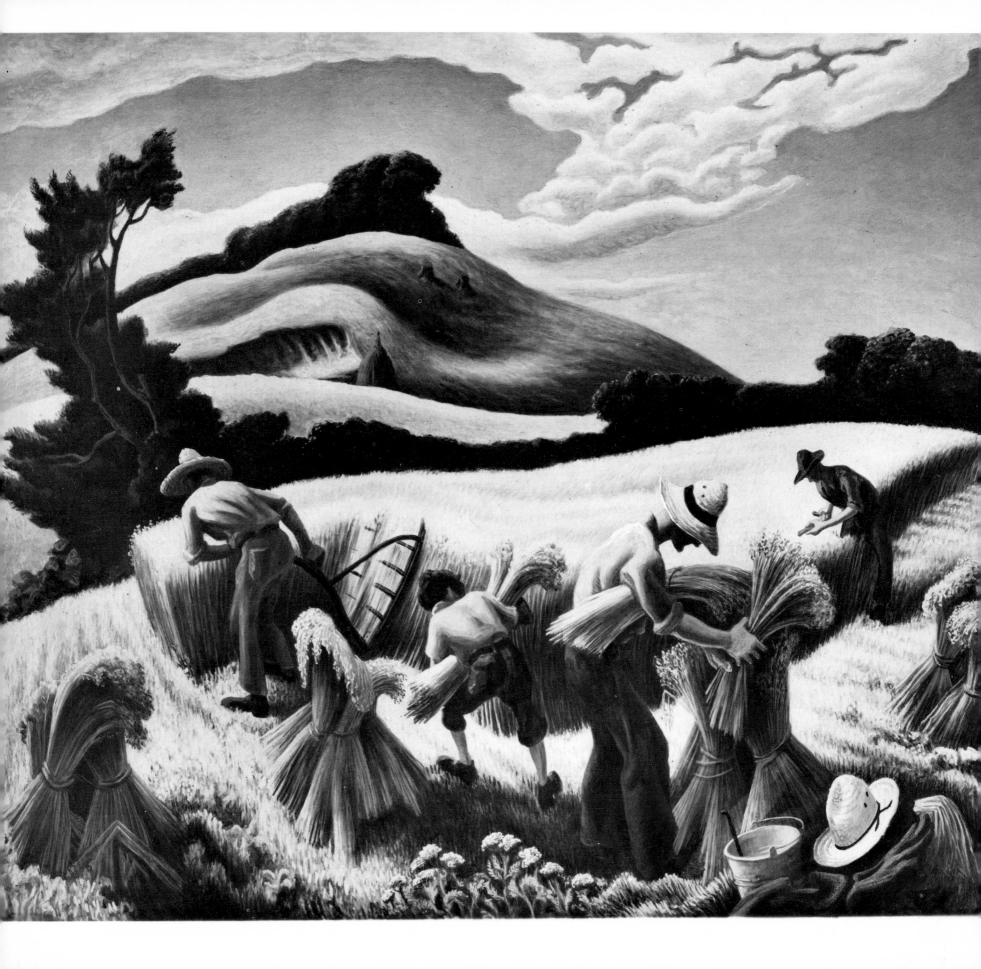

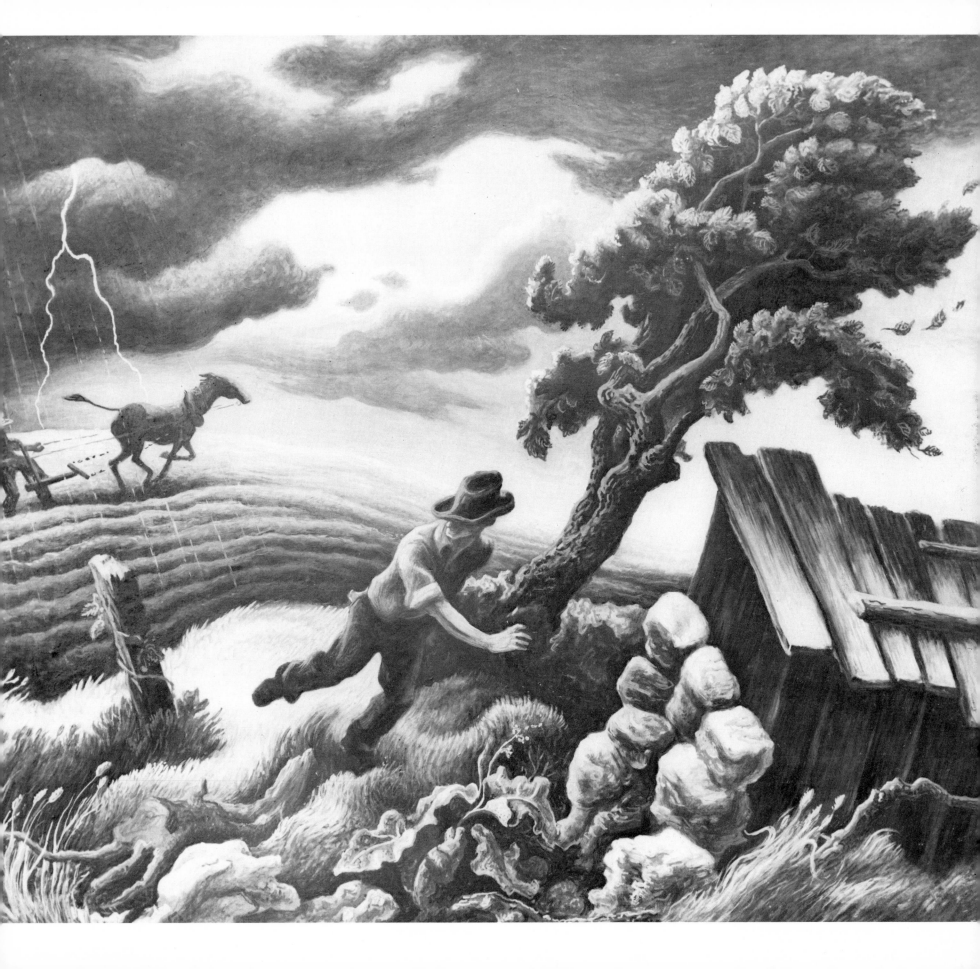

57. Thomas Hart Benton, *Henry Look Unhitching*, 1941. Tempera, 23⅛ x 27⅝ inches. Indianapolis Museum of Art; Gift of Mr. and Mrs. Joseph Cantor.

GRANT WOOD

Grant Wood's *American Gothic* (*Ill. 1*) was first exhibited in 1930 at the Art Institute of Chicago, the Middle West's major museum. It was the right painting shown at the right time in the right place. Capturing the public's fancy immediately, it became the emblem of the rising American Scene movement and the most popular painting of the decade. As a result of its success, and because of the praise lavished on a few of his other works, Wood became one of the most famous artists of the period, more for what he represented than for his ability as a painter. In 1942, after the American Scene had lost all momentum, the retrospective exhibition of Wood's paintings at the Art Institute of Chicago was judged a failure.[1] His reputation, inflated beyond reason, did not survive the 1930's.

But *American Gothic* has survived and has become one of the most famous American paintings of this century. Evidently, it touched and still touches a nerve in the American psyche, one that is difficult to fathom and reserved for such paintings as Gilbert Stuart's portraits of Washington and Whistler's portrait of his mother.[2] It is also difficult to determine precisely the place of *American Gothic* within Wood's artistic development and its relationship to his other paintings. Ultimately, the painting provokes questions (and surprising answers) concerning Wood's feelings about the Middle West.

Throughout the 1920's Wood painted in an undistinguished Barbizon-Impressionist style, the kind of style spread across America in the late nineteenth century and that still turns up at countless country exhibitions. Although he traveled abroad in the years 1920, 1923–24, 1926, and 1928, he always returned to his home in Cedar Rapids, Iowa, and he remained largely untouched and uninfluenced by modern art styles. He is said to have tried to paint a few abstract canvases in 1924 and, after his trip in 1926, he provisionally discovered material for art in commonplace objects.[3] On his last and most significant visit abroad, Wood journeyed to Munich to execute a stained-glass window that had been commissioned for the Cedar Rapids Memorial Building and City Hall, in memory of the veterans of World War I. While in Munich, he responded to the sharp, realistic detail and to the glazing techniques of fifteenth- and sixteenth-century German paintings, which he studied in the Alte Pinakothek. Wood also saw several paintings of Otto Dix, the contemporary German realist, and felt that Dix's style could be adapted for American use.[4] Altogether, Wood left Munich with a new respect for smooth, tautly defined forms and for a less expressionistic handling of the paint brush. Quite possibly, he also became increasingly preoccupied with the idea of revealing through art one's sense of national heritage or at least one's national awareness. At some point following his Munich trip, these new interests were suddenly modified and galvanized by his responses to Currier and Ives prints, to decorations on old chinaware, to illustrations in old furniture catalogues, and possibly to old daguerreotypes.[5]

The first painting in the new style, *Woman with Plants* (*Ill. 58*) of 1929, still showed traces of the free brushwork and textural interest of his early manner, particularly in the treatment of the hands and the landscape. A sympathetic and sentimental portrait of his mother (a Middle Western *Mona Lisa*), the work suggests that Wood was beginning to develop a hard-edged style, reasonably straightforward in its presentation of materials, which by its very plainness would convey the quality and character of life led by people such as his mother. In mood, *Woman with Plants* seems influenced by the work of the conservative and then-popular artist, Charles Hawthorne, twenty-five of whose paintings were exhibited in Cedar Rapids in 1929.[6] Hawthorne's *The Captain's Wife* (1924) and *Three Women of Provincetown* (*ca.* 1921), possibly included in the exhibition, may have served as models for two works Wood painted in the immediately succeeding years: *Victorian Survival* (1931) and *Daughters of Revolution* (1932), respectively (*Ills. 59–61*).[7] But the mood of these paintings

109

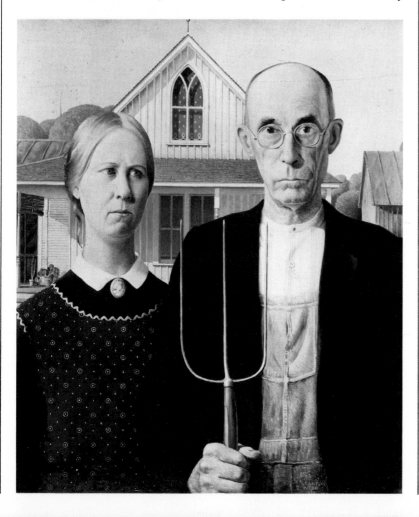

Grant Wood, *American Gothic*, 1930.

differs quite a lot from Hawthorne's work, as well as from the paintings Wood executed just after his return from Munich.

American Gothic was the first work to deviate in mood from earlier paintings such as *Woman with Plants*. Intending to satirize the kind of people who would live in a pretentious house with medieval ornamentation, as well as the narrow prejudices associated with life in the Bible Belt,[8] Wood's gibe seems to have gone much farther than we are usually inclined to believe. The people in these later paintings, Middle Western descendants of the Puritans who were so pilloried in the literature of the 1920's, exude a generalized, barely repressed animosity that borders on venom. They appear to typify what historian Richard Hofstadter has called the "one-hundred per cent mentality," a synthesis of fundamentalist religiosity, of morality, and of Americanism.[9] One wonders if the farmer, who holds a pitchfork rather than a rake or hoe, is turning over the soil to sow the Devil's hate rather than God's love. This farmer is hardly the mythic yeoman —the new Jesus—of the Middle West, but, more understandably, a symbol of the malevolent spirits that inhabited this region.[10] Certainly the couple seem to embody those feelings of bitterness that "poisoned the springs of human feeling," a bitterness which Middle Western writers had observed over the decades.[11]

What could have prompted Wood to undertake such a painting? No previous work suggests the total lack of tenderness or the quality of savagery that these people convey. Before he painted *American Gothic,* the Daughters of the American Revolution and the American Legion had attacked him viciously, because he had traveled to Germany, the land of the enemy, to complete the stained-glass window commemorating the dead of World War I. Furthermore, Wood was a Democrat in a Republican section of the country, and he was responsive enough to New Deal legislation to become director of the Public Works of Art Project in Iowa in 1934.[12] Perhaps he wanted to settle a few arguments in his own way, and in so doing created the famous couple who exude the peculiar quality that, as Sherwood Anderson once noted, "separates people, curiously, persistently in America."[13]

A similar acerbity characterizes other paintings that Wood completed at this time. If the couple in *American Gothic* suggest the presence of the Devil in the Iowan (perhaps American) soul, then the old woman of *Victorian Survival* (*Ill. 60*) may represent the presence of decay in the Iowan (perhaps American) mind. She is old enough to be a granddaughter of one of George Caleb Bingham's Missouri River boatmen, but she hardly qualifies as a proud child of the pioneers. Her stiff pose, unyielding stare, rigid mouth, and air of emotional repression hardly continue the legacy of old-fashioned pragmatic flexibility and love of life.

Wood's dislike of the DAR did not abate over the years, and he is reported to have said, apropos of his *Daughters of Revolution:* "They [the DAR] could ladle it out. I thought I'd see if they could take it."[14] Accordingly, the criticisms suggested in this painting are even more pointed than those in *Victorian Survival*. Posed against one of the most famous paintings in America, Emanuel Leutze's *Washington Crossing the Delaware*—a work that embodies the impetuous bravery and improvisatory derring-do of the American Revolutionary forces—stand three old snobs, one of whom is clearly senile. Destroyers, perhaps victims, of their heritage, they preserve what no longer exists. Wood, therefore, may well have offered this work as a comment upon the perversion of Iowa's (perhaps America's) democratic birthright.

The *Midnight Ride of Paul Revere* (*Ill. 63*) fits into the same critical mold suggested by these works. Wood portrayed the event long since turned to myth—the ride that marked the beginning of the American war of independence—as if it were a cardboard tableau, an illustration for a child's book. No heroism, no nationalism, no flag-waving, just a figure bobbing on his rocking horse in Toytown. The very purpose of the ride and the selfless devotion that it implied are dismissed with something akin to a giggle.

Wood painted a work with similarly sardonic overtones on only one other occasion. In *Parson Weems' Fable* (*Ill. 64*), he portrayed George Washington admitting that he had chopped down the cherry tree. As in Charles Willson Peale's famous self-portrait in his museum (*Ill. 65*), Parson Weems smiles wryly and pulls back the curtain showing Washington (as Gilbert Stuart painted him) caught in the act. Hardly a work praising the father of the country, the painting mocks the sacrosanctity with which Americans have cluttered their view of Washington. Wood clearly was not dignifying the manner in which Americans have paid their respects to the man.

All of these works, with the exception of *Parson Weems' Fable,*

were completed within a two-year period. Just possibly, they may reflect Edmund Wilson's observation that many artists in 1932 were wondering "about the survival of republican institutions."[15] In any event, Wood seems to have suggested that life in America in the early 1930's was an experience in the oppression of the mind and in the suppression of the spirit, that Americans were bigoted, narrow-minded, prematurely aged, self-righteous, and careless with their democratic heritage. No other American artist of the period so devastatingly mocked those who considered themselves the country's spiritual backbone, the keepers of its traditions, and the torch-bearers of its culture.

During and after the years in which these works were painted, Wood completed a series of landscapes that lend themselves to similar interpretations. With their carefully plumped up and manicured vegetation, they would seem to comprise a vision of the Iowa landscape created by a loyal Iowa son (*Ills. 66,68, Colorplate 14*). The occasional bird's-eye view, perhaps influenced by the paintings of Hans Burkmair the Elder (1473–1531) and undoubtedly seen in Munich, allowed Wood the pleasure of showing large chunks of the Iowa countryside.

Although *Dinner for Threshers* (*Ill. 67*) depicts an indoor scene, it is about the landscape as well. Threshing was the banner event for rural Iowans, the most important social experience of the year and the climax of a season's work.[16] In painting a dinner scene, Wood not only showed the communal and productive aspects of the threshing season, but suggested as well a religious significance to the meal. With its general aura of solemnity, the painting must have evoked in the rural viewer feelings of pride, nostalgia, and self-identity.

At first glance, these works seem to imply meanings contrary to those of paintings like *American Gothic*. Wood himself wrote very sympathetically about the land, finding that its "infinite solidity and permanence" dominated even seasonal changes. "The naked earth in rounded massive contours," he wrote, "asserts itself through everything that is laid upon it." Three generations of cultivation, he felt, had not altered the primal character of the Middle Western landscape.[17]

Clearly, he loved the land, but he did not necessarily love all that occurred on it. Possibly, his landscapes are not the love poems they seem to be. Wood was neither a provincial hayseed nor a buffoon. He must have been aware of the number of farm foreclosures during 1931 and 1932, which ran as high as 25 per cent in some areas of the state.[18] He must also have been conscious of the false local pride that afflicts many rural areas in the best, and certainly in the worst, of times. His concern for Middle Western subjects did "not proceed from a 'booster spirit' for any particular locality," he said.[19] As one looks at his immaculately groomed, cartoonlike landscapes, one almost expects Porky Pig to bounce out of the shrubbery. Thus, it is possible that Wood knowingly allowed his landscapes to accord with the Iowan image of the land and ignored the current realities. The paintings look too neat to be taken seriously.

Wood's attitudes toward the development of American art are much easier to fathom than his paintings, since his feelings are in fact representative of the entire American Scene movement. Like others seeking an American cultural expression, he opposed an art that merely reflected foreign styles or that emanated from a single part of the country: "A national expression cannot be built upon the activity of a few solitary individuals or be isolated in a few tourist-ridden localities or tourist centers."[20] But unlike Benton, he did not seek an American style. The time was not ripe for such an occurrence. Rather, a first step lay "in the development of regional art centers and competition among them."[21] Subsequently, the fusion of regional expressions would produce a genuine American art, Wood believed. He and his contemporaries were, in effect, carrying on the basic research necessary for such a development. He further believed that a breakthrough would occur in the Middle West, because this region was not already "covered with palette scrapings" and because its people had the strength of character to break the European mold that gripped art in the East.[22]

During the two summers he taught at the Stone City Art Colony (1932 and 1933) and during the years he served on the staff of the University of Iowa (1934–41), Wood fought against imposing particular formulas and techniques on younger artists. In his view, such action would inhibit efforts toward promoting "a genuine comprehensive interpretation . . . of our part of the country" and toward forming an "accumulated vision" of the Middle West.[23] He did not believe that this vision could be reached through numerous paint-

ings of barns, silos, and corn shocks, or through any kind of band-wagon American Scene movement. Instead, he hoped that his Middle West and other regions of the country would manifest themselves in paintings "in a thousand elusive but significant ways."[24]

He viewed his own paintings as a series of personal choices rather than as statements representative of a particular region.[25] Thus he hoped merely to serve as an example to younger painters who, one imagines, would ultimately synthesize the values implicit in his works with those of other artists. If such a development had taken place, the younger generation of artists could have taken from Wood's art an ambivalent love-hate relationship with the Middle West. They could also have found an abundance of similar attitudes in the novels of Sinclair Lewis, Sherwood Anderson, James Farrell, Zona Gale, Willa Cather, and Hamlin Garland. Indeed, such ambiguous feelings may constitute a basic component of a yet-to-be-defined Middle Western regionalism.

58. Grant Wood, *Woman with Plants*, 1929. Oil and tempera, 20½ x 18 inches. Cedar Rapids Art Association, Cedar Rapids, Iowa.

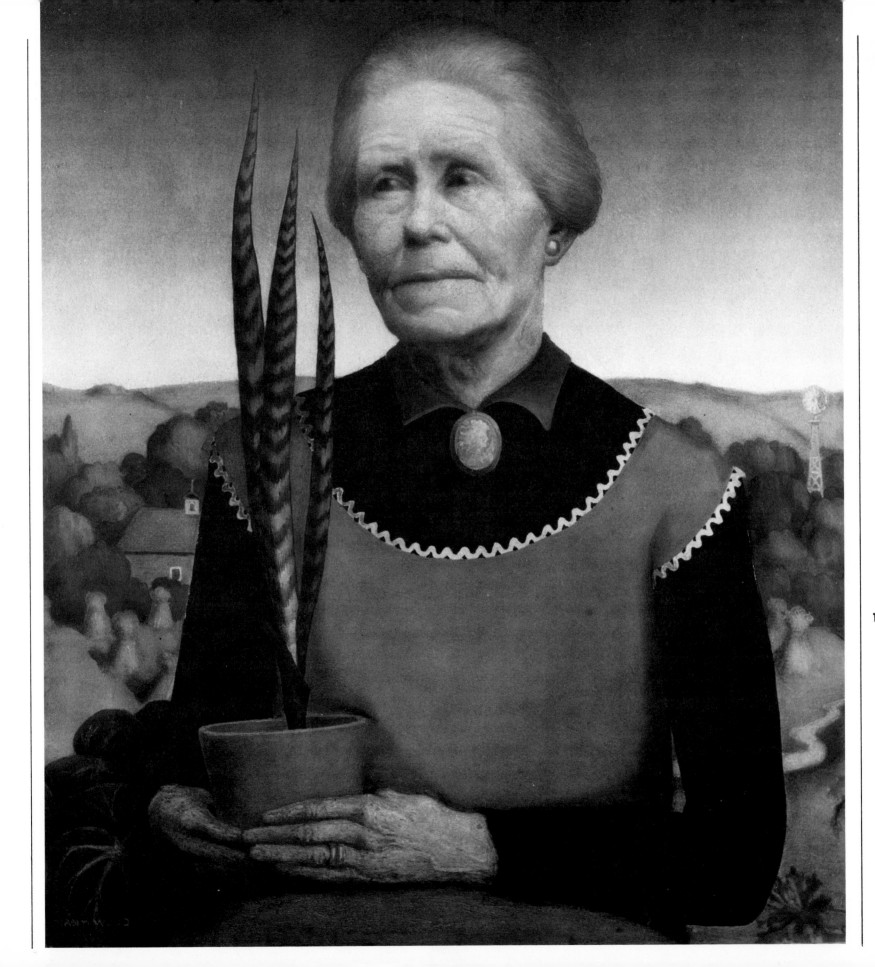

114

59. Charles Hawthorne, *Three Women of Provincetown*, ca.
1921. Oil, 48½ x 60 inches. Amherst College, Amherst, Massa-
chusetts.

60. Grant Wood, *Victorian Survival*, 1931. Oil, 32¼ x 26½
inches. Anonymous collection.

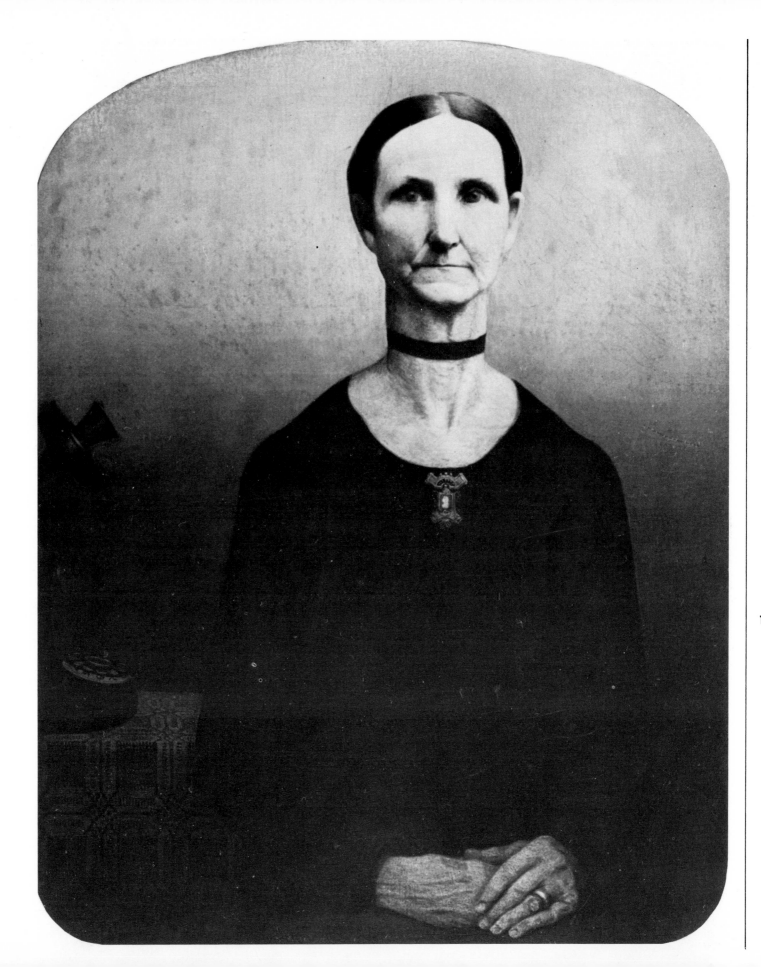

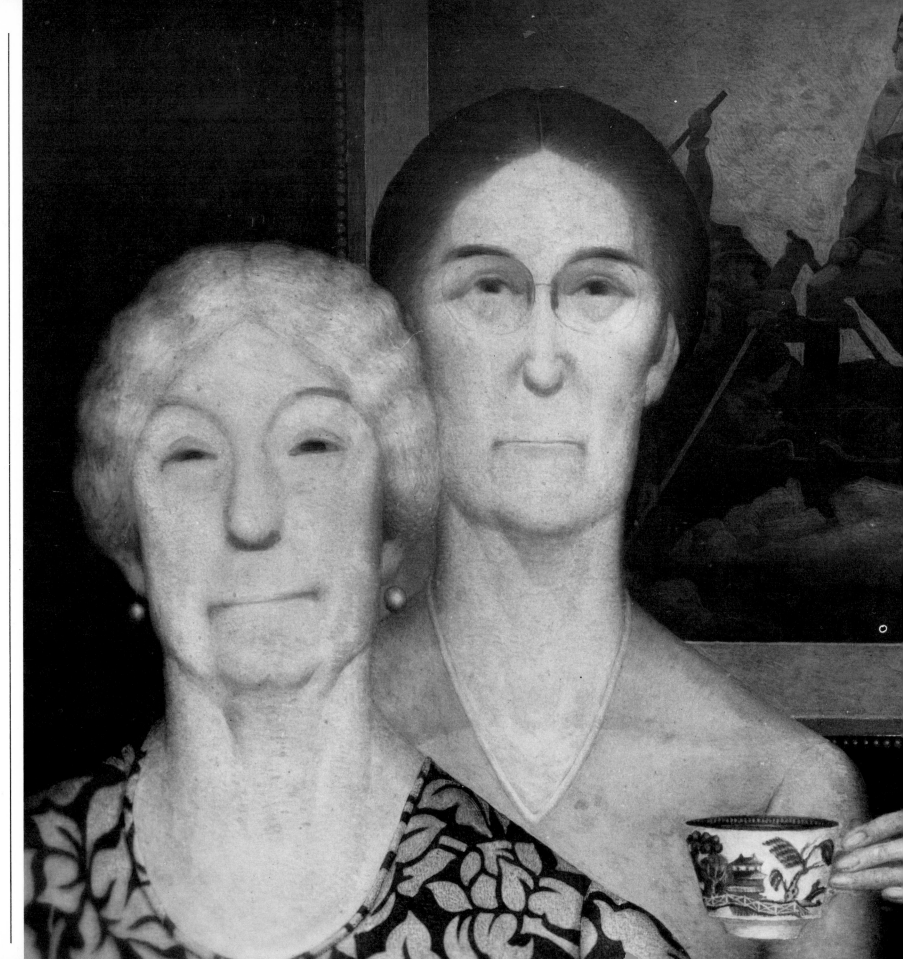

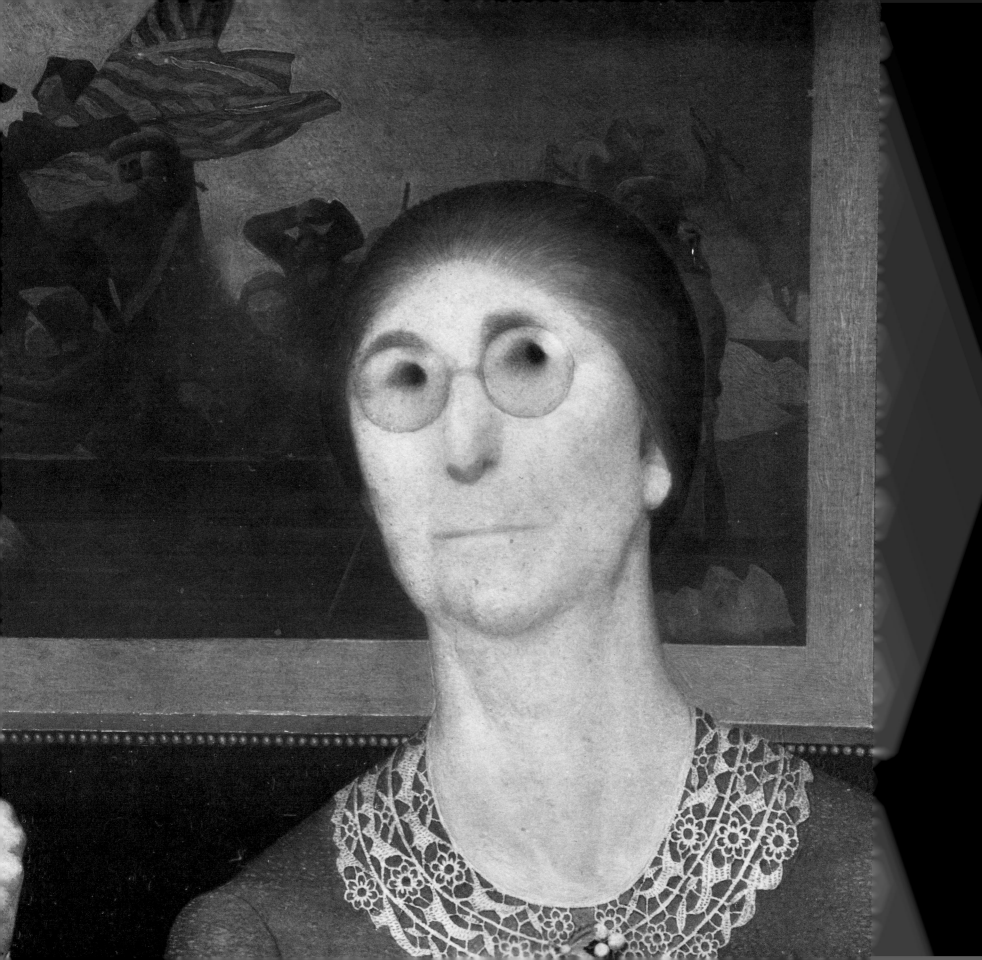

2

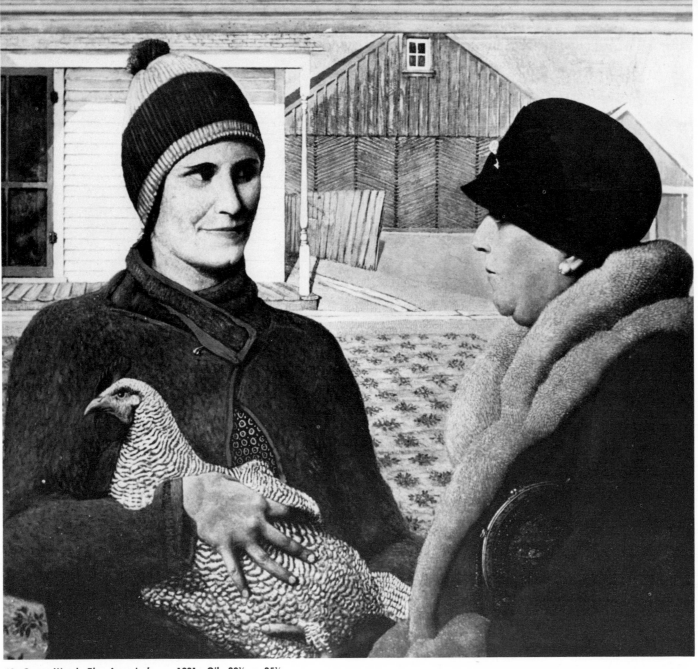

62. Grant Wood, *The Appraisal*, ca. 1931. Oil, 29½ x 35¼ inches. Anonymous collection.

Pages 116–17:

61. Grant Wood, *Daughters of Revolution*, 1932. Oil, 20 x 40 inches. Cincinnati Art Museum. Courtesy Associated American Artists, Inc., New York.

63. Grant Wood, *Midnight Ride of Paul Revere*, 1931. Oil, 30 x 40 inches. The Metropolitan Museum of Art, New York; George A. Hearn Fund. Courtesy Associated American Artists, Inc., New York.

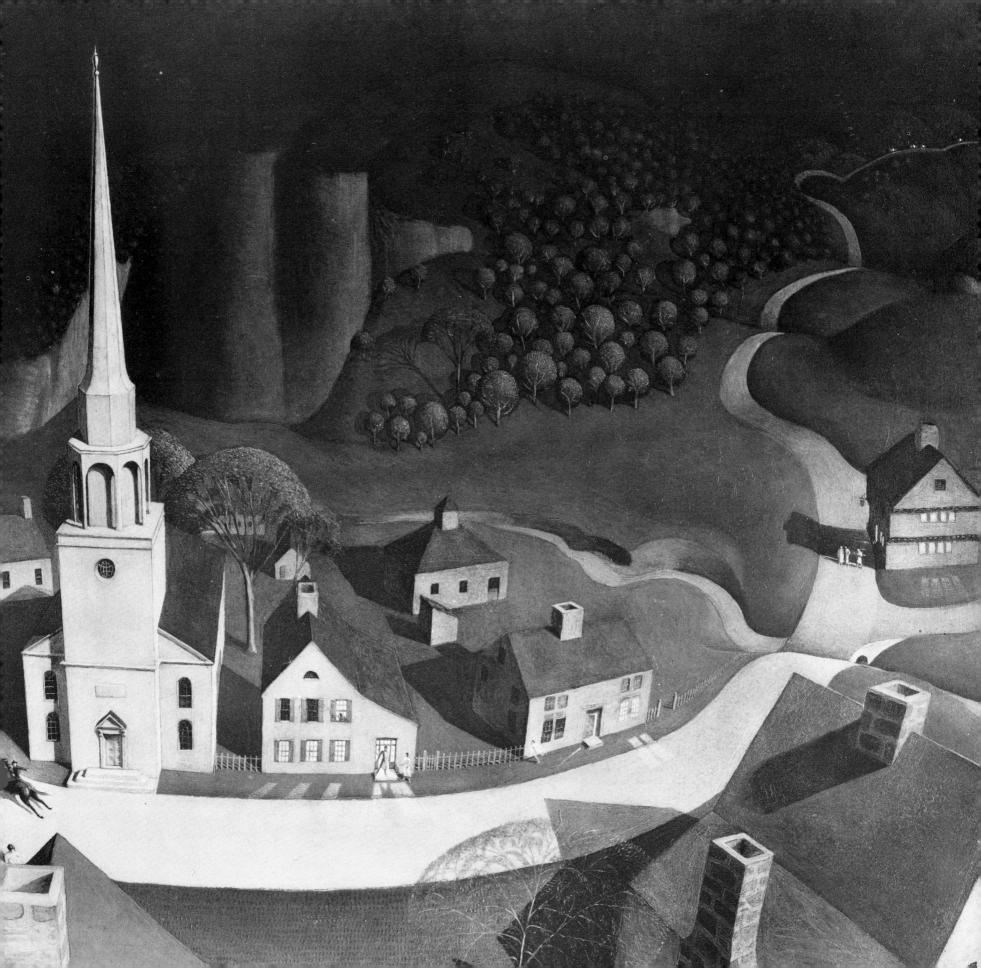

64. Grant Wood, *Parson Weems' Fable*, 1938–39. Oil. Private collection. Courtesy Associated American Artists, Inc., New York.

65. Charles Willson Peale, *The Artist in His Museum*, 1822. Oil, 103½ x 80 inches. Courtesy Pennsylvania Academy of the Fine Arts, Philadelphia.

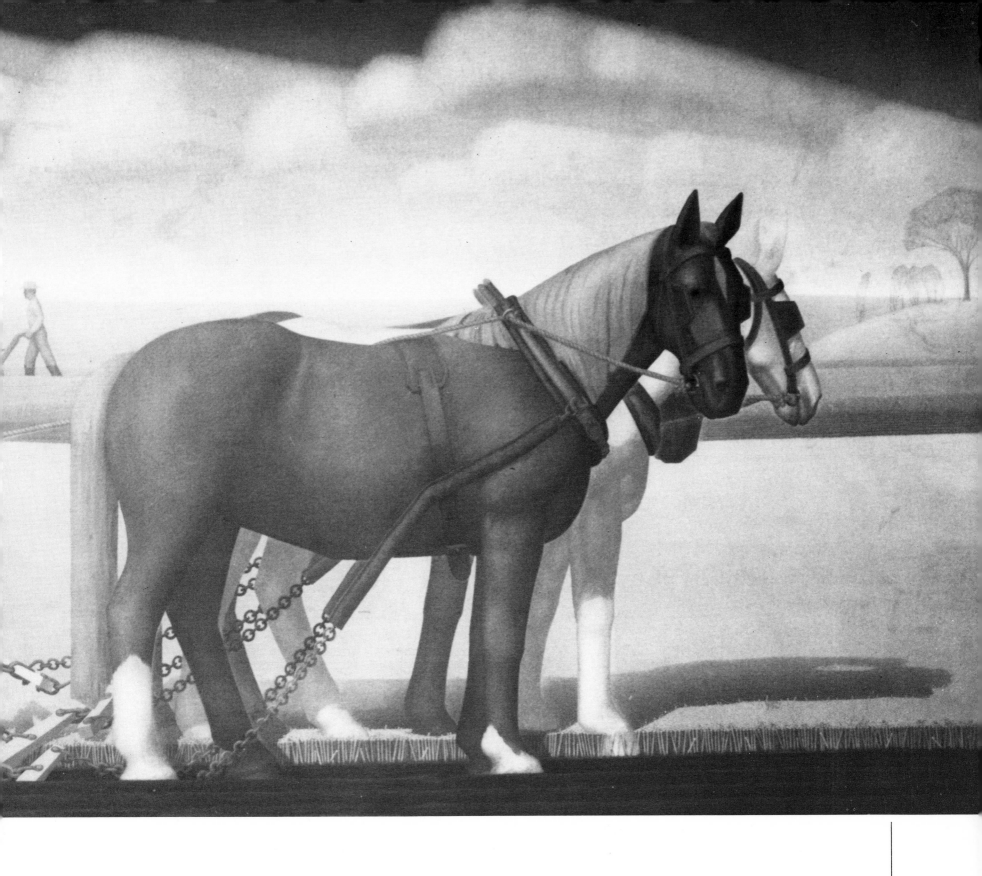

66. Grant Wood, *The Breaking of Iowa's Virgin Soil*, 1936. Oil, 108 x 279 inches. University Archives, Department of Special Collections, Iowa State University Library, Ames. (Detail.)

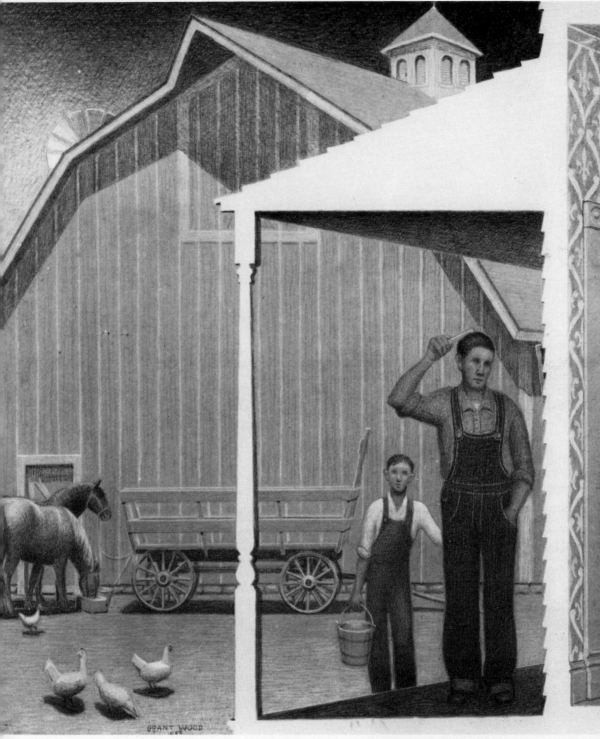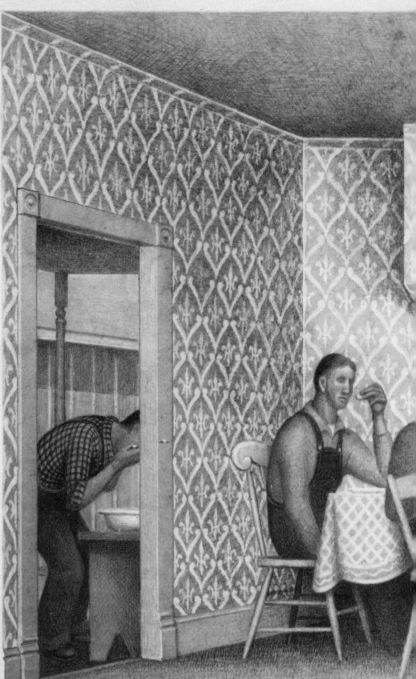

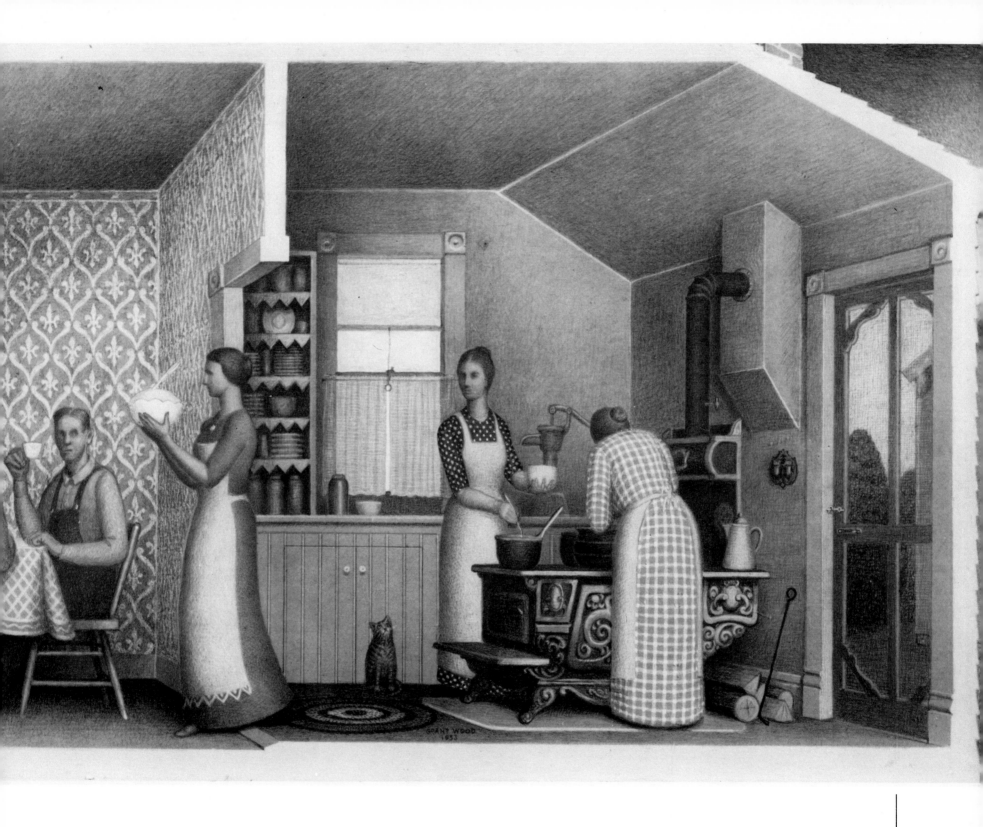

67. Grant Wood, *Dinner for Threshers*, 1933. Pencil, 17¾ x 53½ inches. Collection Whitney Museum of American Art, New York.

2

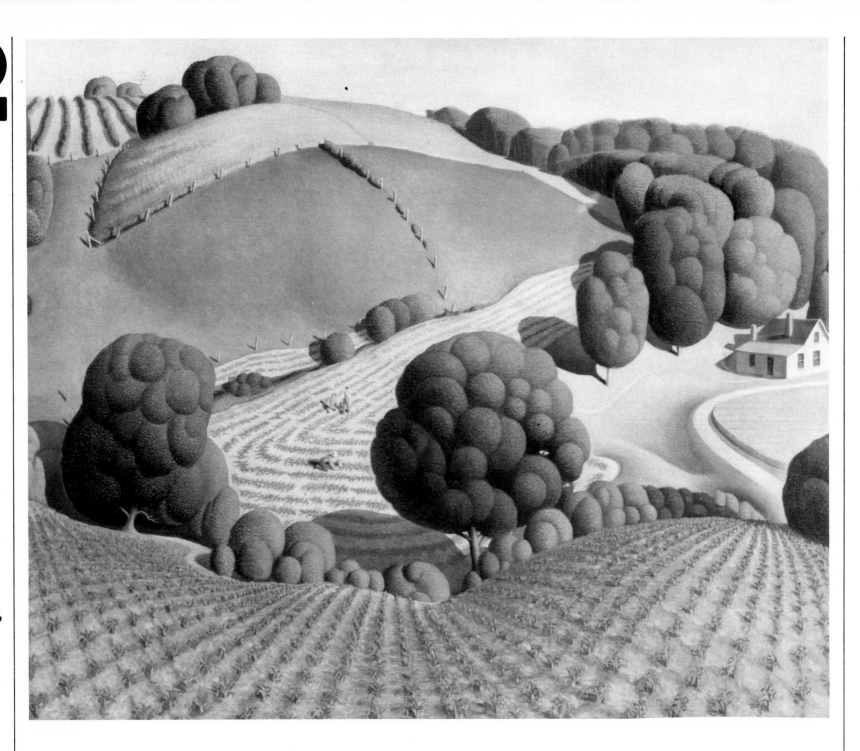

126

68. Grant Wood, *Young Corn*, 1931. Oil, 23 x 29 inches. Cedar
Rapids Community Schools, Cedar Rapids, Iowa. Courtesy
Associated American Artists, Inc., New York.

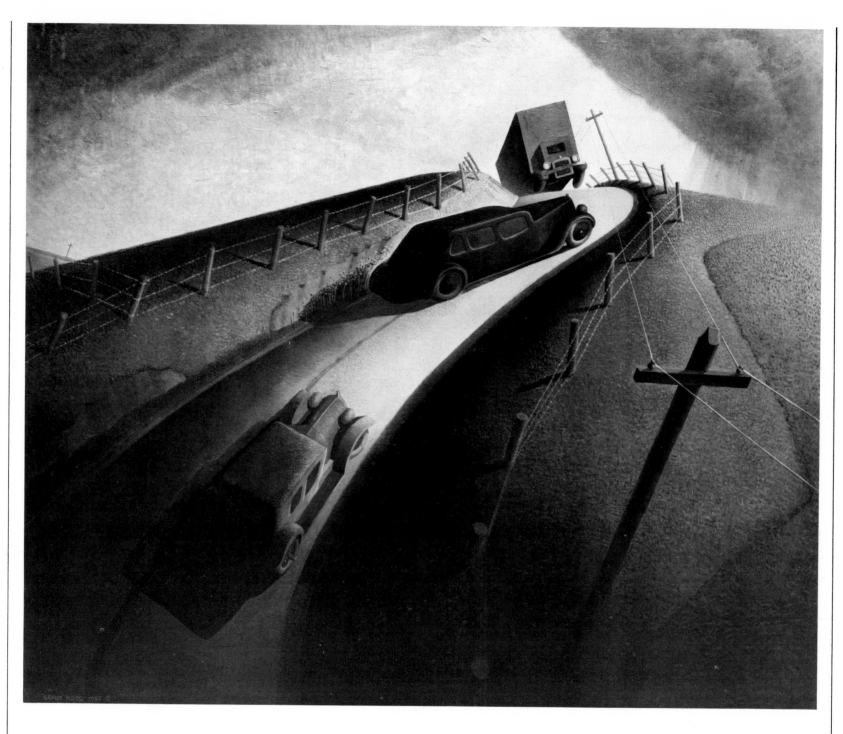

69. Grant Wood, *Death on the Ridge Road*, 1935. Oil, 32 x 39 inches. Williams College Museum of Art, Williamstown, Massachusetts; Gift of Cole Porter, 1947.

2 THE ARTISTS

JOHN STEUART CURRY

Of the three Middle Westerners, John Steuart Curry is the easiest to understand and the least problematical. He never sought a national style, and he never criticized regional foibles. Rather, his art reflected an easy acceptance of Middle Western life and values. He gloried in the spread of the landscape, in the richness of the soil, and in the violence of the weather. Possessing a social conscience, he was concerned with justice, although he couched this concern in old-fashioned American concepts rather than in modern political language. All of his work is laden with nostalgia—a nostalgia for his own youth as well as for the old and simple distinctions between right and wrong.

Even though Curry lived in the New York area from 1919 to 1936, the Middle West remained his chief source of inspiration. However, his view of the Middle West was more idealized than real, and perhaps for this reason he did not penetrate as effectively as Benton or Wood the minds or life styles of his subjects. When looking at one of his paintings, the viewer often feels that Curry was interested in creating a general record of a scene, in which all the proper objects appear in their appropriate places. One feels also that he re-created scenes dispassionately, that ultimately he was an historian of the activities that he painted rather than a participant in them. But within this limitation Curry could deftly manipulate details and expressions, thus giving to a scene a sense of immediacy that was beyond the grasp of Benton and Wood. That is to say, his art, more than theirs, approached the level of illustration.

Curry actually worked as an illustrator from 1919 to 1926, until he left New York for a year of serious study in Paris.[1] Ignoring twentieth-century art movements in France, he responded most avidly to the works of older masters such as Gustave Courbet and Peter Paul Rubens. Curry admitted a profound debt to Rubens,[2] and perhaps his interest in rich coloristic and textural effects, as well as the sense of spaciousness in his landscapes, reflects his keen study of the Baroque artist. Curry's use of themes of violence, evident as early as 1917 in studies he made of farmers fighting with each other, could have been reinforced by his observation of Rubens's work, although such themes were common to much Baroque art.

After his return from Paris in 1927, and for reasons that remain obscure, Curry developed an extraordinary interest in subject matter based on his own youthful experiences. Almost immediately, he painted *Baptism in Kansas* (*Ill. 70*), exhibited in 1928, his first important American Scene painting. It was immediately considered a significant work, one that reflected the changing attitudes toward rural America, and it helped bring the growing American Scene movement to the public's attention.[3] As Lawrence Schmeckebier, Curry's biographer, has stated, through works such as *Baptism in Kansas,* rural America was finally beginning to discover its artists, those who would create a portrait of the countryside equivalent to the urban scenes depicted by the Ash Can School a generation earlier.[4]

Curry did not revisit the Middle West until the summer of 1929, after he had completed *Baptism in Kansas.* Until 1936, when he became artist-in-residence in the College of Agriculture of the University of Wisconsin, he made annual summer excursions to the Middle West, returning to New York with notes for paintings that he completed during the winters. This biographical fact is of some importance because Curry placed such emphasis on painting what he knew best. Clearly, he remained on most comfortable terms with his past. (His circus paintings, based on a tour with the Ringling Brothers Circus in 1932, can be viewed as a digression rather than an integral part of his career.) He obviously preferred rural society to that of the city and tried to keep alive within himself the traditional ties to family, home, and the land.

The land itself particularly appealed to him and he considered the landscape "the most fruitful and genuine medium of a national expression."[5] To Curry, man's actions on the land, his contest with nature for dominance, was the basic American experience. Curry recognized the capacities of both—nature's ability to devastate the land and man's ability to bring great riches from the soil. Some of his most memorable paintings—such as *Tornado, Storm over Lake Otsego,* and *Spring Shower* (*Ills. 71–72, Colorplate 6*)—illuminate aspects of the struggle. Of works such as these, Curry stated, "I don't feel that I portray the class struggle, but I do try to depict the American farmer's incessant struggle against the forces of nature."[6] This attitude distinguishes his art from that of the Social Realists.

Although tornadoes and storms were real to Curry, and although he respected their powers, his paintings inevitably strike a note of optimism—a quality occasionally lacking in the storm scenes of painters like Charles Burchfield. Even in Curry's paintings of floods, where he could easily have shown nature triumphant in its rage against man, he invariably shows man prevailing. In *The Mississippi* (*Colorplate 15*), a distressed family miraculously survives, astride the ridgepole of its submerged house; in *Line Storm* (*Ill. 73*), a farmer rushes his hay to the barn before the storm arrives.

Curry celebrates these struggles because he knows man is not the victim but the triumphant adversary. After all, the Middle West was America's bread basket, where man did prevail and did grow rich at the expense of nature, but only after much sacrifice and hardship. Malcolm Vaughan, a rabid supporter of the American Scene, extolled *Line Storm* in the following way:

In it the spirit of the artist and perhaps his generation stands disclosed, a powerful spirit born of America, inspired by America and dedicated to American ideas and ideals. To my mind, the canvas is an historical work of art, historical in that it mirrors our contemporary will to believe in ourselves, to believe in our own resources and in our native beauty.[7]

Even Grant Wood, who could read between the lines of the American character, found *Line Storm* one of the most moving creations in the whole of American art.[8] And because critics like Vaughan discerned a host of national values in a rural landscape, it is no wonder that the urban Social Realists reacted so violently to the Middle Western painters.

Curry's popularity was derived in great measure precisely from his ability to paint scenes of general interest, so that his audience could easily identify with the subject and could add their own interpretations and variations. Thus, they could dovetail their own experiences with those portrayed. In *Kansas Wheat Ranch* (*Ill. 76*), for example, Curry conveys information about life in rural America, but avoids the particularized episodes and details that a painter like Aaron Bohrod included in his *Landscape near Chicago* (*Colorplate 16*).

Despite the retrospective quality of his art, Curry was not unmindful of the vital concerns of the day and of the artist's responsibility to deal with them. He was pleased to note that his contemporaries had seized the opportunity to use current significant issues as subject matter for their paintings and that "effective works for the cause of social and political justice" were being produced.[9] By the middle of the decade, certainly, many artists had painted scenes of racial injustice.[10] As early as 1931, Curry had painted a night scene of a manhunt, and a few years later he gave the same subject racial overtones in *The Fugitive* (*Ill. 28*).[11] Curry pursued the theme further in 1935, when he was invited by the Section of Painting and Sculpture to make two murals for the Justice Department. One study that depicted the freeing of the slaves was rejected, an action that Curry felt was taken because of "the racial implications of the subject matter, and [because] it was felt that Washington was not the appropriate place in which to erect this mural."[12] In its place Curry substituted a group of figures representing justice triumphing over mob rule. Ultimately the rejected sketch served as the basis for his 1942 mural, *The Freeing of the Slaves* (*Ill. 78*), which he executed for the University of Wisconsin's law library.

To be sure, the degrading conditions in which blacks were forced to live would have been a more forceful subject, and one might criticize Curry for having depicted blacks as little more than Godloving, Hallelujah-shouting people. Yet, the important point is that Curry willingly confronted this sensitive issue at a time when such confrontations were relatively rare. *The Freeing of the Slaves* suggests, as does his *Tragic Prelude* (*Ill. 39*) in the Kansas State Capitol, that he sought to enlarge the scope of his art beyond the confines of a Middle Western landscape. One has only to recall the treatment of blacks in Marc Connelly's immensely popular play, *Green Pastures* (which won a Pulitzer Prize in 1930), and in subsequent motion pictures to realize the seriousness of Curry's intentions.

He wanted especially to see in his lifetime the development of an American Renaissance comparable to the Mexican mural movement.[13] He may even have imagined that its rallying point lay in the combination of regional description and social concern that pervaded such paintings as *The Tragic Prelude*. Surely, the figure of John Brown is, in spirit, the equivalent of the Mexican heroes Juárez and Zapata. But

129

by the early 1940's, such paintings marked the dead end of the American Scene, and not the birth pangs of a renaissance. Like Grant Wood, Curry painted until his death (in 1946) as if social and political conditions had not changed. Thus Curry's death, like that of Wood, seemed to mark the passing of an artist who had outlived his time.

130

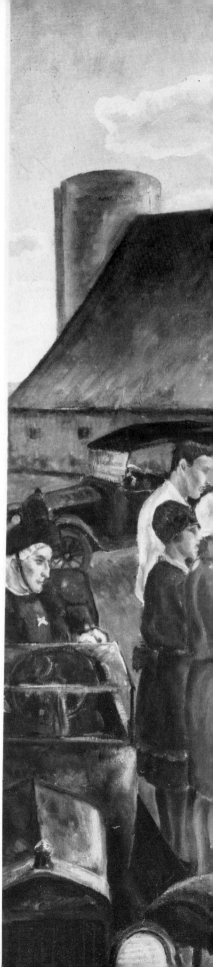

70. John Steuart Curry, *Baptism in Kansas*, 1928. Oil, 40 x 50 inches. Collection Whitney Museum of American Art, New York.

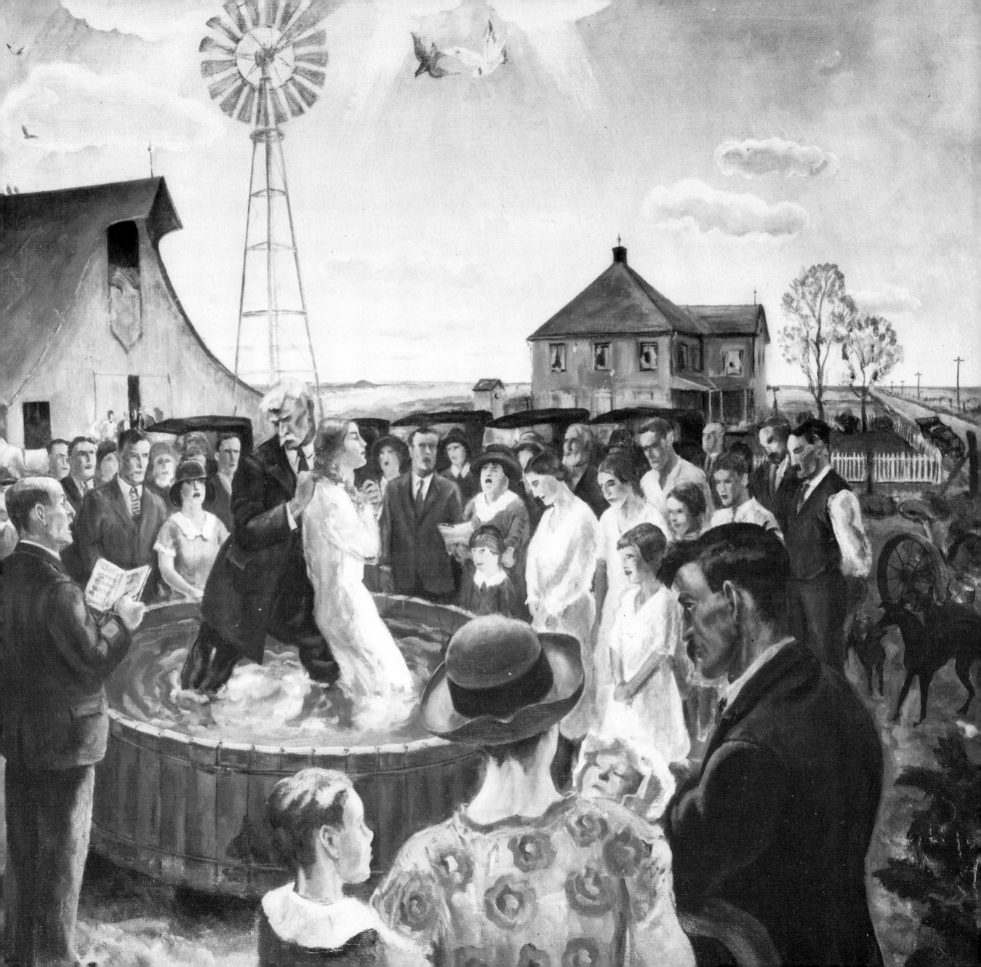

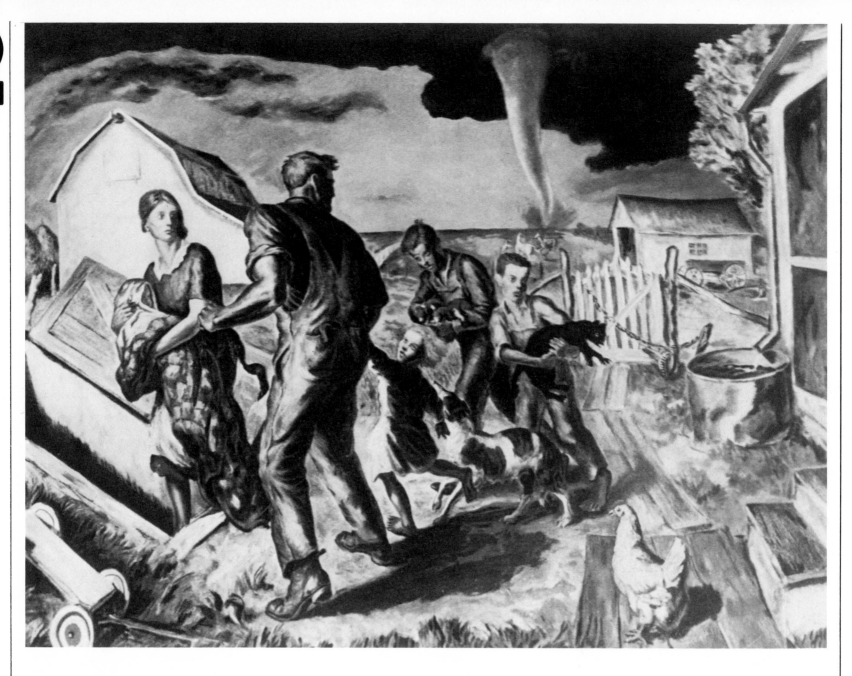

132

71. John Steuart Curry, *Tornado*, 1929. Oil, 46¼ x 60⅜ inches. The Hackley Art Gallery, Muskegon, Michigan.

Colorplate 13. Thomas Hart Benton, *Persephone*, 1938–39. Oil and tempera, 71 x 52½ inches. Collection Rita Benton.

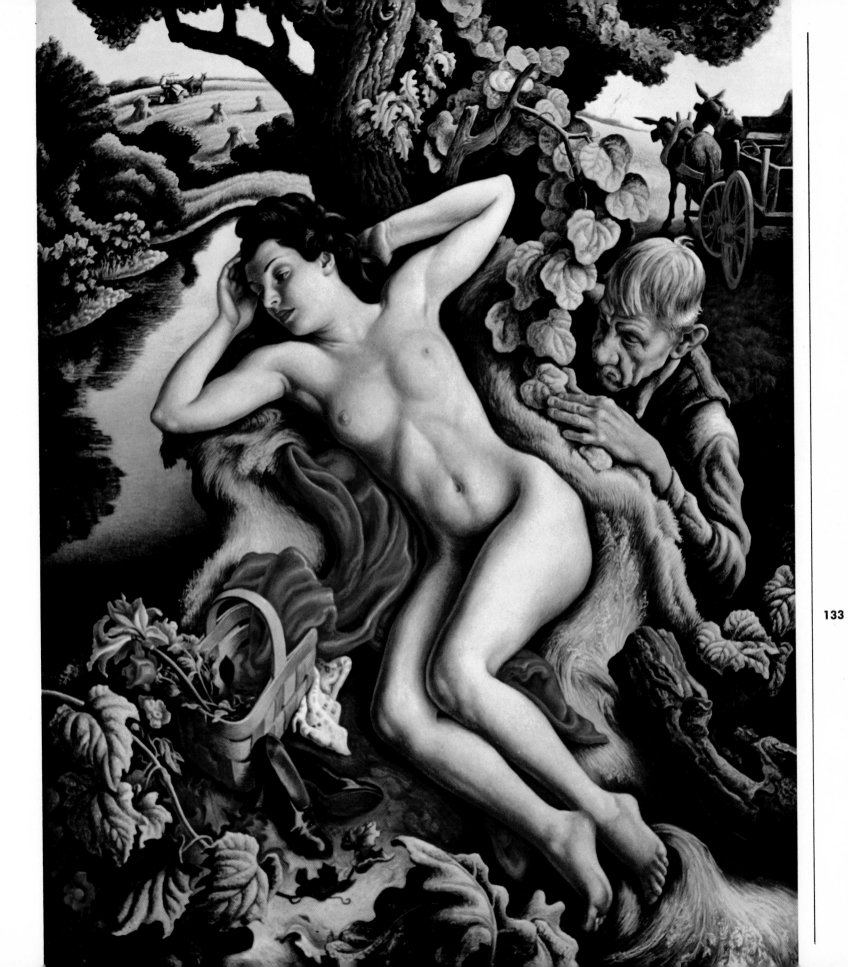

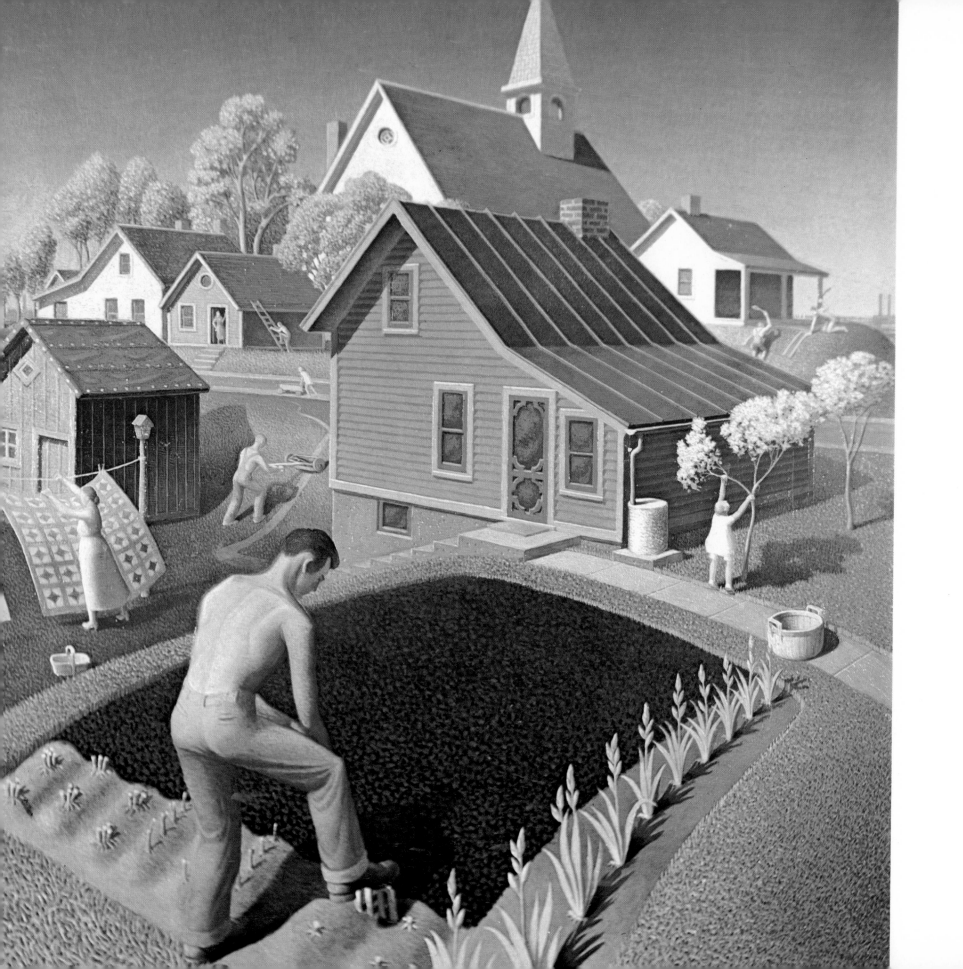

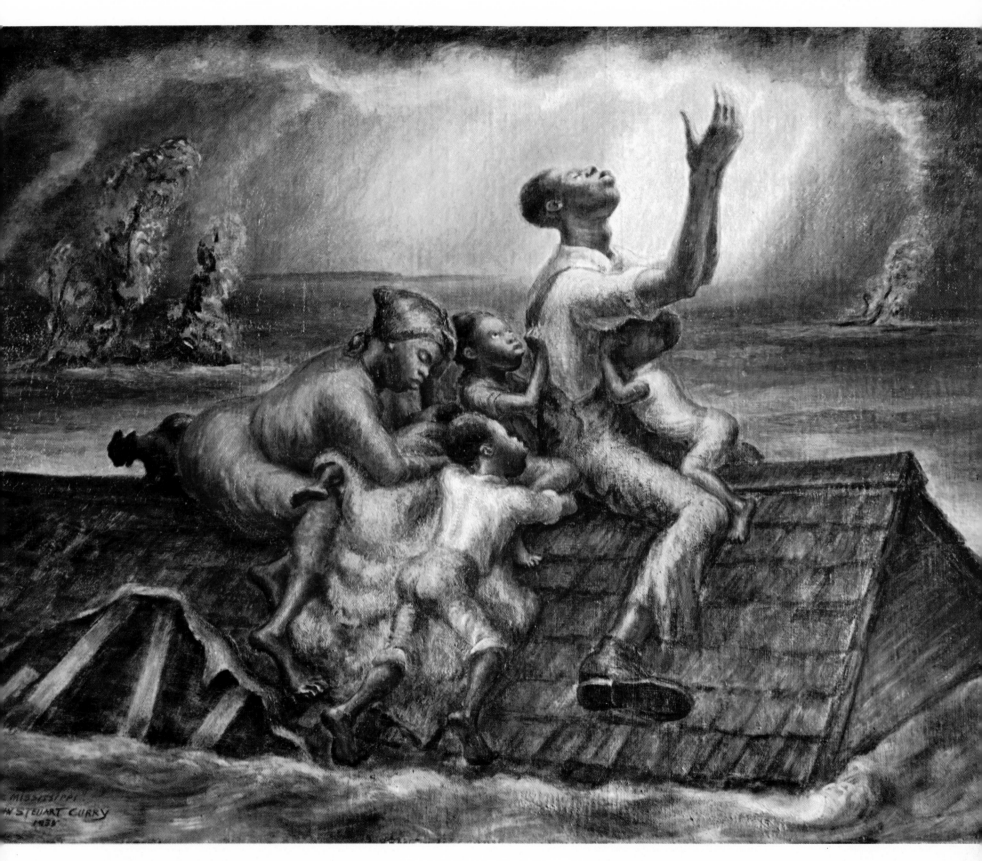

Colorplate 14. Grant Wood, *Spring in Town*, 1941. Oil, 26 x 24½ inches. Courtesy The Sheldon Swope Art Gallery, Terre Haute, Indiana.

Colorplate 15. John Steuart Curry, *The Mississippi*, 1935. Tempera, 36 x 47½ inches. The St. Louis Art Museum.

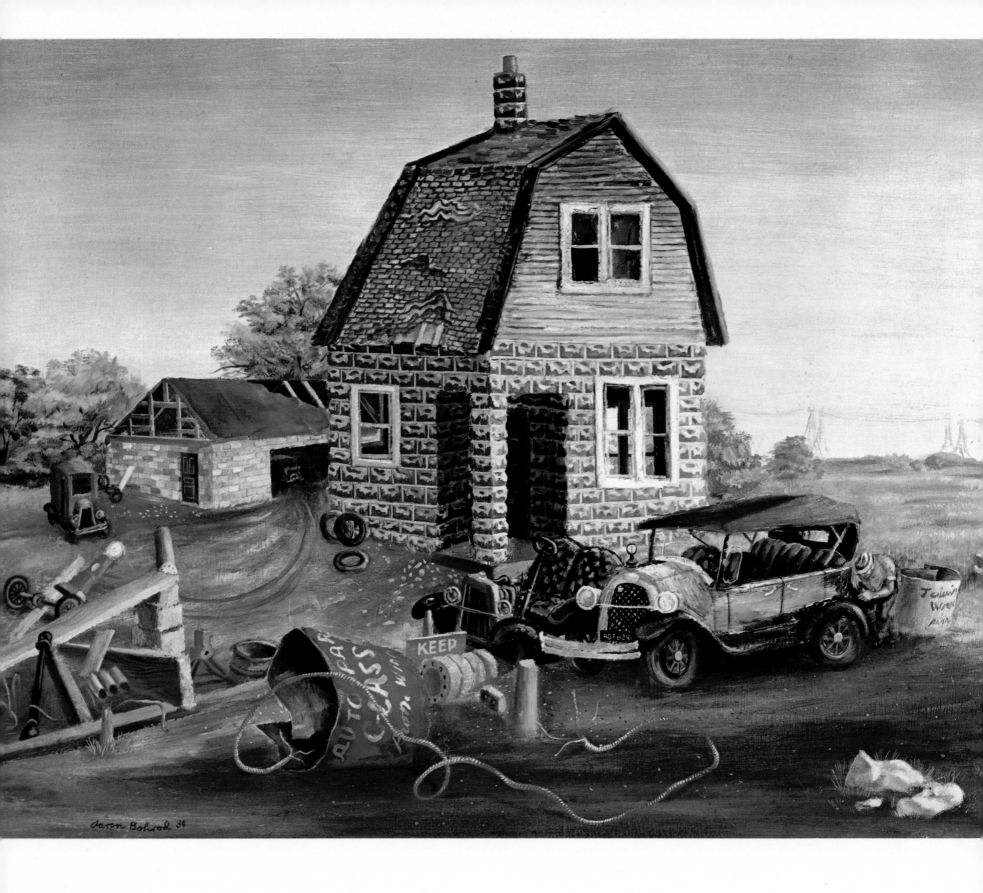

Colorplate 16. Aaron Bohrod, *Landscape near Chicago*, 1934,
Oil, 24 x 32 inches. Collection Whitney Museum of American
Art, New York.

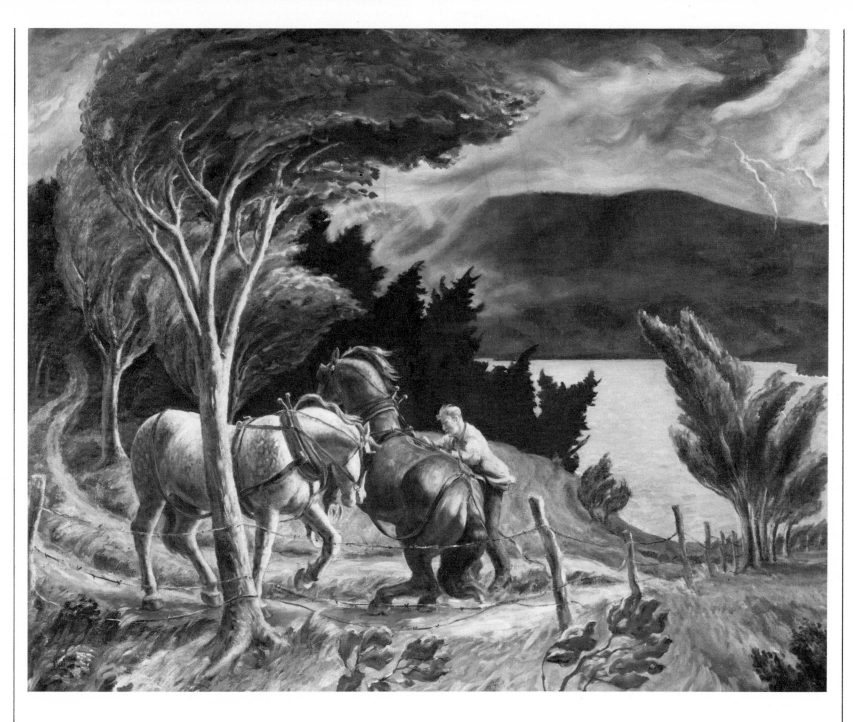

72. John Steuart Curry, *Storm over Lake Otsego*, 1929. Oil,
40 x 50 inches. Courtesy Museum of Fine Arts, Boston; Gift
of Mr. and Mrs. Donald C. Starr.

138

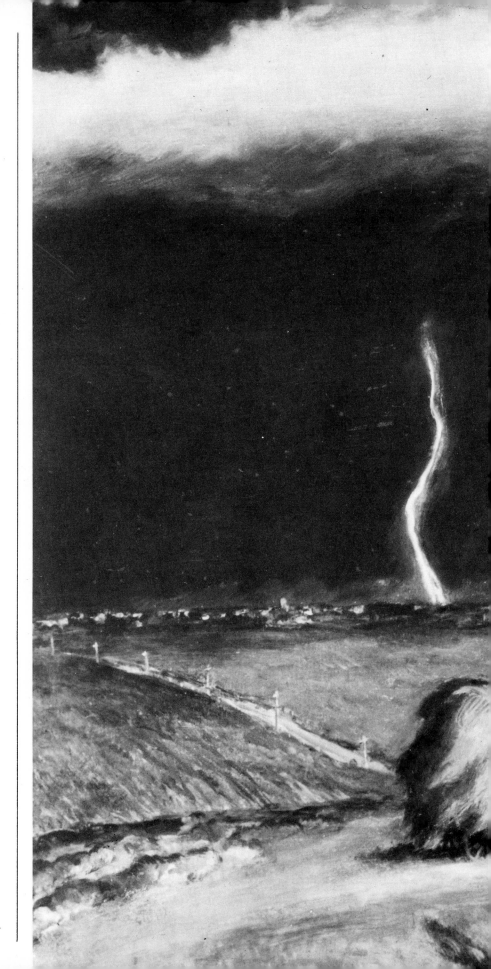

73. John Steuart Curry, *Line Storm*, 1934. Oil. Collection unknown.

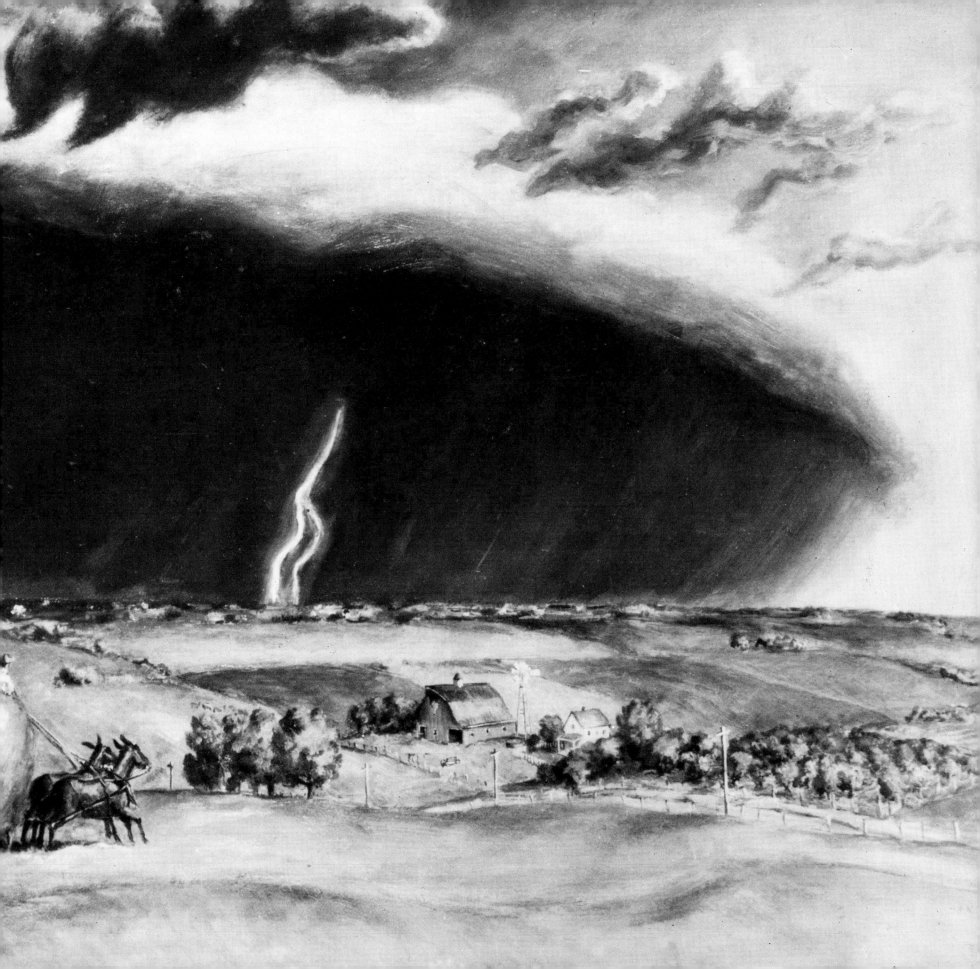

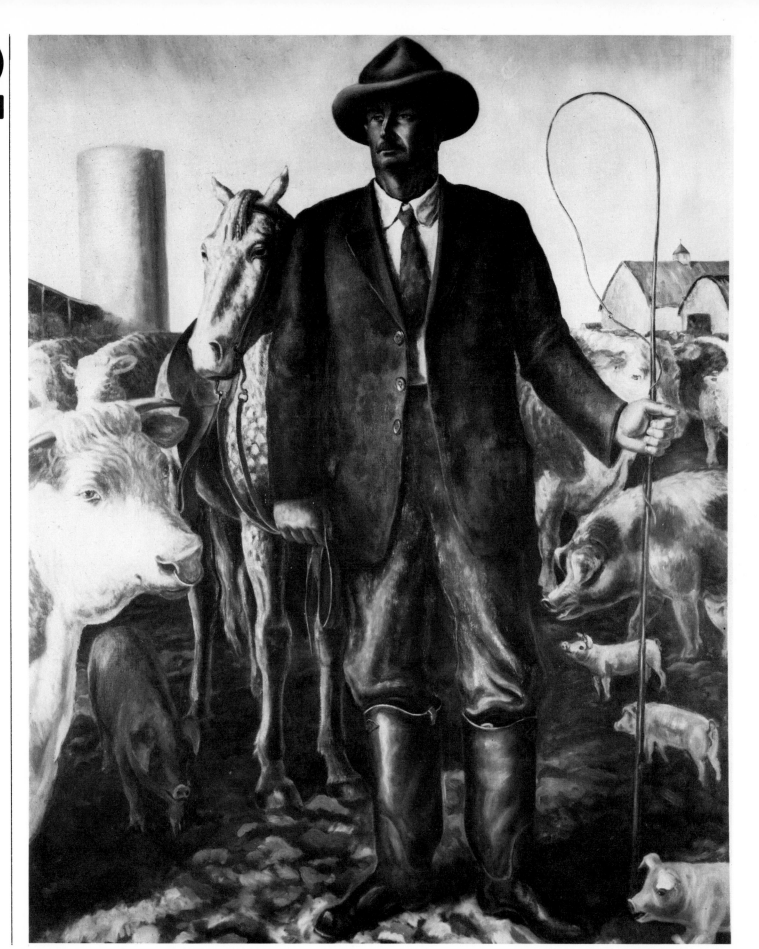

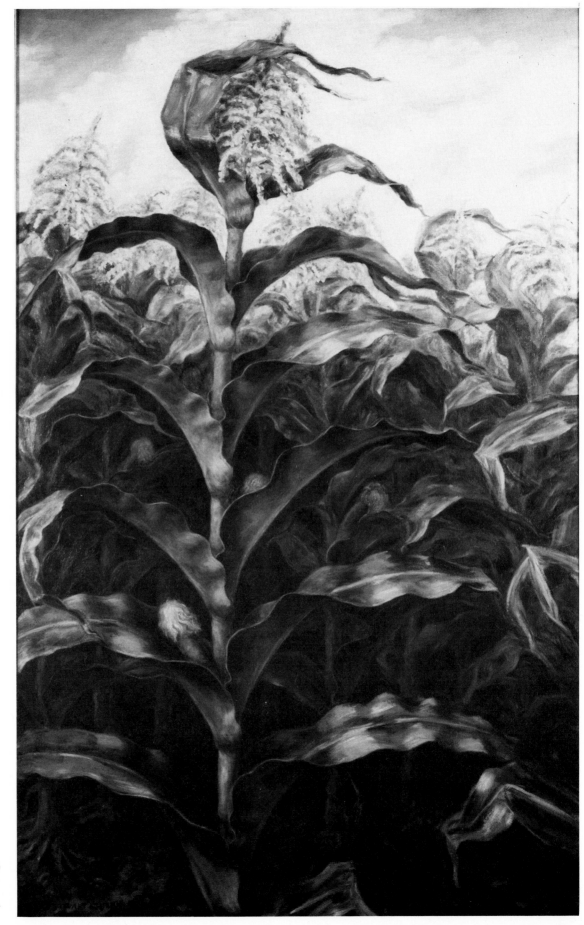

74. John Steuart Curry, *The Stockman*, 1929. Oil, 52 x 40 inches. Collection Whitney Museum of American Art, New York.

75. John Steuart Curry, *Kansas Cornfield*, 1933. Oil and tempera, 60 x 38¼ inches. Collection unknown.

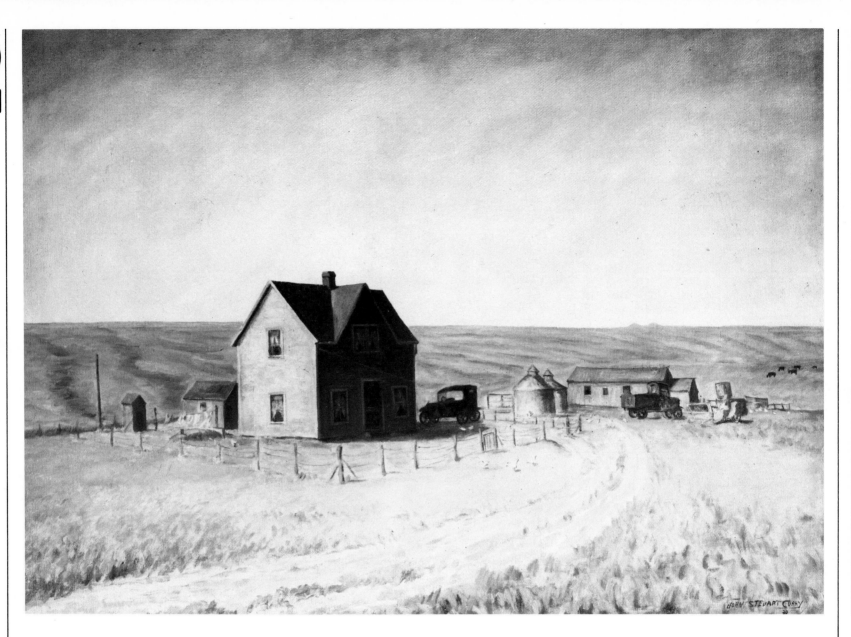

76. John Steuart Curry, *Kansas Wheat Ranch*, 1930. Oil, 28 x
40 inches. Collection Charles F. Stein.

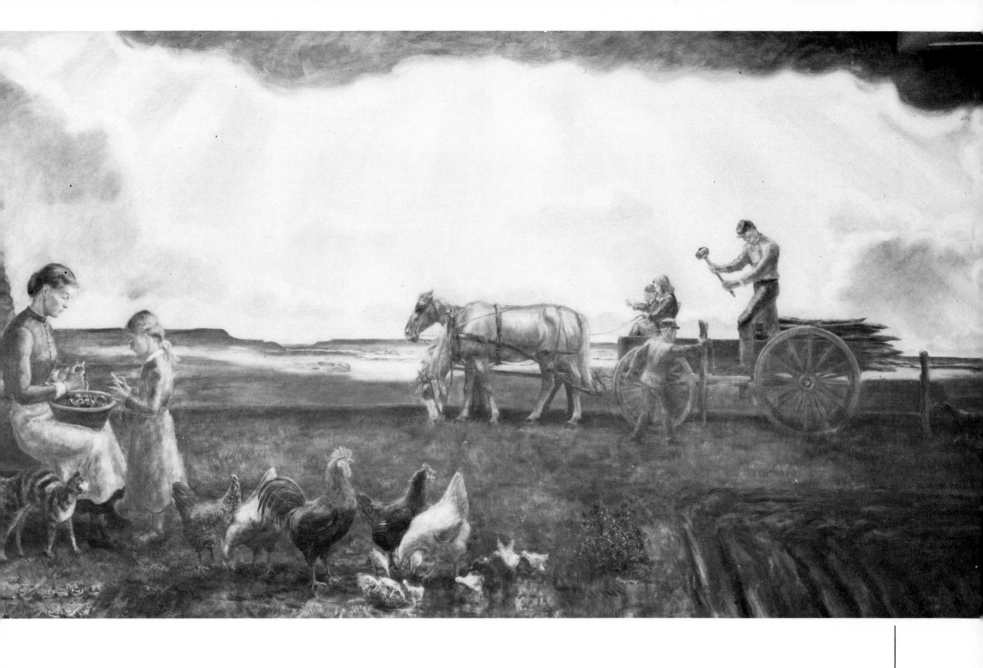

77. John Steuart Curry, *The Homesteading*, 1939. Oil and tempera, 110 x 386 inches. Department of the Interior, Washington, D.C. (Section of Painting and Sculpture.) Photograph, Public Buildings Service.

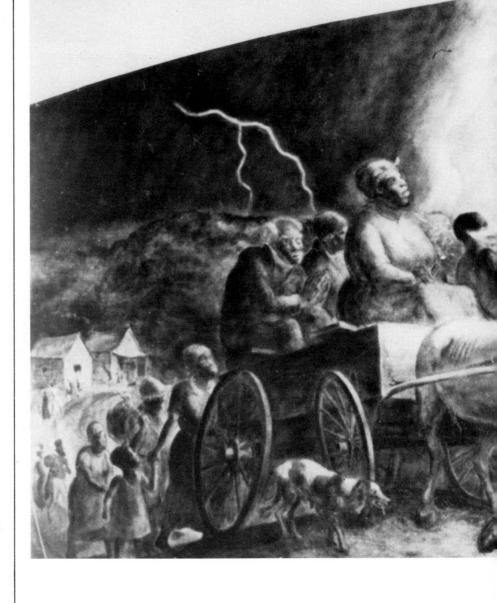

78. John Steuart Curry, *The Freeing of the Slaves*, 1942. Oil and tempera, 168 x 444 inches. Library of the Law School, University of Wisconsin, Madison. Photograph, University of Wisconsin, University Extension.

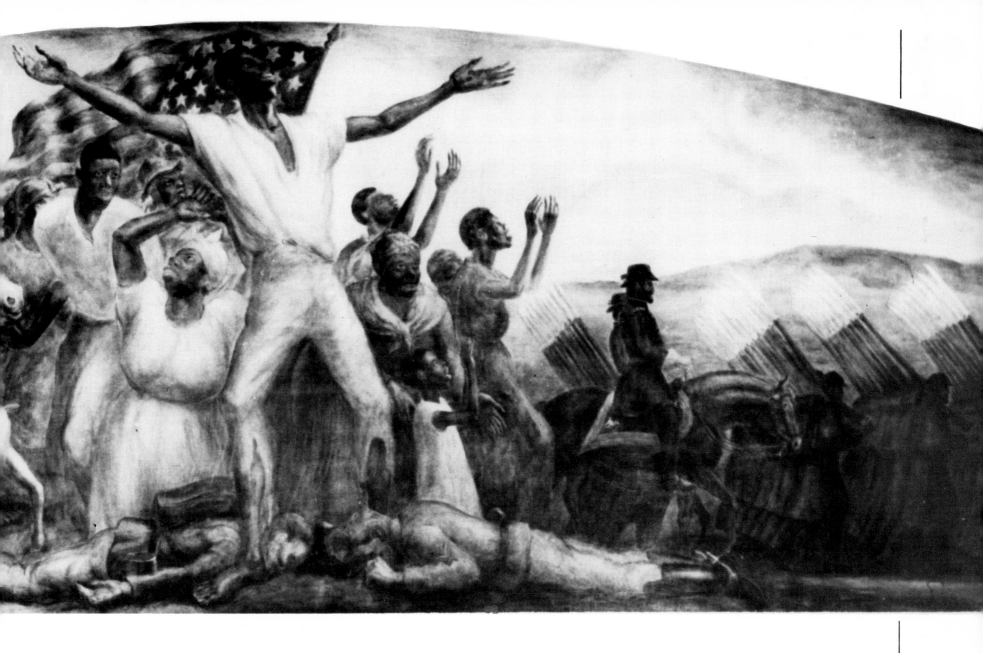

THE ARTISTS

REGINALD MARSH

In the highly charged art world of New York in the 1930's, Reginald Marsh occupied a curious position. Although he painted urban views, the Social Realists tended to reject his work, and Thomas Craven liked it. Craven considered him a major American figure, equal to the favored Middle Westerners, and the latter considered him part of the "Coney Island School" of painting.[1] In effect, Marsh was an urban regionalist, supported by a critic who preferred an art of rural scenes and dismissed by painters who usually depicted urban ones.

Craven may have become acquainted with Marsh's work through Thomas Hart Benton, since we know that Benton and Marsh were on friendly terms in the late 1920's. (It was Benton who introduced Marsh to the egg tempera medium in 1929.)[2] However, Benton did not get along with Marsh's mentor, Kenneth Hayes Miller, so that the relationship between Benton and Marsh was cordial, but never intimate. The more likely reason for Craven's interest was his genuine liking for Marsh's work, and it is probable that Craven viewed Marsh as a kind of big-city regionalist.[3]

The reasons for Craven's delight in Marsh's paintings are easy to discern. No other painter captured so well the physical sensations of urban activities—the feeling of movement through crowds of people, the frantic quality of shoppers rushing up a street or down onto a subway platform, the mindless quickstep of the city pedestrian. The restless surge of energy that Craven thought typical of American life exploded across the surfaces of Marsh's paintings. Clearly, they were the closest conceivable urban equivalents of Benton's work and, therefore, they suggested both an American content and an American style.

Marsh's rejection by the political left is also easy to understand. Although he exhibited at the John Reed Club on at least one occasion (in 1932), Marsh was apolitical:[4] he never articulated any sort of social or political philosophy. In fact, at a meeting of the American Artists Congress in 1940, then a Stalinist-controlled organization, he stated his opposition to the large amount of political opinion that he saw paraded as art criticism.[5]

When he painted the working class and the unemployed, he did not depict them as the dupes of capitalist oppression, for his characters in general never seemed to be victims of societal injustices. Even though he frequently painted the downtrodden, both black and white, their responses to their plight are blurred by the frenzies of urban bustle and noise. It is as if they took part in a gigantic stage show, frozen in mid-gesture, and as if they never actually lived the roles they portrayed. His characters do not live in their environments, but usually exist in front of them. And these characters rarely react. Psychologically neutral, they project an emotional sameness whatever their economic class or immediate motivation (*Ills. 79–81*). Marsh did not assume responsibility for their actions and he made no comment on their activities. To him, rich and poor, black and white were part of the same undifferentiated spectacle of the urban scene. Marsh was concerned with humanity rather than with individuals, with an abstract vision of urban life rather than with the personal encounter.

A chronic outsider, he was an observer at a time when the city was filled with participant painters. Not unlike John Sloan, Marsh was an artist-voyeur who studied his subjects with field glasses from his studio overlooking New York's Union Square. In fact, Marsh seems to have been born a generation too late, for his art recalled that of the Ash Can painters. His paintings project the same kind of enchantment with city views, though he avoids the intimate neighborhood scenes of the older group. Marsh seems closest to George Bellows, because of their mutual interest in multi-figured compositions and their common fascination with action and energy.

More than any other artist of the 1930's, Marsh kept alive the earlier brand of realism. Few, if any, could evoke such joyous lower- and middle-class images, in a decade hardly noted for its lighthearted views. Marsh reminded people of how much fun city living could really be, of how much visual and physical excitement could be found there, even though one was poor or out of a job. His paintings were a needed tonic, and they reassured the public of the city's underlying amiability and livability (*Ills. 83–84*).

Marsh especially enjoyed the beaches and burlesque houses of the metropolitan area, primarily because he could observe semi-naked bodies in action and perhaps because he genuinely enjoyed these

forms of popular entertainment. Unlike Benton, who seems to have cultivated popular entertainments consciously, Marsh's pleasure appears to have been wholly spontaneous.

In his theater interiors, he observed the audience as much as, if not more than, the performers. In the burlesque scenes, the men (usually older men) sit quietly and stare, hardly enjoying the spectacle before them (*Ill. 85*). This perhaps reveals an ambivalence on Marsh's part—a dislike for the idea of burlesque and a simultaneous pleasure in the action of the nearly nude bodies. By contrast, the crowds in his opera-house paintings are usually quite lively (*Colorplate 17*).

In the beach scenes, however, everybody shares the pleasures of the moment (*Ill. 86*). Women play at being sex queens, men are champion athletes, and all are proud of what they have to display. These densely packed views mirror Marsh's unabashed joy in bending the human body into as many postures as possible. "I like Coney Island," he once said, "because of the sea, the open air, and the crowds—crowds of people in all directions, in all positions, without clothing, moving—like the great compositions of Michelangelo and Rubens."[6]

Of the two Old Masters, Marsh was drawn more strongly to Rubens[7]—to his flicking lines, quick brush strokes, and theatrical lighting. However, at the root of Marsh's style lay a different conception of what constituted a finished painting. Marsh shared with many American artists before and since an unwillingness to organize a painting around an obvious center of focus. One reads his paintings almost as one would watch an unwinding newsreel: segment by segment the action unfolds until it comes to a stop at the edges of the painting. Marsh's canvases are filled with episodes that do not necessarily relate to the whole; a sequence of words, for example, may have no apparent compositional function or a cluster of people may have no psychological relation to the principal, or foreground, activities.

Marsh seems to have preferred an organizational emphasis that was more daring than traditional schemes, one that is based on pulsating energy. Hardly a square millimeter of any of his painted surfaces contains a constant coloration, a constant intensity of color, or a constant value structure. A given red, for example, is repeatedly modified by touches of yellows or blues. Its intensity ranges from strong to weak as the pigment is diluted with mixing agents, its value is continually altered by the addition of white or black (which lightens or deepens a pigment). Coupled with these highly volatile, and potentially dangerous, combinations, Marsh often used difficult and odd perspectival systems—particularly his views of swing carousels and second-story windows (*Ill. 87*).

Marsh's technical powers were extremely sophisticated. Depths, however shallow or expansive, are logical and easy to read, and forms hold their assigned positions within the spatial field. Rarely does a particular object fall out of or back into the picture space. The total effect is one of continually flickering vibration from left to right and from top to bottom, which forces our eyes to move as rapidly as the figures themselves. The nervous tensions that Marsh's strokes elicit are resolved only when the viewer turns away from the painting. His work certainly suggests a pulsating America, and it is no wonder that Craven liked it!

Marsh worked as a magazine and newspaper illustrator in New York during the 1920's. Looking for subject matter beyond the immediate requirements of his next deadline, he began to paint beach and street scenes, theater interiors, and general views of people at their pleasures. Occasionally he painted landscapes and seascapes but, by the end of the decade, he began to concentrate exclusively on the human form. He then relegated the animated city and harbor scenes to the background. In 1927–28, he studied with Kenneth Hayes Miller, subsequently an intimate friend to whom Marsh reportedly showed every picture he painted. Perhaps Miller, who found Fourteenth Street in New York to be the world's greatest landscape, encouraged Marsh to concentrate on urban views. Miller himself often painted women shoppers, and occasionally the figures in these paintings appear to be walking abruptly out of the picture space. Although some of Marsh's nude studies of the 1920's resemble the older artist's work, Miller's style was fundamentally different. Many of his paintings seem to combine Renoir at his most academic with Raphael at his most static and to drain both artists of all of their lushness. Thus, Miller's style was antithetical to the nervous and energetic manner that Marsh subsequently developed.

147

Marsh's mature style emerged around 1930, the year in which he was first recognized as a major figure.[8] In his immediately preceding work, contours were so heavily emphasized that figures resembled poster cutouts. Occasionally, the characters seemed menacing. The man in the center of *Subway Station (Ill. 88)* is one of these early creatures, although he is surrounded by figures in Marsh's more mature style. By 1932, Marsh had learned to monumentalize his forms and to suggest consistently rounded volumes. Because of these subtle adjustments, he was called, at a time of renewed interest in mural painting, "a misplaced muralist."[9] In the years that followed, he received two major opportunities to demonstrate his abilities in this format. An acknowledged master by 1935, he was invited by the recently formed Section of Painting and Sculpture to decorate the new Post Office Building in Washington, D.C., with a mural depicting the processing and sorting of mail *(Ill. 89)*. In 1937, he painted twelve scenes representing the arrival of ships in New York Harbor for the U.S. Customs House in that city.

Perhaps it was Miller who helped to prevent Marsh from hearing the siren song of the School of Paris. In any event, Marsh allowed his hostility to modernism to become well known and well documented: "Many talents of today are committing artistic suicide on the artificial gas piped commercially into America by the *Ecole de Paris*."[10] While the more prominent French painters rejected the conventions of the past, Marsh believed that American painters should not discard the great traditions of Western art. (Logically, the one American painter who appealed to him above all others was the realist Thomas Eakins, about whom Marsh once wanted to write a book.)[11] Marsh also believed that contemporary art functioned best when it took as its source "the characteristic life" of the day.[12] Like Benton, Marsh found this characteristic life in the activities of the masses and not in the preoccupations of elite groups. His art, too, reached out toward the people.

Like Grant Wood, who continued painting as if World War II had not occurred,[13] Marsh seems not to have allowed the current world situation to influence him. He did not re-evaluate either his attitudes toward art or the premises upon which his choice of subject matter rested. His subjects still went to the beach, still rode the carousel, and still got drunk on Skid Row. Marsh acknowledged his unwillingness to accept the changes in temperament, character, and physical appearance that New Yorkers and their city were undergoing; by extension, he rejected as well the new influences entering the art world. His paintings became increasingly nostalgic as he continually recalled the New York of the 1930's. As he said toward the end of his life, "All the things of the old days were so much better to draw. I hate to go down to Chatham Square where they're tearing down the span [elevated subway]; the light and shadow on the characters walking around down there—you can't find anything better to draw."[14]

149

79. Reginald Marsh, *Twenty-Cent Movie*, 1936. Tempera, 30 x 40 inches. Collection Whitney Museum of American Art, New York.

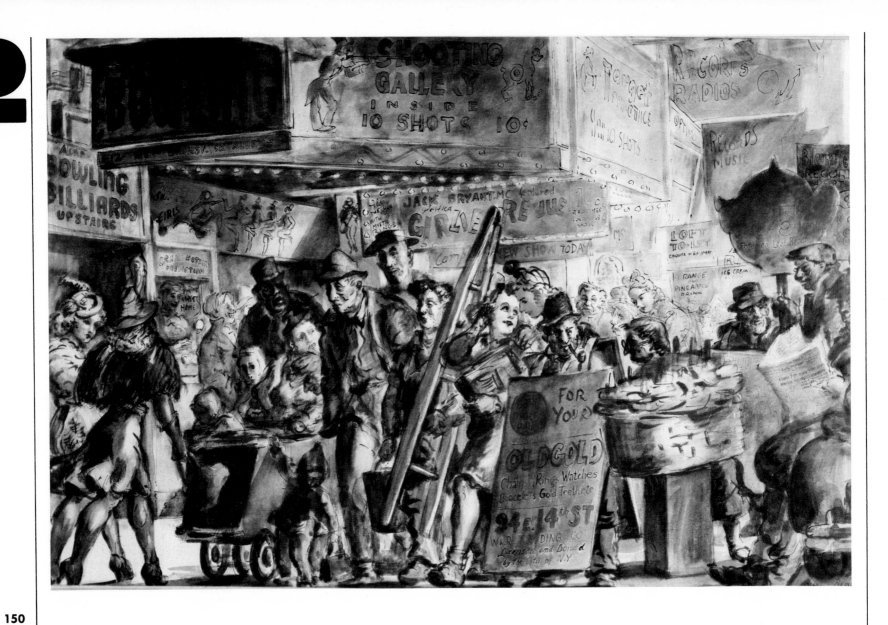

80. Reginald Marsh, *Ten Shots, Ten Cents*, 1939. Watercolor, 27 x 40 inches. The St. Louis Art Museum; Gift of Eliza Mc-Millan Fund.

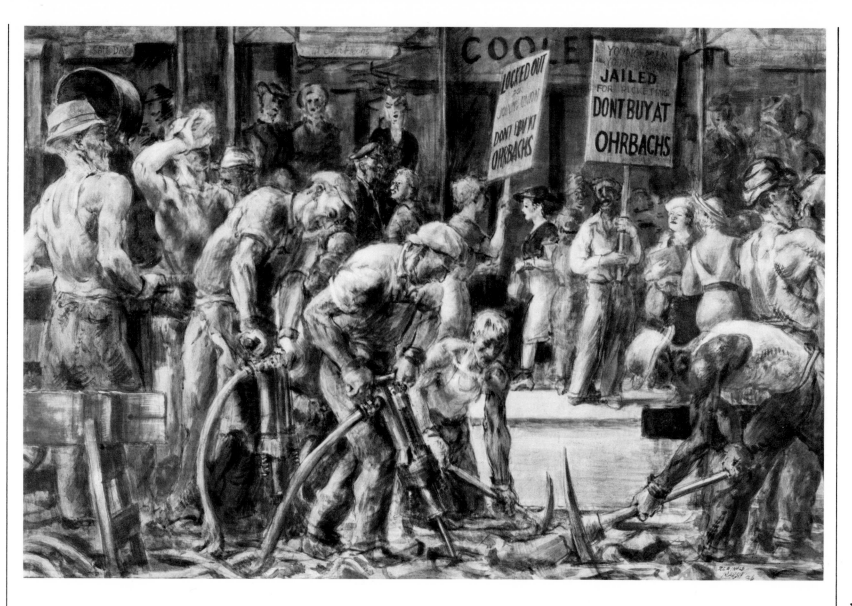

81. Reginald Marsh, *End of the Fourteenth Street Crosstown Line*, 1936. Oil and tempera, 24 x 36 inches. Courtesy Pennsylvania Academy of the Fine Arts, Philadelphia.

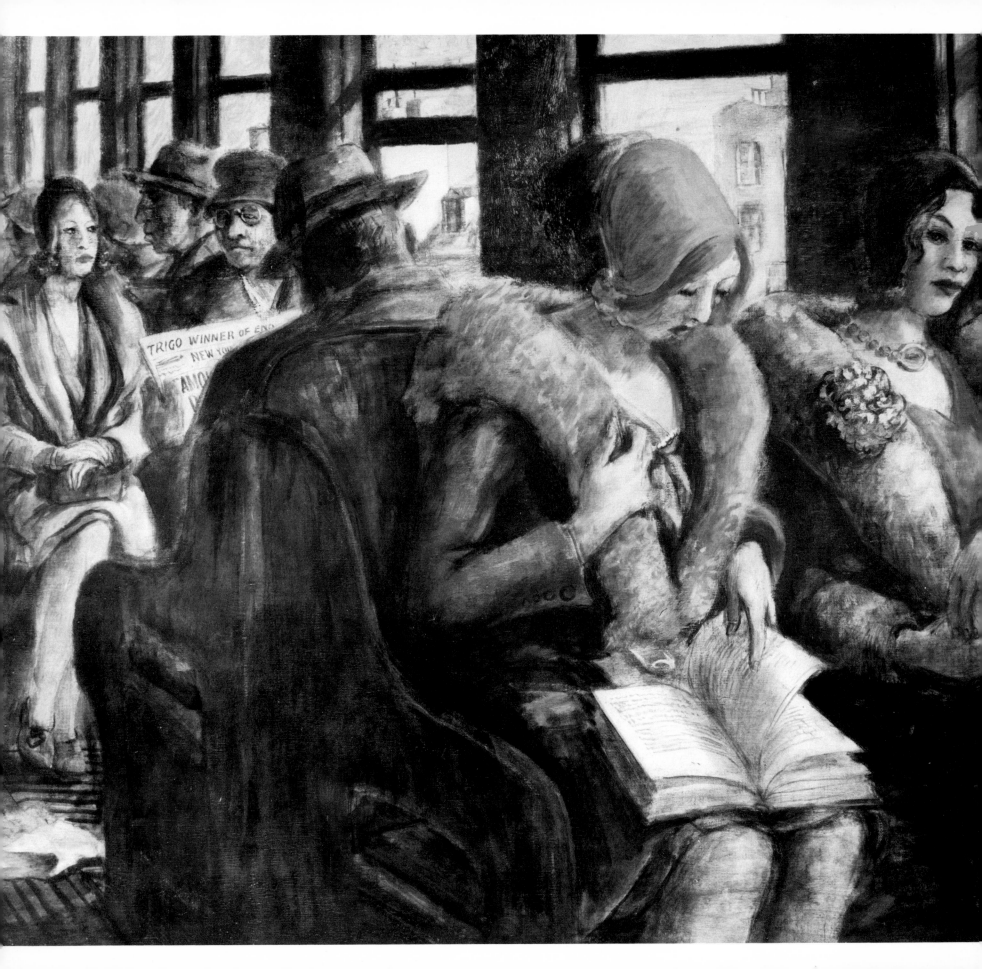

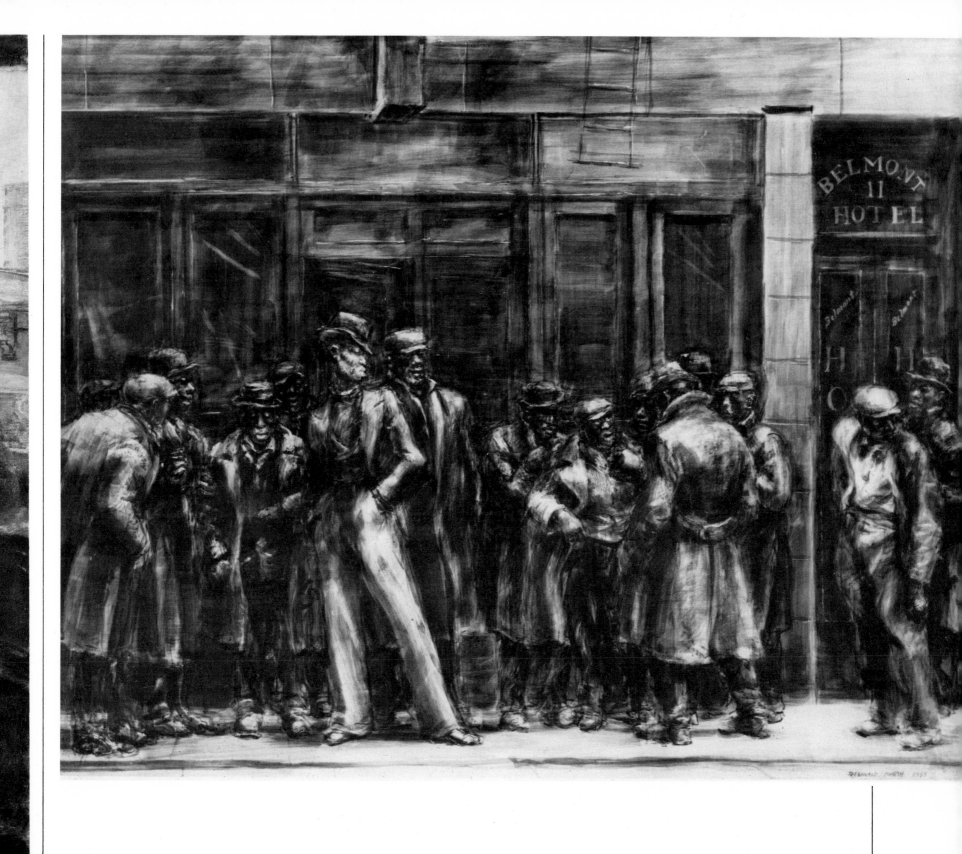

82. Reginald Marsh, *El Riders*, ca. 1930. Tempera, 30 x 40 inches. Collection Mrs. Reginald Marsh.

83. Reginald Marsh, *Belmont Hotel*, 1933. Tempera, 36 x 48 inches. Collection Mr. and Mrs. John W. Callison.

85. Reginald Marsh, *New Gotham Burlesque*, 1931. Tempera, 30 x 36 inches. Courtesy Frank Rehn Galleries, New York.

84. Reginald Marsh, *Human Pool Tables*, 1938. Tempera, 29¾ x 40 inches. Collection Whitney Museum of American Art; Gift of Mrs. Reginald Marsh and William Benton.

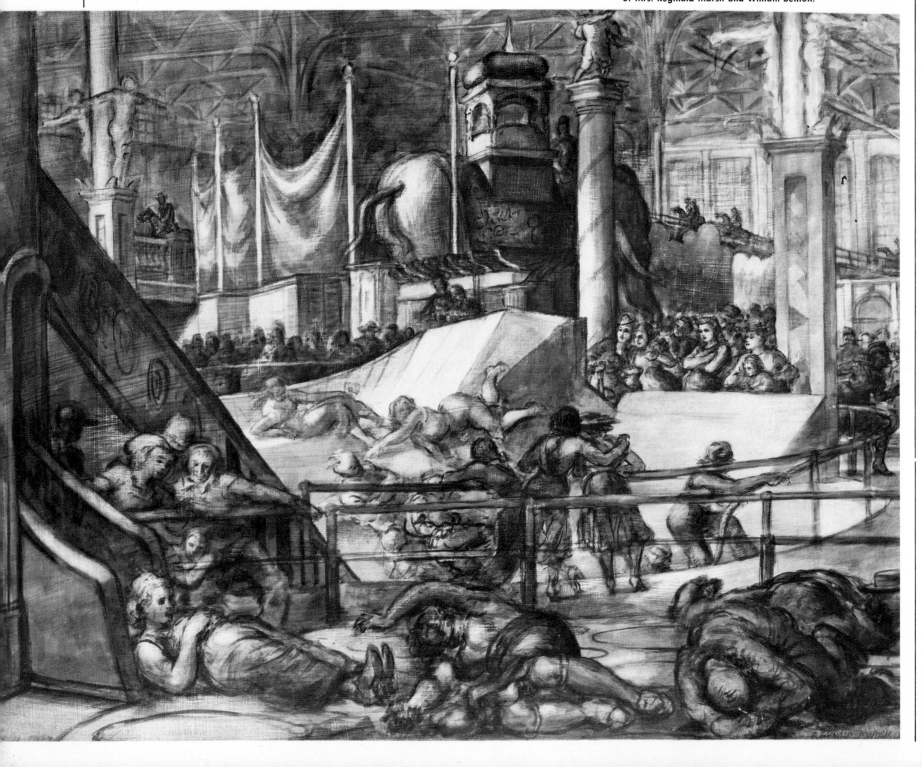

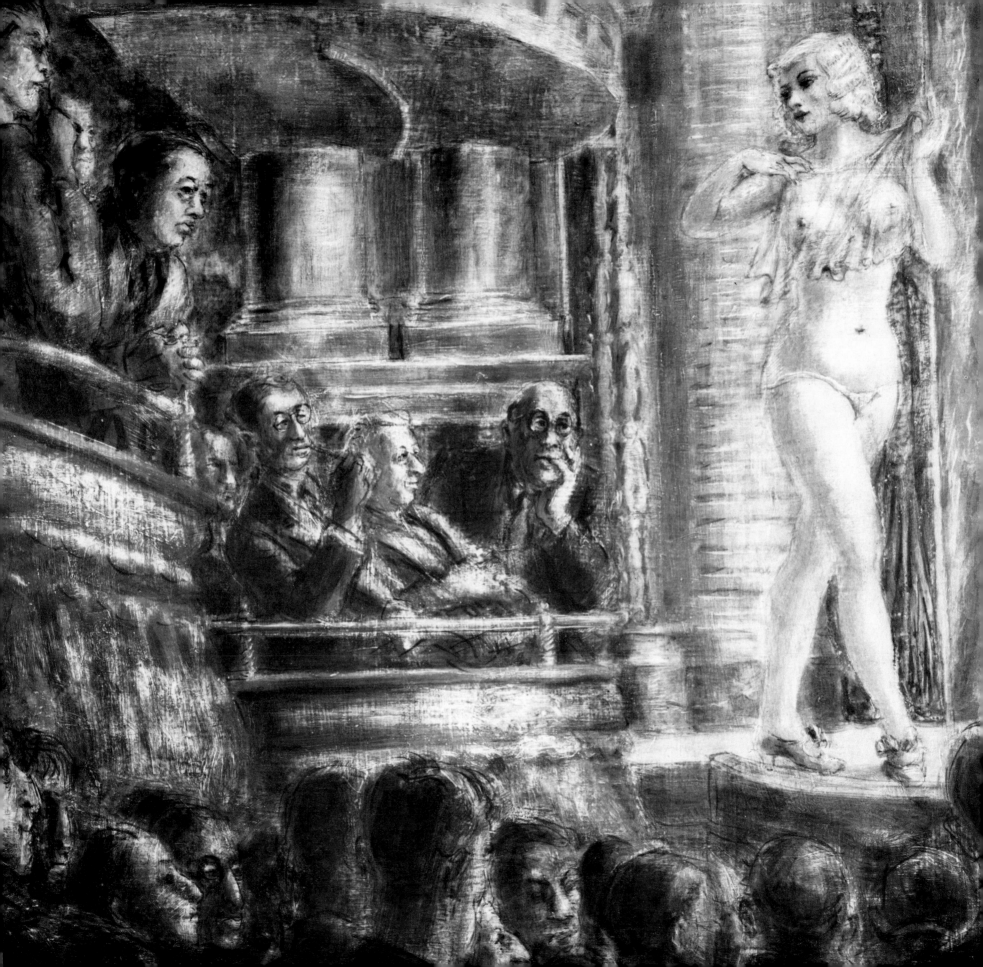

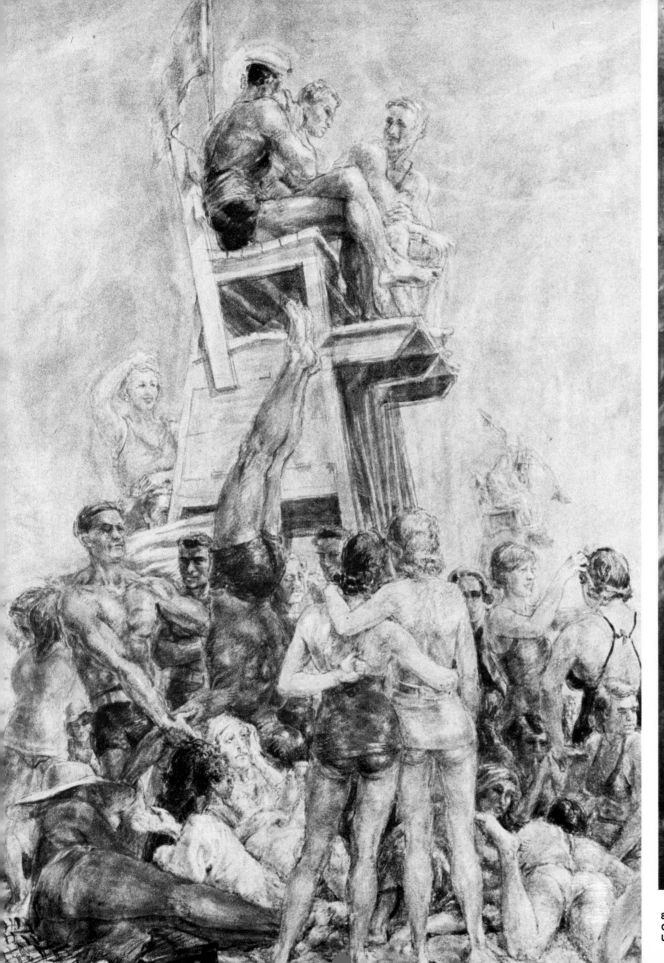

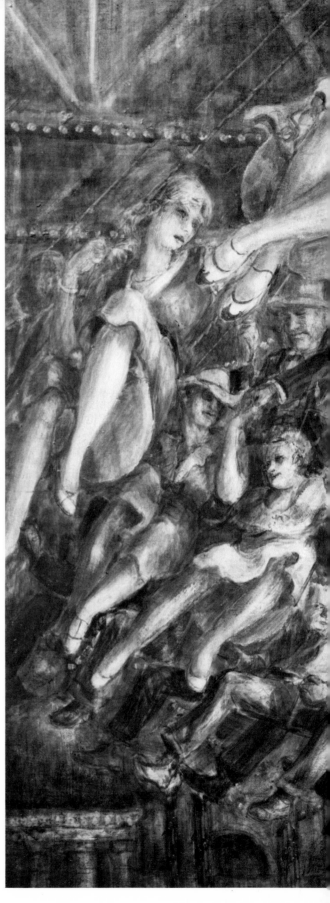

86. Reginald Marsh, *Lifeguards*, 1933. Tempera, 36 x 24 inches. Georgia Museum of Art, The University of Georgia, Athens; University Purchase, 1948.

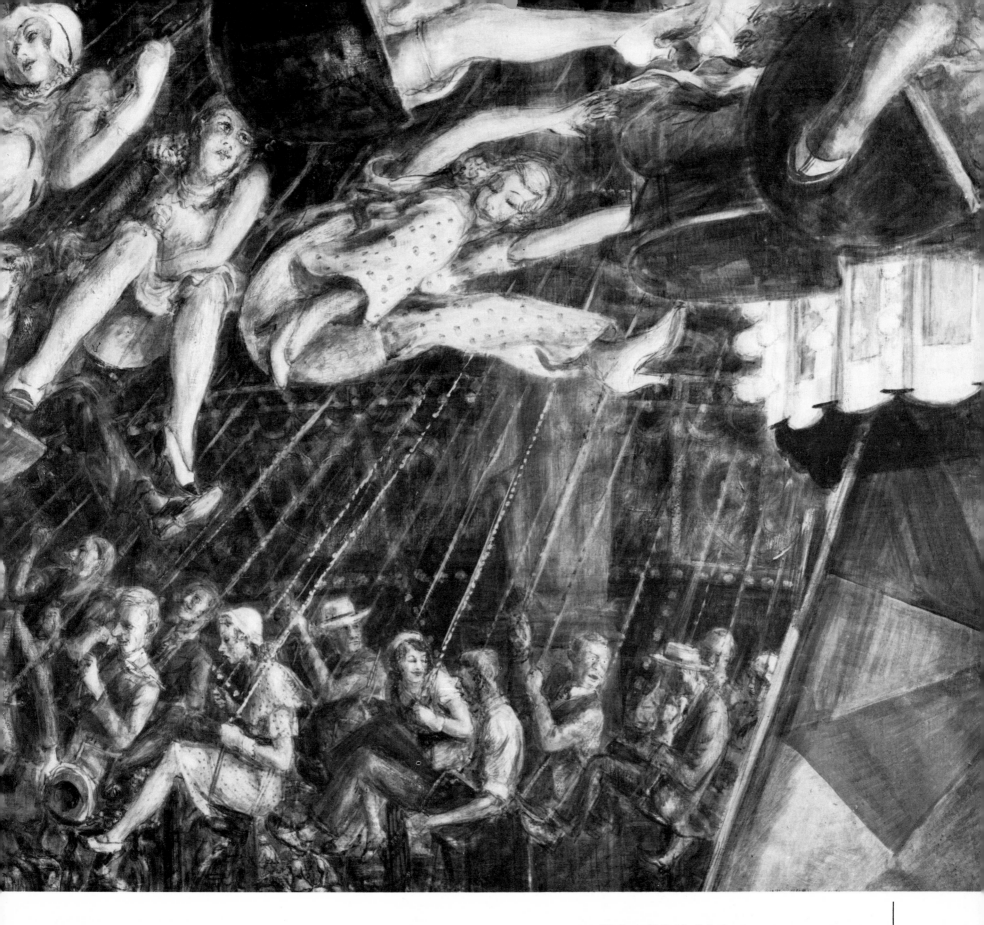

87. Reginald Marsh, *Swinging Carousel*, 1931. Tempera, 36 x 60 inches. Collection Mrs. Reginald Marsh.

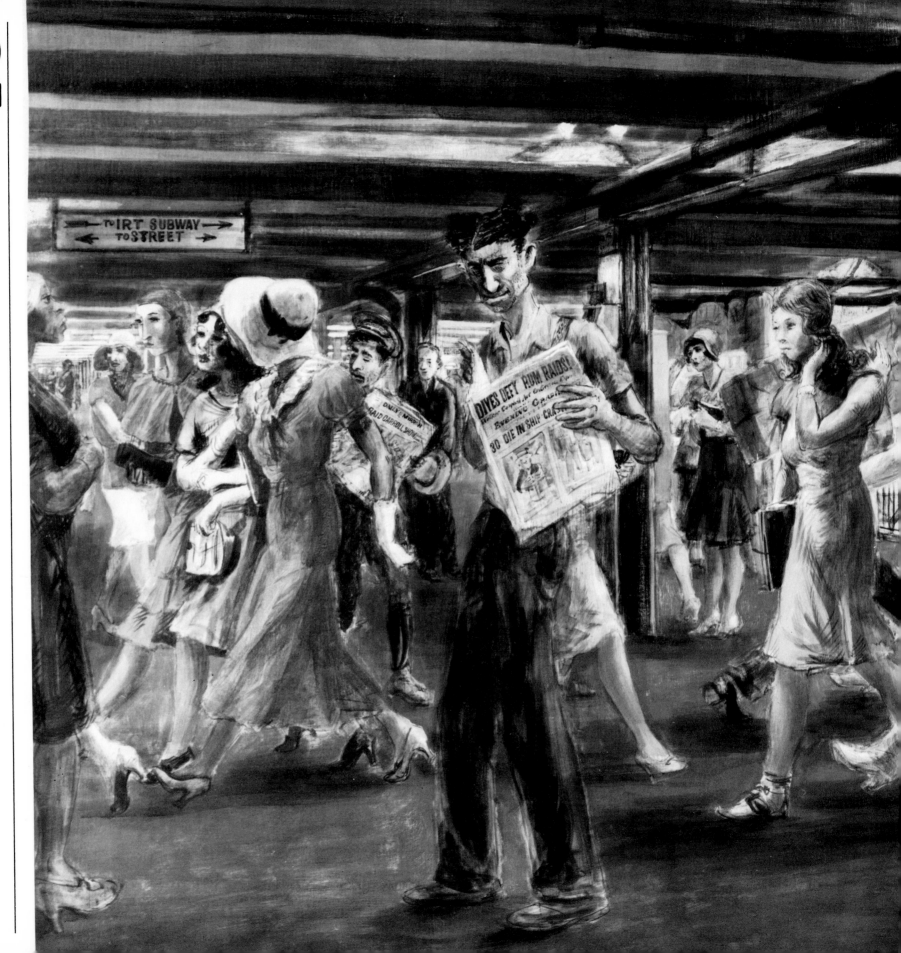

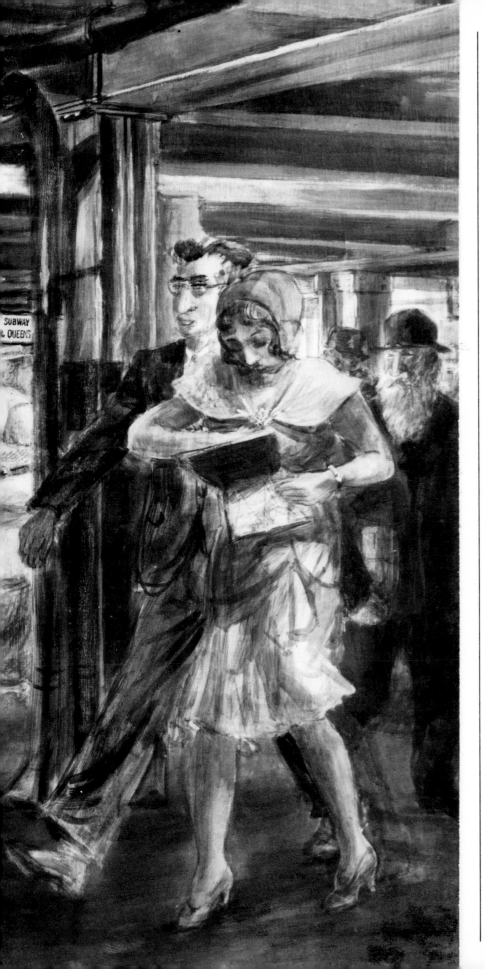

88. Reginald Marsh, *Subway Station*, 1930. Tempera, 36 x 48 inches. Collection Mr. and Mrs. Louis D. Cohen.

2 THE ARTISTS

Colorplate 17. Reginald Marsh, *Monday Night at the Metropolitan*, 1936. Oil and tempera, 40 x 30 inches. The C. Leonard Pfeiffer Collection of American Art, The University of Arizona, Tucson.

89. Reginald Marsh, *Transfer of Mail from Liner to Tugboat*, 1936. Fresco, 84 x 161 inches. U.S. Postal Service Headquarters Art Collection, Washington, D.C. (Section of Painting and Sculpture.)

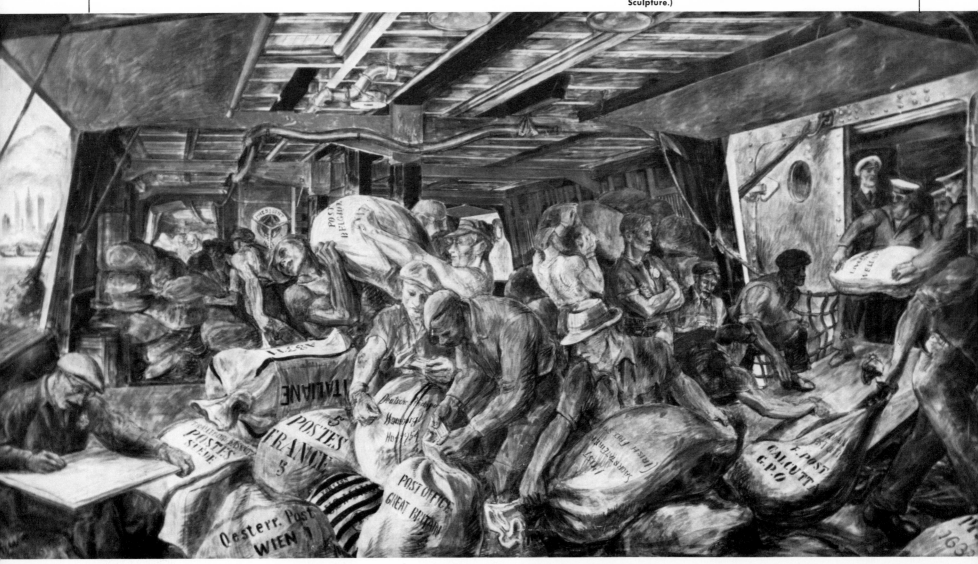

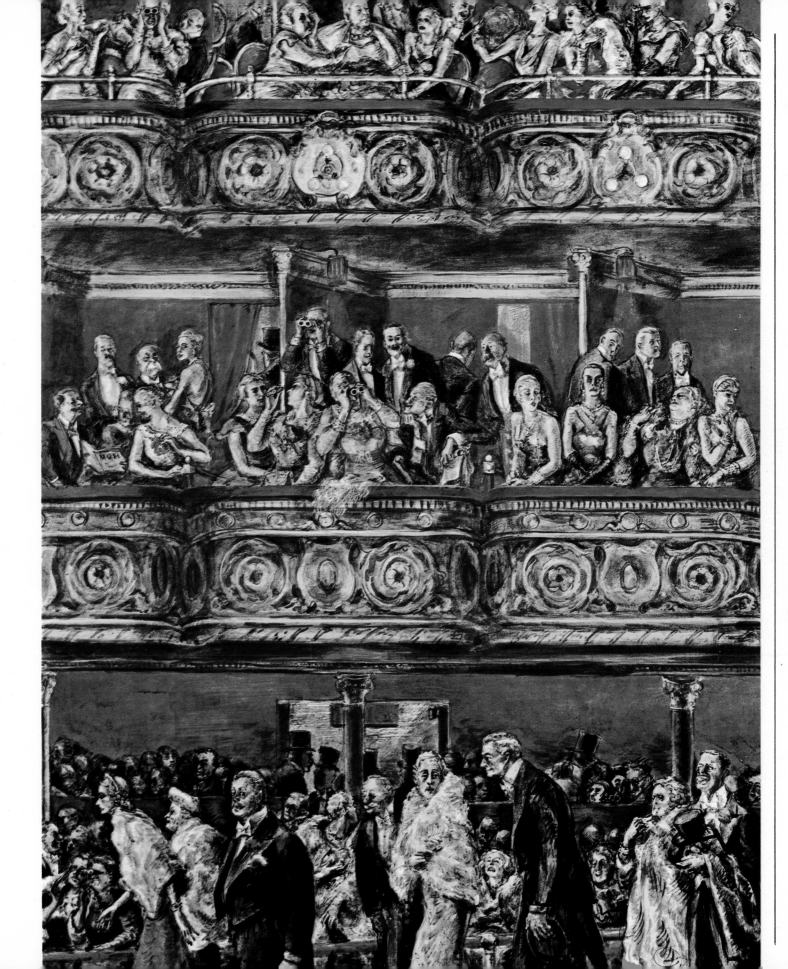

Colorplate 18. Stuart Davis, *Waterfront*, 1935. Oil, 20 x 30 inches. Museum of Art, University of Oklahoma, Norman.

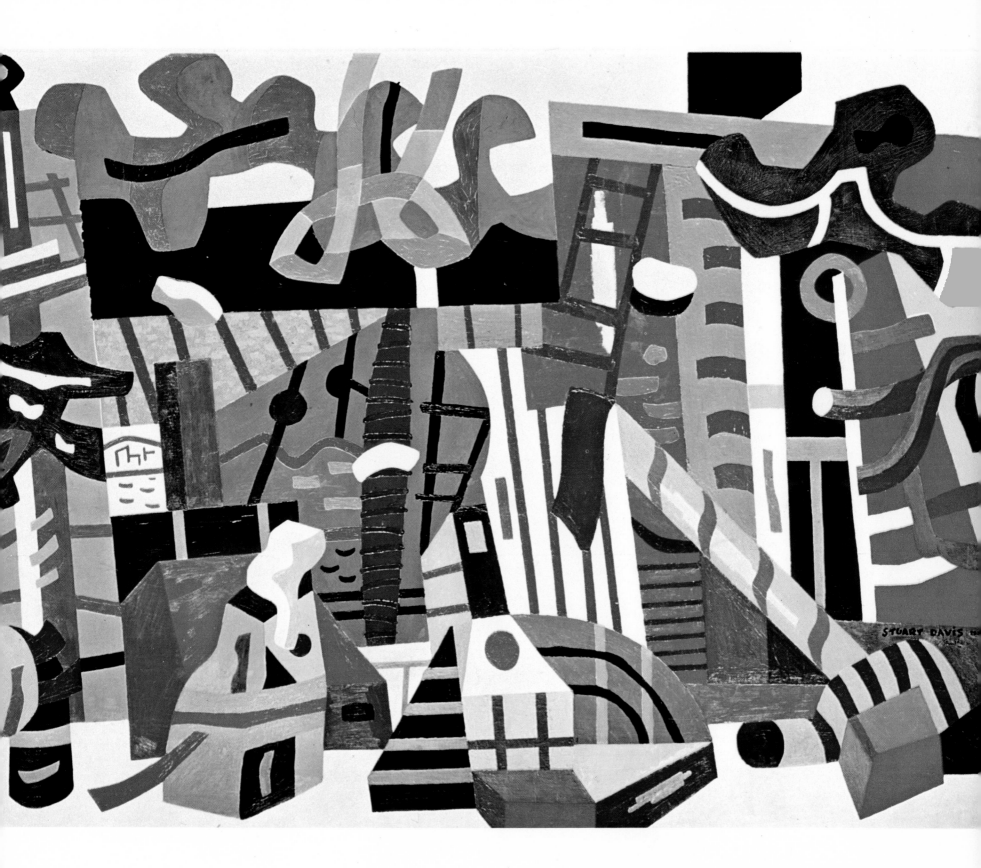

Colorplate 19. Stuart Davis, *Swing Landscape*, 1938. Oil,
85½ x 173½ inches. Courtesy Indiana University Art Museum,
Bloomington.

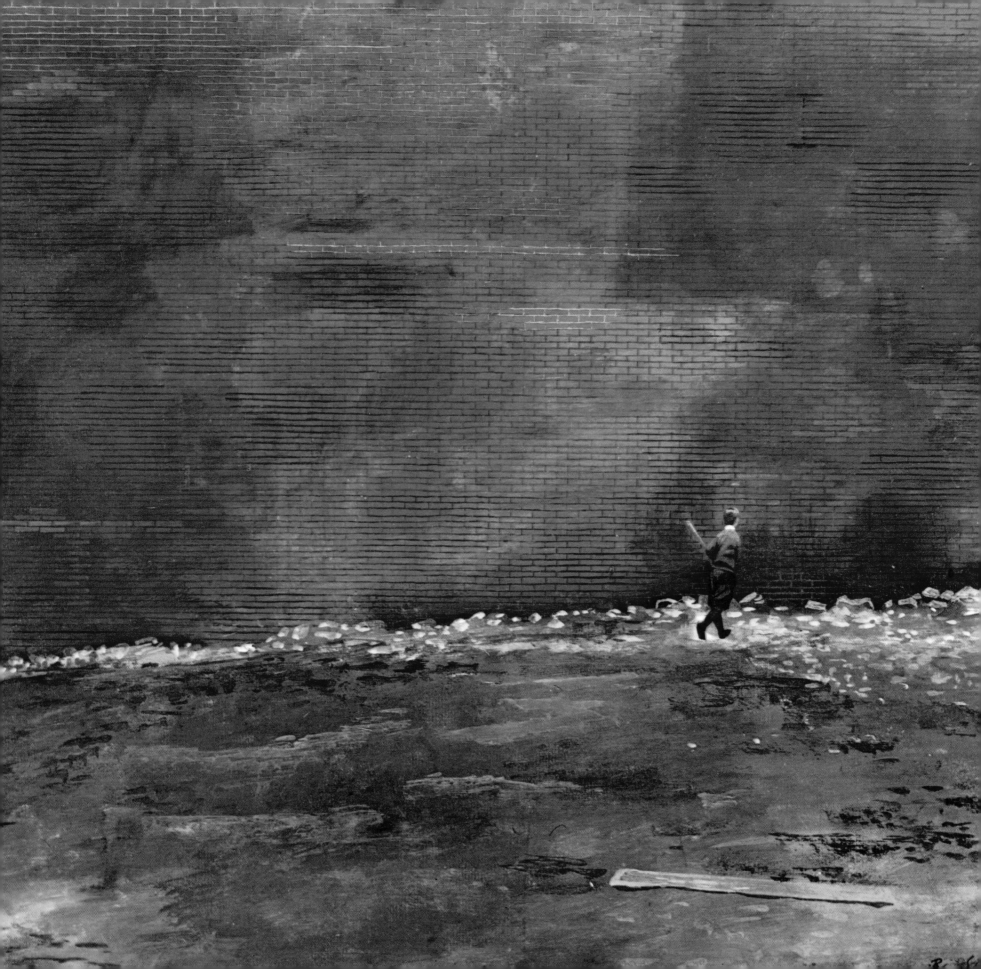

STUART DAVIS

Artists who followed the School of Paris during the 1930's were not usually associated with the American Scene movement. They were not motivated by environmental or representational concerns, and they omitted from their work references to the American landscape, to the Depression, and to personal anecdote. Yet, the American Scene was so pervasive that its attitudes entered the thinking of abstractionists and their public. For instance, the author of a book on modern art in Chicago of the 1930's stated that the city's modernists reflected aspects of the environment in their art (*Ill. 90*). He described these artists in terms that Craven might have used—as "part of the voice" and "part of the spirit of Chicago."[1] Even George L. K. Morris, a passionate defender of abstract art at the time and a founder of the American Abstract Artists (AAA) in 1936, was not immune to the rhetoric of the American Scene. Reviewing a show by members of the AAA in 1936, he observed that the "exhibition-walls [resounded] with a native clarity and color sense that speaks strongly of America."[2] In remarks such as these, he suggested, as did Benton and Craven, that certain stylistic traits could be associated with American art and perhaps with the American character. Moreover, at the root of his comment lay the belief that it was possible to create an art having certain features that were typically American.

Not all American painters of the 1930's were completely representational or completely abstract, and certain artists sought a middleground between the two extremes. The most interesting of these was Stuart Davis. His paintings were not so imitative of the School of Paris that they lost their distinctive personality, nor so American that they became provincial.

Davis had been a student of Robert Henri between 1910 and 1913, and during this time he had painted the urban American scene. After the Armory show of 1913, which profoundly affected him, he began experimenting with abstract techniques; by the 1920's, he forged a style that accommodated both abstract and representational elements. He kept extensive notebooks in which he probed the nature of art and the problems internal to the art-making process. Generally, Davis held that subject matter was secondary to the internal logic of the

painting, to its forms and colors, and that a painting should not reproduce nature, but should contain a reality of its own.[3]

His visual and philosophical explorations culminated in his *Eggbeater* series of 1927–28, a group of paintings, largely nonobjective in character, which were derived from the forms of an eggbeater, an electric fan, and a rubber glove (*Ill. 91*). Davis may well have viewed these works as the climax of one phase in his artistic process. In 1928, he traveled to Europe for the first time; he subsequently described the effects of the American environment on his work, and as the 1930's began he adopted more realistic imagery. (He later wrote that "the period of greatest activity in abstract art in America was probably from about 1915 to 1927," a period that coincides with his own early interests in abstract art.)[4]

But Davis never forced the issue of representation versus abstraction or of American versus European influence. Instead, his paintings and writings reflect a constant give-and-take between the various modes of thought. For example, during his trip abroad in 1928, he realized that European art was not as impressive as he once thought. New York was a more exciting city than Paris because of "the enormous vitality of the American atmosphere."[5] Yet, a few years later, in response to a critic who considered Davis's paintings too close to European models, he suggested that an important distinction existed between the acceptance of foreign influences and the appropriation of foreign styles. He admitted the former but denied the latter, and added that he saw no reason to remain oblivious to European art.[6] Almost ten years later, he restated his position when he said that abstract art—the only valid contemprary expression in art—developed most fully in France and that if Americans were to benefit from it, they must treat it with humility. At the same time, however, he rejected a completely nonobjective art, believing that it reduced "the very real achievements of man to the level of a spiritualistic seance."[7]

When Davis wrote of his need "for the impersonal dynamics of New York City,"[8] he suggested the importance of environmental influences upon his work. Needless to say, his concept of environmental influence differed a great deal from Benton's. Davis believed that an artist derived from his society a particular sense of order, one that was relevant to pictorial organization and composition. In the modern

165

Colorplate 20. Ben Shahn, *Vacant Lot*, 1939. Watercolor and gouache, 19 x 23 inches. Wadsworth Atheneum, Hartford; The Ella Gallup Sumner and Mary Catlin Sumner Collection.

period, society had been altered by the spread of airplane and auto-mobile travel, by the development of the motion picture, and by the popularization of the telephone and the radio—all of which demanded new responses to the problems of pictorial form and space. The dynamism of the times, Davis held, required the twentieth-century artist to approach a painting with the same spirit of discovery that inaugurated the new technology. For Davis, this spirit was modified by elements he found interesting and exciting in the American environment[9] (*Colorplate 18*). Thus, Davis's environmentalism was not dependent upon historical and traditional American experiences but upon those of modern American society.

If all successful works of art were necessarily influenced by the environment, it did not follow that all works influenced by the environment were necessarily successful. Davis reasoned that we respond to an artist such as El Greco primarily because we respond to certain formal qualities inherent in his painting, and not because of our interest in sixteenth-century religious symbolism. And Davis concluded that these formal qualities were significantly more important and had more lasting effects than the topical content of a particular work. Not surprisingly, therefore, he found that most Regionalist and Social Realist paintings contained little of lasting artistic value. Such works, he thought, provided information or encouraged the viewer "to take action in some field outside Art," but they rarely led to new experiences within art itself.[10] Although he admitted that a successful work of art could refer to immediate events and could convey information, he replied that this happened all too rarely in the art of his time. The validity of a work of art did not depend upon its ideological content, he held, but upon its basic artistic value.

By committing himself to an apolitical art, Davis transcended many polemical battles of his day. With an attitude of "a pox on all your houses," he condemned, as steps toward artistic Fascism, isolationism, the demands of left-wing artists and critics for collective action, and the totally subjective work of nonobjective artists.[11]

Such an Olympian outlook did not prevent Davis from participating in the everyday struggles that dominated the art world of the 1930's. In fact, few artists worked so wholeheartedly, or gave of their energies so willingly, to defend and to improve the position of the artist during the Depression. Davis helped to organize the American Artists Congress in 1936 and acted as its executive secretary and national chairman. An intense supporter of the government projects, he considered the initiation of the Federal Arts Project "the birth of American art," because for the first time support for the arts had been provided on a scale appropriate to the potential development of American art.[12] In 1940, after the American Artists Congress defended the Hitler-Stalin Pact and the Russian attack on Finland, he resigned from the organization.[13] Although disillusioned, he never abandoned his concern for democratic enlightenment in the art world, believing in a system of open patronage, available to all who could qualify.

As one can well imagine, Davis's work never suggested political themes and never lauded the American land and its traditions. But he did, evidently, require an external stimulus to set in motion the complex process that ultimately resulted in a finished work. He always began a painting "with a simple impulse to make something, which is always specific, something outside myself"; this initial stimulus, "the emotional energy, so to speak, would be brought about by some external event."[14] When he executed the work, however, he did so "without regard to historical accuracy, civic pride or the name of the town or place." In the finished painting, he concentrated upon formal qualities, in the belief that "color-shape relationships [were] beautiful independently of the objects they [were] associated with."[15]

Conveniently for us, Davis created a work at the start of the 1930's that clearly illustrates the various ideas that influenced him. *House and Street* (*Ill. 93*) is a double, but not a simultaneous, view of an urban landscape. Each half can be read separately, so that the painting suggests two motion-picture stills (a device that Andy Warhol used some three decades later in his studies of soup cans, postage stamps, and movie stars) or views seen, one at a time, through the windows of a moving vehicle. Davis's use of the double scape is not, however, like the Cubist principle of multiple views; had he adopted the Cubist manner, images in the painting would have been intermingled and shown from several viewpoints simultaneously. Davis's images are, by contrast, sequential; they are progressive, linear, and easy to understand; and they are neither abstract nor interpenetrative. This use of sequential time—together with the flat, sharply cut areas of unmodulated color—seems to reflect well the "impersonal dynamics of New York City."

The great majority of his later paintings are less problematic. His landscapes contain, in seemingly random juxtaposition, barber poles, gas pumps, boats, lighting fixtures, telegraph-telephone wires, and segments of architecture. All of these elements were bent, deflected, cut in pieces or otherwise altered for the sake of pictorial organization. At times, Davis's composition was episodic, like Benton's, or constantly flowing, like Marsh's. In any case, his work suggested the unresolved flux of modern American life and society.

Toward the end of the decade, Davis allowed pictorial processes to subsume physical events, so that the abstract energies that he felt coursing through the American environment became more important than the delineation of specific objects. Although occasional works during the 1930's were quite abstract in nature, it was the mural paintings of 1938 and 1939 that seem to have been the chief vehicles for exploring the nonobjective terrain. These included *Swing Landscape* (*Colorplate 19*) and a mural designed for New York City's municipal broadcasting station. At a time when he found Regionalist and Social Realist paintings, as well as nonobjective art, increasingly distasteful—when he found these styles inimical to the foundation of a democratic art—he came perilously close to dematerializing his subject matter completely.[16] Despite the resurgence of abstract images in his work, the "feel" of it remained American. Like Benton, Davis felt the need to loosen the grip of the American environment from his work. By the early 1940's, the direction of his art had altered. Even when he returned to themes and ideas developed during the 1930's, he invariably interpreted them in a much more abstract manner.

90. George L. K. Morris. *New England Church*, 1935. Oil, 36 x 30 inches. Museum of Art, University of Oklahoma, Norman.

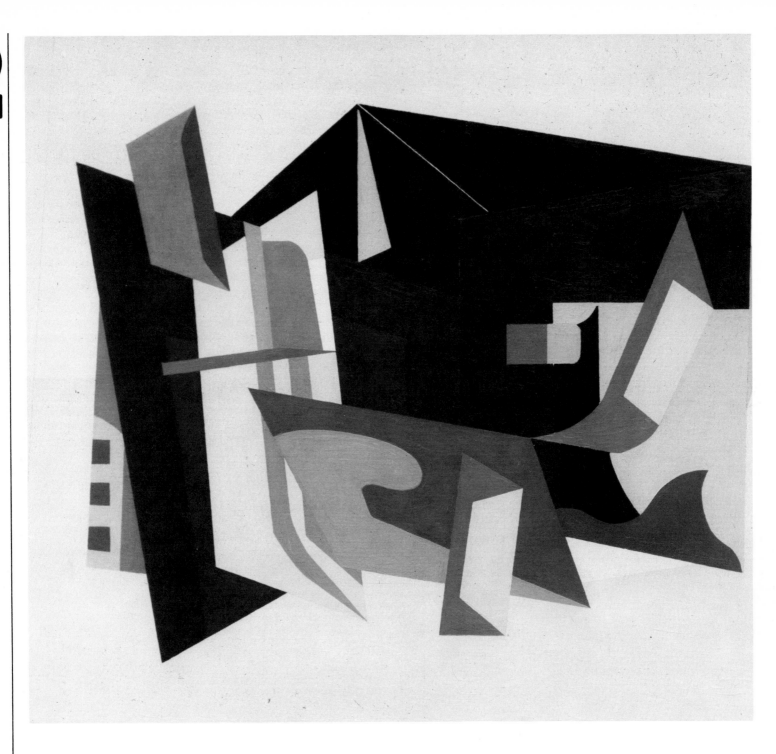

91. Stuart Davis, *Eggbeater No. 2*, 1927. Oil, 29⅛ x 36 inches.
Collection Whitney Museum of American Art, New York.

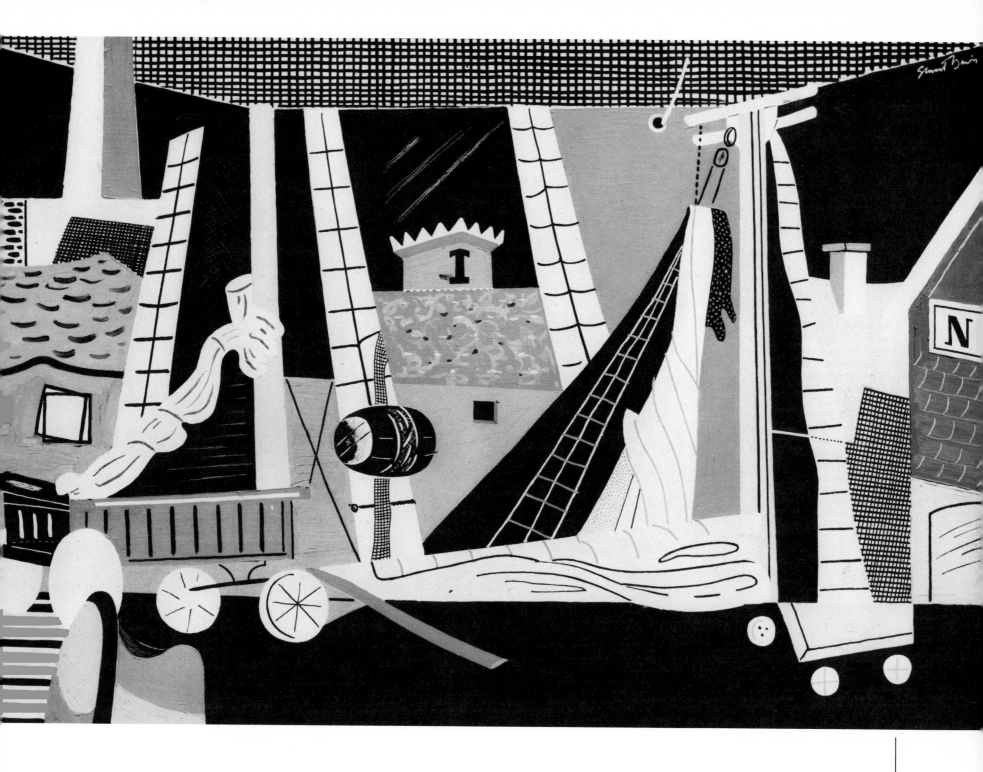

92. Stuart Davis, *Red Cart*, 1932. Oil, 32 x 50 inches. Addison Gallery of American Art, Phillips Academy, Andover, Massachusetts.

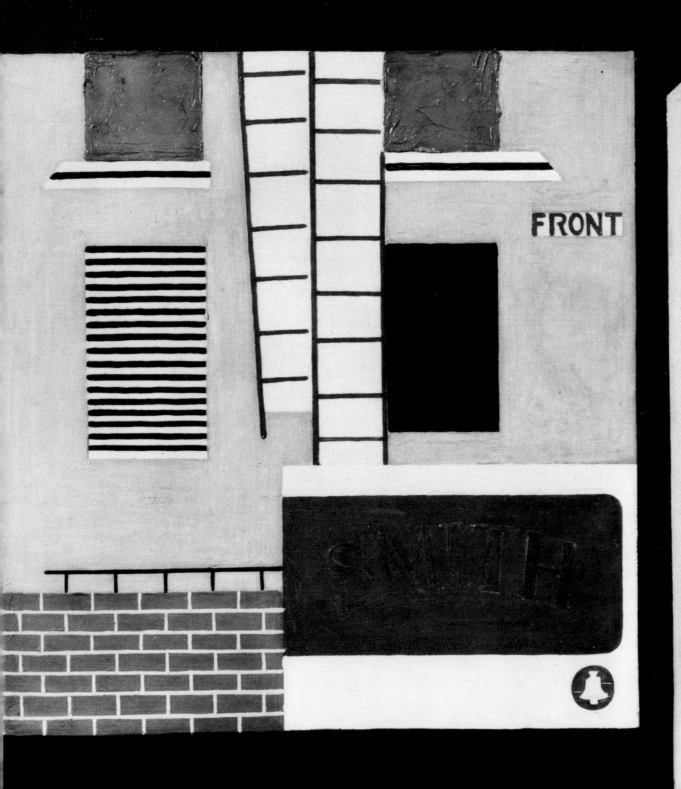
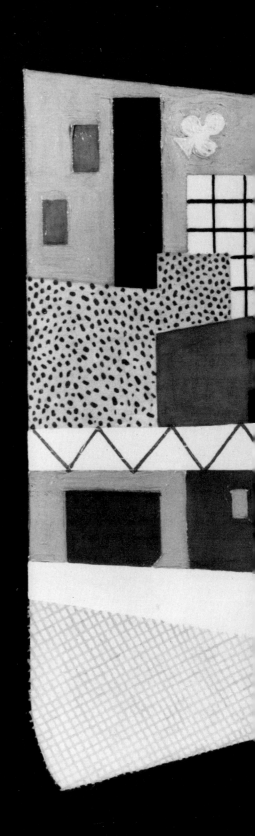

94. Stuart Davis, *Trees and El*, 1931. Oil, 25 x 32 inches. The Henry Gallery, University of Washingon, Seattle.

93. Stuart Davis, *House and Street*, 1931. Oil, 26 x 42 inches. Collection Whitney Museum of American Art, New York.

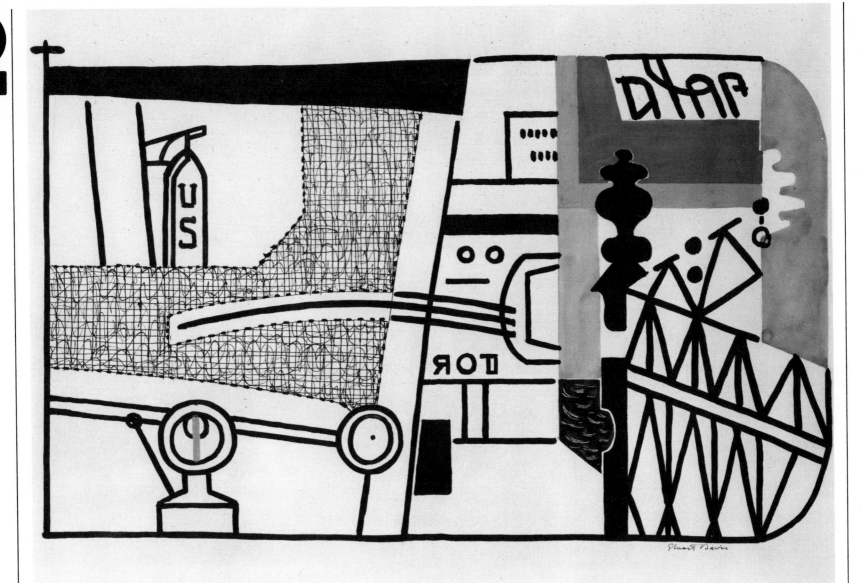

95. Stuart Davis, *Windshield Mirror*, 1932. Gouache, 15⅛ x 25 inches. Philadelphia Museum of Art; Given by Mrs. Edith Halpert, '55-61-1.

96. Stuart Davis, *New York Waterfront*, 1938. Oil, 20¼ x 22 inches. Albright-Knox Art Gallery, Buffalo, New York; Room of Contemporary Art Fund.

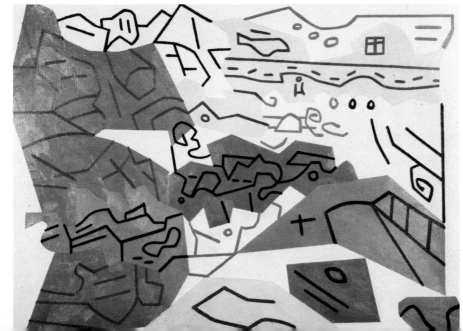

97. Stuart Davis, *Bass Rocks No. 1*, 1939. Oil, 33⅛ x 43 inches. The Roland P. Murdock Collection, Wichita Art Museum, Wichita, Kansas.

THE ARTISTS

BEN SHAHN

Artists who began to paint the American Scene around 1930 found models almost everywhere. Works by contemporaries such as Edward Hopper were readily accessible, and .an endless variety of themes, subjects, and styles could be culled from earlier American realistic painting and from the popular arts. But what models could be used by those artists who gave their art political overtones, and what guidelines could be followed to provide their art with appropriate revolutionary overtones?

One line of reasoning held that an artist had to learn to compromise between his desire as an individual to create unique forms and his responsibility to the masses for whom his art was intended. In other words, an artist had to constrain his sense of self by trying to enter into the psyche of the masses and by trying to create as if he were one of them.[1] Not an easy task at best, this notion was further complicated by the fact that, despite the abundance of rhetoric, class-consciousness and revolutionary vision were really minor aspects of the American workers movement. Since few artists knew proletarians intimately, they could not easily translate the workers' struggle into meaningful artistic statements. Reportorial melodrama usually took the place of penetrating insight.[2] Moses Soyer, for example, who grew up in a highly cultured, polylingual household, once confessed that, although he painted the American scene, he did not yet feel able to paint working-class subjects properly. Then, realizing that he should not develop his art in isolation, he made what was really an intellectual effort to bridge the gap between himself and the worker: "One would be utterly blind in these days of race hatred, depression, and the Blue Eagle," he said, "not to align himself with the class to which he feels he belongs." Philip Evergood, too, tried to identify himself with a social and economic class to which he was a stranger. Believing that an artist must experience the kind of life that he portrays, Evergood once said that "you can't just sit down at a desk and write a *Nana* unless you've lived it, by God, unless you've damn well sat in a cold basement half the night with down-and-outers and felt their suffering."[3] Nor could a revolutionary art movement root itself in an American revolutionary tradition, despite the urgings of the Popular Front, partly because such a tradition did not exist and partly because many left-wing artists were unfamiliar with American history.[4]

Since most artists had little firsthand knowledge of the working class and since they were perhaps more closely attuned to Marxist, rather than American, patterns of radical thought, where were they to turn? As one careful observer noted as late as 1935, there were no classic representations of themes of the class struggle.[5] The names of Goya and Daumier were often invoked, but primarily as examples of committed artists and not as painters whose styles shoud be emulated. Similarly, although Russian revolutionary art was of considerable interest at the time, it attracted attention for its ideological content rather than for its syle. Artists such as William Gropper and Louis Lozowick who visited the Soviet Union (in 1930 and 1935, respectively) did not return with new styles of painting.[6]

Most Social Realists were not ideologists. It is probable that most of them found humanitarian concerns more compelling than any others and that they painted with a sense of sympathy for those made victim by "the System." But the Social Realists lacked specific visual models and, in trying to combine ideological and environmental references in uncertain mixtures, they usually had to work through the problems of their art alone and without help. Ultimately, they invented entirely personal styles which, although often understandable to the masses, were also more idiosyncratic than those of the Regionalists. Left-wing artists, despite their bonds of spiritual, intellectual, and political brotherhood, were artistically very isolated.

Over the decades, Ben Shahn has been recognized as a major Social Realist of the 1930's, on the basis of the intrinsic qualities of his work and the values it projects and not because of his participation in organized activities. His work also exemplifies the various dilemmas that left-wing artists faced.

Shahn initially attracted widespread attention when his twenty-three studies entitled *The Passion of Sacco and Vanzetti (Ill. 98)* were exhibited in 1932. (Rockwell Kent was probably the first artist to commemorate the execution of the two men, which took place in 1927, with his woodcut *Echo of Sacco and Vanzetti*. Another artist of the early 1930's, A. Z. Kruse, depicted them nailed to crosses and set against the Boston skyline.)[7] At the time of the execution, Shahn was in France; he had been painting in modernist styles, and he continued

to do so after his return to this country in 1929.[8] The following summer, in 1930, he turned to a social theme almost by chance. While vacationing on Cape Cod, he agreed to exhibit some works there with Walker Evans, the photographer. Shahn then painted a number of works on the subject of the Dreyfus Case, a theme that was prompted by a small book that he had discovered.

Around this time, evidently, Shahn began to redefine what he considered to be the purposes of art, finding that his paintings of the 1920's were often restatements of the works of others. His delight in Matisse's paintings, for example, waned considerably at this time, and Shahn later described how the Frenchman's style seemed "so full of verve in Paris . . . a little illogical here. His idiom was without roots in our country and it languished like a hot house plant."[9] Although this passage was written in the 1960's, its tone reminds one of the kind of remark that Benton or Craven might have made thirty years earlier.[10] However, Shahn's frame of reference was different from that of Benton or Craven. Shahn seems to have been less concerned with rooting an art in American society than with identifying his work with his own person.[11] Consequently, the execution of Sacco and Vanzetti became more than just an American tragedy, or even a major political event, for Shahn. "Ever since I could remember," he once said, "I'd wished that I'd been lucky enough to be alive at a great time—when something big was going on, like the Crucifixion. And suddenly I realized I was. Here I was living through another crucifixion. Here was something to paint."[12] In the Sacco and Vanzetti paintings, Shahn allowed the subject matter to reflect his own beliefs and feelings, and he used the series as a means of shedding his earlier Parisian style; his paintings consequently assumed universal implications as well.

Shahn did not, however, communicate his feelings by dramatizing the event in religious or propagandistic terms, for he did not portray Sacco and Vanzetti as symbols of oppression and suffering. Rather, in a very personal way, he revealed their humanity (and his own, as well) by presenting them as two sad-faced men who seem to be suffering from some inner sense of ruin. In fact, without prior knowledge of the case, the viewer would find most of the paintings meaningless and the martyrdom of the two men a riddle. Shahn later stated that he tried "to take advantage of the spectator's existing feeling and set fire to that. . . . By presenting the two anarchists as the simple, gentle people they essentially were, I increased the conviction of those who believed them innocent."[13]

Shahn did not create stereotypical personalities, therefore, as Benton and Wood had done, nor did he construct theatrical tableaus in the manner of Curry. Instead, he concentrated on those overlooked moments that Marsh might have dashed by and missed. This concern for the intimate response within the context of larger issues characterized much of Shahn's work through the 1930's. It also typifies the kind of painting that still has meaning today, decades after the sectarian appeal of Social Realism has passed. This branch of the American Scene (more in its easel paintings than in its murals) based its motifs on people's activities rather than on traditions or stock situations. The subject matter of these painters had nothing to do with American mythology: indeed, they had no mythology at all.

But a personal approach has its hazards as well as its strengths. Shahn's studies of the Tom Mooney case (1932–33), which are similar in format to *The Passion of Sacco and Vanzetti,* have such randomly chosen subject matter that one learns nothing of Mooney's "crime" and nothing of the circumstances surrounding it. Courtroom scenes are mixed with family scenes, and the events are given no intelligible context. Nevertheless, critics of the time were delighted to find an artist who located his subject matter in contemporary events. Even Malcolm Vaughan, a critic favoring Regionalism, felt that if other artists would follow Shahn, "painting might come to mirror in America—as it reflected in Renaissance Italy—the rhythm of our day, perhaps even clarify the bewilderment in our manifold modern activities."[14]

These comments are, of course, part of the hyperbole of the American Renaissance. Vaughan's feelings about the mural designs that Shahn and Lou Block prepared in 1934 (*Ill. 99*) are unknown, but he would no doubt have praised them for their clarification of the need for prison reform. The set, intended for New York's Riker's Island Penitentiary, was rejected, but it is important nevertheless.[15] Compared with the earlier Sacco and Vanzetti and Tom Mooney series, this set has a specific theme and a unified point of view. The panels contrast modern, humanitarian attitudes toward prison reform and the rehabilitation of prisoners with old, traditional methods of punish-

ment and their appalling consequences. The studies do not contain abstract figures of Justice and Charity, nor do they record prison activities in mindless kaleidoscopic fashion. Instead, they offer a program of renewal and reform. An investigative kind of American Scene painting, in which the artists' views are clearly stated, the panels reflect the harsh criticism which Social Realists often leveled against American institutions.

Possibly, Lou Block suggested the thematic development of the set. Possibly, Shahn, who began to work in photography at this time, learned to focus more clearly on his subject matter in both a thematic and visual way. And possibly the influence of the Mexican mural painters, and of Diego Rivera in particular, was now felt by Shahn. In 1933, Shahn worked with Rivera on the latter's ill-fated fresco *Man at the Crossroads,* which was intended for Rockefeller Center in New York, but destroyed when Rivera would not remove Lenin's portrait from it (*Ill. 12*). The themes of both projects are similar in that both suggest choices between old and new or good and bad modes of existence. (In Rivera's fresco, man was offered a choice between two conflicting ways of life—fascism and capitalism versus Communism and freedom.)[16] But Rivera's influence should not be emphasized too strongly, because Orozco employed similar themes of choice, particularly in his frescos on the third floor of the National Preparatory School (*ca.* 1926), and because the compositional arrangements of the Riker's Island studies are closer to Orozco's work than to Rivera's.

There is no ambivalence about the theme of Shahn's mural for the community center of Roosevelt (formerly Jersey Homesteads), New Jersey, painted in 1937–38 (*Ill. 100*). The most satisfying Social Realist mural of the 1930's, it depicts Jewish refugees who achieve a happier life in the United States through trade unionism and through government resettlement programs. Each part of the mural adds a special meaning to the whole: from the groups of immigrants leaving the Ellis Island debarkation station (after passing the corpses of Sacco and Vanzetti), to the crowded conditions of the sweatshops in which the immigrants worked, to their subsequent political enlightenment and education under union auspices, and finally to the realization of a healthful life in semirural surroundings. Like Philip Evergood's *Story of Richmond Hill* (*Ill. 23*) of 1936–37, Shahn's mural reflected the American Dream rather than the American Scene. Where Benton might have shown the growth of social and cultural patterns, whatever they might be, Shahn and Evergood outlined specific kinds of social progress.

Between the Riker's Island studies and the Roosevelt mural, Shahn created some of his most "political" paintings. One of them depicted a soap-box orator protesting the bosses' usurpation of the workers' rights to satisfy their own needs (*Ill. 101*). In part a product of New York City's political ambience, these works also developed out of Shahn's direct observations of poverty and oppression in the South and in the Middle West. In 1935, after joining the Painting Section of Special Skills of the Resettlement Administration, he traveled through the heartland for the first time to photograph the activities of that organization. He returned with a number of brilliant photographic documents and with ideas for many paintings on related themes.

His travels also served another purpose, since they brought him in contact with many different types of people. Like Benton, Shahn found that all-encompassing theories explained very little about America, about the behavior of its people, or about their possibilities of future social action. However, unlike Benton, Shahn did not try to develop an all-encompassing American style. Rather, he began to stress the importance of his personal view of art, becoming increasingly reluctant to reconcile his social view of art with his own interior vision.[17] Consequently, in place of "working-class" messages, he began to emphasize personal interpretation and invention, but always within understandable limits.[18] A painting such as *Vacant Lot* (*Colorplate 20*) was not a comment on life in a ghetto community as much as it was a symbol to Shahn of his own loneliness and his own feeling of imprisonment as a child.[19]

No wonder, then, that his two late mural commissions (*Ills. 38, 105*) lack the passionate commitment of the Roosevelt mural. In 1938–39, Shahn designed thirteen panels for the Bronx Central Annex Post Office in New York "to show the people of the Bronx something about America outside of New York."[20] In 1940–42 his murals for the Social Security Administration Building (now the Department of Health, Education, and Welfare) in Washington, D.C., portrayed the benefits of social security to the young, the disabled, the dispossessed, the old, and the poor. What Shahn had lost in political

commitment was more than compensated by the gains in the intensity of his personal vision. Of all the artists associated with either Regionalism or Social Realism, Shahn made the transition to the 1940's most successfully.

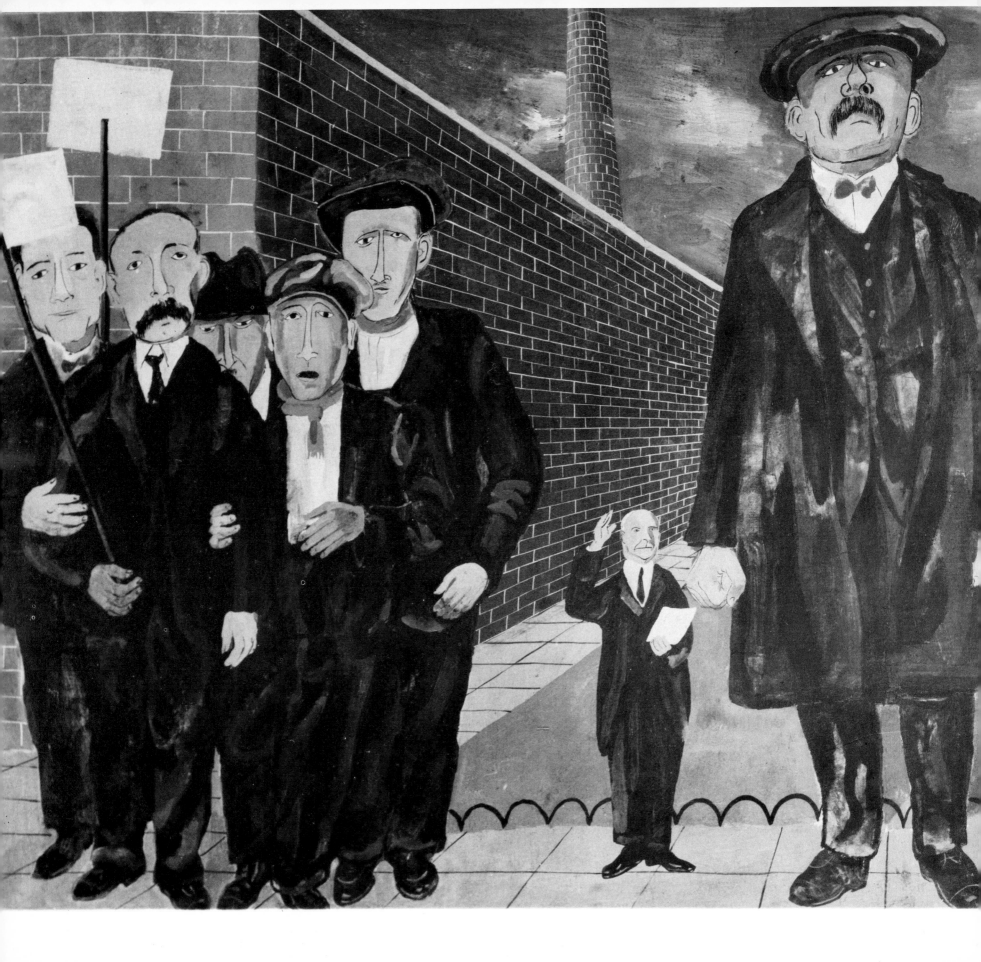

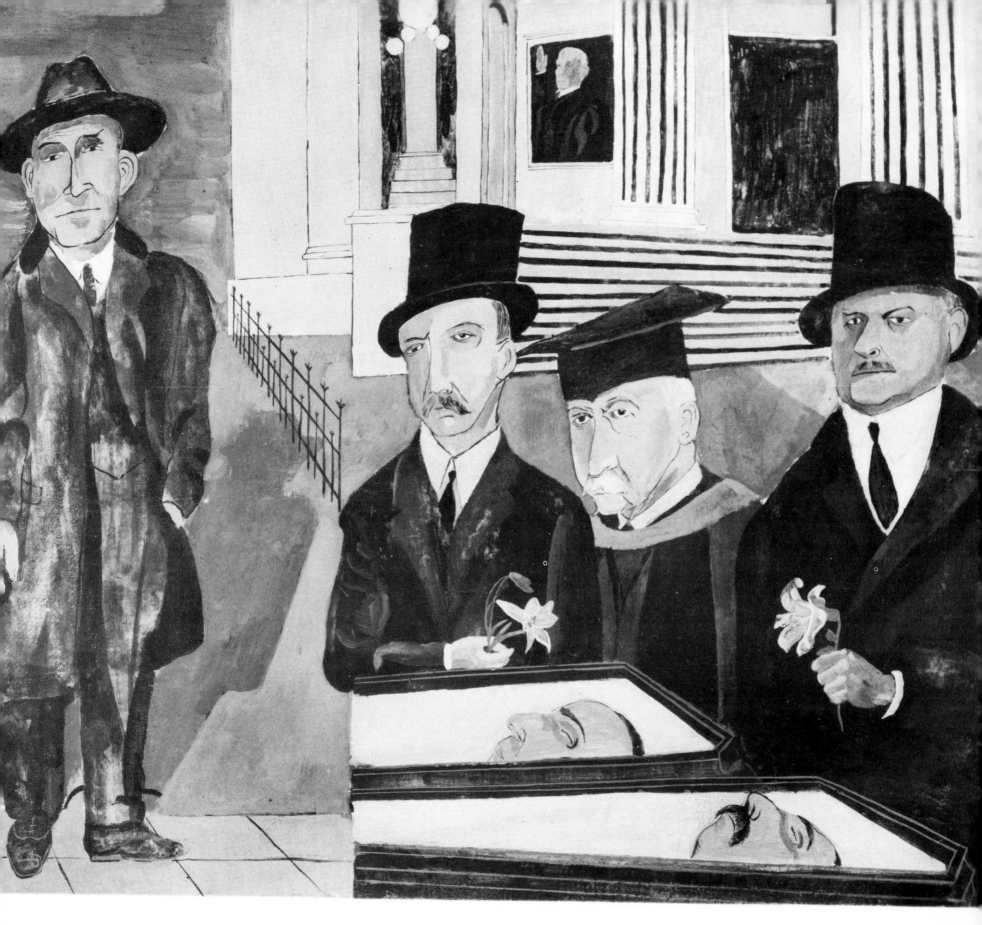

98. Ben Shahn, Sacco and Vanzetti, 1931–32. From The Passion of Sacco and Vanzetti. Tempera, 21 x 48 inches. Courtesy Kennedy Galleries, New York.

100. Ben Shahn, Mural in the Community Center, Roosevelt, New Jersey, 1937–38. Fresco, 144 x 540 inches.

99. Ben Shahn, *Prisoners Milking Cows*, 1934–35. Study for *Rikers Island*, New York. Tempera, 14 x 19½ inches. Courtesy Kennedy Galleries, New York.

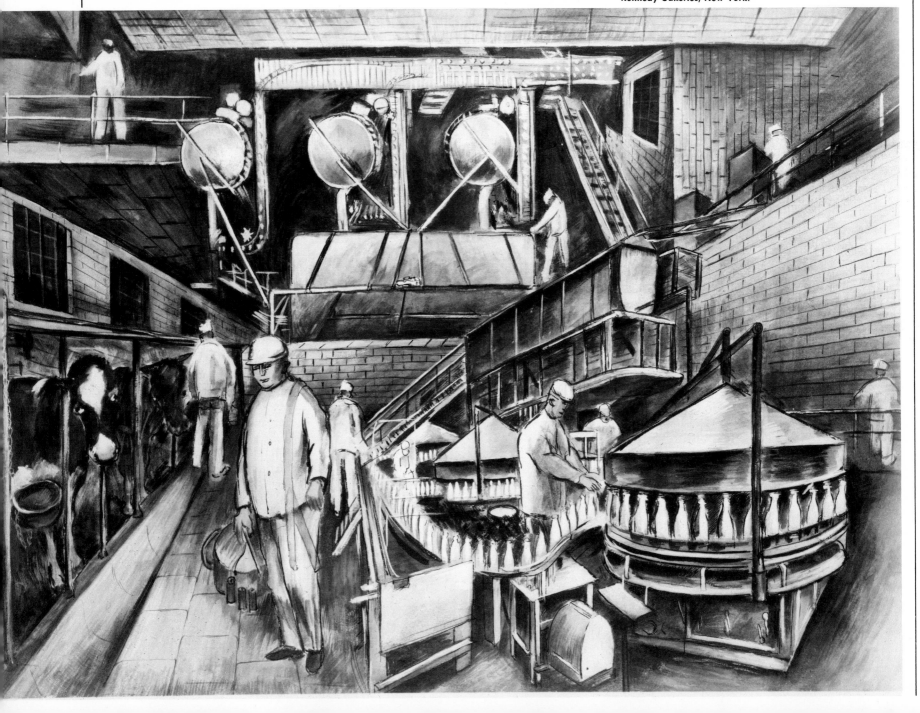

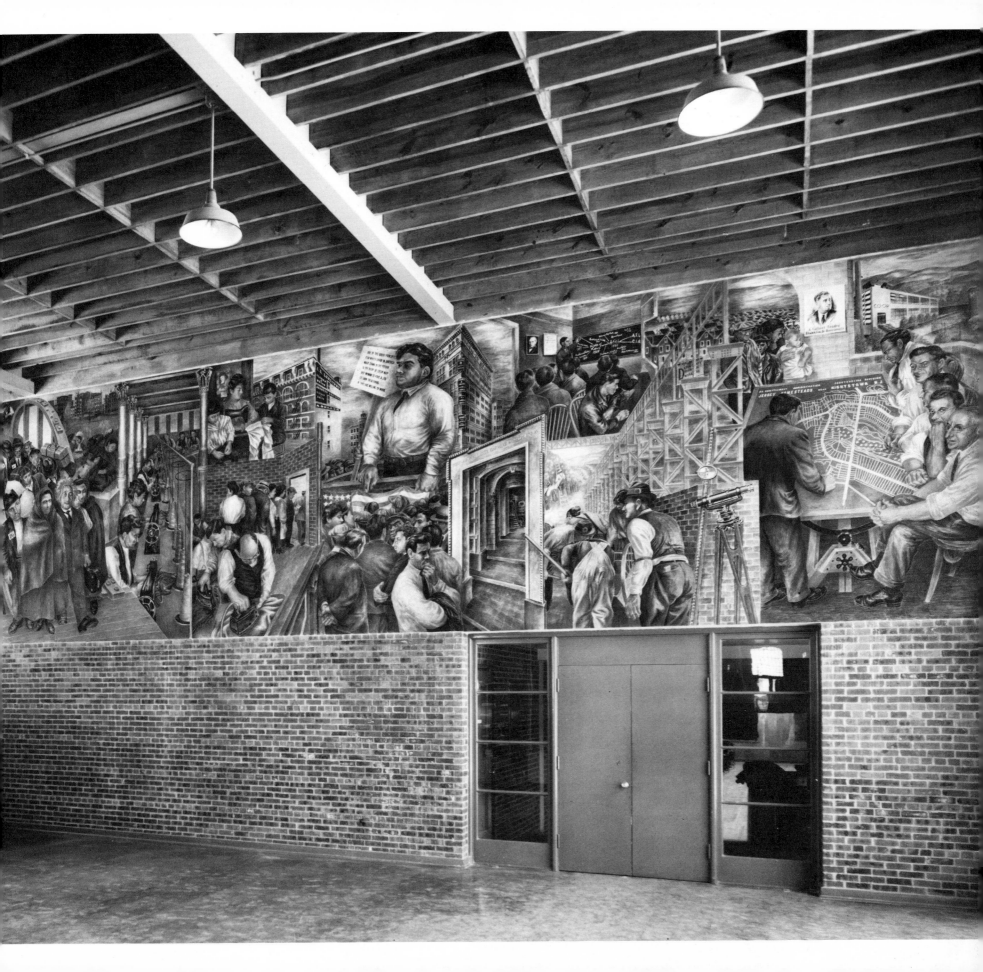

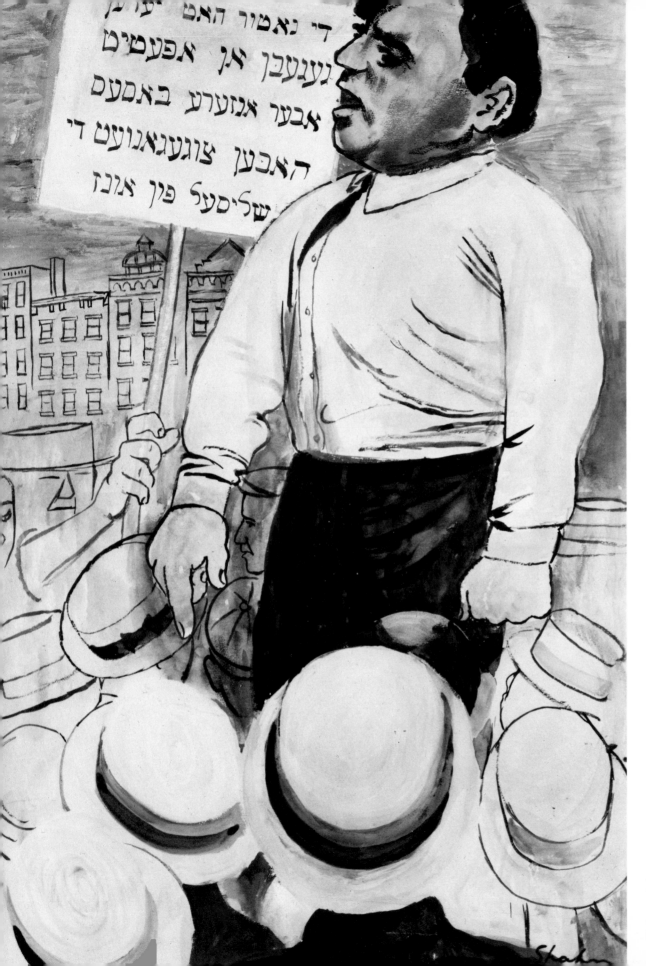

101. Ben Shahn, *East Side Soap Box*, 1936. Gouache, 18½ x 12¼ inches. Courtesy Kennedy Galleries, New York.

102. Ben Shahn, *Crowd Listening*, 1936. Tempera, 13 x 12½ inches. Courtesy Kennedy Galleries, New York.

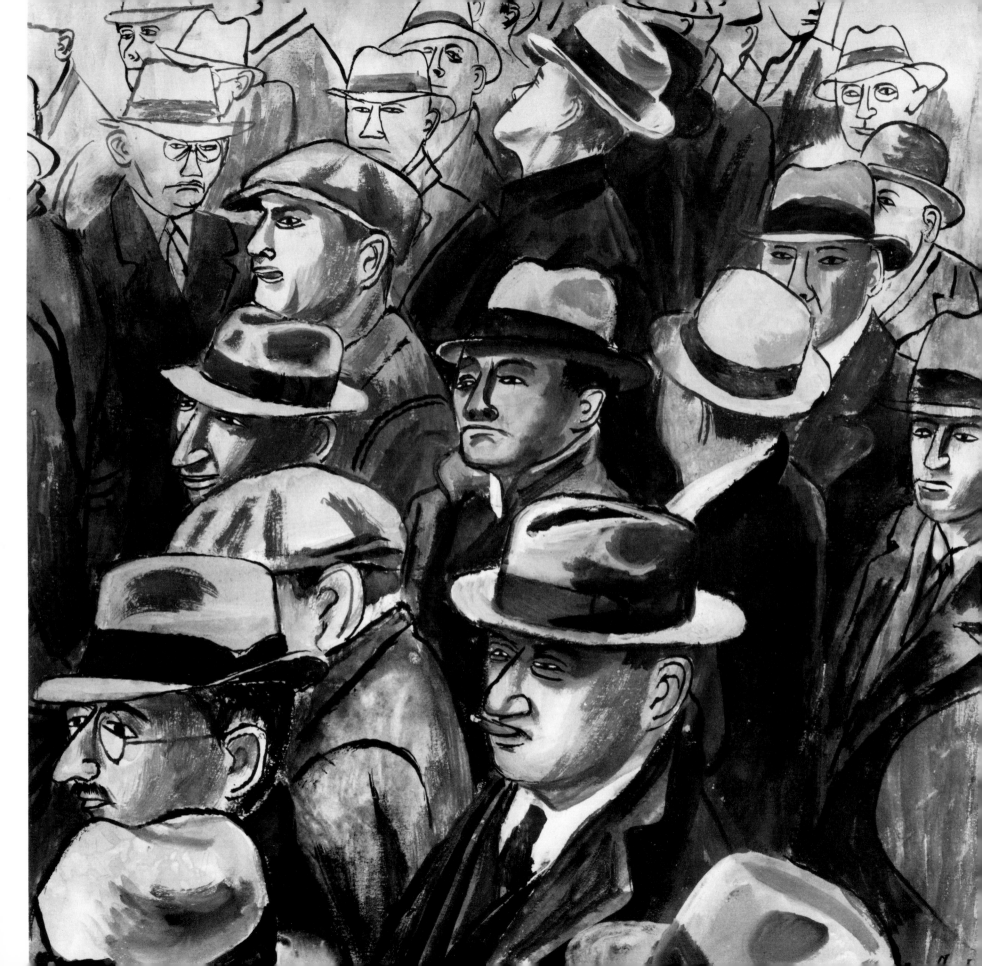

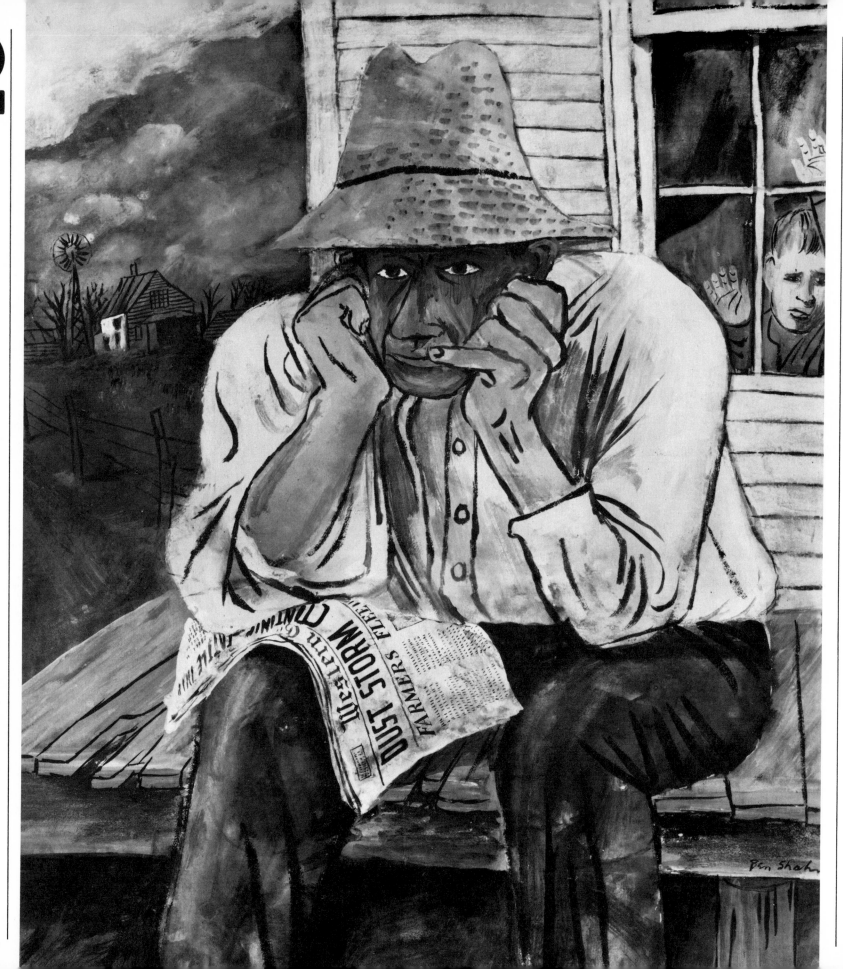

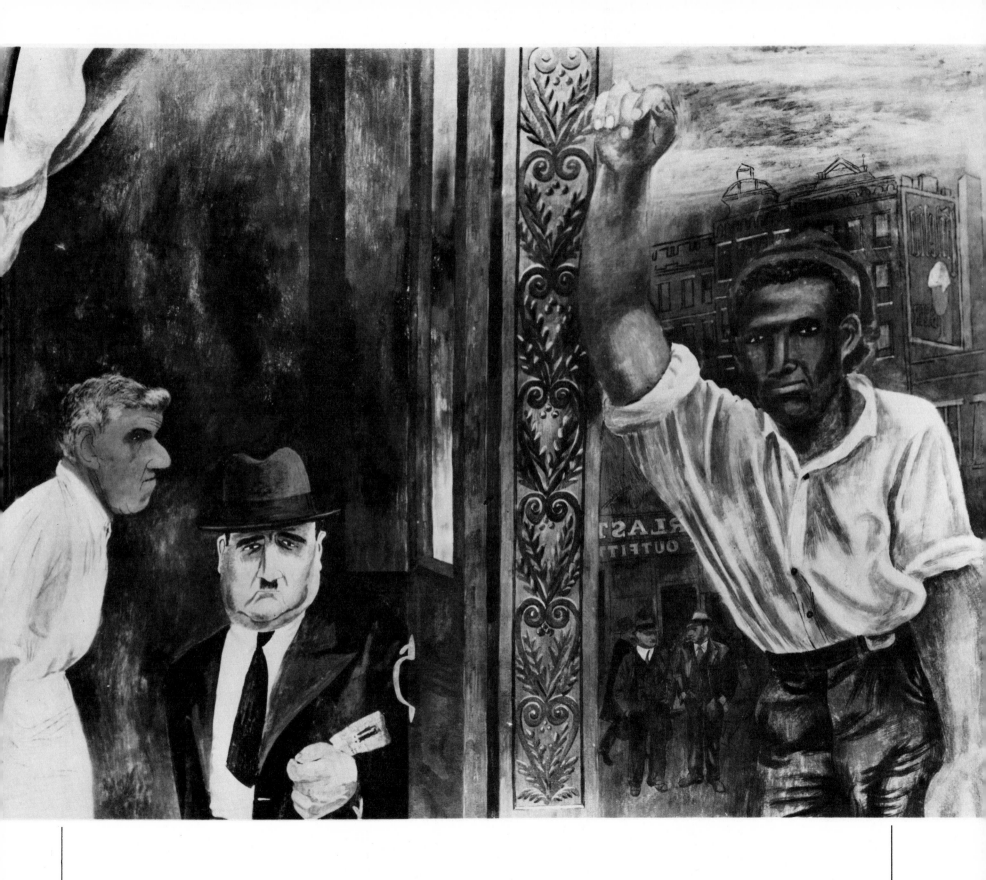

103. Ben Shahn, *Dust*, 1936. Gouache, 16½ x 13¼ inches. Courtesy Kennedy Galleries, New York.

104. Ben Shahn, *Three Men*, ca. 1936–38. Tempera, 21¼ x 30¼ inches. Courtesy Kennedy Galleries, New York.

105. Ben Shahn, *Grain Harvesting*, 1938–39. Bronx Central
Annex Post Office, Bronx, New York. (Section of Fine Arts.)
Photograph, Public Buildings Service.

PART 3

PAINTING AMERICA

3 PAINTING AMERICA

PAINTING AMERICA

One of the most interesting aspects of the American Scene movement is its relationship to American cultural and to American social history. In fact, the movement probably has as much fascination for the social historian as for the student of art. Certainly, the very need to develop and support an American Scene movement, when artists had been painting the American scene since the early nineteenth century, is in itself a phenomenon of social history. The appearance of the movement in the late 1920's clearly attests to the dilemmas of a country caught between conflicting standards of values, as rural America was on the wane and urban America on the rise.[1] The American Scene seems to have appealed to those who wanted to retain a way of life that was already slipping away or at least to those not yet ready to embrace the new.

In the 1920's, the new era was symbolized by the concept of the Machine Age to which people responded somewhat ambivalently. Although society offered a variety of goods and services never before as easily available, it also threatened older patterns of neighborliness and friendliness with the potential for mechanization and dehumanization.

Perhaps the rapid changes occurring in society prompted the need to summarize American accomplishments, to explore, define, certainly to find meaning in American culture. Who were its heroes, and what were its myths, its moods, its typical patterns, experiences, and aspirations? Knowledge of these could provide guideposts for a confused public as well as for artists who, with each painting, had to mediate between American institutions and environments and the grand traditions of European art. The Depression, which called into question the very survival of the country, added to the over-all insecurity of public and artist alike. Presumably, many artists did not consciously choose to paint the American Scene, but painted from the American scene because it was there, as it had been there for generations. The American Scene absorbed these painters, even though they did not necessarily join any movement. For some, the revival or perpetuation of old customs provided a temporary respite from the difficult problems of forging new identities. Others chose to observe the American scene either critically or amiably, while political radicals found solutions by seeking to destroy the old fabric completely. The "American way of life," a phrase that gained currency during the 1930's, became something to defend or attack, or simply to record.

Colorplate 21. Dale Nichols, *End of the Hunt*, 1934. Oil, 30¼ x 40 inches. The Metropolitan Museum of Art, New York; Arthur H. Hearn Fund, 1938. (Detail.)

Pages 190–91:

Colorplate 22. Raphael Soyer, *Transients*, 1936. Oil, 34⅛ x 37½ inches. The Michener Collection, The University of Texas at Austin.

Colorplate 23. Max Weber, *At the Mill*, 1939. Oil, 40 x 48¾ inches. The Newark Museum, Newark, New Jersey; M. Scudder Bequest.

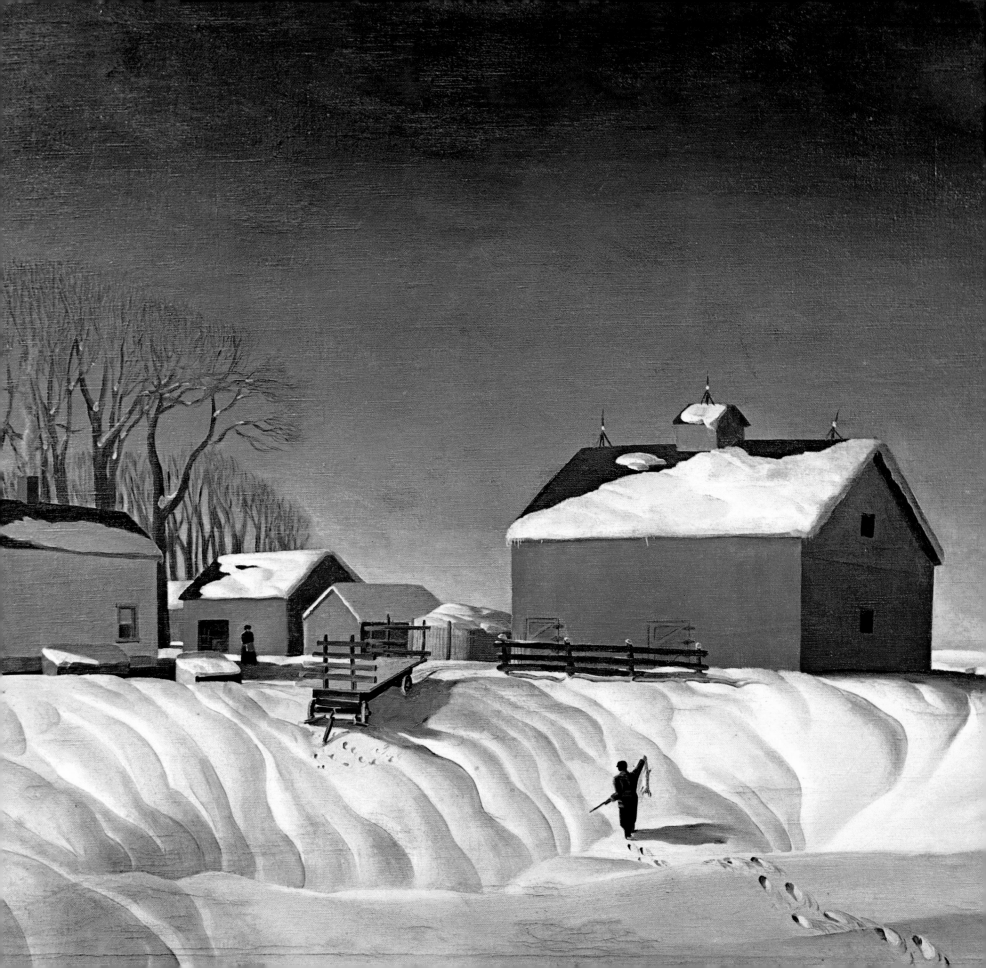

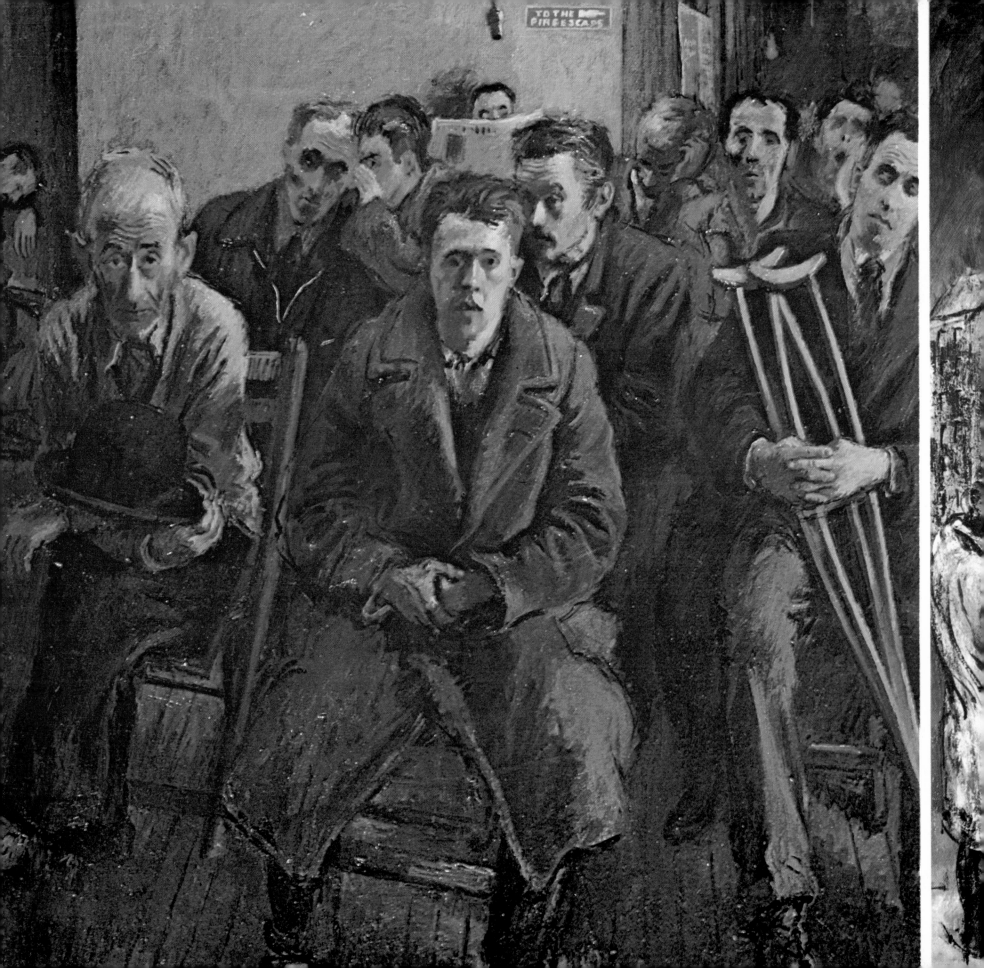

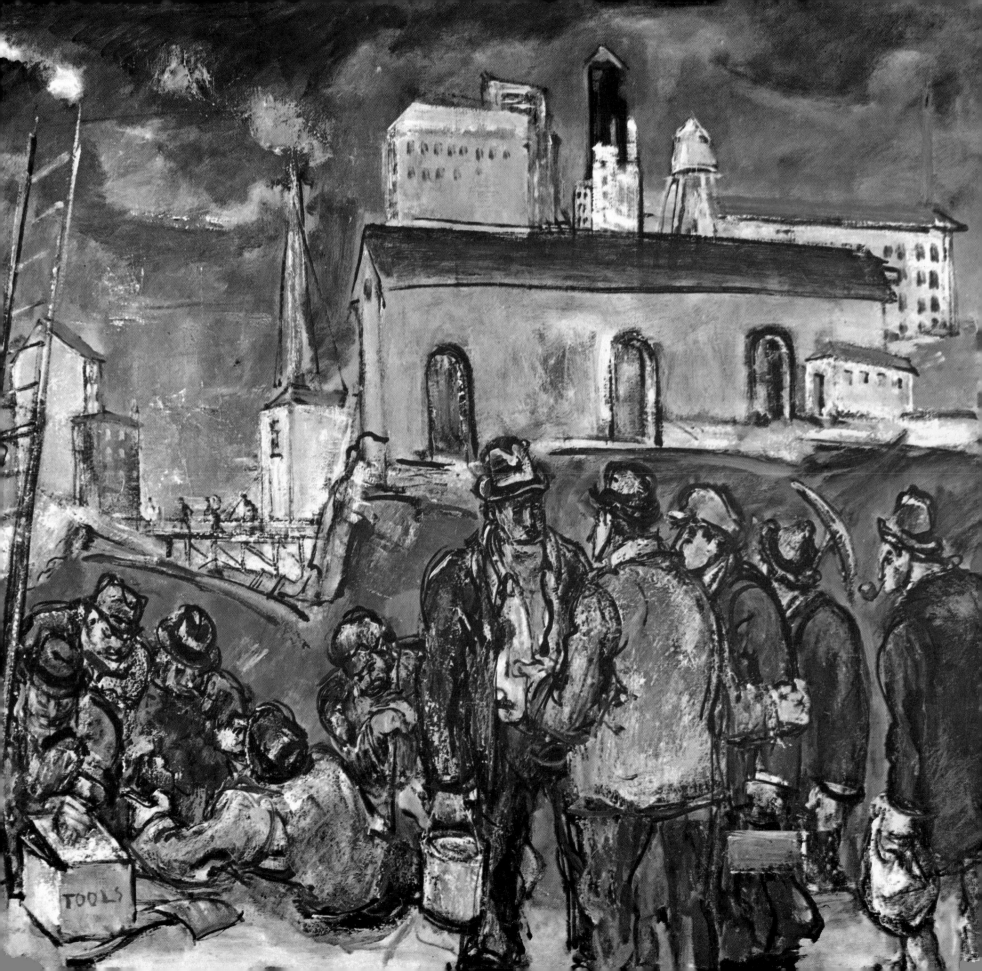

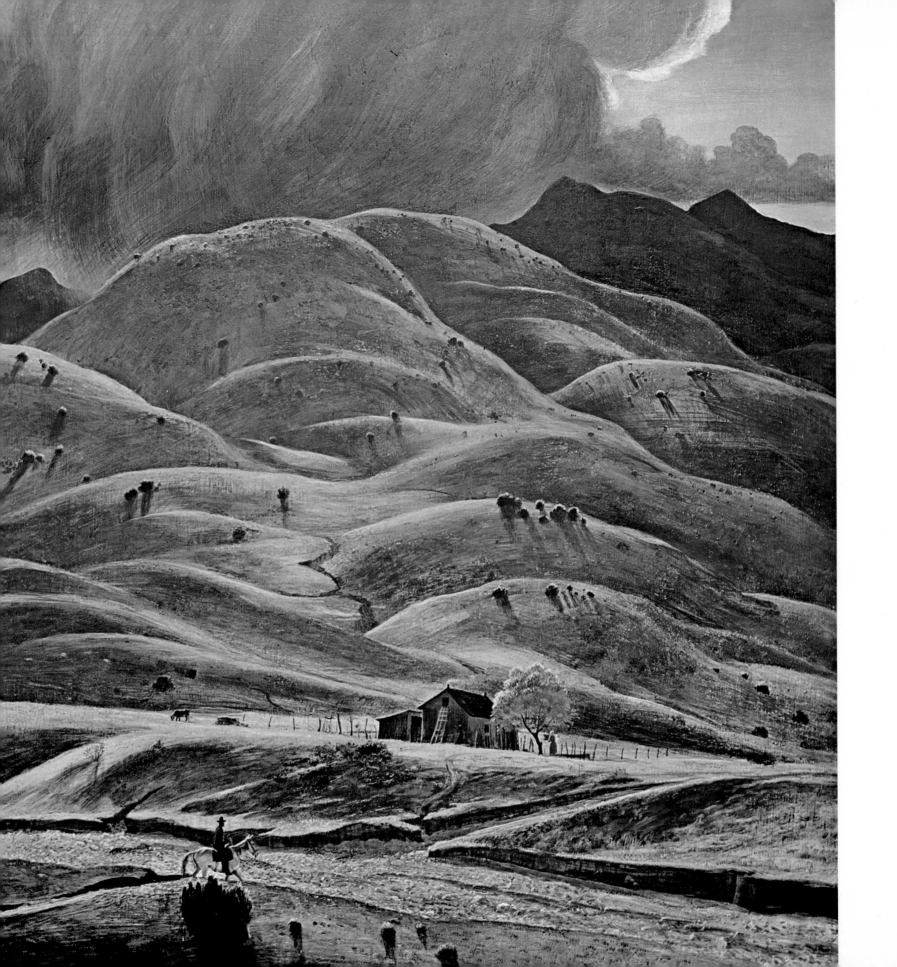

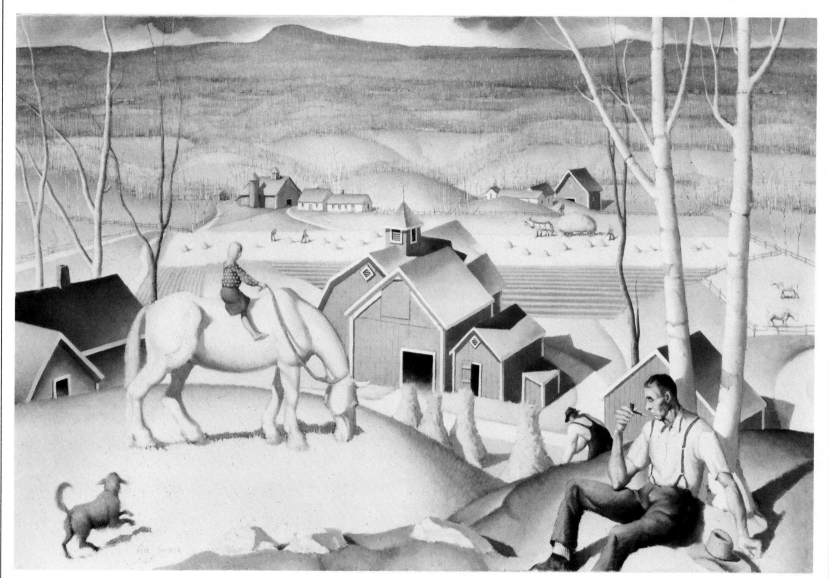

Colorplate 24. Peter Hurd, *The Dry River*, 1938. Tempera, 47 x 41 inches. Rosewell Museum and Art Center, Rosewell, New Mexico; Permanent Collection.

106. Paul Starrett Sample, *Janitor's Holiday*, 1936. Oil, 26 x 40 inches. The Metropolitan Museum of Art; Arthur H. Hearn Fund, 1937.

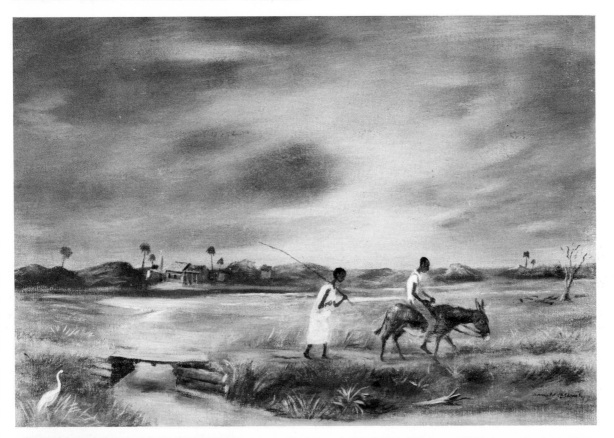

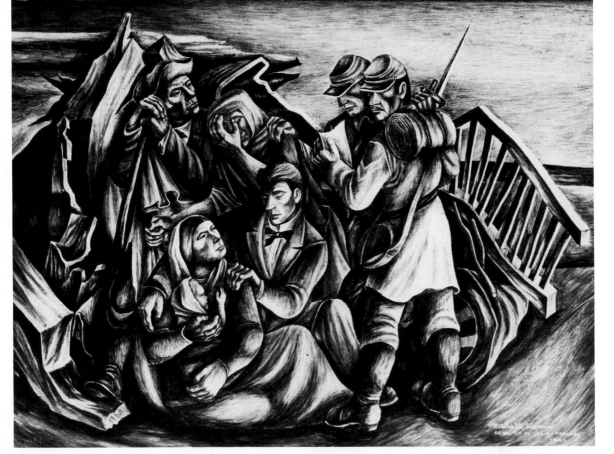

107. Arnold Blanch, *Swamp Folk*, 1939. Oil, 20 x 30 inch
The Brooklyn Museum; J. B. Woodward Memorial Fund.

108. Mitchell Siporin, *Order Number Eleven*, ca. 1930–
Tempera, 14¼ x 20 inches. The C. Leonard Pfeiffer Collection
American Art, The University of Arizona, Tucson.

109. Tom Lea, *Back Home, April, 1865*, ca. 1937. Post Offi
Pleasant Hill, Missouri. (Section of Fine Arts.) Photograph, N
tional Archives.

110. Julian E. Levi, *Fisherman's Family*, 1939. Oil 16 x
inches. The Metropolitan Museum of Art; Arthur H. Hearn Fur
1940.

111. Philip Evergood, *Toiling Hands*, 1939. Oil, 24 x 30 inch
Courtesy ACA Galleries, New York.

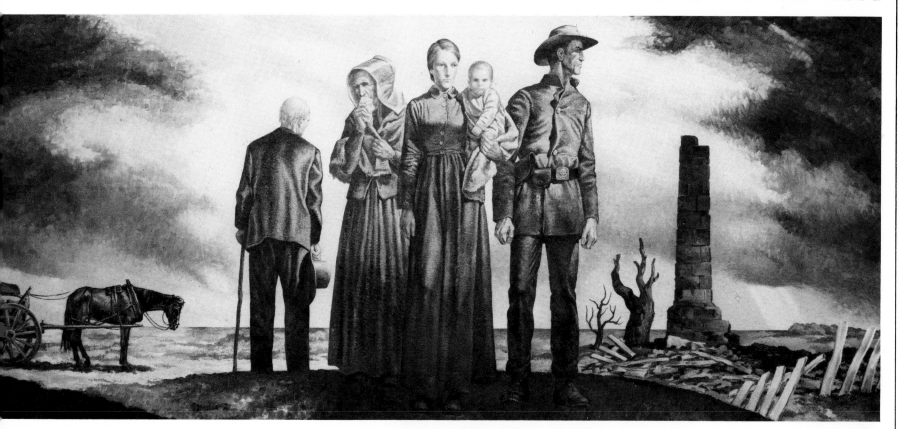

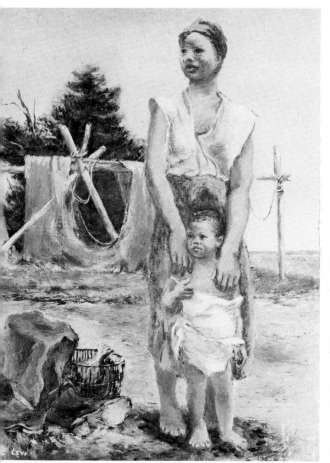

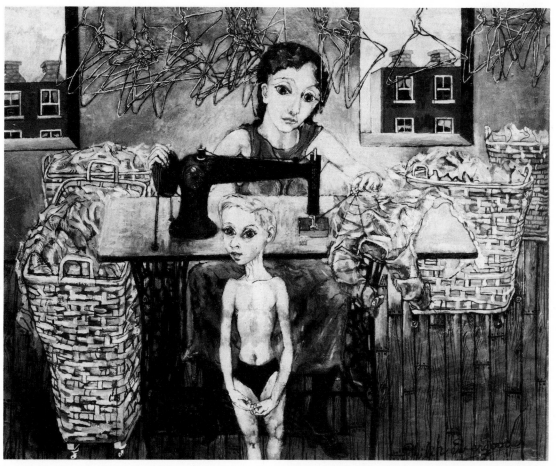

PAINTING AMERICA RECREATION AND LEISURE

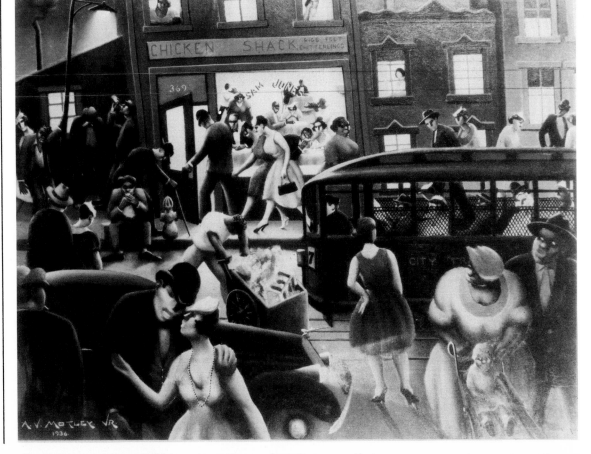

112. Jacob Lawrence, *Café Scene*, ca. 1930–40. Watercolor, 19½ x 27 inches. The C. Leonard Pfeiffer Collection of American Art, The University of Arizona, Tucson.

113. Archibald Motley, *Chicken Shack*, 1936. Post Office, Wood River, Illinois. (Treasury Relief Art Project.) Photograph, National Archives.

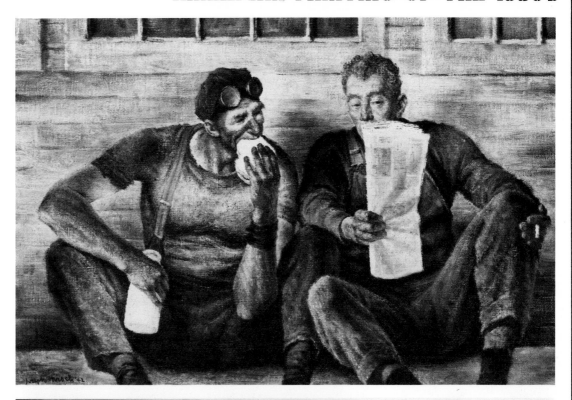

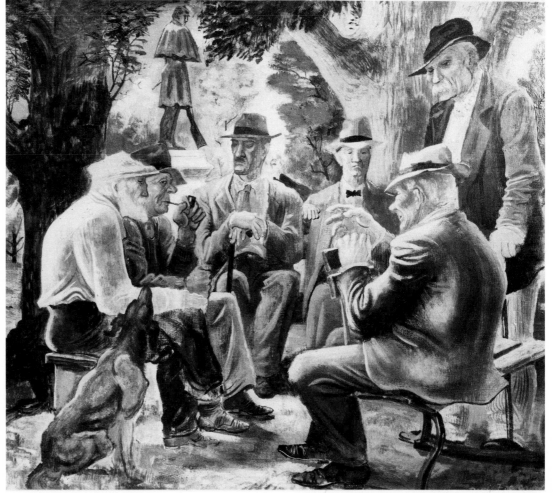

114. Joseph Hirsch, *Editorial*, 1942. Oil, 18 x 26 inches. The C. Leonard Pfeiffer Collection of American Art, The University of Arizona, Tucson.

115. David Fredenthal, *The People*, ca. 1930–40. Oil and tempera, 16½ x 19¼ inches. The C. Leonard Pfeiffer Collection of American Art, The University of Arizona, Tucson.

116. Isaac Soyer, *Cafeteria*, 1930. Oil, 23 x 27½ inches. Brooks Memorial Art Gallery, Memphis, Tennessee; Gift of E. R. Bromley.

198

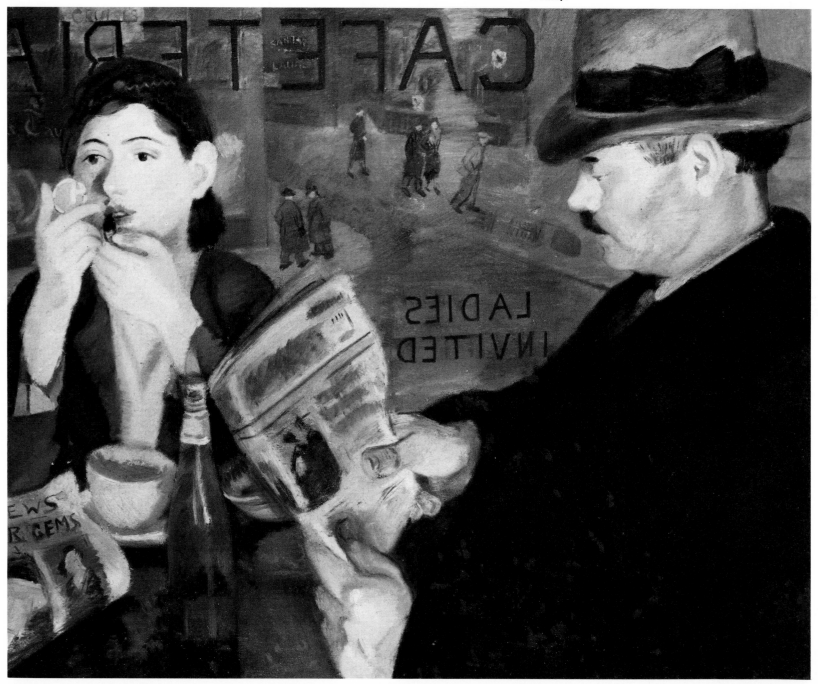

117. Jack Levine, *Street Scene No. 1*, 1937. Tempera, india ink, oil, and gold leaf, 30 x 40 inches. Courtesy Museum of Fine Arts, Boston; Gift of the National Council of Jewish Women, Boston.

118. Jack Levine, *Street Scene No. 2*, 1937. Oil, 27 x 37½ inches. The Portland Art Association, Portland, Oregon.

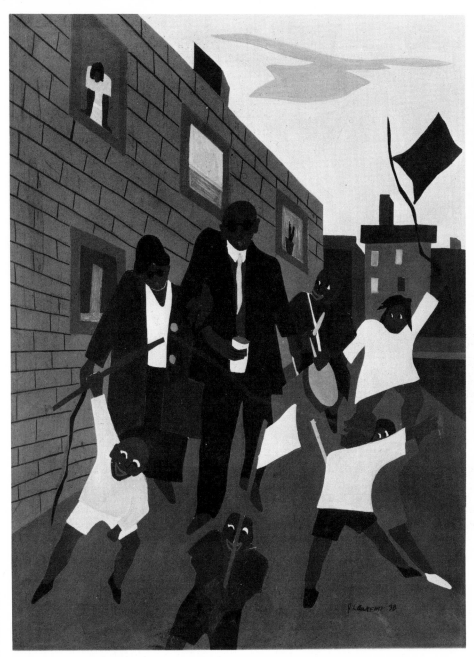

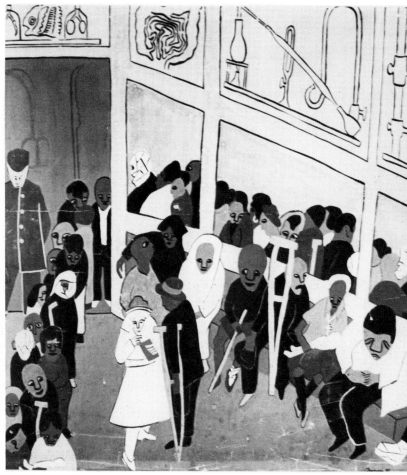

200

119. Jacob Lawrence, *Blind Beggars*, 1938. Gouache, 20 x 15 inches. The Metropolitan Museum of Art; Gift of the New York City Works Progress Administration, 1943.

120. Jacob Lawrence, *Free Clinic (Harlem Hospital)*, 1937. Casein, 30 x 29 inches. Collection Mrs. Gwendolyn Lawrence.

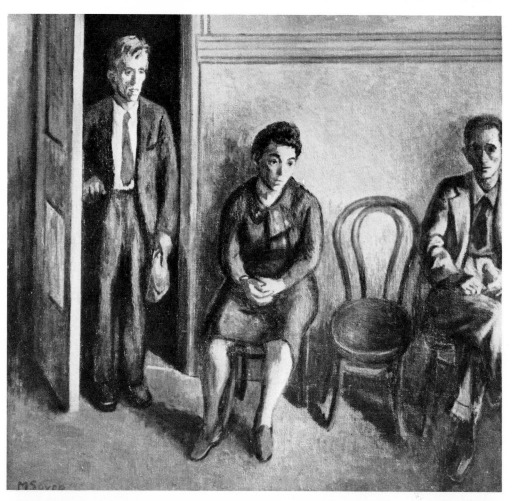

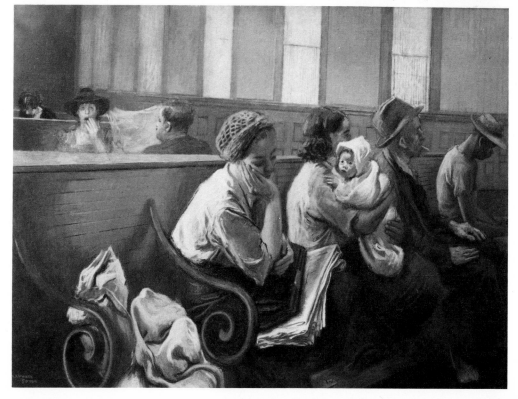

121. Moses Soyer, *Employment Agency*, 1935. Oil, 30 x 32 inches. Collection the artist.

122. Raphael Soyer, *Railroad Station Waiting Room*, ca. 1938–40. Oil, 34¼ x 45¼ inches. In the collection of the Corcoran Gallery of Art, Washington, D.C.

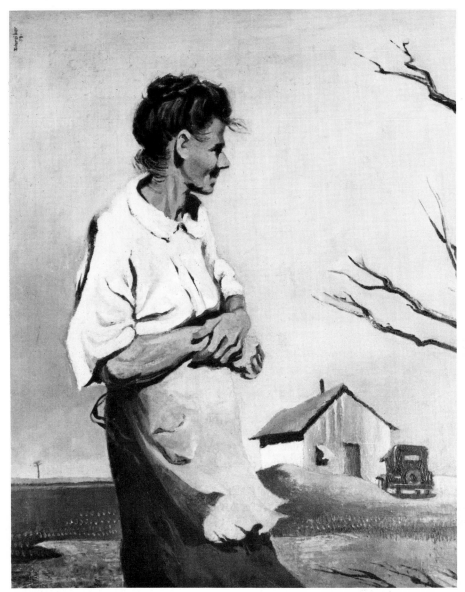

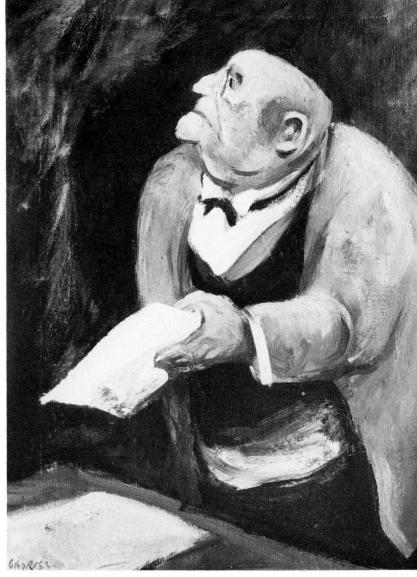

202

123. George Schreiber, *From Arkansas*, 1939. Oil, 25 x 20 inches. Courtesy The Sheldon Swope Art Gallery, Terre Haute, Indiana.

124. William Gropper, *The Speaker*, ca. 1930–40. Oil, 20 x 16 inches. The C. Leonard Pfeiffer Collection of American Art, The University of Arizona, Tucson.

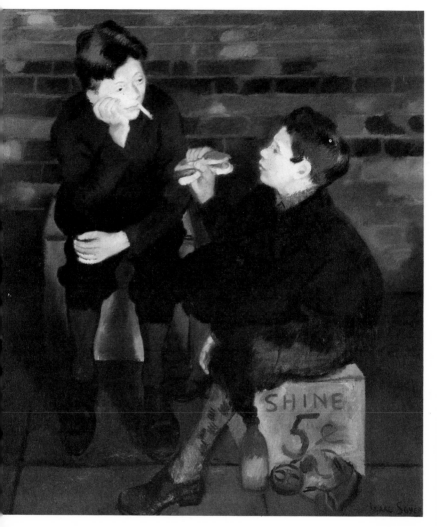

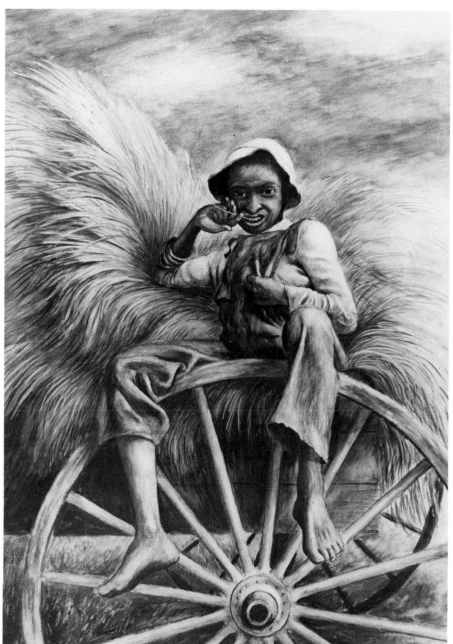

203

125. Isaac Soyer, *Bromide*, 1931. Oil, 30 x 35 inches. Private collection.

126. James Turnbull, *Son of a Sharecropper*, ca. 1930–40. Oil, 26 x 19 inches. The C. Leonard Pfeiffer Collection of American Art, The University of Arizona, Tucson.

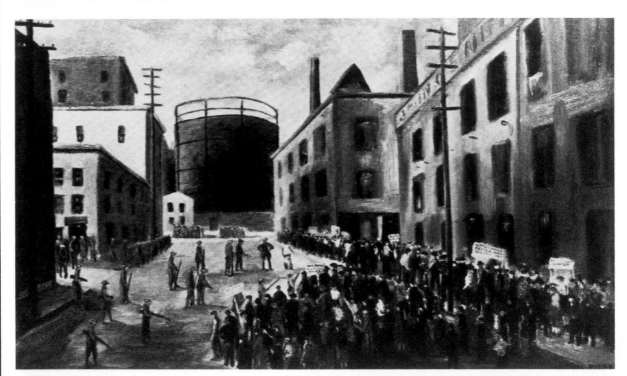

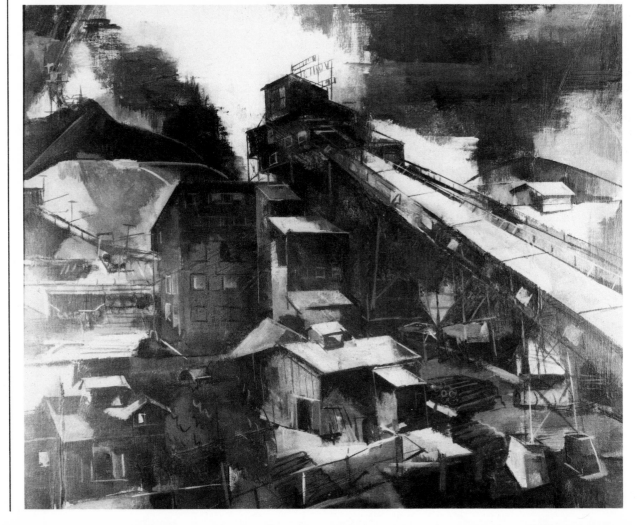

127. George Picken, *Strike*, ca. 1934–35. Collection unknov

128. Zoltan Sepeshy, *Scranton Coal Chute*, 1935. Oil a
gouache, 20 x 25 inches. Cranbrook Academy of Art Museu
Bloomfield Hills, Michigan.

129. Fletcher Martin, *Mine Rescue*, 1939. Mural study intended for Post Office, Kellogg, Idaho. (Section of Fine Arts.) Tempera, 15 x 36 inches. University of Maryland, College Park.

130. Edward Lanning, *Building of the Union Pacific Railroad*, 1935–36. From *Role of the Immigrant in Industrial America*, Ellis Island, New York. (Works Progress Administration.) Photograph, Public Buildings Service.

131. Mitchell Siporin, *Coal Pickers*, 1936. Gouache, 18 x 24½ inches. The Newark Museum; Gift of the Works Progress Administration.

206

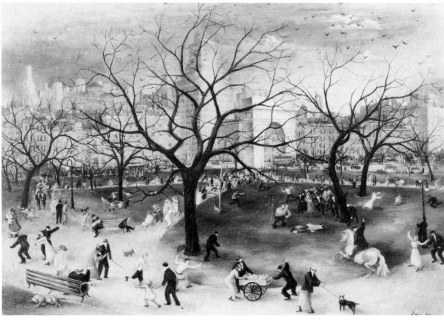

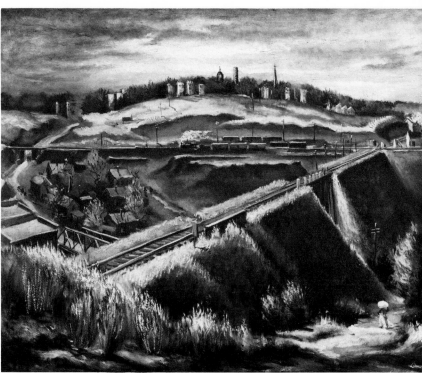

132. Louis Bunce, *Gutted Building*, ca. 1935–40. Oil, 28 x 35 inches. The Portland Art Association, Portland, Oregon.

133. Doris Lee, *April Storm, Washington Square, New York City*, ca. 1932. Oil, 26 x 36 inches. Museum of Art, Rhode Island School of Design, Providence.

134. Adolf Dehn, *Spring in Central Park*, 1941. Watercolor, 18 x 27¼ inches. The Metropolitan Museum of Art, New York; Fletcher Fund, 1941.

135. Lamar Dodd, *View of Athens*, 1939. Oil, 30 x 40 inches. Collection Dr. Fred C. Davison.

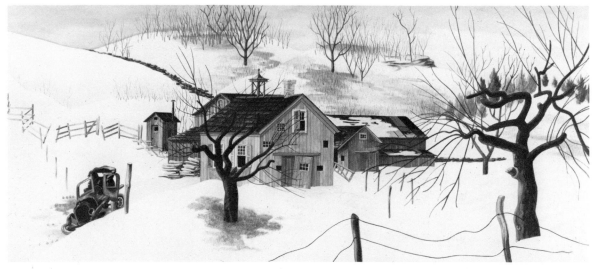

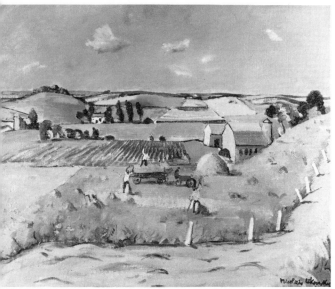

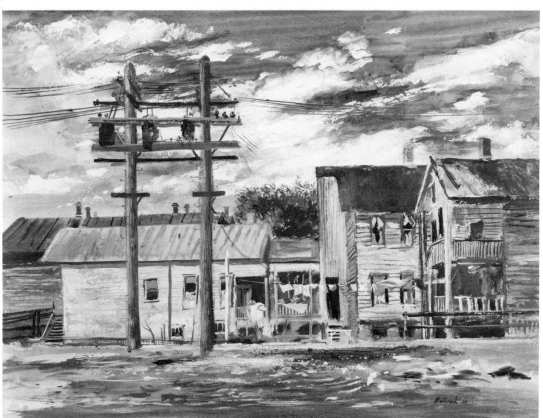

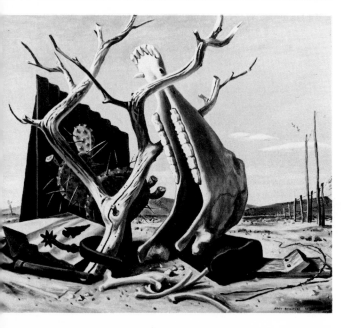

136. Clarence Carter, *City View*, 1940. Oil, 36 x 45¼ inches. Courtesy The Sheldon Swope Art Gallery, Terre Haute, Indiana.

137. Nicolai Cikovsky, *Wisconsin Landscape*, ca. 1930–40. Oil, 20 x 28 inches. The C. Leonard Pfeiffer Collection of American Art, The University of Arizona, Tucson. (Detail.)

138. Jerry Bywaters, *On the Ranch*, 1941. Oil, 20 x 26 inches. Dallas Museum of Fine Arts, Dallas, Texas. (Detail.)

139. Peter Blume, *Beatty's Barn*, ca. 1938. Watercolor, 12 x 28 inches. National Collection of Fine Arts, Smithsonian Institution, Washington, D.C.

140. Aaron Bohrod. *Frame Houses*, 1939. Gouache, 14½ x 19¾ inches. The Metropolitan Museum of Art, New York: George A. Hearn Fund, 1939.

NOTES

To simplify the notes, I have included titles and authors for important or lengthy articles but indicated only dates and pages for exhibition reviews, notes, and miscellaneous items. During the 1930's, particular questions were frequently discussed through a number of issues of a given journal. Consequently, I have usually listed only the most important of these discussions.

These abbreviations will be used for the following journals:

AD *The Art Digest*
AF *Art Front*
AMOA *The American Magazine of Art*
AN *Art News*
CA *Creative Arts*
MOA *Magazine of Art*
NM *New Masses*

THE AMERICAN WAVE

1. Peyton Boswell, Sr., in *The Americana Annual, 1932* (New York: Americana Corporation, 1932), p. 72. See also *AD* 5 (September 1, 1931), 17; *AD* 6 (February 15, 1932), 18; and *AD* 6 (May 1, 1932), 1.
2. Lionel Trilling, *The Liberal Imagination* (Garden City, N.Y.: Doubleday and Company, 1953), p. 8. First published in 1950.
3. "The International Exhibition at Pittsburgh," *AMOA* 21 (December, 1930), 679. See also *AD* 4 (January 1, 1930), 10; *AD* 4 (February 1, 1930), 11; *AD* 4 (February 15, 1930), 9; *AD* 5 (November 1, 1930), 5; and *AD* 5 (December 15, 1930), 17–18.
4. *AD* 5 (November 1, 1930), 19.
5. *AD* 4 (January 1, 1930), 7, 9; *The Arts* 16 (April, 1930), 519; and *AMOA* 23 (November, 1931), 430–31.
6. Edward Alden Jewell, *Americans* (New York: Alfred A. Knopf, 1930), p. 9; and *AD* 4 (April 1, 1930), 8.
7. *AD* 6 (November 1, 1931), 6; and *AMOA* 23 (December, 1931), 470. See also Jewell, "Toga Virilis: The Coming of Age of American Art," *Parnassus* 4 (April, 1932), 1–3.
8. For the Whitney Museum debate, see *AD* 6 (March 15, 1932), 15, 21; and *AD* 6 (April 1, 1932), 15, 16, 21. For the Artists' Professional League, see *AD* 6 (April 1, 1932), 31; and *AD* 6 (July 1, 1932), 31. For the Surrealist show, see *AD* 6 (January 15, 1932), 32. For the Reinhardt Gallery exhibition, see Matthew Josephson's review in *The New Republic* 70 (March 2, 1932), 73; and *CA* 10 (March, 1932), 227–28.
9. Forbes Watson, "The Star-Spangled Banner," *The Arts* 18 (October, 1931), 45. See also Jacques Mauney, "Paris Letter," *The Arts* 18 (October, 1931), 21. For artists' groups, see *AD* 2 (December 15, 1927), 6; *CA* 5 (December, 1929), xiv; *AD* 6 (November 1, 1931), 8; *Parnassus* 3 (November, 1931), 11; *AD* 6 (May 15, 1932), 32; and *AD* 8 (October 15, 1933), 21. For attitudes toward artists, see *AD* 6 (October 1, 1931), 10.
10. Edmund Wilson, "The Literary Consequences of the Crash (1932)," in *The Shores of Light* (New York: Farrar, Straus and Young, 1952), p. 492; *AD* 7 (September 1, 1933), 10; and William Aylott Orton, *America in Search of Culture* (Boston: Little, Brown and Company, 1933), p. 14.
11. B. D. Zevin (ed.), *Nothing to Fear: The Selected Addresses of Franklin Delano Roosevelt 1932–1945* (Boston: Houghton Mifflin Company, 1946), p. 14.
12. *AD* 6 (November 1, 1931), 4.
13. *The Nation* 136 (January 18, 1933), 72.
14. These observations ase a composite of opinions gleaned from articles and reviews written during that season.
15. Moses Soyer, "Three Brothers," *MOA* 32 (April, 1939), 207.
16. Dixon Wecter, *The Age of the Great Depression, 1929–41* (Chicago: Quadrangle Books, 1971), pp. 17, 62. First published in 1948.
17. *AD* 6 (October 1, 1931), 9; *AD* 7 (October 15, 1932), 13; *AD* 7 (December 1, 1932) 18; and *AD* 7 (February 1, 1933), 6–7.
18. For Burchfield, see *The Arts* 5 (April, 1924), 219; *AD* 2 (April 15, 1928), 19; and *AD* 4 (April 1, 1930), 16. For Hopper, see *AD* 1 (March 1, 1927), 14; Lloyd Goodrich, "The Paintings of Edward Hopper," *The Arts* 11 (March, 1927), 136; *AD* 3 (February 1, 1929), 16; and *Parnassus* 3 (October, 1931), 6.
19. George Biddle, "Tropics and Design" *AMOA* 20 (August, 1929), 438–39.
20. Stuart Davis, "Self Interview," *CA* 9 (September, 1931), 211.
21. Erle Loran, "Artists from Minnesota," *AMOA* 29 (January, 1936), 25.
22. John I. H. Baur, *Philip Evergood* (New York: published for the Whitney Museum of American Art by Frederick A. Praeger, 1960), p. 44. See also *AD* 4 (November 1, 1929), 27; and Waldo Frank, *The Rediscovery of America* (New York: Charles Scribner's Sons, 1920), p. 5.
23. *New York Times* (October 27, 1929), Section 9, p. 13.
24. Thomas Craven, "Men of Art: American Style," *The American Mercury* 6 (December, 1925), 425–32.
25. "Group of American Painters of Paris," digest of reviews of exhibition at the Brooklyn Museum, *AD* 1 (May 1, 1927), 14.
26. Craven, "The Curse of French Culture," *Forum* 82 (July, 1929), 57–63.
27. R. L. Duffus, *The American Renaissance* (New York: Alfred Knopf, 1928), pp. 317–18.
28. Eugen Neuhaus, *The History and Ideals of American Art* (Palo Alto, Calif.: Stanford University Press, 1931), p. vii.
29. *AD* 2 (April 15, 1928), 3; *AD* 3 (January 15, 1929), 7; *AD* 3 (March 1, 1929), 10; *CA* 4 (April, 1929), xxiii.
30. *AD* 6 (November 15, 1931), 1.
31. John Cotton Dana, *American Art* (Woodstock, Vt.: Elm Tree Press, 1914), p. 26; and Jewell, *Americans, op. cit.*, p. 32. See also *American Art News* 22 (October 27, 1923), 1; *AD* 5 (October 15, 1930), 3; *AD* 5 (July 1, 1931), 20; *AD* 6 (November 1, 1931), 3, 6; *CA* 9 (November, 1931), entire issue; *AD* 6 (January 1, 1932), 5; Holger Cahill, "American Art Today," in Fred J. Ringel (ed.), *America as Americans See It* (New York: Literary Guild, 1932), p. 244; *AD* 6 (August 1, 1932), 10; E. M. Benson, "Art on Parole," *AMOA* 29 (November, 1936), 696; Martha Davidson, The Government as a Patron of Art," *AN* 35 (October 10, 1936), 11–12; *AD* 10 (June 1, 1936), 7; and *AD* 10 (July 1, 1936), 3.
32. Cahill, introduction to *New Horizons in American Art* (New York: Museum of Modern Art, 1936), p. 9; and Cahill "American Art Today," *Parnassus* 11 (May, 1939), 15.
33. Stated by De Witt Clinton, in Lillian Miller, *Patrons and Patriotism: The Encouragement of the Fine Arts in the United States, 1790–1869* (Chicago: University of Chicago Press, 1966), p. 19. See also Robert E. Streeter "Association Psychology and Literary Nationalism in the *North American Review, 1815–25*," *American Literature* 17 (November, 1945), 243–44. Alison's book, *Essays on the Nature and Principles of Taste,* was published in 1790.
34. Hippolyte Taine, *Lectures on Art* (including *The Philosophy of Art* and *The Ideal in Art*) (trans. John Durand) (New York: Henry Holt and Company, 1883), p. 30.
35. John La Farge, *Considerations on Painting* (New York: Macmillan and Company, 1895), pp. 14–17; Homer Saint-Gaudens, "Why American Art Leads the World Today," *Arts and Decoration* 17 (May, 1922), 22, 76; Edward Hooper, "John Sloan and the Philadelphians," *The Arts* 11 (April, 1927), 170; Max Weber, *Essays on Art* (New York: no pub., 1916), p. 9; *Max Weber* (New York American Artists Group, 1945), unpaged. See also John Dewey, "Americanism and Localism," *The Dial* 68 (June, 1920), 684; *CA* 3 (July, 1928), xxv; Mary Austin, "Regionalism in American Fiction," *The English Journal* 21 (January, 1932), 97; Orton, *op. cit.*, p. 166; *AD* 7 (March 1, 1933), 1–2; and Cahill, *New Horizons in American Art, op. cit.*, p. 9.
36. Constance Rourke, *The Roots of American Culture* (New York: Harcourt, Brace and Company, 1942), p. 291. See also Rourke, "American Art: A Possible Future," *AMOA* 28 (July, 1935), 390–405; and Craven, "American Painters: The Snob Spirit," *Scribner's Magazine* 91 (February, 1932), 86.
37. Craven, "The Independent Exhibition," *The New Republic* 34 (March 14, 1923), 71; *AD* 5 (September 1, 1931), 9; and Craven, *Men of Art* (New York: Simon and Schuster, 1931), pp: 510–11.
38. *AD* 1 (August, 1927), 6; Lee Simonson, "Diego Rivera," *CA* (September, 1928), xviii–xxii; Frank, *op. cit.*, pp. 126–27; *The Frescoes of Diego Rivera* (New York: Harcourt, Brace and Company, 1929); José Juan Tablada "The Arts in Modern Mexico" *Parnassus* 1 (March 15, 1929), 8–9; Alma Reed, "Orozco and Mexican Painting," *CA* 9 (September, 1931), 199–207; *AD* 7 (April 1, 1933), 3; Walter Pach, "Rockefeller, Rivera, and Art," *Harper's Magazine,* 167 (Sep-

tember, 1933), 476–83; E. M. Benton, "Orozco in New England," *AMOA* 26 (October, 1933), 443–49; Charmion von Wiegand, "Mural Painting in America," *The Yale Review* 23 (June, 1934), 788–99.

39. *AD* 2 (January 15, 1928), 1; *AD* 5 (October 15, 1930), 36; *AD* 5 (May 15, 1931), 10; *AD* 6 (December 1, 1931), 8; and *Diego Rivera* (New York: The Museum of Modern Art, 1931).

40. *Rivera:* Luncheon Club of the San Francisco Stock Exchange; California School of Fine Arts, San Francisco; home of Mrs. Sigmund Stearn, Fresno; four portable panels for exhibition in the Museum of Modern Art, all 1931; the Detroit Institute of Arts, 1932–33; Rockefeller Center (now destroyed), 1933; the New Workers School, New York, 1933. *Orozco:* Pomona College, 1930; the New School for Social Research, 1930–31; Dartmouth College, 1932–34. *Siqueiros:* Chouinard Art School, Los Angeles (disintegrated), 1932; home of Dudley Murphy, Santa Monica, 1932; Plaza Art Center, Los Angeles, 1932.

41. *AD* 1 (May 15, 1927), 16; *AMOA* 18 (June, 1927), 298–302; *CA* 3 (December, 1928), xlv; *The American Year Book,* 1928 (New York: The American Year Book Company, 1929), article by Frances Henderson, p. 809; *AD* 3 (March 1, 1929), 4; *AD* 3 (May 15, 1929), 4; J. Mortimer Lichtenaur, "A Mural Painter's Attitude Toward the Old and the New in Art," *AMOA* 20 (October, 1929), 565–68; *The American Year Book, 1929,* article by Frances Henderson, p. 802; *AMOA* 21 (August, 1930), 426–34; *AMOA* 21 (September, 1930), 504–5; *American Art Annual XXVII* (Washington, D.C.: The American Federation of Art, 1930), p. 17; *AMOA* 21 (March, 1931), 234; *The American Year Book, 1931,* pp. 847–48; *American Art Annual XXIX,* pp. 15–16; *AD* 6 (May 15, 1932), 11, 20, and *The American Year Book, 1932,* pp. 865–68.

42. Craven, "Politics and the Painting Business," *The American Mercury* 27 (December, 1932), 471; Oliver M. Sayler, *Revolt in the Arts* (New York: Brentano's, 1930), pp. 45–46. Sloan's essay is entitled "Art Is, Was and Ever Will Be," pp. 318–21, and Robinson's is "Learning by Working on the Job," pp. 314–17. José Clemente Orozco, "New World, New Races and New Art," *CA* 4 (January, 1929), xlv–xlvi. See also Diego Rivera, "The Revolutionary Spirit in Modern Art," *The Modern Quarterly* 6 (Autumn, 1932), 51–57; Rivera, "The Revolution of Painting," *CA* 4 (January, 1929), xxvii–xxx; Rivera, "What Is Art For?" *The Modern Monthly* 7 (June, 1933), 275–78; and David Alfaro Siqueiros, "Rivera's Counter-Revolutionary Road," *NM* 10 (May 29, 1934), 16–19.

43. *AD* 6 (February 15, 1932), 5; *AD* 6 (April 1, 1932), 6; *AD* 6 (May 15, 1932), 7; *AMOA* 25 (August, 1932), 93–102; and *Murals* (New York: The Museum of Modern Art, 1932).

44. Avery Craven, "Frederick Jackson Turner and the Frontier Approach," *The University of Kansas City Review* 18 (Autumn, 1951), 3.

45. *Ibid.;* and Ray Allen Billington (ed.), *Frontier and Section: Selected Essays of Frederick Jackson Turner* (Englewood Cliffs, N.J.: Prentice-Hall, 1961).

46. Donald Davidson, *The Attack on Leviathan* (Chapel Hill: University of North Carolina Press, 1938), p. 81. See also Ruth Suckow, "The Folk Idea in American Life," *Scribners Magazine* 88 (September, 1930), 245–55; editorial in *The Saturday Review of Literature* 10 (April 7, 1934), 606; Jospeh E. Baker, "Regionalism in the Middle West," *The American Review* 4 (March, 1935), 607; Davidson, "Regionalism and Nationalism in American Literature," *The American Review* 5 (April, 1935), 48–61; B. A. Botkin, "Regionalism: Cult or Culture," *The English Journal* 25 (March, 1936), 183–84; "Regionalism: Pro and Con" (arguments in favor by Joseph E. Baker; against, by Paul Robert Blath), *The Saturday Review of Literature* 15 (November 28, 1936), 4, 14; Howard W. Odum and Harry E. Moore, *American Regionalism* (New York: Henry Holt and Company, 1938), *passim;* and Merrill Jensen (ed.), *Regionalism in America* (Madison: University of Wisconsin Press, 1951), *passim.*

47. Lewis Mumford, "The Theory and Practice of Regionalism," *The Sociological Review* 20 (April, 1928), 133. See also first part of article in *The Sociological Review* 20 (January, 1928), 25–27; and "Regionalism and Irregionalism," *The Sociological Review* 19 (October, 1927), 277–88.

48. Allen Tate, "Regionalism and Section," *The New Republic* 59 (December 23, 1931), 158–61; and Alexander Karanikas, *Tillers of a Myth: Southern Agrarians as Social and Literary Critics* (Madison: University of Wisconsin Press, 1966), *passim.*

THE GOVERNMENT PROJECTS

1. Paul Schofield, "The Midwest Scene Comes of Age," *Parnassus* 4 (April, 1937), 15.

2. F. A. Gutheim, "Tenth Hoosier Salon, Chicago," *AMOA* 27 (March, 1934), 152.

3. *AMOA* 24 (February, 1932), 121–22; and *AMOA* 26 (December, 1933), 521–22.

4. Audrey McMahon, "May the Artist Live," *Parnassus* 5 (October, 1933), 2.

5. *AF* 1 (November, 1934), entire issue; and *NM* 17 (October 8, 1935), 20.

6. Biddle, *An American Artist's Story* (Boston: Little, Brown and Company, 1934), p. 268. See also Edward B. Rowan, "Will Plumber's Wages Turn the Trick?" *AMOA* 27 (February, 1934), 80–83; Suzanne La Follette, "The Government Recognizes Art," *Scribners Magazine* 95 (February, 1934), 132. See also Grace Overmeyer, *Government and the Arts* (New York: W. W. Norton and Company, 1939); Ralph Purcell, *Government and Art* (Washington, D.C.: Public Affairs Press, 1956); Francis V. O'Connor, *Federal Art Patronage 1933 to 1945* (exhibition catalogue; College Park: University of Maryland, 1966); and O'Connor, *Federal Support for the Visual Arts: The New Deal and Now* (Greenwich, Conn.: New York Graphic Society, 1969).

7. Public Works of Art Project, *Report of the Assistant Secretary of the Treasury to the Federal Emergency Administration, December 8, 1933–June 30, 1934* (Washington, D.C.: U.S. Government Printing Office, 1934), pp. 2, 5, 7.

8. Watson, "The Public Works of Art Project," *AMOA* 27 (January, 1934), 7. See also Edward Bruce, "Implications of the PWAP," *AMOA* 27 (March, 1934), 113–16; Watson, "A Steady Job," *AMOA* 27 (April, 1934), 168–82; and Benson, "Art on Parole," *AMOA* 29 (November, 1936), 695–709.

9. "For Jobs and Adequate Relief," *AF* 1 (November, 1934), unpaged; and *The Nation* 138 (June 20, 1934), 705–6.

10. Peter Vane, "Big Words by Bigwigs," *AF* 3, nos. 3–4 (1937), 5–7, 26.

11. Cahill, "Report on Art Projects: Federal Art Project," p. 1. Typewritten copy, dated February 15, 1936, in New York Public Library.

12. Cahill, introduction to *New Horizons in American Art, op. cit.,* p. 18.

13. Biddle, *An American Artist's Story, op. cit.,* p. 279.

14. Cahill, *New Horizons, op. cit.,* p. 34.

15. Craven, "Art and Propaganda," *Scribners Magazine* 95 (March, 1934), 194. See also Craven, "Nationalism in Art," *The Forum* 95 (June, 1936), 361.

REGIONALISM AND SOCIAL REALISM

1. *Time* 24 (December 24, 1924), 24–27; Gutheim, "American Art: A Geographic Interpretation," *AMOA* 28 (May, 1935), 262–70; Peippino Mangravite, "The American Painter and His Environment," *AMOA* 28 (April, 1935), 198–204; Philippa Whiting, "Speaking About Art," *AMOA* 28 (February, 1935), 106; *AD* 9 (September 1, 1935), 7; and Whiting, "Speaking About Art," *AMOA* 28 (September, 1935), 556–60.

2. Turner, "Contributions of the West to American Democracy," in Billington (ed.), *op. cit.,* p. 81. Turner's essay was first published in 1903. See also Odum and Moore, *op. cit.,* p. 462.

3. For Stone City, see F. A. Whiting, Jr., "Stone, Steel and Fire: Stone City Comes to Life," *AMOA* 25 (December, 1932), 333–42; "Stone City's Second Season," *AMOA* 26 (August, 1933), 391. See also *AMOA* 25 (August, 1932), 127. For d'Harnoncourt, see *AMOA* 26 (October, 1933), 477. For Craven, see "Our Art Becomes American" *Harper's Magazine* 171 (September, 1935), 439. See also *The Arts* 16 (December, 1929), 215; *AD* 4 (January 1, 1930), 10; *AMOA* 23 (December, 1931), 487; *AD* 7 (February 15, 1933), 3; A. Washington Pezet, "The Middle West Takes Up the Torch," *Forum and Century* 96 (December, 1936), 285–89; and Odum and Moore, *op. cit.,* p. 519.

4. *AD* 9 (February 15, 1935), 14; *Parnassus* 7 (March, 1935), 24; and *NM* 14 (March 19, 1935), 29.

5. Essay by Herman Baron; written *ca.* 1945, in Archives of American Art, Box D304, frames 566 ff. (microfilm).

6. Benjamin Gitlow, *I Confess* (New York: E. P. Dutton and Company, 1939), p. 309.

7. *NM* 5 (December, 1929), 20; *NM* 5 (February, 1930), 20; *NM* 6 (April, 1931), 22; and *NM* 7 (April, 1932), 28.

8. *AD* 7 (January 15, 1933), 26.

9. For the John Reed Club School of Art, see *AD* 9 (October 1, 1934), 26; *AF* 1 (January, 1935), 3; *AF* 2 (February, 1936), 11; *AMOA* 29 (November, 1936), 758; and *AF* 3, nos. 3–4 (1937), 21. For John Reed Club exhibitions, see *CA* 12 (March, 1933), 216–18; *AD* 7 (March 1, 1933), 32; *AD* 8 (January 1, 1934), 14; *NM* 10 (January 2, 1934), 27; *AF* 1 (January, 1935), 6. See also Jacob Burck, "Revolution in the Art World," *The American Mercury* 34 (March, 1935), 332–37; *NM* 17 (October 1, 1935), 17; and Louis Lozowick, "Towards a Revolutionary Art," *AF* 2 (July–August, 1936), 12–14.

10. Walter B. Rideout, *The Radical Novel in the United States, 1900–1954* (New York: Hill and Wang, 1966), p. 179. First published in 1956.

11. *Parnassus* 7 (December, 1935), 24–25.

12. *AD* 9 (September 1, 1935), 29.

13. Craven, *Modern Art, op. cit.,* p. 312.

14. *The Nation* 136 (May 10, 1933), 519; and Craven, *Modern Art, op. cit.,* p. 260. For Hitler's policies, see *AD* 7 (March 15, 1933), 7; *AD* 8 (August 1, 1934), 9; *AD* 8 (September 1, 1934), 13; *AD* 8 (November 1, 1934), 7; *AD* 10 (October 1, 1935), 3; *AD* 11 (November 15, 1936), 9; *AD* 11 (December 15, 1936), 3; *AF* 2 (January, 1937), 3; *MOA* 30 (January, 1937), 65; *AD* 11 (August 1, 1937), 7; *MOA* 30 (August, 1937), 496–97; *NM* 24 (September 7, 1937), 3–5; *AD* 13 (October 15, 1938), 8.

15. Moses Soyer, "The Second Whitney Biennial," *AF* 1 (February, 1935), 7–8.

16. Orrick Johns, "The John Reed Clubs Meet," *NM* 13 (October 30, 1934), 26; *NM* 14 (January 22, 1935), 20; *AD* 10 (October 1, 1935), 7; *AMOA* 28 (December, 1935), 752; ACA Gallery Papers, Archives of American Art, Box 304, frame 640 (microfilm). See also Daniel Aaron, *Writers on the Left* (New York: Avon Books, 1965), pp. 298–301. First published in 1961. Donald Drew Egbert, *Socialism and American Art* (Princeton, N.J.: Princeton University Press, 1967), p. 72, and Rideout, *op. cit.,* p. 241.

THE END OF THE 1930's

1. *AD* 14 (January 1, 1940), 14. See also *AMOA* 28 (March, 1935), 161–66; *AMOA* 28 (July, 1934), 434; *AD* 11 (November 1, 1936), 5; *Parnassus* 4 (April, 1937), 15; *NM* 27 (May 17, 1938), 27; *MOA* 31 (December, 1938), 679; and *AD* 13 (October 15, 1938), 9.

2. Peyton Boswell, Jr., *Modern American Painting* (New York: Dodd, Mead and Company, 1939); Edward Alden Jewell, *Have We an American Art* (New York: Longman, Greene Co., 1939); Martha Chandler Cheney, *Modern Art in America* (New York: McGraw-Hill Book Company, 1939); and Forbes Watson, *American Painting Today* (Washington, D.C.: The American Federation of Art, 1939).

3. *Parnassus* 11 (May, 1939), 14–25; *MOA* 32 (March, 1939), 152–53; *MOA* 32 (May, 1939), entire issue; *AD* 13 (June 1, 1939), entire issue; *AD* 13 (September 1, 1939), 3; *MOA* 32 (November, 1939), 628–37; *MOA* 32 (December, 1939), 671–82; and *AD* 14 (November 15, 1939), 12.

4. Cheney, *op. cit.,* p. 175.

5. Sheldon Cheney, "Art in America Now," in Harold E. Stearns (ed.), *America Now* (New York: Charles Scribner's Sons, 1938), p. 88.

6. Biddle, *An American Artist's Story, op. cit.,* p. 261.

7. Thomas Hart Benton, *An Artist in America* (Columbia: University of Missouri Press, 1968), pp. 297–330.

8. Boswell, Jr., "Fletcher Martin," *Parnassus* 12 (October, 1940), 8.

9. *AD* 13 (October 15, 1940), 9; *Parnassus* 12 (January, 1940), 5–12; *MOA* 33 (December, 1940), 680–81; and *Parnassus* 12 (December, 1940), 8–9.

10. Martha Cheney, *op. cit.,* pp. 7, 81–82; and Cahill, "American Art Today," *Parnassus* 11 (May, 1939), 14–15, 35–37.

11. Irving Sandler, *The Triumph of American Painting* (New York: Praeger Publishers, 1970), p. 31.

12. Benton, "Art and Nationalism," *The Modern Monthly* 8 (March, 1934), 235; Peter Blume "The Artist Must Choose," in *First American Artists' Congress* (New York: no pub., 1936), p. 30; and Robert Motherwell, "The Painter's Responsibility," *Dyn* 6 (1944), 12.

13. For Benton, see John I. H. Baur (ed.), *New Art In America* (Greenwich, Conn.: New York Graphic Society, 1951), p. 131. For Hirsch, see statement in *Americans 1942* (New York: The Museum of Modern Art, 1942), p. 60. For Motherwell, see *The New Decade* (New York: The Whitney Museum of American Art, 1955), p. 59.

14. Quoted in *Modern Artists in America,* 1st series (New York: Wittenborn Schultz, 1951), p. 16.

THOMAS HART BENTON

1. Biographical information is taken from Benton, *An Artist in America,* 3d ed. (Columbia: University of Missouri Press, 1969); Benton, *An American in Art* (Lawrence: The University Press of Kansas, 1969); and Baigell, *Thomas Hart Benton* (New York: Harry N. Abrams, 1974).

2. Benton, "American Regionalism: A Personal History of the Movement," *The University of Kansas City Review* 18 (Autumn, 1951), 47. (Reprinted in *Benton, An American in Art,* op. cit.)

3. *Ibid.,* 45.

4. *Ibid.,* 42.

5. Suzanne La Follete, "America in Murals," *The New Freeman* 2 (February 18, 1931), 540.

6. Benton, *The Arts of Life in America* (New York: The Whitney Museum of American Art, 1932), p. 4.

7. Baigell (ed.), *A Thomas Hart Benton Miscellany* (Lawrence: The State University Press of Kansas, 1971), pp. 33–34.

GRANT WOOD

1. *AD* 17 (November 15, 1942), 23; and *AD* 17 (December 1, 1942), 4.

2. See Baigell, "Grant Wood Revisited," *Art Journal* 26 (Winter, 1966–67), 116–122.

3. Darrell Garwood, *Artist in Iowa* (New York: W. W. Norton and Company, 1944), pp. 83, 181.

4. Letter from Daniel Catton Rich to Baigell (March 14, 1967). Rich was employed by the Art Institute at the time. See also H. W. Janson, "The International Aspects of Regionalism," *College Art Journal* 2 (May, 1943), 110–14.

5. *The London Studio* 4 (July, 1932), 36; and *AD* 9 (May 1, 1935), 18.

6. *AMOA* 20 (June, 1929), 359; and *AMOA* 21 (May, 1930), 289.

7. *The Captain's Wife* was illustrated in *AMOA* 23 (August, 1931), 103.

8. Garwood, *op. cit.,* pp. 119–20.

9. Richard Hofstadter, *Anti-intellectualism in American Life* (New York: Random House, 1963), pp. 118–19.

10. For the mythic yeoman, see Henry Nash Smith, *Virgin Land: The American West as Symbol and Myth* (New York: Random House, 1950), p. 152.

11. *Ibid.,* p. 286.

12. Garwood, *op. cit.,* pp. 162, 165.

13. Sherwood Anderson, *Kit Brandon* (New York: Charles Scribner's Sons, 1936), p. 255.

14. Garwood, *op. cit.,* p. 138.

15. Wilson, *op. cit.,* p. 499.

16. Grant Wood, ms. entitled "Return from Bohemia," Archives of American Art, Box D24, frames 209–10 (microfilm).

17. *Ibid.,* frame 165.

18. Remley J. Glass, "Gentlemen, The Corn Belt," *Harper's Magazine* 166 (July, 1933), 200–206; cited in David Shannon (ed.), *The Great Depression* (Englewood Cliffs, N.J.: Prentice-Hall, 1960), p. 23.

19. *AMOA* 25 (August, 1932), 126.

20. *AMOA* 26 (August, 1933), 391.

21. Garwood, *op. cit.,* p. 182.

22. *Ibid.,* p. 153; and *AD* 9 (October 15, 1934), 13.

23. From catalogue of Stone City Colony and Art School, Archives of American Art, Box D10, frames 1752–53 (microfilm); and *AMOA* 25 (December, 1932), 337.

24. *AMOA* 25 (August, 1932), 127.

25. Jensen (ed.), *op. cit.,* p. 216.

JOHN STEUART CURRY

1. For biographical information, see Lawrence E. Schmeckebier, *John*

Steuart Curry's Pageant of America (New York: American Artists Group, 1943).

2. Nathaniel Pousette-Dart, "John Steuart Curry," *Art of Today* 6 (February, 1935), 7. See also Craven, "John Steuart Curry," *Scribner's Magazine* 103 (January, 1938), 40.
3. According to a review by Edward Alden Jewell, cited in Schmeckebier, *op. cit.*, p. 41.
4. *Ibid.*, p. 52. See also *The Arts* 16 (February, 1930), 425; *AD* 5 (December 15, 1930), 16; and *AD* 6 (November 1, 1931), 19.
5. Schmeckebier, *op. cit.*, p. 97.
6. *The Capital Times* (Madison, Wisconsin), December 4, 1936, in Archives of American Art, John Steuart Curry Papers, Box 165, frame 899 (microfilm).
7. *AD* 9 (February 15, 1935), 16.
8. Wood, "John Steuart Curry and the Midwest," *Demcourier* 11 (April, 1941), 4.
9. Schmeckebier, *op. cit.*, p. 294.
10. See note 4 in section on Regionalism and Social Realism.
11. See Baigell, "The Relevancy of Curry's Paintings of Black Freedom," *Kansas Quarterly* 2 (Fall, 1970), 19–29.
12. Curry, "The Freeing of the Slaves" (mimeograph provided by The Law School, University of Wisconsin, undated), p. 2.
13. Undated statement, John Steuart Curry Papers, Archives of American Art, Box 164, frame 6 (microfilm).

REGINALD MARSH

1. Craven, "Our Art Becomes American," *Harper's Magazine* 171 (September, 1935), 436–37; *AF* 1 (May, 1935), unpaged review by Jerome Klein. For biographical information, see Lloyd Goodrich, *Reginald Marsh* (New York: Hary N. Abrams, 1972).
2. Letter from Thomas Hart Benton to Baigell (December 5, 1972).
3. *Ibid.*
4. *New York Times,* January 6, 1932 (in clippings file at New York Public Library).
5. *New York Times,* February 16, 1940 (in clippings file at New York Public Library).
6. Reginald Marsh, "Let's Get Back to Painting," *MOA* 37 (December, 1944), 294.
7. William Benton, "Reginald Marsh," *The Saturday Review of Literature* 38 (December 24, 1955), 7.
8. *The Arts* 17 (November, 1930), 124.
9. *AD* 6 (March 15, 1932), 19.
10. Marsh, "What I See in Edward Lanning's Art," *CA* 10 (March, 1933), 188.
11. Reginald Marsh Papers, Archives of American Art, Letter to Mrs. T. E. (December 21, 1929), Box D308, frame 255 (microfilm).
12. "A Half-Day in the Studio of Reginald Marsh," *American Artist* 5 (June, 1941), 5.
13. Garwood, *op. cit.*, p. 237.
14. *New York Herald Tribune,* March 10, 1954 (in clippings file at New York Public Library).

STUART DAVIS

1. J. Z. Jacobson (ed.), *Art of Today: Chicago, 1933* (Chicago: L. M. Stein, 1932), p. xix.
2. George L. K. Morris, "Art Chronicle," *Partisan Review* 4 (March, 1938), 37–38.
3. From notes dated 1922, cited in Diane Kelder (ed.), *Stuart Davis* (New York: Praeger Publishers, 1971), pp. 34–36.
4. From "Abstract Painting in America 1935," cited in Kelder, *op. cit.*, p. 113.
5. Stuart Davis, "Self-Interview," *CA* 9 (September, 1931), 211.
6. Letter to Henry McBride, in *CA* 6 (February, 1930), suppl. 34–35.
7. Letter to George Biddle (July 1, 1940), George Biddle Papers, Archives of American Art, Box P17, frames 536–37 (microfilm).
8. Stuart Davis (New York: American Artist Group, 1945), unpaged.
9. From Bulletin of *America's Town Meeting of the Air* V (February, 1940); cited in Kelder, *op. cit.*, p. 122.
10. From notes dated 1939, cited in Kelder, *op. cit.* p. 89.
11. From notes dated 1939, cited in Kelder, *op. cit.*, p. 86; and Letter to Editor, *New York Times* (August 20, 1939.) Section 9, p. 7.
12. Davis, "The American People and Art," *American Artist* (News Bulletin of the American Artists Congress) 2 (Spring, 1938), 7.

13. *AD* 14 (April 15, 1940), 9; and *AD* 14 (May 1, 1940), 3, 14.
14. Cited in *Stuart Davis* (Minneapolis: Walker Art Center, 1957), pp. 44–45.
15. Cited in *Exhibition of American Paintings and Sculpture from the Museum's Collection* (Newark: The Newark Museum, 1944), p. 102.
16. See note 10; and Letter to the Editor, *New York Times,* August 20, 1939, Section 9, p. 7; and *AD* 14 (October 1, 1939), 34.

BEN SHAHN

1. To the best of my knowledge, this was never spelled out so baldly, although it is clearly inferred from the various art reviews in *The New Masses.*
2. See editorial, "The Pulse of Modernity," in *The Modern Quarterly* 4 (Summer, 1932), 8–9.
3. Soyer, "About Moses Soyer," *AF* 1 (February, 1935), 6; and John I. H. Baur, *Philip Evergood* (New York: Published for the Whitney Museum of American Art by Frederick A. Praeger, 1960), p. 52.
4. For an example of such rhetoric, see Philip Evergood "Building a New Art School," *AF* 3, nos. 3–7 (1937), 21.
5. Thomas S. Willison, "Revolutionary Art Today," *NM* 17 (October 1, 1935), 17.
6. Aaron, *op. cit.*, p. 236; and Louis Lozowick, "The Artist in the U.S.S.R.," *NM* 20 (July 28, 1936), 18–20. See also, *AD* 3 (February 15, 1929), 16; Theodor Schmit, "The Story of Art in the U.S.S.R., 1917–1928," *Parnassus* 1 (February 15, 1929), 7–10; Huntley Carter, "The Challenge of the New Russian Art Expression," *The Modern Quarterly* 4 (November–February, 1929–30), 254–65; Joseph Freeman, Joshua Kunetz, and Louis Lozowick, *Voices of October: Art and Literature in Soviet Russia* (New York: The Vanguard Press, 1930); Eliot O'Hara, "Russia Today as a Field for Painters," *AMOA* 21 (April, 1930), 214–18; Clara R. Mason, Pictures and Peasants," *Parnassus* 5 (December, 1933), 24–25; Lozowick, "The Artist in Soviet Russia," *The Nation* 135 (July 13, 1932), 35–36; Lozowick, "Aspects of Soviet Art," *NM* 14 (January 29, 1935), 16–69; and *AD* 11 (December 1, 1936), 10.
7. *AD* 2 (November 1, 1927), 2; and *Studio News* 5 (December, 1933), 5.
8. For biographical information, see Bernarda Bryson Shahn, *Ben Shahn* (New York: Harry N. Abrams, 1972).
9. Ben Shahn, *The Passion of Sacco and Vanzetti* (Syracuse, N.Y.: Syracuse University Press, 1968), pp. 48, 52.
10. See especially Thomas Hart Benton, "Art and Nationalism," *The Modern Monthly* 8 (May, 1934), 232–36.
11. Ben Shahn, *The Shape of Content* (New York: Vintage Books, 1960), p. 44. First published in 1957.
12. John D. Morse, "Ben Shahn: An Interview," *MOA* 37 (April, 1944), 136.
13. Seldon Rodman, *Conversations with Artists* (New York: The Devin-Adair Company, 1957), p. 225.
14. Malcolm Vaughan, in the *New York American* (April 29, 1933), Archives of American Art, Papers of the Downtown Gallery, New York City, Box ND36, frame 74 (microfilm).
15. *NM* 15 (June 11, 1935), 28; *AF* 1 (July, 1935), 4–5; and *AMOA* 28, August, 1935), 492–94.
16. Rivera painted a virtually identical mural in the National Palace of Fine Arts, Mexico City.
17. Shahn, *Shape of Content, op. cit.*, p. 45–48.
18. *AN* 38 (May 18, 1940), 11.
19. Katherine Kuh, *The Artist's Voice* (New York: Harper and Row, 1960), p. 210; and *Wadsworth Atheneum Handbook* (New Haven, Conn.: Wadsworth Atheneum, 1958), p. 161.
20. Museum of Modern Art, *Bulletin* 14, nos. 4–5 (1947), 23. The entire issue is devoted to the Shahn retrospective exhibition held at the Museum.

PAINTING AMERICA

1. Some of the ideas suggested here are based on two brilliant essays written by social historian Warren Susman. See Susman, "The Thirties," in Stanley Coben and Lorman Ratner (eds.), *The Development of an American Culture* (Englewood Cliffs, N.J.: Prentice-Hall, 1970), pp. 179–218; and Susman (ed.), *Culture and Commitment, 1929–1945* (New York: George Braziller, 1973), pp. 1–24.

BIBLIOGRAPHY

HISTORIES AND CRITICISMS

AGEE, WILLIAM C. *The 1930's: Painting and Sculpture in America.* New York: Whitney Museum of American Art, 1968.

BOSWELL, PEYTON, JR. *Modern American Painting.* New York: Dodd, Mead and Company, 1939.

BRUCE, EDWARD, and WATSON, FORBES. *Art in Federal Buildings: An Illustrated Record of the Treasury Departments New Programs in Painting and Sculpture.* Washington, D.C.: Art in Federal Buildings, Inc., 1936.

CAHILL, HOLGER. *New Horizons in American Art.* New York: The Museum of Modern Art, 1936.

———. *American Art Today.* New York: National Art Society, 1939.

CAHILL, HOLGER, and BARR, ALFRED H., JR. (eds.). *Art in America.* New York: The Museum of Modern Art, 1934.

CHENEY, MARTHA CHANDER. *Modern Art in America.* New York: McGraw-Hill Book Company, 1939.

CRANE, AIMEE. *Portrait of America.* New York: The Hyperion Press, 1945.

CRAVEN, THOMAS. *Men of Art.* New York: Simon and Schuster, 1934.

CRAVEN, W. S. *Eyes on America.* New York: The Studio Publications, n.d.

JEWELL, EDWARD ALDEN. *Have We an American Art?* New York: Longmans, Green Company, 1939.

KEPPEL, FREDERICK P., and DUFFUS, R. L. *The Arts in America.* New York: McGraw-Hill Book Company, 1933.

KINGSBURY, MARTHA. *Art of the Thirties: The Pacific Northwest.* Seattle: University of Washington Press, 1972.

McKINZIE, RICHARD D. *The New Deal for Artists.* Princeton, N.J.: Princeton University Press, 1973.

O'CONNOR, FRANCIS V. *Federal Art Patronage, 1933 to 1945.* Exhibition catalogue, University of Maryland, College Park, 1966.

———. *Federal Support for the Visual Arts: The New Deal and Now.* Greenwich, Conn.: New York Graphic Society Ltd., 1969.

O'CONNOR, FRANCIS V. (ed.). *The New Deal Art Projects: An Anthology of Memoirs.* Washington, D.C.: Smithsonian Institution Press, 1972.

PARKER, THOMAS C. *Frontiers of American Art.* San Francisco: M. H. De Young Memorial Museum, 1939.

PEARSON, RALPH M. *Experiencing American Pictures.* New York: Harper and Brothers, 1943.

PURCELL, RALPH. *Government and Art.* Washington, D.C.: Public Affairs Press, 1956.

SAYLER, OLIVER M. (ed.). *Revolt in the Arts.* New York: Brentano's, 1930.

WATSON, FORBES. *American Painting Today.* Washington, D.C.: The American Federation of Art, 1939.

WHEELER, MONROE. *Painters and Sculptors of Modern America.* New York: Thomas Y. Crowell Company, 1942.

MONOGRAPHS
Arranged alphabetically by artist

BAIGELL, MATTHEW. *Thomas Hart Benton.* New York: Harry N. Abrams, Inc., 1974.

BENTON, THOMAS HART. *An Artist in America.* 3d ed. Columbia: University of Missouri Press, 1968.

BIDDLE, GEORGE. *An American Artist's Story.* Boston: Little, Brown and Company, 1939.

SCHMECKEBIER, LAURENCE E. *John Steuart Curry's Pageant of America.* New York: American Artists Group, 1945.

GOOSSEN, E. C. *Stuart Davis.* New York: George Braziller, Inc., 1959.

KELDER, DIANE (ed.). *Stuart Davis.* New York: Praeger Publishers, 1971.

BAUR, JOHN I. H. *Philip Evergood.* New York: Praeger Publishers for the Whitney Museum of American Art, 1960.

GETLEIN, FRANK. *Jack Levine.* New York: Harry N. Abrams, Inc., 1966.

GOODRICH, LLOYD. *Reginald Marsh.* New York: Harry N. Abrams, Inc., 1972.

MORSE, JOHN D. (ed.). *Ben Shahn.* New York: Praeger Publishers, 1972.

SHAHN, BERNARDA BRYSON. *Ben Shahn.* New York: Harry N. Abrams, Inc., 1972.

WERNER, ALFRED. *Moses Soyer.* New York: A. S. Barnes and Company, 1970.

GOODRICH, LLOYD. *Raphael Soyer.* New York: Harry N. Abrams, Inc., 1972.

BROWN, HAZEL E. *Grant Wood and Marvin Cone: Artists of an Era.* Ames: The Iowa State University Press, 1972.

GARWOOD, DARRELL. *Grant Wood.* New York: W. W. Norton and Company, 1944.

BOOKS OF RELATED INTEREST

AARON, DANIEL. *Writers on the Left.* New York: Harcourt, Brace and World, 1961.

AARON, DANIEL, and BENDINER, ROBERT (eds.). *The Strenuous Decade.* Garden City, N.Y.: Doubleday and Company, 1970.

ALLEN, FREDERICK LEWIS, *Since Yesterday.* New York: Harper and Brothers, 1940.

BIRD, CAROLINE. *The Invisible Scar.* New York: David McKay Company, 1966.

EKIRCH, ARTHUR A., JR. *Ideologies and Utopias: The Impact of the New Deal on American Thought.* Chicago: Quadrangle Books, 1969.

LEUCHTENBURG, WILLIAM E. *Franklin D. Roosevelt and the New Deal.* New York: Harper and Row, 1963.

ODUM, HOWARD W., and MOORE, HARRY E. *American Regionalism.* New York: Henry Holt and Company, 1938.

ORTON, WILLIAM AYLOTT. *American in Search of Culture.* Boston: Little, Brown and Company, 1933.

RIDEOUT, WALTER B. *The Radical Novel in the United States, 1900–1954.* Cambridge: Harvard University Press, 1956.

RINGEL, FREDERICK J. *America as Americans See It.* New York: The Literary Guild, 1932.

ROURKE, CONSTANCE. *The Roots of American Culture.* Edited by Van Wyck Brooks. New York: Harcourt, Brace and Company, 1942.

SUSMAN, WARREN (ed.). *Culture and Commitment, 1929–1945.* New York: George Braziller, Inc., 1973.

SWADOS, HARVEY (ed.). *The American Writer and the Great Depression.* Cleveland: The Bobbs-Merrill Company, 1966.

WECTER, DIXON. *The Age of the Great Depression.* New York: The Macmillan Company, 1948.

INDEX

(Page numbers in italics denote illlustrations.)

944 A7 M8710
04/25/05 31584 SELB